Adobe® Illustrator® for Fashion Design

Susan M. Lazear
San Diego Mesa College

PEARSON

Prentice
Hall

Upper Saddle River, New Jersey
Columbus, Ohio

Vice President and Executive Publisher: Vernon Anthony
Acquisitions Editor: Jill Jones-Renger
Editorial Assistant: Doug Greive
Project Manager: Alexandrina Benedicto Wolf
Design Coordinator: Diane Ernsberger
Cover Designer: Ali Mohrman
Cover art: Samantha Song
Operations Specialist: Deidra Schwartz
Director of Marketing: David Gesell
Marketing Manager: Leigh Ann Sims
Marketing Coordinator: Alicia Dysert

This book was set in Arial MT by S4 Carlisle Publishers Services. It was
printed and bound by Courier/Kendallville. The cover was printed by Phoenix Color Corp.

Pearson Education Ltd.
Pearson Education Singapore Pte. Ltd.
Pearson Education Canada, Ltd.
Pearson Education—Japan

Pearson Education Australia Pty. Limited
Pearson Education North Asia Ltd.
Pearson Educación de Mexico, S.A. de C.V.
Pearson Education Malaysia Pte. Ltd.

10 9 8 7 6 5 4 3 2 1
ISBN-13: 978- 0-13-119274-4
ISBN-10: 0-13-119274-4

Table of Contents

Fashion Illustration and
Flats by Gentry Cole

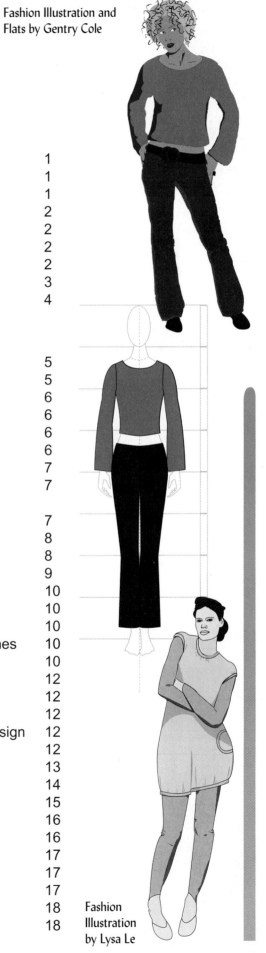

Fashion
Illustration
by Lysa Le

Traced Fashion
Poses

Emily
Blickle

Kinsey
Wilton

Destiny
Askin

Textile Design by Leah Sheets

Technical How-To's: Sonia Barton and author

Flat Drawing of an Ethnic Garment, by author

Facial Details illustrated by
Florence Yamul

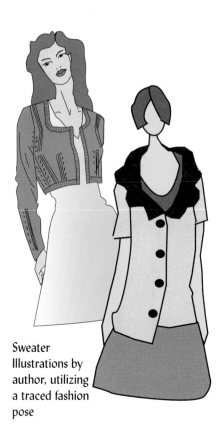

Sweater
Illustrations by
author, utilizing
a traced fashion
pose

Technical Schematic Drawing
of a knit top. (author)

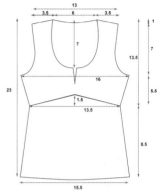

DS83-2U chinese red

DS314-3U green tea

Snapshots of Colorways
of a Garment,
by Saya Ichiki

Merchandise Layout by
Liz Hunt

Traced Illustration of a
hand-drawn garment by
Keith Antonio

Textile Design by
Stephanie Saucier

Style # 1979
Color: Grass

Textile Design Exercises pages 295–338

Presentation Techniques pages 339–360

Bathing Suit and Fabric Design
by Monica Mitchell

#4321
Spaghetti Stape
One Piece/Wrap
Scarf/ Low Open
Back

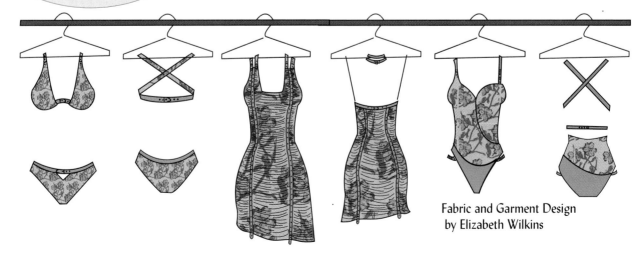

Fabric and Garment Design
by Elizabeth Wilkins

Preface

The writing of *Adobe Illustrator for Fashion Design* has been a labor of love. It is the culmination of many years of teaching design techniques to fashion students at the college level. I have worked with computers since the mid-1980s, and so I have witnessed the growth and development of art tools in software over time. I came into computer design early on, and at that time I naïvely thought that a computer could do the designing for me. I didn't "draw" well, and I just believed that a computer somehow could do that for me…like magic! I was successful, however, at learning how to design, and I taught myself how to manipulate basic paint programs to perform my task. Then one day, I realized it was indeed I who was pushing the mouse and making the design decisions: I, and not the computer, was doing the designing. So, for those of you embarking on this path with apprehension, fear not: The computer will make your life easier. It will help you tear down your barriers and eliminate your fear of drawing.

My career path has been a varied one. I have taught at the college level since 1980. A move to San Francisco led me to employment in the fashion industry where I worked for Zoo-Ink, a textile printing company, and then for American Design Intelligence Group, a fashion computer graphics service bureau that blazed the trail to merchandising apparel using computer graphics. This freelance work led me to knitwear design work with Esprit, Levi Strauss, and other San Francisco-based companies. While doing this work I developed a link between a knitting machine and a personal computer. With this discovery Cochenille Design Studio (www.cochenille.com) was born, a business that develops software for the textile arts. It was through Cochenille that all my skills came together: I could teach, write, create, and develop tools for others to use. My business and skills allowed me to travel the world extensively and to share my love and passion for computer design.

Yet, even though I continued to be excited by my work in software development, I was drawn back to teaching and passing on the love of fashion and technology to my students. I feel that my role as an educator is manifold. Not only do I teach students how to use tools such as Adobe Illustrator and Photoshop to design, I also teach them how to think and how to see as a designer sees. I hope that I inspire them as they inspire me. I share with students with full heart and soul, and their positive feedback keeps me moving forward to discover the next creative tool or approach to performing fashion design tasks on the computer.

I hope you will benefit from the materials presented in this book. I have made every effort to make the instructions clear and easy-to-follow. Samples of my students' work are given to inspire you. Many students come into class with absolutely no drawing skills and with great fear of what lies ahead. By the end of the semester, however, they have gained the knowledge and confidence to proceed forward on their own. I wish the same results for everyone. We should not be afraid of technology: We should embrace it and let it make our lives simpler.

Susan Lazear

Acknowledgements

Where does one begin? I have traveled a wonderful path in the development, conceptual planning, and writing of this book, and many people have aided me along the way. My initial thank you goes to the computer world for the technological advances that have made the computer a viable and productive tool for design. A thank you also to the Honors program at Mesa College; through this program I have been able to test new ideas in fashion design and bring technology into our curriculum in a grand way. My students through the years have served not only as a testing team, but also as inspiration for new ways to do things. Their eagerness to learn spurs me on to find new and better ways of performing creative tasks.

Many thanks to my business, Cochenille Design Studio, through which I learned the art of writing technical manuals, and to my employees, Tracy and Sonia, whose running of day-to-day operations over the years has given me the freedom to continue teaching. Thank you to all my tech readers and testers around the world, who meticulously scoured through my chapters and provided additional insight on how information is received and processed. Thank you also to Adobe, for giving us this wonderful design tool, Illustrator, as well as to the staff at Pearson, who have waited patiently for me to finish this project, which grew in scope by leaps and bounds.

Last of all, thanks to my family and friends. Blake and Danny, you mean the world to me: Your support of my passion to work in this creative realm is more than any mother could ask. I appreciate all the friends who put up with my absence at their activities, and I thank my extended family for their support and faith that this project would come to completion.

Introduction

Welcome to the design world of Illustrator! You are about to embark on a creative digital journey through which you will explore the abilities of one of the most powerful software programs in the world, Adobe Illustrator. Through a series of exercises you will explore the basics of designing fashion and related drawings.

Intended Audience

This book is written to assist Illustrator users, both new and old, in developing skills relevant to designing fashion apparel and textiles. You will use many of the tools and functions in the same manner that you use them for other types of drawings. At the same time, however, you will learn how to "think" and prepare drawings of clothing, fashion poses, textile prints, etc. Instructions are written with the assumption that you know very little about Illustrator and its operation. Experienced users should be able to skim sections at times, but it is recommended that you read all that is written, in case you can pick up a new trick.

Layout of the Book

The early chapters of this book will provide you with an overview of Adobe Illustrator. Chapter 1 introduces you to the Illustrator approach to design, and lays out several design concepts that, once understood, will form the foundation for greater learning. These teach you to understand vector graphics as an approach to design. You will find a quick drawing exercise in Chapter 2. This will allow you to get our feet wet, with a fun yet constructive exercise. Chapters 3 through 5 take you on a tour of Illustrator, as you explore the Toolbox, Menus, and Panels (called palettes in versions prior to CS3).

Once you have started to build your solid foundation with Illustrator, you can move on to the *Basic Drawing Exercises* section of the book. Each exercise is designed to teach you something about a basic skill that is commonly used in design and/or will be utilized more fully in a fashion sense in the next section of the book. The drawing exercises will teach you about fills and strokes, drawing basics, using the grid, using layers, and many other basic techniques. The *Fashion Drawing Exercises* section of this book has specific exercises that teach you how to utilize the tools and skills you have achieved with Illustrator to draw flats, fashion poses, and other fashion-related techniques. The *Textile Design* and *Presentation* exercises will teach you how to design fabric, create swatches, and prepare merchandise presentations.

Files on the DVD

The DVD that accompanies this book includes files utilized in the exercises as well as additional files for your viewing. These are organized in folders, which are labelled with regard to their content and/or correlation to specific chapters in this book.

"When you enter this world (of Illustrator), you are given a blank canvas and the tools to create, to build. Then, when it's time to exit, you will have created a masterpiece; the beautiful illustration that is your life."

Cynthia Martinez
Mesa College Fashion Student

Illustration by Masaki Suka

Note: Sample Note
Notes will be presented in the sidebar to reinforce a point or to make a comment.

Tip: Tips
Check the sidebar for tips, which typically are designed to save you time in working in Illustrator.

Ksenia Galyga

Note:
Macintosh vs. Windows

The User Interface of Illustrator is nearly identical between Macintosh and Windows operating systems. Keyboard shortcuts, however, do vary slightly, specifically in reference to what are known as modifier keys. When keyboard shortcuts are given in this book, they will be presented with the Macintosh shortcut first, followed by the Windows shortcut. For example, if instructions ask you to press the Option/Alt key on the keyboard, the Option key refers to the Macintosh while the Alt key refers to the Windows key.

Note:
Keyboard Shortcuts

You may use both upper- and lowercase letters for the keyboard shortcuts.

Artwork Used in the Book

The artwork used throughout this book and on the DVD was created either by the author, Susan Lazear, or by her students in the Fashion Program at San Diego Mesa College. Susan has taught at Mesa since 1989 and she oversees all the computer fashion classes.

Version of Illustrator?

As is known, software program versions can roll out quickly, causing software and books to become outdated before they've barely been used. The information presented in this book attempts to discuss Illustrator in a manner that is generic to multiple versions of the software. Instructions are specific to the Creative Suite versions of Illustrator (CS3, CS2, and CS1), but owners of prior versions will be able to utilize the vast majority of the techniques discussed.

How to Approach Your Studies with This Book

To get the most out of this book, you should be comfortable with your Windows or Macintosh computer. Be familiar with mouse and menu operations as well as loading/saving files, and working with dialog boxes/windows. If you are a new user, you may want to take the time to work with these basic operations. Refer to your operating system's manual or Help files for assistance.

This manual was written in a format that, once understood, will make your learning easier. The main text of the manual appears in this column of each page. Additional comments, tips, notes, and illustrations will generally appear in the sidebar.

Working with Menu Operations

Various types of menus exist in Illustrator. The most common menus are found in the Menu bar at the top of the screen. In addition to these menus, you have panel menus and context menus.

Menu Bar Menu Commands

Text in bold italic type tells you that reference is being made to a Menu Bar command item, as the following example demonstrates:

- On the *File* menu, click . . .

Text in regular italic type tells you that an action occurs through the selection of a menu and commands, as the following examples illustrate:

- On the *File* menu, click on the *Save As* command. To do this, single-click on the *Save As* command from the *File* menu. OR

- Choose the *File>Save As* menu function. To do this, single-click on the *Save As* command from the *File* menu.

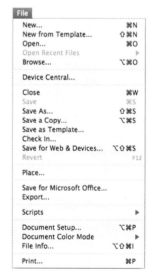

The File menu in Illustrator

Panel Menus (Palette Menus in versions prior to Illustrator CS3)

The term Panel will be used throughout this book, as this is the new name given to the traditional palettes of Illustrator (as of CS3). Most of the panels in Illustrator have menus, which are accessed by clicking on the arrowhead that appears on the upper right corner of the panel. When you click with your mouse on this arrow, a menu, with function options, specific to the panel appears. You can slide down to the appropriate command. Typically, several of the functions can also be accessed through the icon bar at the bottom of the panel.

Context Menus

Context Menus appear when you *Ctrl+click* (Mac) or *right mouse+click* (Windows) as you are using a tool. The context menus present various options available to the selected object and/or tool currently being used.

Working with Tools, Dialogs, Panels, etc.

Text in bold non-italic type tells you that an action occurs through the use of a tool, dialog box field, or other non-menu function, as the following examples show:

- Click on the **OK** button in the window.

- Choose the **Selection** tool....

Since the use of keyboard shortcuts allows you to speed up the design process, you will often be given the keyboard shortcut to certain menu commands, tools, and operations. In general, on the Macintosh, the *Command (Cmd)* key is used in conjunction with another key. The Windows equivalent is the *Control* (Ctrl) key. These keys as well as other keys such as the *Shift, Option/Alt* keys are known as *modifier* keys. In this book, these will be presented as follows:

Cmd/Ctrl+C	To copy an object or selected text to the clipboard.
Spacebar+Cmd/Ctrl	Press these keys and click with the mouse to zoom in.
Opt/Alt+Drag	Use this key operation to copy a selected object.

In all cases, the Macintosh key will precede the Windows key. In the first two examples above, the Mac *Command* key (Cmd) is followed by the Windows *Control* key (Ctrl) and then the appropriate keyboard letter is given. In the second example above, the Mac *Option* key (Opt) is followed by the Windows equivalent, the *Alt* key.

Various shortcuts for tools in the Toolbox and functions in Illustrator do not use modifier keys. Reference to these will be given as follows:

Select the **Direct Selection** tool (A).

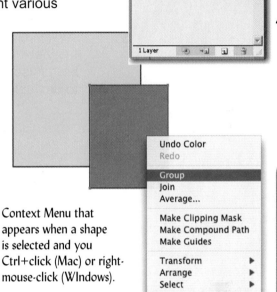

The panel menu is accessed through the arrowhead that appears in the upper right corner of the panel (CS2 above and CS3 below).

Context Menu that appears when a shape is selected and you Ctrl+click (Mac) or right-mouse-click (Windows).

Note: Panels in CS3 vs. Palettes

Illustrator CS3 has renamed the traditional palettes as panels. This book will use the new term, but understand that panels and palettes are interchangeable.

A Tool Tip appears when you place your cursor above a tool and hold it there for a second.

For Sake of Clarity

The following are items or practices within Illustrator and/or this book that should be understood:

♦ Double-clicking on a tool in the Toolbox opens a dialog that allows you to set options for the use of the tool.

♦ For sake of emphasis, strokes used in certain drawings in this book are drawn with a heavier stroke line than the instructions are directing. This is done to assist the user in seeing the path and is for illustrative purposes only.

♦ Illustrator uses the term *Bounding Box* in two different ways. Typically, the bounding box referred to is the box that surrounds the selected object and serves as a quick means for editing the object. This is accessed through the *View>Show Bounding Box* menu command. The second bounding box is used in building Pattern repeats and is a box that defines the area to be duplicated and repeated.

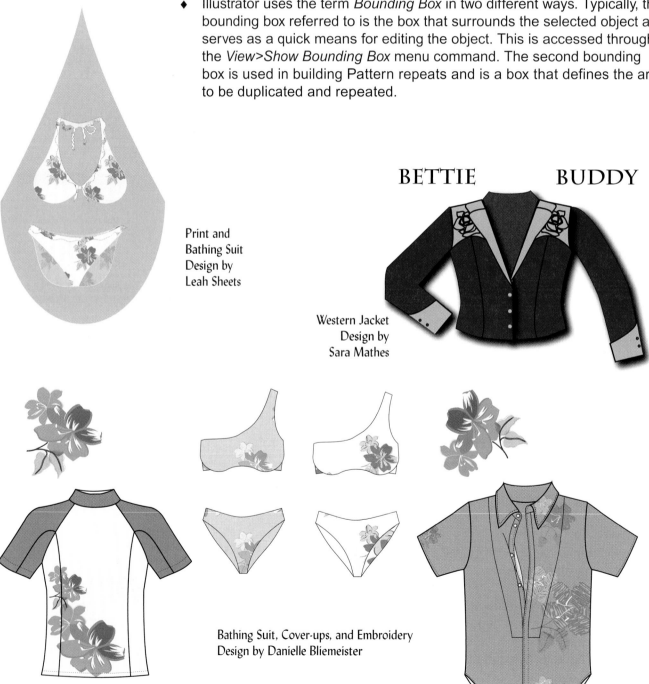

Print and
Bathing Suit
Design by
Leah Sheets

BETTIE BUDDY

Western Jacket
Design by
Sara Mathes

Bathing Suit, Cover-ups, and Embroidery
Design by Danielle Bliemeister

Overview of Adobe Illustrator

Adobe Illustrator is an amazing tool for design! You will find that developing fashions and textiles in a vector program such as Illustrator is unlike any other drawing experience you have had. You will work with new tools that operate in ways similar to, yet distinctly different from your hand tools such as pencils, pens, and the various art media. In this chapter, we will take a quick peek at what Illustrator is all about and introduce you to several basic concepts critical to the understanding of working with a vector-based design tool.

The Illustrator Approach to Design: Vector Graphics

Illustrator is an object or vector-based design program. When you draw in the program, you do so by creating objects that are composed of lines (straight and curved) and/or shapes such as circles, rectangles, and various other polygons. In order to better understand Illustrator, it will help to have an understanding of the two basic types of design software: object (vector) vs. pixel (raster). Illustrator is an example of an object-based program and Photoshop is an example of a pixel-based program.

Object vs. Pixel Design

In comparing the two types of design software, let's examine a circle.

Object

If you draw a circle in a vector program, you choose the tool, click your mouse to set the starting point, and then hold and drag the mouse to define the width and height of the circle. As you thus define the shape, the program notes the initial placement coordinate, and then the current width and height, and it also notes the color and pen thickness. When it prints the circle, it sends similar information to the printer. It tells the printer to print a circle by giving the size, position, and the thickness and color of the line. The circle will print a perfectly smooth shape.

Pixel

If you draw a circle in a pixel-style program, you choose the tool, click your mouse to set the starting point, and then hold and drag the mouse to define the width and height of the circle. As you define the shape, the program notes the initial placement coordinate, and then draws a series of pixels (picture elements) to form curved arcs that define the width and height of the shape. The color and pen thickness are included in the drawing of the pixels. Once the image is drawn, each pixel or dot becomes a fixed point on the document and if you want to edit the circle, you must erase part or all of it, and redraw the section erased. When the circle prints, each pixel or dot is sent to the printer. If you use a low document resolution (e.g., 72 dots per inch), you will see the jagged edge of the pixels. If you use a higher document resolution (e.g., 300 dots per inch), the shape will appear smoother, but one can still see the slightly jagged edge upon close examination.

Illustration by Megumi Inoue

A circle drawn in Illustrator (above) and Photoshop (below). The close-up snapshot below shows you the anti-aliasing that occurs in a paint-style program.

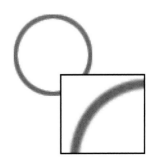

Object-Based Documents . . .
- when saved, store the basic information of each object in the image.
- tend to be smaller in file size.
- have individual objects that are remembered as such and thus may be easily edited and resized.

Pixel-Based Documents . . .
- when saved, store the exact location and color of each and every pixel in the drawing.
- tend to have a larger file size.
- are created through scanning, digital cameras, etc.
- are generally more difficult to edit due to pixels drawn to represent an image.

Note: Shape Tools
When you draw with the Shape tools you create closed objects/paths only.

What Is Anti-Aliasing?

Anti-aliasing is a function commonly found in a raster or pixel-based program such as Photoshop. Aliasing is when pixels of sharp edges appear jagged. Anti-aliasing is when edges of your drawing are smoothed out through an averaging process. This is achieved by adding pixels that are averaged in color between the sharp colored edge of your drawing and the background color. If you zoom in close to look at the edge of an anti-aliased image, it will appear slightly blurred. However, the edge will appear smoother in zoomed-out modes and in printing. One does not need to concern himself/herself with anti-aliasing in Illustrator unless a raster file is being used as part of the design.

Vector Terminology and Concepts

The initial learning curve of Illustrator is somewhat steep as you will need to study and understand numerous concepts that are rather foreign to the typical process of drawing by hand. Illustrator and similar vector-based software programs have their own unique language. Understanding the concepts that follow will serve you well. Drawing is generally performed with the **Pen** tool or **Shape** tools.

Concept 1: Illustrator Objects

When you draw with Illustrator you create objects or shapes composed of one or more segments.

 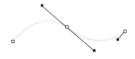

Three straight segments　　A circle composed of four curved segments　　Two curved segments

Concept 2: Segments and Paths

The use of these two terms is somewhat confusing. Segments are the lines (straight or curved) you use to create an object. A path is made up of one or more segments, so as you draw, you are building an object through the drawing of a path that is composed of one or more segments.

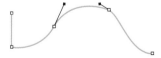

One straight segment and three curved segments create the path shown here.

Concept 3: Open and Closed Paths/Objects

The paths you create may be either *open* (as in the case of an arc), or *closed* (as in the case of a circle where the beginning and end points are the same).

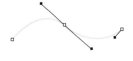

An open path (left) and a closed path (right)

Concept 4: Anchor Points and Endpoints

Anchor points define the beginning and ending points of each segment. Endpoints are the two outer anchor points of an open path. Therefore, closed paths are composed of multiple anchor points, and open paths are composed of two endpoints and anchor points (if there is more than one segment). You control the shape of a path through its anchor point type (see Concept 6 below); thus, the manner in which you set or edit anchor points dictates the shape of your object.

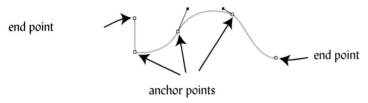

end point

end point

anchor points

Concept 5: Curved vs. Straight Segments

Straight segments are created by simply clicking and releasing the mouse button as you set your anchor points. Curved segments are created by clicking and dragging the mouse, as you place an anchor point. A *direction line* will appear and extend from the anchor point and *control points* will appear at the ends of the direction line. The angle of the direction line and the distance of the control points from the anchor point together dictate the arc of the curve. You can edit the control points at any time to change the shape of the curve.

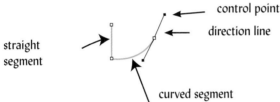

control point

direction line

straight
segment

curved segment

Concept 6: Corner vs. Smooth vs. Combination Anchor Points

There are three types of anchor points; corner, smooth, and combination. At a *corner* anchor point, a path will abruptly change its direction (think of a rectangle). At a *smooth* anchor point, two curved paths are connected as a continuous curve (think of a circle). Thus a corner anchor point connects two straight segments, and a smooth anchor point connects only two curves. A *combination* anchor point joins a straight and a curved segment. **Note**: Some people classify anchor points as either corner or smooth, and treat what others call a combination point as a corner point. You may change corner points to smooth points and vice versa at any time using the **Convert Anchor Point** tool.

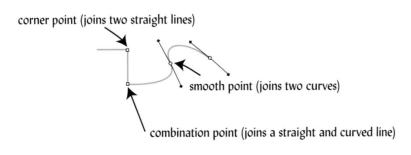

corner point (joins two straight lines)

smooth point (joins two curves)

combination point (joins a straight and curved line)

Note: If an anchor point joins two curved segments, there will be two direction lines extending from that anchor point. One direction line controls the arc of the first segment, and the second direction line controls the arc of the second segment. You can have direction lines at both ends of a segment, which gives you yet more control over the shape of the curve.

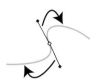

One direction line controls the segment to the left of the anchor point and the other direction line controls the segment to the right of the anchor point.

Concept 7: Stroke and Fills

Stroke of Purple and Fill of Beige in the Toolbox

A path is composed of a *stroke* (outer edge) and/or a *fill.* A fill may be the color that extends between two anchor points on an open path or the entire internal color of a closed path. The *stroke attributes* are set using the *Control* panel (CS2 and CS3) and/or the *Stroke* panel (*Window>Stroke*). Attributes include thickness (weight), color, and whether the stroke is solid or dashed. Dashed strokes are used to indicate top-stitching. The *Appearance* panel (*Window>Appearance*) displays the current attributes.

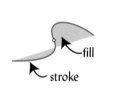
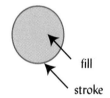

Stroke color of purple and Fill color of beige on an open object (left) and a closed object (right)

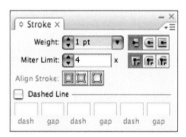

The Stroke panel (left) and the Appearance panel (right)

Concept 8: Selecting Points

The Selection tool (left) and the Direct Selection tool (right)

In order to edit anchor points, you need to select them. This is done by using the various *Selection* tools. The **Selection** tool (black arrowhead) selects all points in an object and allows you to move it or transform it by scaling, rotation, etc. The **Direct Selection** tool allows you to select only the points you click on, or drag around, providing greater editing control. You can move selected points, convert them to a different type of anchor point, or perform other transformations on them such as rotate, scale, etc. Selected anchor points appear as a solid square, whereas unselected points appear as a hollow square. The **Direct Selection** tool also allows you to select a segment by clicking on it.

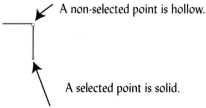

A non-selected point is hollow.

A selected point is solid.

There are two ways to select chosen points with the **Direct Selection** tool:

Click—Using the **Direct Selection** tool, click on a point to select it. It will become solid. Be careful not to shake or jiggle your hand as you select a point as you could inadvertently move it. If you want to select multiple points, you may press and hold the *Shift* key down as you click on additional points. The first time you click on a point it is selected (solid). If you click on the point a second time, it becomes deselected (hollow).

Drag+Select—Using the **Direct Selection** tool, click and hold your mouse near an anchor point and then drag a box around it to select it. If you want to select multiple points, *drag+select* around a group of points.

The **Group Selection** tool is hidden under the **Direct Selection** tool. You can tear the Direct Selection toolset off the Toolbox by clicking and dragging on the **Direct Selection** tool and sliding over to the Tearoff bar to the right of the tools.

The **Group Selection** tool allows you to select specific segments and anchor points on objects that are grouped. This means that you do not have to "ungroup" a group in order to perform changes on it.

Concept 9: Mouse Actions

There are three mouse movements you will use when *drawing* with the Pen tool:

Click+release – which is used to set an anchor point with no curve control arms.

Click+hold+drag – which is used to set an anchor point with a curve control arm.

Click+release on a Combination Point or Smooth Anchor Point during the process of drawing – which allows you to turn off or remove the second curve control arm (the control arm set up for the segment you are about to draw) of the anchor point. You must perform this action immediately after you create the combination or smooth anchor point or use a different technique later.

There are two mouse movements you will use when *selecting anchor points* for editing (using the Selection tools). *These are:*

Click+release – which is used to select an object (with the Selection tool) or a chosen point or segment on an object (with the Direct Selection tool).

Click+hold+drag – which is used to select multiple points by dragging a box around them. This action will be referred to as *Drag+Select* throughout this text.

Selected Points?
How can you tell if a point is selected? If it is solid, it is selected. If it is hollow, it is not.

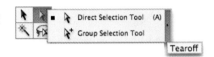

The Group Selection tool is stacked under the Direct Selection tool.

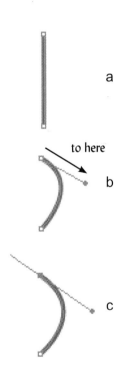

Various Mouse Actions and Results
a click+release
b click+hold+drag
c click+release on a Combination Anchor Point or a Smooth Anchor Point during the drawing process.

End open paths by either clicking away or selecting a different tool.

Concept 10: Ending an Open Path

When you are drawing an open object/path (with the **Pen** tool), you may want to end the object prior to closing it. *There are two ways to achieve this:*

Click away – Press and hold the *Cmd* key (Mac) or the *Ctrl* key (Windows) and click away from the object. While depressed, this modifier key changes the cursor and thus the tool to the most recently used **Selection** tool (either Selection or Direct Selection). Using this approach allows you to keep the **Pen** tool handy for drawing the next object, without going to the Toolbox to choose a different tool and then back again to reselect the **Pen** tool. If you are using a Selection tool, you simply click away from the object.

Select a different tool – The selection of a different tool while drawing with the **Pen** tool ends the drawing of the current object. You will need to move to the Toolbox to do this (or use a keyboard shortcut for a different tool). You will need to choose the **Pen** tool once again to continue drawing a new object.

Constrained segments result in lines that are perfectly horizontal, diagonal, or vertical.

Concept 11: Drawing Straight Segments

Pressing the *Shift* key on the keyboard as you draw constrains lines to be straight (horizontal or vertical) or diagonal. Holding this modifier key causes the line you draw to be perfectly horizontal, vertical, or diagonal (45 degree), according to how you position and drag the mouse.

Concept 12: Learning to Nudge

If you want to move a segment and/or anchor point(s) in a controlled manner, use the **Direct Selection** tool to select the desired points/segments, and then press and tap the appropriate *arrow key* on the keyboard, which will *nudge* the selected points/segments in the direction of the arrow. You can continue tapping the key until you have moved the selection the desired amount.

Concept 13: Understanding the Use of Direction Lines

You can use direction lines to alter the shape of a curve. Extending the length of a direction line deepens the arc of the curve. Changing the angle of the direction line affects the shape of the curve.

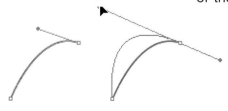

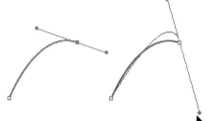

The left image is the original curve. The image to the right shows you how extending the direction line deepens the arc of the curve.

The left image is the original curve. The image to the right shows you how repositioning the angle of the direction line affects the arc of the curve.

Terminology Refresher

The following is a summary of the different terms discussed in this chapter. See if you understand each one and review the concepts as necessary to firm up your knowledge.

Object—a unit of design in Illustrator, created through the drawing of paths.

Paths—The outer edge of an object, composed of anchor points and segments. Paths are easily edited after drawing.

Closed Path—An object that has the same beginning and ending anchor point (e.g., a full circle).

Open Path—An object that has different beginning and ending anchor points (e.g., an arc).

Anchor Point—A single point on the drawing or a point that joins two segments of a path. It is represented by a small square on the screen.

End Point—The beginning or end point of an open path.

Corner Point—joins two straight segments. It is represented by a small square on the screen.

Smooth Point—joins two curved segments. It is represented by a square on the screen with two direction lines, one arm for each curved segment.

Combination Point—joins a straight and curved segment. It is represented by a square on the screen with direction line extending from the curved segment side.

Direction Lines—An antenna or pair of antennae that project from an anchor point and thus define the arc of the curve of the segment it is attached to.

Segments—A straight or curved drawing or path.

Straight Segment—The segment between two corner points.

Curve Segment—The segment between one corner point and a smooth point, OR the segment between two smooth points.

Stroke—The outline or edge of a path/object. One can control its color and thickness as well as its continuity (continuous or dashed).

Fill—The color, pattern, or gradient assigned to the inside of an object.

Selections/Select—The process of highlighting an object or points on an object to make them active. One must select an object or path in order to edit them. The two primary Selection tools are the **Selection** and **Direct Selection** tools. A complete object is selected by clicking either on its outer outline (if there is no fill), or inside the object (if there is a fill). Individual segments or points are selected by choosing the **Direct Selection** tool and

performing any of the following operations:
- clicking on the segment itself
- *drag+select* around the desired segment(s)
- clicking on an anchor point to select it.

The General Process of Design

The process of drawing in Illustrator typically involves a routine combination of steps. *These are:*

1. Set up the Document

This involves choosing the document size, orientation, and color mode to open a document on the screen. You then need to choose which panels you want available for use while you work on the project. These are opened using the *Window* menu.

2. Define Stroke and Fill Attributes for Your Path

Prior to drawing, you need to decide which fill and stroke attributes will be needed by the object you are about to draw. You set these by choosing the *Fill* or *Stroke* icon in the Toolbox and setting the color using the *Color Picker* or *Swatches* panel. In addition, you need to set the weight and continuity (solid line or dashed line) of the stroke.

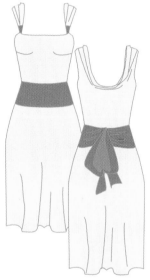

3. Create the Various Objects Necessary for the Design

Once you have set the *fill* and *stroke* options, you are ready to begin drawing your design. Through the creation of closed and open objects, and the use of the various drawing and editing tools, you build your fashion drawing. The **Pen** tool is the most commonly used drawing tool. The general process of drawing involves setting anchor points and establishing straight and curved segments between the points. To familiarize yourself with the process of drawing use the practice exercises found in the *Basic Exercises* section of this book. If the initial drawing is not perfect, do not concern yourself as you may easily edit the drawings at any point in time.

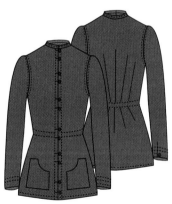

Garment flats by
Natalie Richardson

4. Edit and/or Transform the Objects

It is not critical that you draw with extreme and final precision when first creating an object. Editing the points and segments is easy to do. Once the basic framework of the object has been drawn, use the various editing tools described on pages 42–44 to edit/reshape your drawing. *Typical editing functions involve the following:*
- repositioning an anchor point
- reshaping a segment
- changing a straight segment to a curved segment (by using the **Convert Anchor Point** tool found stacked under the **Pen** tool in the Toolbox)
- moving an object
- resizing an object
- changing fill and stroke attributes

User Interface and the Working Environment

The first step to mastering any software program is to become familiar with its working environment and the tools provided for your use. The depth of Illustrator is great, so don't expect to learn everything quickly. Initially you may need to switch gears from working in a typical paint environment to working with an object-oriented program. When you open Illustrator and a document window, you will see several components appear on your screen. Primarily, you will see a **Toolbox**, **Menu Bar**, various **Panels**, and a **Document** window. On the lower left corner of the Document window you will see an **Info** or **Status Bar**. It is assumed that you know the basics of your operating system (Windows or Macintosh), in that you know how to create folders, load and save documents in their desired locations, and use the various options found at the perimeter of your document (such as the close box, zoom field, scroll bars, etc.)

When you first open Illustrator, you will discover that a document doesn't appear automatically. It is up to you as the user to either create a new document or open an existing file. This is achieved via the *File>New* menu or the *File>Open* menu.

Once a document is open, you will see the following on your screen:
- o Document Window
- o Menus
- o Toolbox
- o Various Panels

> ### Is Illustrator Open?
> Many new users do not even realize the program is open. A quick scan of the Menu Bar at the top of the screen should confirm that the program is indeed open and ready for use.

The Macintosh Environment, CS3

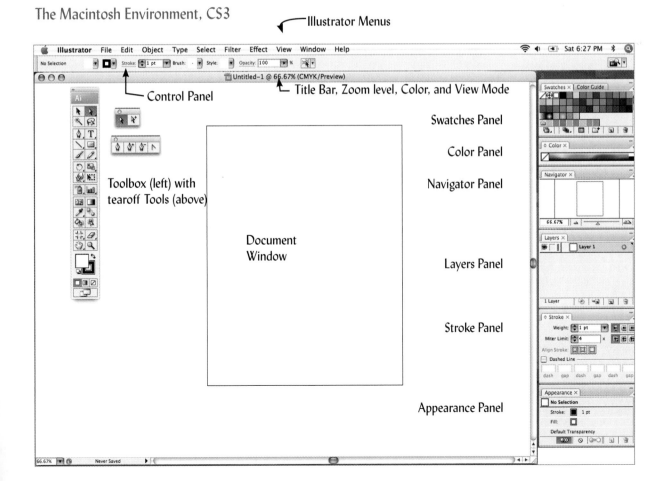

Illustrator Menus

Control Panel

Title Bar, Zoom level, Color, and View Mode

Swatches Panel

Color Panel

Navigator Panel

Toolbox (left) with tearoff Tools (above)

Document Window

Layers Panel

Stroke Panel

Appearance Panel

The Windows Environment, CS3

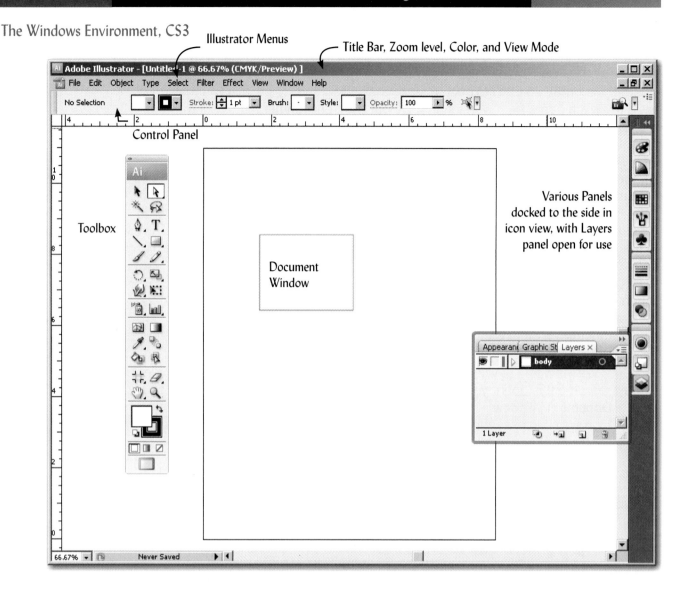

Illustrator Menus

Title Bar, Zoom level, Color, and View Mode

Control Panel

Toolbox

Document Window

Various Panels docked to the side in icon view, with Layers panel open for use

Window Control

Macintosh

Red— close
Yellow—minimize
Green— zoom

Windows

X - close
box - maximize
dash - minimize

The Document Window

The **Title Bar** of your document will provide you with four pieces of information; the document name, the current zoom level, the color mode you are working in (RGB vs. CMYK), and the current View mode (Preview vs. Outline). You will see the typical document close, minimize, and zoom icons on the title bar as well. On the Macintosh, these icons are positioned on the upper left; in Windows they are positioned on the upper right. On the lower left corner of the Document window you will see a **Status Bar**.

The Macintosh Document (above) and the Windows Document (left)

The Toolbox

The Toolbox contains various tools, grouped according to type. The tools vary slightly in different versions of Illustrator, so if you are using a version earlier than CS1, consult your manual. To select or activate a tool, you simply click on it and the tool will darken to show you that it is the active tool. *The following tools exist in the Toolbox of Illustrator CS3:*

Selection Tools—(the top four tools plus hidden tools) These allow you to select paths and/or objects in order to move or manipulate them.

Drawing and Editing Tools—(the next six tools plus hidden tools) These functions allow you to create paths and objects as well as type.

Transformation Tools—(four tools plus hidden tools) These tools are used to manipulate or change paths and/or objects.

Miscellaneous Tools—(eight tools plus hidden tools) This group of tools serve various specialty functions such as gradient fills, spraying symbols, etc. Two new tools, Live Paint Bucket and Live Paint Selection, were first added in version CS2.

Document Management Tools—(four tools plus hidden tools) The top two tools in this group allow you to slice documents for the web and/ or cut objects into pieces. The lower two tools allow you to maneuver around your document by either zooming in or out and panning around the document.

Fill and Stroke Functions—The *fill* and *stroke* options are positioned beneath the tool groups. You can choose to set the default fill (white) and *stroke* (black) by clicking on the *Default Fill and Stroke* icon. You can swap the *fill* and *stroke* by clicking on the *Swap Fill and Stroke* icon (or press 'X' on the keyboard). There are three color options positioned directly below the stroke and fill. These are Color, Gradient, and None (left to right).

Screen Modes—The lower icon in the Toolbox allows you to choose which screen display you want. Choose between Maximized Screen Mode, Standard Screen Mode, Full Screen Mode with Menu Bar, and Full Screen Mode. *Clicking+holding* on the current mode will open a pop-up menu and allow you to change modes.

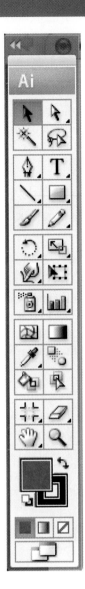

The Toolbox
in Illustrator CS3

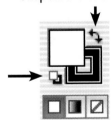

Swap Fill and Stroke

Default
Fill and
Stroke

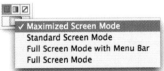

Screen Modes accessed
through a pop-up window

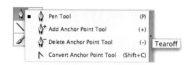

Tearing off the Pen tools. Drag over to the tearoff bar and release your mouse. A Pen tool panel appears.

Tearoff Tools

The most handy toolbars to tear off are the Selection tools, the Pen tools, and the Rotate/Reflect tools.

Selection tools (left) and Pen tools (below)

Rotate and Reflect tools

Window	
New Window	
Minimize Window	⌘M
Bring All To Front	
Actions	
Align	⇧F7
✓ Appearance	⇧F6
Attributes	F11
Brushes	F5
✓ Color	F6
Document Info	
Flattener Preview	
Gradient	F9
✓ Graphic Styles	⇧F5
Info	F8
✓ Layers	F7
Links	
Magic Wand	
✓ Navigator	
✓ Pathfinder	⇧F9
✓ Stroke	F10
SVG Interactivity	
✓ Swatches	
Symbols	⇧F11
✓ Tools	
Transform	⇧F8
✓ Transparency	⇧F10
Type	▶
Variables	
Brush Libraries	▶
Graphic Style Libraries	▶
Swatch Libraries	▶
Symbol Libraries	▶
✓ Dress Design @ 157% (CMYK/Preview)	

The Window menu allows you to access the panels.

Tool Tearoffs

If the tool has a small triangle or arrowhead in the lower right corner, additional tools are stacked or hidden beneath it. These are sometimes called *Tool Sets*. To access the additional tools, click and hold on the top tool to access a pop-up menu that displays all the tools. Hidden tools can be torn away from the panel to become a floating tool strip. *To tear tools off:*

1. Click and hold the top tool with your mouse button. This will open a small window displaying the stacked tools.

2. Drag your mouse so that the cursor is placed over the vertical tearoff bar of the window. When you release the mouse button, the tools appear in their own strip/panel.

You can move the panel around the document by clicking and holding the top bar of the panel and dragging the mouse. If you want to close a panel, simply click on the close icon on the top bar of the window.

The following are helpful Toolbox Tips:

o Placing and holding your cursor over a tool allows you to see the tool name and keyboard shortcut.
o When a tool is selected, its name appears in the *Info Bar* at the lower left corner of the document.
o Pressing the *Tab* key on the keyboard will hide/show the Toolbox and all open panels on the screen.

Panels (called Palettes in versions prior to CS3)

A panel is a floating window that contains functions according to a theme. Panels allow you to modify images or to monitor your status. They are accessed through the *Window* menu. If a panel is open, a check mark appears beside the panel name in the *Window* menu. The choice of which panels to open will vary from user to user, and from project to project. Any given panel window may contain multiple functions, each organized like a manila folder with a tab.

The *Control* panel (introduced in version CS2) is different from most other panels in that its contents change depending on which object is currently selected. This panel appears at the top of the screen (but may be moved to the bottom of the screen) and allows you quick access to options related to the objects you select.

The following is true of panels (other than the Control panel):

o Each panel (other than the *Control* panel) has a tab to indicate the name of the panel.
o Panels can be docked or grouped so that several appear in a window together. Clicking on a panel tab brings the selected panel to the front.
o You can tear a panel away from the group by clicking on its tab and dragging the panel away from the others. You can group panels by dragging independent panels into a window that contains a group.
o Many panels have menus accessed by clicking on the arrowhead (panel menu button) that appears on the upper right side of the panel. These menus contain commands pertinent to the function of the panel.

o Panels can be collapsed to the panel title only (by double-clicking on a tab). Double-clicking a second time returns the title to the full panel.
o The layout and position of panels are stored when you close Illustrator so that the next time you open it, all will appear as you last left it.

Note: Tab Key
Pressing the tab key hides all the Illustrator panels. Pressing tab a second time brings them back into display.

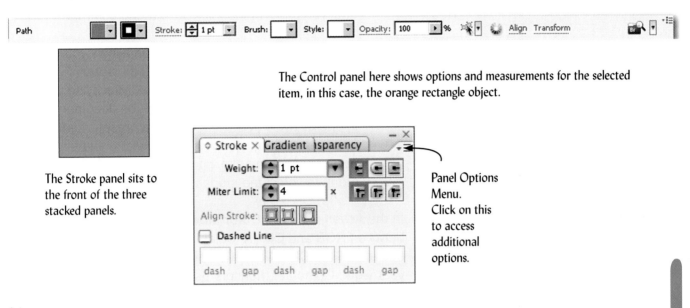

The Control panel here shows options and measurements for the selected item, in this case, the orange rectangle object.

The Stroke panel sits to the front of the three stacked panels.

Panel Options Menu. Click on this to access additional options.

Menus

Illustrator's menus are organized according to function. Each menu has numerous commands, some of which open a dialog (those ending with …) and some of which have additional submenus (those containing a black arrowhead). When you examine the menus, you will see that various commands have keyboard shortcuts that are shown to the right of the command name. These begin with the *Cmd* (command) key on the Mac, and with the *Ctrl* key on Windows.

The Select menu and submenu of the Same option

Basic Maintenance Operations

Preferences

Most work or design-oriented software programs allow you to control and set your personal preferences. When you choose your settings (accessed through the *Illustrator>Preferences* menu on the Mac OSX and the *Edit>Preferences* menu on Windows) and click **OK**, you are essentially creating a default document that will load each time you select *File>New*.

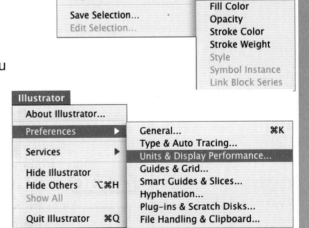

The most common preferences to set are:
o Units of measurement (for the grid, rulers, font sizes, etc.)
o Grid increments and color
o Guideline increments and color

Requesting the Units dialog Preferences

Preference changes do not apply to an open document. They will be active for the next document you open.

Setting up a Document

To create a new document, choose the *File>New* command. *A dialog will open and present you with several options as follows:*

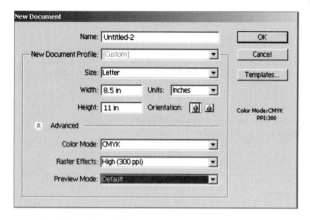

The File>New dialog

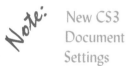

New CS3 Document Settings

CS3 provides you with greater capabilities in the New Document settings. You can now create and save template files to customize your initial documents. These settings can include resolution settings, which is pertinent to print vs. web design.

o You can name a document when you create it, or later. Type the file name you want to use into the blank box. Note that the file is not actually saved with this name until you perform the *File>Save* menu command.

o The *New Document Profile* section allows you to set the size of your document utilizing the various options provided in the pop-up menus or by specifying your own custom size. You can choose the document size in one of two ways. Either select a preset size from the pop-up menu, or type in the size, width, and height in pixels, inches, cm, mm, points, or picas. Use the pop-up menu to select the mode of measurement.

o In the Advanced area, **Color Mode** allows you to choose between RGB and CMYK or lab color. Whether you choose to use RGB or CMYK depends on how you will view or print your work. Computer monitors use RGB, as do many ink jet printers. Conventional printing presses use CMYK inks and so this color mode is the preferred choice for projects going to press.

What Is Resolution?

In order to discuss resolution, one must have an understanding of what a pixel is. A pixel (from Picture Element) is the smallest drawing unit on the screen.

There are three types of resolution used in computer graphics. These are image resolution, monitor resolution, and printer or output resolution.

o **Image resolution** is measured by the number of pixels per inch (ppi) in the image. Images with a high resolution (e.g., 300 ppi) will have more pixels and thus the file size will be larger. Imagery will print smoother, but will take longer to save and print. In Illustrator, this type of resolution becomes important only when you are working with raster-based effects such as drop shadow, inner glow, etc. (found in the **Filters** menu) or when you are introducing a raster image into your file (e.g., a piece of scanned fabric from Photoshop). Choose the *Effect > Document Raster Effects Settings* menu. Settings vary from 72 ppi to 300 or more ppi. If you are preparing images for the web, use 72 ppi. If you are preparing images for printing, use higher resolutions (such as 300 ppi).

o **Monitor resolution** is measured in dots per inch (dpi). The translation of image resolution to monitor resolution is one to one, so if you have an image with 100 ppi image resolution displayed on a monitor with 72 dpi display, the image will be approximately 30 percent larger on the screen when displayed at 100 percent.

The Document Raster Effects Settings dialog in CS2

o **Output or printer resolution** is the number of dots per inch printed by the printer. Higher resolution printers will print higher resolution images with smoother results.

Saving Files

When you save a file you have several options to choose from. *These are:*

File>Save	saves changes made to the current file.
File>Save As…	saves changes to a different file.
File>Save a Copy	saves an identical copy of the file you are working on and leaves the original file active.
File>Save as Template	saves a file in AIT (Adobe Illustrator Template) format (introduced in CS2).
File>Save for Web	assists you in saving files with smaller file size, suitable for Web graphics.

> *Note:* **Export**
> Most files, once exported (using the File>Export command), cannot be altered or edited back in Illustrator.

File Formats

A file format is the language in which a file is saved. Traditionally, various graphic software developers created their own unique file language to save files. As years passed, greater standardization of file formats occurred.

By default, Illustrator saves files in its own native language, which saves not only the objects themselves but various other functions such as layers, stroke/fill, etc. The following file formats are available in the *File>Save* menu.

> *Note:* **File Formats**
> All of the file formats discussed here are interchangeable between Windows and Macintosh computers. On the Macintosh you can choose to view the file extension on all your files by leaving the "Hide extension" box unchecked.

.ai – Adobe Illustrator native file format

.eps – Encapsulated PostScript – a file format that is used in many publishing packages.

.pdf – Portable Document Format – a file format developed by Adobe that allows files to be read and viewed using Adobe Acrobat Reader. Users can download the Reader at no charge from Adobe's website and view files without owning the software that the files were created in. Editing the files is typically not possible. PDF is fully cross-platform compatible, and thus serves as a means for Macs and Windows to see the same thing.

.svg – Scalable Vector Graphic (version CS1 or greater) is a vector format based on XML. The format describes images as shapes, paths, text, and filter effects. The files are compact and provide high-quality graphics for the Web and publishing.

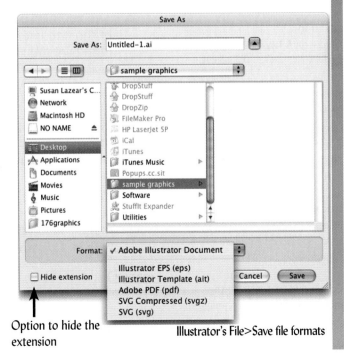

Option to hide the extension

Illustrator's File>Save file formats

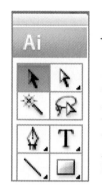

In CS2, clicking on the Ai icon at the top of the Toolbox takes you to Adobe's online help.

Using Built-in and Online Help

Online help can be found in the **Help** menu. Choosing *Help>Illustrator Help* will load the built-in Help. Choosing *Help>Illustrator Online . . .* will take you to Adobe's website where various help documents can be found in the Support area.

In CS2, clicking on the "Ai" icon at the top of Illustrator's Toolbox will take you to Adobe's online Help.

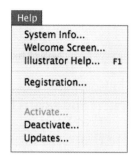

Maneuvering Your Way around a Document

As you work on project documents, you will need to move around a document either by zooming in or out or by panning.

Zooming in and out

If you look at the title bar of a document you can see the zoom level of the image you are working on.

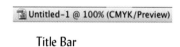

Title Bar

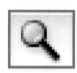

The Zoom tool (above) and the zoom-in and zoom-out cursors

There are several ways to zoom in and out of a document. *These include:*

o Choose the **Zoom** tool in the Toolbox, then move to the area of the image you want to magnify. Note how the cursor has changed to a magnifier with a *plus* symbol. If you click, you will zoom into the image. You can also drag a box around the area you want to zoom. If you want to zoom out, press the *Option* key (Mac) or *Alt* key (Windows) and note how the magnifier cursor now displays a *minus* symbol. When you click, you will zoom out.

o The zoom level is displayed in the lower left corner of the document. You can double-click, or click and drag over the zoom level and type in a new number to zoom to that level.

Keyboard Shortcuts for Zooming (without the use of the Zoom tool)

Zoom in
Cmd+ (plus key) (Mac)
Ctrl+ (plus key) (Windows)
or
space bar+Cmd+click (Mac)
space bar+Ctrl+click (Windows)

Zoom out
Cmd– (minus key) (Mac)
Ctrl– (minus key) (Windows)
 or
space bar+Cmd+option + click (Mac)
space bar+Ctrl+Alt + click (Windows)

Continuing to click with the mouse continues the zooming in/ out process.

o In the *Navigator* panel you have the option to drag the magnification slider left or right to decrease or increase the magnification. You can also double-click on the magnification number and type in a new number.

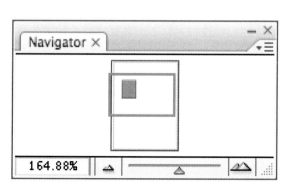

Panning

Panning allows you to move the document up or down, or left or right without changing the zoom level. You can pan only when the document is larger than the area currently viewed on screen. *There are three ways to pan an image:*

o Choose the **Hand** tool, move over to the document, and click and hold your mouse down. Now, drag the mouse, left or right, up or down, to pan in the desired direction.

o In the *Navigator* panel you have the option to drag the proxy preview window (the red rectangle) around the work area in the panel.

o You can use the scroll bars on the document window to move up and down, or left or right in the document.

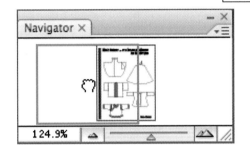

Panning with the Hand tool (above) and using the Navigator panel (left)

Power Three-Finger Shortcut

If you can train yourself to use the following shortcuts, you will pick up great speed in working with Illustrator (and Photoshop for that matter, as the shortcuts used are the same).

1. Place your index finger on the spacebar, your third finger on the *Cmd/Alt* key to the left, and your fourth or fifth finger on the *Option/Ctrl* key.

2. Keep your hand positioned here at all times while working in the software and use the various combinations of these three keys to pan around the document, zoom in, or zoom out.

The advantage of using these shortcut keys is that you do not need to swing your mouse/cursor over to the Toolbox to select the appropriate tool. Rather, you keep the cursor where you are as you work. As long as the keys are depressed you are in the zoom or panning mode. As soon as you let go of the keys you are returned to your working mode.

View Options

In addition to the **Zoom** functions already discussed, there are two additional **View** options that warrant discussion at this point.

Preview vs. Outline View

There are two display modes that control how you view your artwork:
1. **Pixel Preview**—which displays your artwork with both paths and color fills. This mode represents how your image will look when printed.
2. **Outline**—which displays your artwork as paths only, hiding the various object paint attributes. This mode speeds up the screen refresh when you are working with complex drawings. It is often handy when working with multiple overlapping objects as the view simplifies what you see on screen.

Preview vs. Outline menu options in CS1 or greater. When you are in Preview view, you will see the Outline option, and vice versa.

You can use the *Layers* panel to change the view mode of an object, group, or layer. Click on the layer and *Cmd+click* (Mac) or *Ctrl+click* (Windows) on the **Eye** icon to toggle the layer between *Preview* and *Outline* modes.

Note: Printing will always print the document with strokes, fills, etc. Outline view pertains only to the on-screen display.

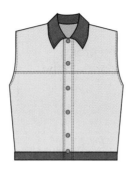 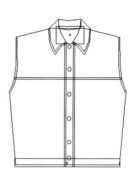

Preview view (left) and
Outline view (right)

Outline view is used on the body layer. You can achieve this by pressing the Cmd/Ctrl key and clicking on the eye icon on the layer you want to change.

Bounding Box

A **Bounding Box** is a rectangular box that surrounds single objects or a group of objects, once selected using the **Selection** tool. It has hollow squares called "handles" in each corner of the box.

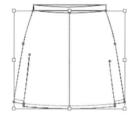 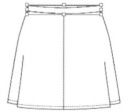

In the above example, the skirt and waistband were drawn as separate objects. Selecting the skirt (left), waistband (center), and both skirt and waistband (right). Note that when two objects are selected, only one bounding box surrounds both.

Clicking and dragging on a *handle* allows you to scale an object. Positioning your mouse cursor to the outside of a corner handle of the bounding box causes the cursor to change to a rotation cursor; then you can *click+drag* to rotate the object.

The Show Bounding Box menu command in CS1 or greater. Once the bounding box is turned on, the menu command changes to Hide Bounding Box.

The scaling cursor (left) and the rotation cursor (right) as shown in the lower right corner of each image. Use the Shift key to retain the proportions of your drawing as you drag.

The scaling cursor (left) and rotation cursor (right), used to manipulate objects with bounding boxes

You can choose to view the bounding box, or to turn it off. Often, it is easier to work with complex objects with multiple points if the bounding box is turned off. This is particularly true if you want to move a corner anchor point.

a b

The process of scaling a skirt. Select the skirt by clicking on the lower center handle and dragging it downward (a) to create the longer skirt (b).

Note: **Bounding Box Confusion**

Illustrator actually has two types of bounding boxes, one that you activate using the View menu and a second that is used in creating advanced textile designs. It can be confusing at times. This will be discussed further in the Textile Design section.

Going back in Time

During the editing process, you will often find that it's helpful to return to a previous point in time and undo some/all operations just performed. Fortunately, Illustrator provides a few ways to backtrack your work.

Multiple Undo's

You can perform multiple undo's to backtrack to a prior point. Choose the *Edit>Undo* menu, or use the keyboard shortcut, *Cmd+Z* (Macintosh) or *Ctrl+Z* (Windows).

File>Revert

Choosing the *File>Revert* menu command reloads the document you are working on, in its last saved version. Thus, if you are working and become unhappy with various changes you have just made but not saved, you can revert to the last saved version of the file.

This completes the quick overview of Adobe Illustrator. Chapter 2 will walk you through a quick exercise to get you going. Chapter 3 will discuss the various functions of Illustrator's Toolbox. Chapter 4 covers the menu commands and Chapter 5 discusses the most commonly used panels, accessed through the **Window** menu. Basic Drawing Exercises, Fashion Drawing Exercises, Textile Design Exercises, and Presentation Exercises will follow and these will teach you skills necessary for fashion design.

Student Gallery:
Miscellaneous Work
Mesa College Fashion Students

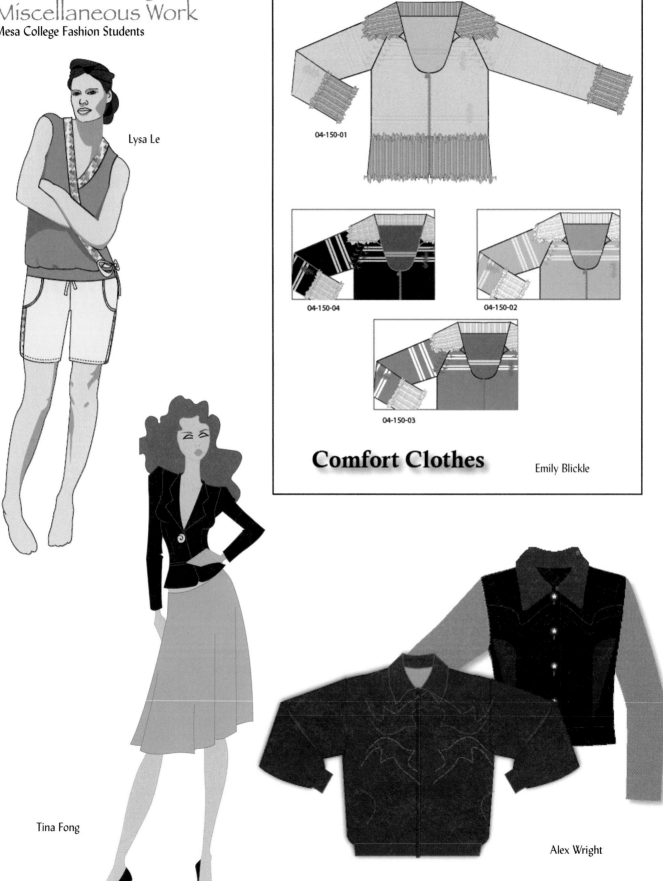

Lysa Le

04-150-01

04-150-04

04-150-02

04-150-03

Comfort Clothes

Emily Blickle

Tina Fong

Alex Wright

Quick Start: Basic Drawing in Illustrator

This chapter walks you through a quick overview of the drawing process in Illustrator. This will be followed by a drawing lesson that allows you to get your feet wet without a lot of Illustrator experience. In the first part of the lesson, you will use a limited number of tools and functions to draw a simple stick-type figure. Make yours as stylized as you want, using Picasso, Monet, or your 6-year-old niece as an inspiration. In the second part of the exercise, you will use more tools and functions to add details to your stick figure.

Jessica Coburn

The General Process of Design

The drawing process in Illustrator typically involves a routine combination of steps. *These are:*

1. Set up Your Document

- Create a new document. Choose the *File>New* menu or press *Cmd+N* (Macintosh) / *Ctrl+N* (Windows) keys on the keyboard. Set the Units to Inches. Choose your paper size. Letter size is suitable to most projects. Select the *Portrait* or *Landscape* Orientation. Click on the Advanced arrowhead, and choose the *CMYK* setting if you are planning to take your project to press printing. Otherwise, you may use either *CMYK* or *RGB* as your Color Mode. Click **OK**.
- Using the docking panels (CS3) or the **Window** menu, choose to display the panels you need for drawing. These are the *Control, Colors, Swatches, Appearance, Stroke,* and *Layers* panels. If you use the docking panels, tear the panels off so they remain on the screen.

> **Cross-Reference**
> Exercises 1 and 2 in the Drawing Exercise Chapter walks you through the setup of a document and prepping the Stroke and Fill.

2. Define the Fill and Stroke Attributes for Your Path

- Click on either the *Fill* or *Stroke* icon in the Toolbox and set the color of your choice by clicking on a color in the *Swatches* panel (*Window>Swatches*) or the *Color* panel (*Window>Color*). You may also double-click on the *Stroke* or *Fill* icon in the Toolbox to open the *Color Picker* dialog and set the color in this manner. If you choose to have a fill or stroke of none, choose this option by clicking on the None icon (the diagonal line icon on the right), directly below the *fill* and *stroke* area of the Toolbox.

Fill and Stroke icon

Stroke weight in the Control Panel

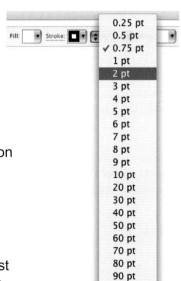

3. Set the Weight and Continuity of Your Stroke

You may use the *Control* panel or the *Stroke* panel to adjust the *weight* of your stroke. If you are using the *Control* panel, you must select an object first so you may see the weight of the stroke in the *Control* panel. Continuity can only be set using the *Stroke* panel.

To use the *Stroke* panel, choose the *Window>Stroke* menu to open it (if it is not already open). *Here you will see two options:*

Setting the Weight

By default (as set in Preferences), the weight of the stroke is 1 point. You may choose to make this heavier or thinner in several ways:

- Click on the up or down arrow to the left to increase or decrease the point size of the stroke by one increment. The position of your mouse determines whether you increase or decrease the number.
- Click on the arrow to the right to open a pop-up menu that displays your various numerical options.
- Lastly, typing in a new number and pressing the *Tab* key is a quick way to change the weight of a stroke.

Setting Continuity of Your Stroke

If you want to create a dotted line to indicate top-stitching or similar, you will use the dashed option.

- Click on the check box to turn the option on. If you type a number in the first box (and no others), Illustrator will alternate dashes and spaces of the size specified. Alternately, you may type in your dash and space sequence. Always make sure you have a stroke color selected when you choose to use the Dashed Line option.

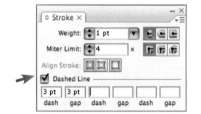

Setting up a dashed line in the Stroke panel

4. Create an Object

Once you have set the *fill* and *stroke* options, you are ready to create an object. You can use any of the built-in shapes or any of the drawing tools to design your fashion drawings. The **Pen** tool is the most commonly used drawing tool. The general process of drawing involves setting anchor points and establishing straight and curved segments between the points. To familiarize yourself with the process of drawing, use the practice exercises found in the *Basic Exercises* section of this book.

The Drawing tools used to create objects

5. Edit and/or Transform the Objects

It is not critical that you draw with exact precision as you establish the initial object, as editing the points and segments is easy to do. Once the basic framework of the object has been drawn, use the various editing tools described in detail on pages 42–44 in Chapter 3 to edit your drawing. *Typical editing functions involve the following:*

- repositioning an anchor point
- reshaping a segment
- changing a straight segment to a curve segment (by using the **Convert Anchor Point** tool found stacked under the **Pen** tool in the Toolbox)
- moving an object
- resizing an object

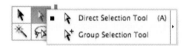

The Selection tools

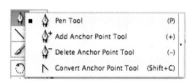

The Pen and related Pen tools and the Convert Anchor Point tool used for drawing and editing

Quick Exercise, Part 1: Drawing a Stick-Man Figure

Goal

To draw a simple stick-type figure using the built-in Shape tools.

Illustrator Tools and Functions

♦ **Shape** tools
♦ Fill and Stroke
♦ **Selection** and **Direct Selection** tools
♦ Bounding Box and Bounding Box functions (Rotate, Scale)
♦ Color Picker
♦ *Swatches* Panel
♦ *Object>Arrange* Menu (to arrange the stacking order of objects)

Sara Mathes

Quick Overview of the Process

In this exercise you will draw a simple figure using various **Shape** tools. Experiment with *fill* and *stroke* colors using the *Control* panel, the *Swatches* panel, or *Color Picker* to alter colors of the various shapes. Use the *Bounding Box* to alter selected objects by scaling or rotating. To move objects forward or backward, use the *Object>Arrange* menu commands to change the stacking order of objects. *The steps are as follows:*

♦ Draw a series of objects using the Shape tools
♦ Scale and rotate them as needed using the Bounding Box functions.
♦ Change the *fill* and *stroke* colors as desired.
♦ Use the **Selection** tools to edit and move the pieces as necessary.
♦ Use the *Object>Arrange* menu commands to move the objects backward and forward in the stacking order as needed.

Gretchen Kauffman

Step-by-Step

Setting up

When you first open Illustrator, it does not open with a document window, so you must create a document prior to starting work. The following steps will walk you through the setup of a standard-sized document, choosing to display the most commonly used panels and specifying the typical stroke/fill setup.

1. Create a new document. Choose the *File>New* menu or press *Cmd+N* (Macintosh) / *Ctrl+N* (Windows) keys on the keyboard.

2. Type in a name for the file.

3. Choose your paper size. Letter is suitable to most projects. Select the *Portrait* or *Landscape* Orientation.

4. Choose the *CMYK* setting if you are planning to take your project to press printing. Otherwise, choose either *CMYK* or *RGB* as your *Color Mode*. Click **OK**. The document will open.

Selecting various panels to be displayed, using the Window menu

Ensuring that the Bounding Box will display

Opening Panels for Use

Ensure that the panels below (which are the most commonly used panels) are open and available for use. These may be turned on by selecting the panel name in the **Window** menu.

> *Control*—This CS2/CS3 panel allows you quick access to the various options related to selected objects. It is typically positioned at the top of the document, but may be moved to the bottom.

> *Swatches*—This panel contains selected color, gradient, and pattern swatches. You may customize the panel or use the defaults.

> *Color*—Use this panel to select colors for your object's stroke and/or fill from a broad range of colors.

> *Navigator*—This panel shows you what portion of the document you are viewing (indicated by the red box) and the zoom level. You may click on the red box and drag it to a new position to view other parts of the document. You may also change the zoom level by clicking and dragging the slider at the bottom of the window.

> *Layers*—Use this panel to create layers as you work on drawings that will contain multiple objects. Layers should be named and used according to theme/function.

Tearing off the Shapes Tool Strip

In this exercise, you will only use shapes to build the various body parts of your stick figure. To access the various shapes you will want to tear off the Shapes from the main Toolbox. *To do this:*

1. Click and hold down on the **Rectangle** tool in the Toolbox.

2. Slide/drag your mouse to the right, across all the tools, and rest on top of the *Tearoff bar*. You will see the word "tearoff" appear on your screen as your mouse sits over the bar. Release the mouse button, and the *Shapes Tool Set* will appear on your screen. You may move this to the desired position on your document.

Tearing off the Shape tools for use

Ensure that the Bounding Box is Turned on

We will use the bounding box of objects to scale and rotate them. Ensure that the display of the bounding box is turned on by choosing the *View>Show Bounding Box* menu command. If you see *View>Hide Bounding Box* in the menu, it means that the bounding box is already active.

To Set the Fill and Stroke Colors:

1. Click on the *Stroke* icon in the Toolbox (which will bring it forward, ahead of the *Fill* icon), then click on a color in the *Color* or *Swatches* panel.

 OR

Click on the Stroke color pop-up menu in the *Control* panel and when the pop-up panel opens, click on a color of your choice.

OR

Double-click on the *Stroke* icon in the Toolbox to open the *Color Picker* window and choose your color there (bypassing the need to use the *Swatches* panel). Click **OK** when you have chosen a color.

2. Click on the *Fill* icon in the Toolbox (which will bring it forward), and then use one of the methods above to select your color.

Drawing Body Parts with the Shape Tools

Using various Shape tools, begin drawing the different shapes that will be components of the figure. Use any of the techniques described below to create your drawing.

The Color Picker dialog

The Document Setup, ready for drawing shapes

To draw a shape:

1. Choose one of the **Shape** tools from the Shapes tearoff strip.

2. Move your cursor over to the document and *click+hold+drag* and *release* the mouse to create the shape. If you want a perfect square or circle, press and hold the *Shift* key on the keyboard as you draw with the rectangle or circle tool to constrain the proportions.
 OR
 Click+release the mouse on the document. A dialog will open. You may type in the size of the shape you want and click **OK**.

Rotate as You Draw

Some Shape tools, such as the Star, allow you to rotate the shape as you are drawing it, simply by dragging your cursor.

The Selection tool

To move a shape:
1. Choose the **Selection** tool.

2. *Click+hold* on the object and drag it to a new position. If you have no fill, you will have to click on the outer edge of the object or the center point to select and move it.

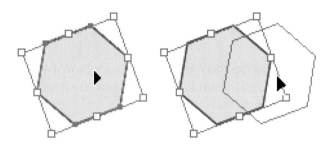

Moving objects by dragging them to a new position

To resize or scale a shape:
1. Ensure that the bounding box is active by looking at the **View** menu and ensuring that it is turned on. Since it is a toggle-type menu item, if you see *Hide Bounding Box*, you know that currently it is active. If you see *Show Bounding Box*, you will need to drag down and select the menu command to activate the bounding box.

2. Choose the **Selection** tool. Click on the object you want to resize. The bounding box will appear. There will be eight handles on the box.

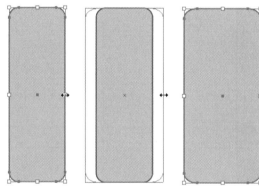

Resizing objects by dragging an edge of the bounding box to a new position

3. Move your cursor around the shape and over the edge or any of the handles until you see a double-sided arrow icon. This indicates that you are ready to resize. *Click+hold+drag* with your mouse to resize the shape. Release the mouse when you are through. You may drag inward or outward to resize an object.

The Resize cursors
(double-sided arrows)

To rotate a shape:
1. Ensure that the display of the *bounding box* is active (check the **View** menu).

2. Choose the **Selection** tool. Click on the object you want to rotate. The bounding box will appear.

The Rotate cursor

3. Move your cursor around an outer corner edge of the shape until you see a curved double-sided arrow cursor.

4. *Click+hold+drag* the mouse and as you move your cursor/mouse, the object will rotate. Release the mouse when you are through.

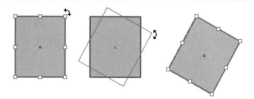

Rotating objects by dragging an edge of the bounding box to a new position

To recolor an object:

1. Ensure that the display of the *bounding box* is active (check the **View** menu).

2. Choose the **Selection** tool. Click on the object you want to recolor. The current fill and stroke color of the object will appear in the Toolbox and in the *Control* panel at the top of the screen.

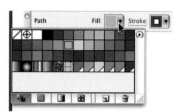

3. *Click+release* on the **Fill** or **Stroke pop-up** in the *Control* panel and a pop-up with colors will appear. Click on the new color of your choice.
OR
Click on either the *Fill* or *Stroke* icon in the Toolbox. Choose a new color from the *Color* or *Swatches* panel. The color will change in the Toolbox and on the object.
OR
Double-click on either the *Fill* or *Stroke* icon in the Toolbox. The *Color Picker* will open. Choose a new color by clicking on the general hue in the long vertical strip. Choose a new value by dragging the cursor to the desired value in the larger colored square. Click **OK** when you are through.

Using the Control panel pop-ups to change colors

To edit the shape of an object:

1. Choose the **Direct Selection** tool. Click on the object you want to edit to see the segments and anchor points. All the points will be selected when you do this, so click away once you have an idea of where the points are located.

Using the Color Picker to change colors

2. Click on the segment or anchor point you want to change. If you want to edit a group of points at one time, *drag+select* around the points. Selected points will be solid. Nonselected points will be hollow. Note that if you move your cursor over an area where an anchor point should be located, the selection cursor will add a small hollow box to the cursor when you are directly above an anchor point. When you are above an object, a solid square will appear next to the cursor.

3. Drag the selected points to the new desired position. If you selected a smooth or combination point that has direction lines, you may drag the direction lines to a new position to reshape the arc of the curve. If you don't want a curve, you can drag the diamond-shape end of the direction line inward and directly over the anchor point to flatten the arc and essentially remove the curve.

The Direct Selection tool, used to select segments or anchor points for editing

The small square to the lower right of the Direct Selection cursor indicates you are directly above an anchor point (hollow box) or an object (solid box).

Selecting a single anchor point and moving it, using the Direct Selection tool

4. *Click+hold+drag* the mouse and as you move your cursor/mouse, the
To rearrange the stacking order of objects:

1. Choose the **Selection** tool. Click on the object you want to reposition in the stacking order.

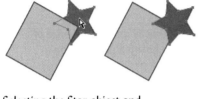

2. Choose the *Object>Arrange* menu command and choose the appropriate option. The object will reposition itself accordingly in the stacking order.

Selecting the Star object and sending it to the front using the Object>Arrange menu command

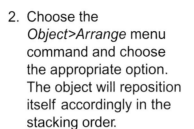

The Object>Arrange menu commands

Kelly Savod

Examples of simple figures created by Mesa College fashion students. These were their very first images created in Adobe Illustrator.

Ksenia Galyga

Katie

Ken

Sara

Alex

Nora

Theresa

Keith

Mildred

Quick Exercise, Part 2: Adding Details

Goal
To utilize the Pen and Shape tools, using Layers to add details to the simple figure created in the first part of this exercise.

Illustrator Tools and Functions
♦ **Shape** tools
♦ Fill and Stroke
♦ **Selection** and **Direct Selection** tools
♦ Bounding Box and Bounding Box functions (Rotate, Scale)
♦ Color Picker
♦ *Swatches* Panel
♦ *Object>Arrange* Menu (to arrange the stacking order of objects)
♦ **Pen** tool
♦ *Layers* Panel and functions (creating, locking, viewing)
♦ *Navigator* Panel (to pan and zoom)

Quick Overview of the Process
In the second part of the exercise you will add details to the body of the figure you created in the first part of the exercise. To facilitate the process you will now work with layers. You will learn how to pan and zoom in order to view your work close up, for fine-tuning the details.
♦ Rename the current layer *Body*. Lock the layer so you don't accidentally draw on it.
♦ Create a new layer and call it *Details*.
♦ Using the **Pen** and **Shape** tools, draw/add details to your figure drawing.
♦ Use the **Selection** tools to edit and move the objects as necessary.
♦ Use the *Object>Arrange* menu commands to move the objects backward and forward in the stacking order as needed.

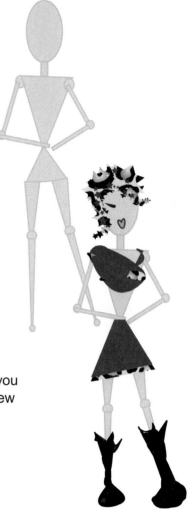

Jessica Coburn

Step-by-Step
Setting up the Layers
In order to organize your objects and simplify making selections, you will utilize two layers: one for the figure objects, and one for the details you are about to draw. Ensure that your *Layers* panel is open (*Window>Layers*).

1. Double-click on *Layer 1* (double-clicking on the title itself). A Layer dialog will open. Rename the layer *Body* and click **OK**. At this point, all your objects are on the *Body* layer, as this was the only layer active at the time you created the objects.

2. Click on the *Create New Layer* icon in the lower portion of the *Layers* panel. A new layer called *Layer 2* will be created and displayed in the panel.

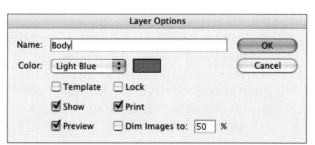

Renaming Layer 1 to Body

3. Double-click on *Layer 2* and rename the layer *Details*.

4. Click on the Lock well on the *Body* layer, which is to the right of the *Eye* icon. This will place a lock icon in the well, and the layer will be locked. You cannot select or edit any of the body objects now, as they are locked. This is what you want.

5. Click on the *Details* layer to highlight it, if it is not already the active layer.

Adding the Details layer, locking the Body layer and clicking on the Details layer to make it active

Drawing the Detail Objects

You are now ready to add various details to your drawing. Consider adding facial features, hair, and any other detail you want to your figure. You do not need to worry about selecting body objects as these are locked on the *Body* layer. Use the **Pen** tool and your **Shape** tools to add details. If you are not familiar with how the Pen tool works, review Chapter 1 and Basic Drawing Exercise #3 (pages 155–161). You may use an assortment of open and closed objects for the details. Experiment, and have fun creating your unique figure. *Consider using the following operations/actions:*

To draw open path/objects:
1. Set the *fill* and *stroke* colors. You may want to draw with a fill of None, as it is easier to see the stroke outline as you draw. You will also be able to see through to the color on the objects on the *Body* layer.

2. Choose the **Pen** tool. Using the knowledge gained in Chapter 1 and Basic Drawing Exercise #3, draw an open path.

3. End the path by pressing the *Cmd* key (Macintosh) or *Ctrl* key (Windows) and clicking away, or choose the **Selection** tool.

To draw closed path/objects:
1. Set the *fill* and *stroke* color you want.

2. Choose the **Pen** tool or a **Shape** tool.

3. Draw the object, completing the path if you are drawing with the **Pen** tool.

To hide/view layers:
1. To view a layer, ensure that the *Eye* icon is displayed on the layer.

2. To hide a layer, click on the *Eye* icon on the layer to turn the eye off, and thus the view of the layer.

To zoom in and out using the Navigator panel:
1. Observe the *Navigator* panel. Look for the red box, which outlines the area you are seeing on the screen. Note the zoom level, as indicated at the bottom of the panel.

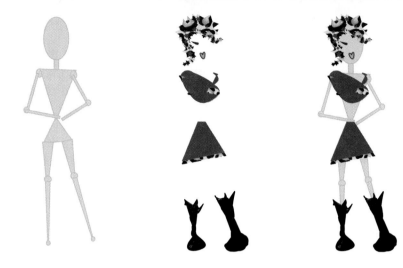

The illustration to the left shows the body (left), added details (center), and the final combination of body and details (right). These correspond to the layers shown below. Note how the Eye icon indicates which layer is displayed.

2. To zoom in, drag the slider on the bottom of the panel to the right. The zoom level will change. To zoom out, drag the slider to the left.

3. If necessary, drag the red box in the panel over the area of the image you want to see. This is a type of *panning*.

Magnification at 300 and 400 percent, as viewed from the Navigator panel

To zoom in and out and pan, using keyboard shortcuts:

If you can train yourself to use the following shortcuts, you will pick up great speed in working with Illustrator (and Photoshop for that matter, as the shortcuts used are the same).

1. Place your index finger on the spacebar, your third finger on the *Cmd/Alt* key to the left, and your fourth or fifth finger on the *Option/Ctrl* key.

2. Keep your hand positioned here at all times while working in the software and use the various combinations of these three keys to pan around the document, zoom in, or zoom out.

Panning
space bar+drag mouse (Mac) space bar+drag mouse (Windows)

Zoom In
space bar+Cmd+click (Mac) space bar+Ctrl+click (Windows)

Zoom Out
space bar+Cmd+option+click (Mac) space bar+Ctrl+Alt+click (Windows)

The advantage of using these shortcut keys is that you do not need to swing your mouse/cursor over to the Toolbox to select the appropriate tool. Rather, you keep the cursor where you are as you work. As long as the keys are depressed you are in the zoom or panning mode. As soon as you let go of the keys you are returned to your working mode.

To move a drawn object:
1. Choose the **Selection** tool.

Kanae Otaka

Quyen

2. Click on the object you want to move. The bounding box will appear.

3. Move your cursor so that it is inside the bounding box (if the object is a closed object), or on top of a path (if the object is an open object). Be mindful of the fact that if your cursor is to the outside of the bounding box, or on an anchor point of the bounding box, that your next mouse action may serve to scale or rotate the object. Look for the center point of the object, and place your cursor there, as this is a safe point to use when dragging the object. Drag the object to its new position.

To resize or scale an object:
1. Choose the **Selection** tool.

2. Click on the object you want to resize. The bounding box will appear.

3. Move your cursor so that it is on top of one of the corner or side points of the bounding box.

4. *Click+hold+drag* your mouse inward or outward to resize the object. Press the *Shift* key on the keyboard as you drag if you want to constrain the resizing to retain the original proportions. Release the mouse button when you are through.

To rotate or recolor an object, or change the Stroke thickness of a path:
Refer to the various operations in the first part of this exercise.

This completes the Quick Exercises.

Cynthia

Crystal

Stephanie

Eva

Kim

Illustrator's Toolbox

This chapter will walk you through Illustrator's Toolbox (called a **Tool panel** in CS3) and discuss the tools most commonly used for drawing and design. The term **Toolbox** will be used in this book. Given Illustrator's depth, it is not possible to cover every tool in-depth; therefore, for the sake of brevity, only tools commonly used for drawing and those used in the various exercises in this book will be covered. The standard formatting used throughout this book for tool names will not be practiced in this chapter. This will reduce redundancy as tool names are used often.

The tools in Illustrator's Toolbox are organized into groups, according to functionality. For the purposes of this book, the Toolbox will be divided into six groups: Selection tools, Drawing and Editing tools, Text tools, Transformation or Reshaping tools, Miscellaneous Special Function tools, and Document Management tools. In addition, there is palette control for the *fill* and *stroke* of your objects. Along the bottom of the Toolbox, there are two strips of three icons each. The upper strip contains color options: solid, gradient, or none. The lower strip contains options for controlling the screen modes of display (standard, full with menus, full screen).

The following is true about the tools in Illustrator's toolbox:

o Version **CS3** of Illustrator refers to the Toolbox as a **Tool panel**. It can be viewed as a single or double-wide strip.

o When you place your cursor over a tool, the name of the tool will appear. This is called a **tool tip**. The keyboard shortcut for the tool appears in parentheses beside the tool tip name. You can quickly pick up speed in designing if you begin to incorporate tool shortcuts into your daily operations.

o The current active tool is **highlighted** (i.e., shown in a slightly darker color). You select tools by clicking on them, or by pressing the keyboard shortcut. Typically, instructions in this book will ask you to click on a certain tool to make it active.

o Tools that have arrows in the lower right corner have additional hidden tools beneath. These are sometimes called tool sets. You can access these tools by clicking and holding on the top tool, and sliding over the tool you want. This tool will remain on top until you select a different tool from the tool set.

o The strip of hidden tools that appears may be separated or *torn away from the main panel*. To do this, *click+hold* on the tool and wait for the toolbar to appear. Then, drag your cursor over to the outer edge of the toolbar to the vertical bar and release the mouse button to *tear off* the strip. You can close the strip by clicking in the upper left corner.

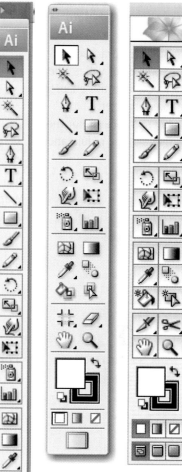

Illustrator's Toolbox, Macintosh CS3 single (left), Windows CS3 double (center), Macintosh CS2 (right)

Tool Tip

The active tool (Pen)

The Pen tool set

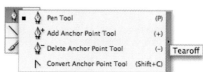

The Tearoff strip

Change to Standard Formatting

The standard practise of bolding tool names will not be strictly followed in this chapter as the tools are referred to often (due to the nature of the discussion) and the redundancy is not necessary.

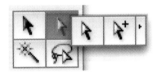

The Selection tools

The Selection tool

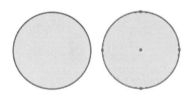

The circle on the left is not selected. The circle on the right has been selected by clicking inside it with the Selection tool. Note that the entire object is selected as indicated by the solid anchor points.

o Many of the **Selection** tools may be augmented by the various menu commands in the *Select* menu (to be discussed later).

Below, each tool will be discussed according to its group, function, and, in some cases, its specific use in fashion design. The tool's keyboard shortcut will be shown in parentheses to the right of the tool name.

Selection Tools

Once you have created objects in Illustrator, you will need to learn how to use the Selection tools in order to work with and/or edit your drawings. When you want to move or change a drawn object you need to select either the entire object, the portion of the object you want to edit, or all objects of the same stroke and color.

The following is true of selections:
o One can select an object *with a fill* by clicking *anywhere* on the object.
o One must select the *outer edge/path* of a *non-filled object* in order to select it.

The following is a discussion of the various Selection tools:

Selection Tool (V)

This tool (represented by the solid black arrow icon in the toolbox and as the black arrow cursor on the screen) lets you select an object in its entirety. Simply click anywhere inside a filled object, or on the outer path of an object with no fill. *One would select the entire object for the following reasons:*
o To change the stroke and/or fill of the object.
o To move the object.
o To transform the object in some manner (scale, rotate, flip, etc.).
o To copy an object to the clipboard so multiples can be created.

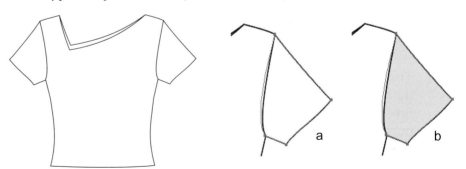

The sleeve of the T-shirt was selected using the Selection tool and clicking on the outline of the sleeve. Note how all anchor points become solid when a selection is made (a). Once selected, a yellow fill was chosen (b).

Selection Tips:
o To select multiple objects, hold the *Shift* key down as you click on objects. You may also deselect an object in the group by clicking on it a second time.
o Alternatively, select multiple objects by dragging a box around the objects you want to select. This is known as *drag+select*.
o You may deselect an object by *clicking away* (i.e., clicking outside of the object).

Direct Selection Tool (A)

This tool (represented by the hollow arrow icon in the toolbox, and the same style cursor on the screen) lets you select *chosen anchor points on an object* or *path segments within an object*.

*You would select **an anchor point** on an object:*
- o if you want to move its position.
- o if you want to change the anchor point type (e.g., from corner to smooth).

*You would select a **segment** or **segments** on an object:*
- o if you want move the position of the segment(s).
- o if you want to delete the segment(s).
- o to copy the segment(s) to the clipboard for use elsewhere or to create a duplicate (by pasting the segments back into a document).

The Direct Selection tool

Note: New Feature in CS3
CS3 of Illustrator has added a feature, whereby when you place the Direct Selection tool over an anchor point, the point is displayed in an enlarged manner.

 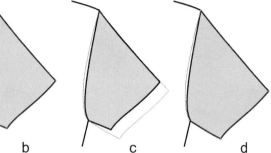

The drag+select operation was performed to select the hem segment (a) and its anchor points. Once selected (b), the hem was dragged downward and to the right (c) to lengthen the sleeve (d).

Selection Tips:
- o To select a single point, click on the point, or *drag+select* around the point. The point will become solid to show that it is actively selected.
- o To select a segment of an object, click on the segment itself. The segment plus its anchor points will highlight.
- o Select multiple segments and/or points by dragging a box around those you want to select. This is known as *drag+select*. OR, you may press and hold the *Shift* key as you click on multiple segments.
- o You may deselect a selected point or segment by clicking away (i.e., clicking outside of the object).

Group Selection Tool (A)

This selection tool (represented by the hollow arrow with a plus sign to the right) allows you to work with selected points or path segments **on grouped objects or nested group objects**. This is very handy as you do not need to ungroup objects in order to edit selected parts of them. There is a sequence to the clicking and selecting of nested group objects. *It is as follows:*
- o The first time you click, you select an object.
- o The second time you click, you select an object's parent group (as controlled by the position of the cursor).
- o The third time you click, you add the next group to the current selection.

The Group Selection tool

Note:

Grouping
Objects

Objects may be grouped by selecting the objects and then choosing the Object>Group menu command.

All objects within the T-shirt have been grouped (the body, sleeves, and the back shaded area). The Group Selection tool can be used to select a single point or segment within the group (in this case, the asymmetrical neck point).

The Magic Wand tool

Magic Wand Tool (Y)

This tool allows you to select all objects of the same fill and stroke (i.e., the same attributes). Simply choose the tool and click on one object. All objects with the same stroke and fill will be selected and ready for moving, editing, etc.

Fashion Use: • To make quick color changes in textile prints or garment parts.

Choose the Magic Wand tool and click on one sleeve. All objects of the same stroke and fill will become selected (in this case, both sleeves). The fill of the objects can be quickly changed and both sleeves are affected.

The Lasso tool

Lasso Tool (Q)

The **Lasso** tool allows you to quickly freehand draw a lasso or circle around the points and path segments you want to select. These will become highlighted or active. You can then use the *arrow* keys on the keyboard to nudge or move the selected points.

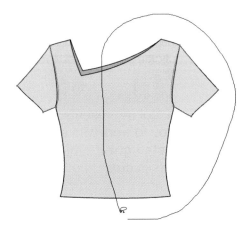

Fashion Use: • To select multiple segments/points for quick widening or lengthening of garments.

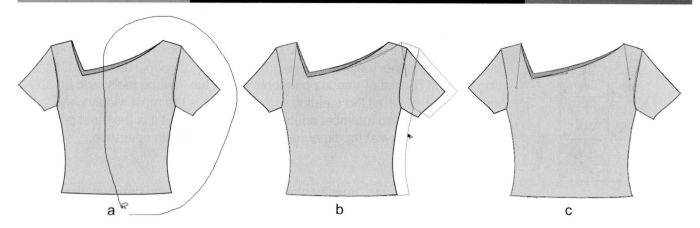

a b c

The Lasso selection tool is used to circle a portion of the T-shirt to select the anchor points or segments encircled (a). The selected points/segments are then dragged to the right, using the Direct Selection tool (b) or by pressing the right arrow key on the keyboard to widen the body of the T-shirt as shown in (c).

Quick Review

At this point, take a few moments to determine the best tools and operation steps to perform the following types of selections:

- ♦ Select a *single anchor point* (e.g., center neckline point, to lower the neckline).
- ♦ Select a *single segment* (e.g., hem segment to lengthen the sleeve).
- ♦ Select *several segments* (e.g., the right side of a garment, so that you can widen the garment).

Selection of Multiple Objects

There are various ways to select multiple objects:

- o Use the **Lasso** tool.
- o Hold the *Shift* key down while you click on each object.
- o With the **Selection** tool active, *click+hold+drag* a marquis box around the objects you want to select. All objects the marquis touches will become active (or selected).
- o Select all the objects (using the *Select>All* menu) if you want all objects selected.

Selected objects may be moved, transformed, deleted, edited, etc.

The Group and Ungroup commands of the Object menu

Grouping Objects

Objects can be *grouped* so that they act as a unit. *To do this:*

1. Select the objects you wish to group using one of the options from the list above.

2. Choose the *Object>Group* menu command or press *Cmd/Ctrl+G* on the keyboard.

To ungroup a group, go to the **Object** menu and choose the *Object>Ungroup* command or press the *Shift+Cmd/Ctrl+G* keys.

Grouping Objects and Layers
Grouping objects places them on the same layer.

Drawing tools

The Pen tool

Drawing and Editing Tools (Creation Tools)

The *Drawing* and *Editing* tools (also called Creation tools) are the second group of tools in the Toolbox. These are the most commonly used tools in the program and consist of various pen tools, a text tool, shape tools, and brush and pencil tools. Of all the creation tools, the **Pen** is the most widely used tool in Illustrator. It is also the most difficult tool to master, yet it is the most powerful one to know. So, invest the time needed to understand its operation.

Pen Tool (P)

This tool allows you to draw by placing anchor points and creating straight or curved segments between these anchor points. The manner in which you *click*, *hold*, and/or *drag* as you set the anchor points dictates the type of segment (straight or curved) that occurs between the points. You will find various related pen-like tools nested under the main Pen tool, and it is highly recommended that you tear this strip of tools off to make them ready for use.

The following operations are true of the Pen tool:
- o Clicking with the Pen tool sets an anchor point.
- o After the first point is set, *clicking* and *releasing* the Pen in a new location draws a straight path segment between the two points.
- o After the first point is set, *clicking* and *dragging* with the Pen sets an anchor point and creates a curved segment between two points. The curved segment has control arms that extend from the anchor point.
- o To end a drawing, you must either select a different tool, or hold down the *Cmd* key (Mac) or *Ctrl* key (Windows) and *click away* from the object.

There are various symbols associated with the Pen tool that aid you in drawing. These appear as you position your cursor for drawing with the Pen tool. The symbol communicates information about how the tool will operate, given its positioning and Illustrator's "intuitive" understanding of what you want to do. *The symbols are as follows:*

Pen symbols in use

The 'x' symbol indicates that you are starting to draw a new object. The Pen will set the first anchor point.

The '/' symbol indicates that your cursor is set above an existing anchor point. If you click, you will be joining an existing path and continue the building of it.

The 'o' symbol indicates that your cursor is above the beginning point of a path, and you are about to close it.

The '+' symbol indicates that your cursor is directly above a path. If you click you will be adding an anchor point to the path at the exact position of your cursor.

The '- ' symbol indicates that your cursor is directly above an anchor point on a path. If you click you will be removing the anchor point.

Refer to the Basic Concepts presented in Chapter 1, and the Basic Drawing Exercises for information and instructions on how to use the Pen tool.

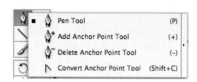

Stacked under the main Pen tool are an assortment of related, yet task-specific Pen tools that allow you to edit your drawings once they are already in place. You may tear off these tools by clicking and holding on the current Pen tool and then moving your cursor over to the tearoff strip to the right of the strip, and dragging the tool set off the toolbox. The following discussion describes the various tools.

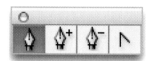

The Pen tool set: Pen, Add Anchor Point, Delete Anchor Point, Convert Anchor Point

Add Anchor Point Tool (+)

This tool allows you to add an anchor point to a path of an object. Simply choose the tool, then position your cursor on an existing path and click to add a point at the location of the cursor.

The Add Anchor Point tool

Fashion Use:
- To add points to change neckline, armhole, and other garment seam shapes.
- To allow for quick garment building using a grid system and key garment points (see Drawing Exercise #6 and Fashion Exercise #2).

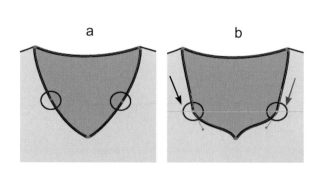

Above and Left: Using the original neckline of the T-shirt (above), anchor points are added to the neckline using the Add Anchor Point tool (a). Using the Direct Selection tool, the points are then repositioned and the curves are adjusted using the direction lines (b).

Delete Anchor Point Tool (-)

This tool allows you to delete an anchor point on an existing path segment. Simply choose the tool, then position your cursor over an existing anchor point and click to remove the anchor point. The point will disappear and the path will redraw itself between the two current anchor points.

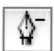

The Delete Anchor Point tool

Fashion Use:
- To remove points to change neckline, armhole, and other garment seam shapes.
- To allow for quick garment building and editing, using a grid system and key garment points (see Drawing Exercise #6 and Fashion Exercise #2).

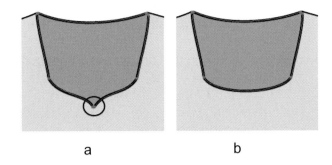

a b

Using the new neckline of the T-shirt, created in the prior example, delete the two anchor points at the center of the neckline (a) to create the new scooped neckline (b).

Convert Anchor Point Tool (Shift + C)

The **Convert Anchor Point** tool allows you to change a corner anchor point to a smooth anchor point and vice versa. This allows you to change segments from straight to curved (and vice versa) after an object is drawn.

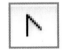

The Convert Anchor Point tool

To change:

o a smooth anchor point to a corner anchor point, *click+release* on the anchor point.

o a corner anchor point to a smooth anchor point, *click+drag* on the anchor point counterclockwise to pull out a new direction line, or twirl until it straightens out the line.

o a smooth curve to a hinged curve (two curves hinged at a point), grab the direction point itself and drag it to the new position.

Fashion Use:

• To quickly reshape garment seams and outlines in areas such as the neckline, armhole, and hem.
• To allow for quick garment editing.

Using the new neckline of the T-shirt created in the prior example, select the Convert Anchor Point tool and click on the anchor points indicated by the arrows in (a) to convert them from smooth points to corner points, thus creating the new squared neckline (b).

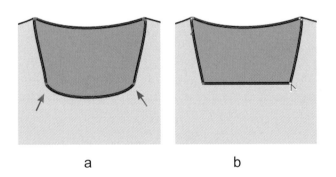

a b

Version CS3 of Illustrator has added many controls for anchor points in the Control panel. This facilitates editing, as you simply jump up to the Control panel to perform your edits. A Convert Anchor Point function exists.

New controls found in the Control panel include a Convert Anchor Point tool.

Type Tools

The Type tools allow you to place and edit text in your Illustrator document. Text can be used for various purposes in fashion drawings including titling, labeling, descriptive explanations, and general desktop publishing uses.

The Type tools. There are three horizontal and three vertical tools.

There are several type-related tools stacked beneath the primary **Type** tool. These tear off to a separate strip should you choose to view them at all times.

The following is true of the various Type tools:

o When inserting text, the default font will be the *last font used* in the program.

o You can reset the font and size prior to typing by choosing these options from the **Type** menu (*Type>Font* and *Type>Size*).

o By default, type has *a fill with no stroke*. You may change this but most fonts do not look good with a stroke unless they are large.

o You can create *fonts with outlines* by choosing a *stroke* color with or without a *fill*.

o Standard *word processing formatting techniques* can be used in Illustrator.

o The *Character* and *Paragraph* panels can be used to format and edit type.

o An **I-beam** indicates your placement when working with type. The size of the I-beam will vary according to the size of the font.

o A **text box** will always exist after typing, regardless of the approach you take to inserting type. This can be resized and repositioned using the **Selection** tools.

o The *clipboard* may be used when working with type. You can import or export type via the clipboard from other programs, or you may copy and paste it from one location to another within Illustrator.

o Illustrator has several *Proofing* tools including *Check Spelling* (**Edit** menu*)* and *Smart Punctuation* (**Type** menu).

o Various additional type functions are found in the **Type** menu.

o *Fill* and *stroke* attributes can be assigned to type, just as any path, using the **Paint Bucket** or **Eyedropper** tools.

o Quick editing can occur by *double-clicking* on a text box with a **Selection** tool. This will automatically select the Type tool and place a cursor for editing.

The Type menu

The I-Beam (left) and a Text box (below)

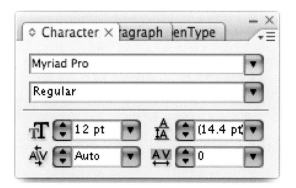

The Character and Paragraph panels, used for editing type

The Type tool

The I-beam

Typing in process

Selected text

Type Tool (T)

The main and most versatile tool for adding text in Illustrator is called the **Type** tool. It is used to insert text in the traditional way. *The following are common operations performed with the **Type** tool:*

Inserting Type

Method 1: Creating Freestanding Type

1. Choose the **Type** tool. Select the *Font* and *Font Size* from the *Control* panel, the **Type** menu, or by using the *Character* panel if you want a font different from the last-used font.
2. Place the cursor where you want to begin typing on the document and click. An I-beam will appear.
3. Begin typing. Press the *return* key (Mac) or *enter* key (Windows) when you want to start a new line. When you are through, you need to choose a different tool, or press the *Cmd* key (Mac) or *Ctrl* key (Windows) and click away to end the action. You may also choose the **Selection** tool and click away from the text.

You have now created a freestanding block of text that is not associated with a path. Now, when you use the **Selection** tool to select the text, you will see it appear on a blue line known as the baseline. You may reposition the text block by using your **Selection** tool.

Dragging the Text Window

This is text being typed into a text window

Typing in the Text Window

This is text being typed into a text window

The Selected Text Window

Method 2: Create a Text Box

1. Choose the **Type** tool. Select the *Font* and *Font Size* from the **Type** **menu**, or by using the *Character* panel if you want a font different from the last-used font.
2. Place the cursor where you want to begin typing on the document and *click+hold+drag* your mouse to create a text box. An I-beam will appear inside the text box to indicate where typing will begin.
3. Begin typing. When you are through, you need to choose a different tool, or press the *Cmd* key (Mac) or *Ctrl* key (Windows) and click away to end the action.

You may *reposition* the text box by using the **Selection** tool. You may *resize* the text box by using your **Direct Selection** tool and clicking on individual corners of the text window and moving them as desired.

While Typing . . .

Various keyboard functions do not work when you are in Type mode, as it is assumed you want to enter text using the keyboard.

this is a block of text

A freestanding block of text is created by clicking on your document and typing.

this is a text window

A window of text is created by clicking and dragging a box and then typing within that box.

Editing and Formatting Type

Once you have created type, you can edit it as follows:

1. Select the Text box using the **Selection** tool.
2. *Double-click on the type* (with the Selection tool active). An I-cursor will appear in the text and the tool will switch to your **Type** tool.

OR

1. Select the **Type** tool.
2. Click directly above the area of the type you want to edit. An I-cursor will appear in the text.

You can select type (as in a word processing program) by dragging the I-beam cursor of the text to highlight it, and then choosing the formatting option of your choice using the *Character* or *Control* panel or *Type* menu options.

Converting Type into Outlines for Graphic Editing

Type can be turned into *Outlines* (or objects) that may then be edited as a graphic image. *To achieve this:*

1. Select the *Text box* using the **Selection** tool.
2. Choose the *Type>Create Outlines* menu command.

Each letter of the type will become a graphic object that may then be edited as any other object in Illustrator. Note that you can no longer use any of the standard text editing features, so you must be sure that you are done editing the text "as text" prior to creating the Outlines.

Top stitching will be used to accent the shape of the various garment details.

Editing text using the I-cursor (above) or by highlighting (below)

Top stitching will be used to accent the shape of the various garment details.

Regular freestanding type (left), Outline Font created (center), and edited graphic (right)

Note: **Outline Fonts**

Outline fonts are used when you are submitting artwork (for printing, publishing, etc.) and do not want to include the fonts (from your System folder) with the submission. By turning text to outlines (i.e., graphic objects), it is no longer necessary to include the fonts.

The editing processes and creation of *Outline fonts* as discussed above can be performed on type that was created using any of the Type tools. The following discussion outlines the unique features of each of the remaining text tools.

Area Type tool

Area Type Tool

This type tool allows type to be created *inside* an open or closed path. *To use the tool:*

1. Create an object using the **Pen** or **Shape** tools. It may be an open or closed object. The *fill* and *stroke* of the object do not matter as they will disappear after the type is inserted.
2. Using the **Selection** tool, select the shape.
3. Choose the **Area Type** tool.
4. Click inside the object and type your chosen text.
5. End the typing by choosing the **Selection** tool and click outside the text area, or press the *Cmd/Ctrl* key and click outside the text area to end the typing.

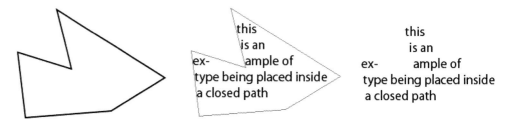

The object (left), typing inside the object (center), the completed text (right). Note how the stroke and fill disappear once the typing is complete. Note also how the word "example" becomes hyphenated to work within the shape of the object.

Path Type tool

Repositioning Type

To reposition the type along the path, click on the type and drag the I-beam to the left or right of the path. To flip the type to the other side of the path, move the I-beam to the opposite side of the path or double-click on the I-beam.

Path Type Tool

The **Path Type** tool allows type to be positioned along the *outer edge* of an open or closed path. *To use the tool:*

1. Create an object/path using the **Pen** or **Shape** tools. It may be an open or closed object. The *fill* and *stroke* of the object do not matter as they will disappear after the type is inserted.
2. Choose the **Path Type** tool.
3. Click on the path, observe the location of the I-beam, and begin typing. You may position the text cursor anywhere along the path; it does not need to be at the beginning of it.
4. End the typing by choosing the **Selection** tool and clicking outside the text area, or press the *Cmd/Ctrl* key and click outside the text area to end the typing.

The path (left), typing along the edge of the path (center), the completed text (right). Note how the stroke and fill disappear once the typing is complete.

Vertical Type Tool

The **Vertical Type** tool behaves just like the Type tool, except the type is positioned vertically.

Vertical Type tool

Vertical Area Type Tool

The **Vertical Area Type** tool behaves just like the Area Type tool, except the type is positioned vertically in an area.

Vertical Area Type tool

Vertical Path Type Tool

The **Vertical Path Type** tool behaves just like the Path Type tool, except the type is positioned vertically along the path.

Vertical Path Type tool

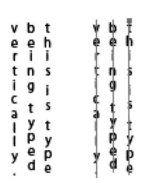

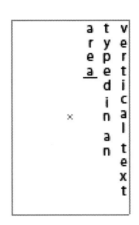

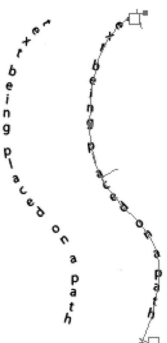

Using the Vertical Type tool (left), Vertical Area Type tool (center), and the Vertical Path Type tool (right)

Segment Tools Overview

Several drawing tools pertaining to segments, shapes, and grids are stacked beneath the **Line Segment** tool. These are the *Arc, Spiral, Rectangular Grid, and Polar Grid*. Only the Line Segment and Arc tools will be discussed here, but feel free to experiment with the other tools at your leisure. Drawing with the **Line Segment** and **Arc** tools differs from drawing with the **Pen** tool in that each line/arc is an independent object, and you do not need to worry about ending a path as you would when drawing these multisided shapes with the **Pen** tool. These tools become particularly handy when drawing details on garments (such as folds, pleats, etc.).

The Segment tools

Once you have selected one of the segment/shape tools, drawing with it can occur in two different ways. *These are:*

 o Clicking and dragging your cursor on the document to create the shape of the segment/shape.
 o Clicking once on the document and releasing the mouse to evoke a dialog that allows you to set the parameters of the tool.

Line Segment Tool (\)

This tool allows you to draw individual line segments, each independent from the others. *To use the tool:*

The Line Segment tool

Using the Mouse to Draw
1. Select the **Line Segment** tool.
2. Position your cursor on the document where you want to set the beginning point of the line and then *click+hold+drag* to where you want the ending point to be. Release the mouse.

Various keyboard commands may be used to achieve specific desired results:
o The *Shift* key constrains the line to 45 or 90 degrees.
o Pressing the *Spacebar* will toggle you to the **Selection** tool so that you may move the line quickly and easily.
o Press the *Option/Alt* key while dragging the line to draw it symmetrically from the central point you created with the click of the mouse.
o Press the ` *(Grave key)* while dragging the mouse to draw multiple lines, all emanating from the same reference point.

Multiple lines emanating from the same central point, achieved by holding the ` (grave) key as you draw

OR

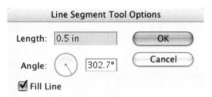

Line Segment dialog

Setting Parameters Through a Dialog
1. Select the **Line Segment** tool.
2. Position your cursor on the document where you want to set the beginning point of the line and then *click+release* the mouse. A dialog will open.
3. Set the *properties* of the line. These include the length, angle from the reference point you set, and whether you want a *fill* to your line.

Drawing the teeth of a zipper using the Line Segment tool

Fashion Use:
o In schematic-type technical drawings, to indicate the areas being measured.
o With the addition of arrowheads, to direct the eye to areas of interest in a garment.
o Drawing fashion details such as pleats, buttonholes, zippers, etc.

Arc Tool

This tool allows you to draw individual arcs, each independent from the others. *To use the tool:*

Using the Mouse to Draw
1. Select the **Arc** tool.
2. Position your cursor on the document where you want to set the beginning point of the arc and then *click+hold+drag* to where you want the ending point to be.

Various keyboard commands may be used to achieve desired results:
o The *Shift* key constrains the arc to 45 or 90 degrees.
o Pressing the *Spacebar* will toggle you to the **Selection** tool so that you may move the line quickly and easily.

The Arc tool

OR

Setting Parameters through a Dialog
1. Select the **Arc** tool.
2. Position your cursor on the document where you want to set the beginning point of the line, and then click and release the mouse. A dialog will open.
3. Set the properties of the line. These include the length, type, base along, slope, and whether you want a *fill* to your arc.

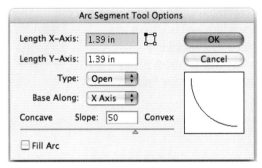

Arc tool options

Fashion Use: o Drawing fashion details such as folds, fullness, etc.

Shape Object Tools Overview

There are various shaped objects for you to utilize in Illustrator. These are the **Rectangle** (M), **Rounded Rectangle**, **Ellipse** (L), **Polygon**, **Star**, and **Flare** tools. Each creates an object that you can use as drawn or as the starting point of building a more complex object. *The following is true of Shape objects;*
o A shape has anchor points and a center point. The center point may be displayed or hidden, but it cannot be removed.
o Clicking and dragging on the center point allows you to move the object.

The Shape tools; Rectangle, Rounded Rectangle, Ellipse, Polygon, Star, and Flare

There are two approaches to drawing with the Shape tools:
Using the Mouse to Draw
1. Select the **Shape** tool of your choice.
2. Position your cursor on the document where you want to set the beginning point of the line, and then *click+hold+drag* to where you want the ending point to be. Release the mouse.

Various keyboard commands may be used to achieve specific desired results:
o The *Shift* key constrains the **Rectangle** and **Ellipse** tools to create perfect *squares* and *circles* (respectively).
o Pressing the *Spacebar* as you draw an object allows you to move the object while you draw.
o Pressing the *Option* (Mac) or *Alt* (Windows) key as you draw allows you to draw the object from the center out.
o If you drag your mouse around the document as you draw the **Star** or **Polygon** shape you can rotate the image as you draw.

OR

Setting Parameters through a Dialog
1. Select the desired **Shape** tool.
2. Position your cursor on the document where you want to draw and then *click+release* the mouse. A dialog will open.
3. Set the *properties* of the object. These include the width, height, and various other settings.
4. Click **OK**.

The Rectangle and Star options

Tip: Using Shapes

You may begin the drawing of a garment by creating a rectangle that defines the width and length of the piece and inserting points where key garment points need to be located. See Fashion Exercise #2.

Fashion Use:

o Use the Flare tool to draw buttons.
o Use the Star tool to draw shaped rivets.

Various shapes created with the Shape tools

Pencil Tools (N) and Paintbrush Tools (B)

When you draw with the **Pen** tool, you click repeatedly to set anchor points to define your path. The **Pencil** and **Paintbrush** tools, however, allow you to simply drag the mouse to set anchor points as you draw the path. Both tools have a *Preferences* dialog that allows you to control how many anchor points are set down as you draw, and how smooth the path is.

Pencil Tool

This tool allows you to draw in a freehand motion, setting points as you move the cursor. The example below will use the Pencil tool to draw a path.

1. Set a *fill* and *stroke* color in the Toolbox.
2. Select the **Pencil** tool.
3. Click and drag, drawing a squiggle on the document. When you release your mouse the path will be selected, and you will be able to see the anchor points of the path. Do not click elsewhere on the document as you will deselect the object.

The Pencil tool

- If you move your mouse away from the drawing, you will see that the Pencil has an 'x' beside it, indicating that you are ready to draw a new object.

- If you move your mouse directly on top of the shape you have just drawn you will see that the Pencil tool is ready to edit the path. If you then click on a point or on part of the path and drag your mouse, you will redraw the object. When you release the mouse button, Illustrator will redraw the path from the point at which you clicked.

Note: Pencil and Grid Snap

The Pencil tool is exempt from Grid Snap.

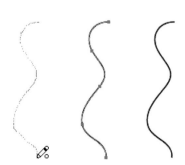

In the above drawing the image was drawn and the cursor was placed over an anchor point midway in the drawing (left). Then, by clicking and dragging from that point, an edited version of the shape was created.

In the above drawing the image is being drawn (left). The cursor is released and the mouse is moved to the right, leaving the object selected and ready for editing (center). Once one clicks away with the mouse, the object becomes deselected (right).

The Paintbrush Tool (N)

As with the Pencil tool, the **Paintbrush** tool allows you to draw in a freehand manner. However, with the Paintbrush, you can select the brush tip of your choice, using the *Brushes* panel. Thus, you can see that a marriage of sorts exists between the tool and the brushes stored in Illustrator. To open the *Brushes* panel, choose the *Window>Brushes* option or press F5 on the keyboard. In the panel you can see the many preset brushes. There are various brush libraries available for your use, accessed using the *Window>Brush Libraries* menu command.

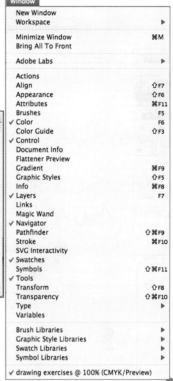

Once you have opened the *Brushes* panel, you may choose a brush tip for drawing. The illustration to the right shows multiple brush tips ready for use.

Pencil and Paintbrush Tool Options

Double-clicking on either the **Pencil** or **Paintbrush** tool opens a dialog with options.

The Brush Libraries menu command is found near the bottom of the Window menu.

Fidelity—controls how precisely the path created follows the path you draw when you drag the mouse. Essentially it controls how far you must move your mouse before a new anchor point is added. Fidelity can range from 0.5 to 20 pixels. A Fidelity value of 5 means that tool movements of less than 5 pixels aren't registered and thus, the higher the value, the smoother and less complex the path (and the fewer the anchor points).

Smoothness—controls the roundness of the curves created while drawing. The higher the setting, the smoother the curve.

> *Options*
> - The **Keep selected** check box allows you to keep the object selected when you finish drawing (for editing)
> - The **Edit selected paths** check box allows you to edit the object and the *Within* slider lets you control how far the tool must be from the selected path in order to edit it.
> - The **Fill new brush strokes** check box of the Paintbrush tool dialog determines whether your brush strokes have a Fill attribute.

In the above example the letter 'B' was drawn with an attempt to have angled corners. The 'B' image on the left has low fidelity and high smoothness (see left dialog). The 'B' image on the right has high fidelity and low smoothness (see right dialog).

Fidelity was set to 1 on the left image and 9 anchor points were created. When fidelity was set to 20, only 3 anchor points were created (right image).

Additional Pencil Tools

Additional **Pencil** tools exist for editing. These are found stacked under the master Pencil tool in the set.

Smooth Tool—This tool allows you to round off the corners of objects by dragging the tool on top of the corners of a selected object.

Path Erase/Erase Tool—Allows you to remove points on a path. Simply drag the tool over the anchor points you want to erase. Version CS3 uses the Path Erase name.

Fashion Use: o The Smooth tool may be used to smooth the curved bottoms of a flared garment.

Original drawing (top)
Smooth tool used (center)
Erase tool used (lower)

Additional Paintbrush Tools

Although no additional Paintbrushes are stacked under the main tool, there are various brushes you may utilize in drawing, achieved through the choice of Brush library and brush tip.

The Brushes panel

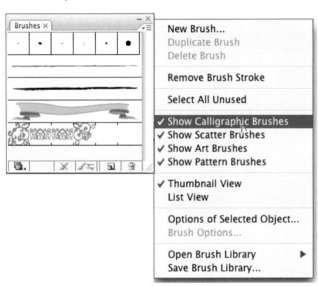

To choose a Brush Library:

1. Click and hold on the right-facing triangle in the upper-right corner of the *Brushes* panel. A pop-up panel menu will appear. You will see four options; Show Calligraphic Brushes, Show Scatter Brushes, Show Art Brushes, and Show Pattern Brushes.

2. Drag your mouse down the menu and highlight the library of your choice so that a check mark appears beside the name.

Brushes may be edited by double-clicking on a brush and opening a dialog where editing may occur. New brushes may be created in various ways according to the brush type. See your Illustrator manual or the Help files.

Calligraphic Brush —This brush has an angled tip that allows you to create tapered lines that get thicker or thinner, depending on the angle and direction of the stroke.

calligraphic brush

Scatter Brush — With this brush, you can take predefined art and distribute it along the stroke that you draw with the Paintbrush tool.

scatter brush

Calligraphic (top), Scatter (center), and Art (lower) brushes

Art Brush — The Art Brush differs from a Scatter brush in that one single piece of artwork is stretched along a stroke (as opposed to multiples of the same image).

art brush

Pattern Brush — The Pattern Brush allows you to take patterns and apply them across a painted stroke. You may define the pattern with different attributes for corners and ends.

For more information on how to work with and create the various types of brushes, consult your Illustrator manual or the Help files.

pattern brush

Fashion Use:
- o To draw with artistic flair.
- o To place a border print on a garment following the flow of the garment edge.
- o To build creative textile patterns, motifs, and designs.

Transformation Tools

The **Transformation** tools are the third group of tools in the Toolbox. The most used of the group are the Rotate (R), Reflect (O), Scale (S), and Free Transform (E). Three out of the four tools in the Toolbox have additional tools stacked beneath them as indicated by the small arrowhead in the lower right corner of the tool.

There are two ways in which you may use most of the tools in this group:
1. Select the object, choose the tool, and perform the transformation by clicking and dragging the mouse on your document in the appropriate way.
OR
2. Select the object, then *double-click* on the desired transformation tool to open a *dialog* and choose the settings you wish to use for the transformation. Click **OK** to complete the process. **Note**: The *Object>Transform* menu and submenus can be used instead of double-clicking on the tool to open the appropriate dialog.

Transformation tools

Rotate Tool

This tool allows you to rotate a selected object around a pivot point (typically the center point of the object(s) unless otherwise specified). You can rotate freeform by choosing the tool and dragging the mouse around the selected object, or you may double-click on the tool to open a dialog that allows you to specify the rotation numerically. Do note that you are able to rotate objects without the use of the **Rotate** tool simply by using the bounding box, provided it is displayed (*View>Show Bounding Box*).

The Rotate tool

To rotate an object using the dragging technique:
1. Select the object or objects.

2. Choose the **Rotate** tool. The cursor will change to a crosshair.

3. To rotate the object around its center point, click and drag your mouse in a circular motion anywhere in the document window. If, however,

The Rotation Cursors:
left—crosshair to set pivot point
center—crosshair to indicate pivot point
right—arrowhead to indicate cursor for dragging object

Origin Point

Prior to performing a rotation, you may change the point of origin for an object selected by moving your cursor to the new location, holding down the Option (Mac)/Alt (Windows) key, and clicking once.

you want to set the point of origin, click on the object at the point you want to serve as your pivot point. A new crosshair (which includes a circle) will appear and remain above the pivot point to indicate the point of rotation. ✛ The cursor will now change to a black arrowhead. ►

4. Click elsewhere on the document and drag your mouse in a circular manner. The object will rotate in the direction the mouse is moved, using the set pivot point established in step #3. Release the mouse when you are finished rotating the piece. The farther you are from the pivot point when you click and drag, the finer the control you have over the rotation.

5. Click away to deselect the object. **Note**: If you press the *Shift* key as you drag, you will constrain the rotation to 45-degree angles.

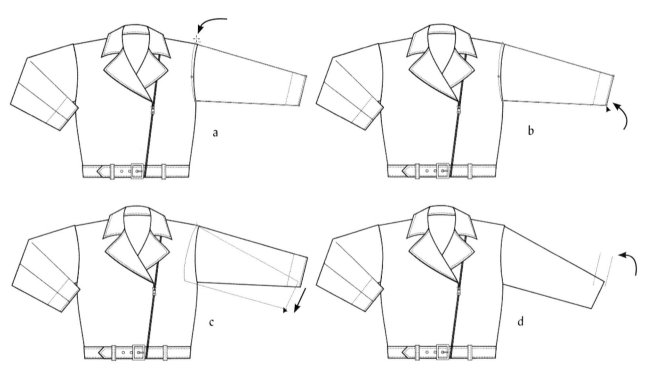

Select the object, choose the Rotate tool and click on the desired pivot point with the crosshair cursor (a). Then, move your new arrowhead cursor to a different point on the object (b) and click and drag with the mouse until you reach the desired point of rotation (c). Notice on illustration (d) above that the top-stitching objects did not rotate with the sleeve as they were not selected or included in the selection.

To rotate an object using the Rotation dialog:
1. Select the object or objects.

2. Double-click on the **Rotate** tool (or choose the *Object>Transform>Rotate* menu command). A dialog will open. Note that the pivot point on the object will automatically be set as the center point of the object.

The Rotate dialog

3. Type in the desired angle of rotation. You may use positive or negative numbers. If you click on the **Preview** button, you can see the rotation prior to approving the amount. The Options area of the dialog allows you to specify if you want both the object and pattern to rotate, or if you want one or the other to rotate. This is very handy if your garment is filled with a textile pattern design, in that you can have both the pattern and the garment rotate together. The **Copy** button allows you to create a rotation that is a copy of the original. This is helpful if you are rotating one sleeve but not the other.

Note: Alternate Approach
Rotations may also be achieved using the bounding box or the Object>Transform>Rotate . . . menu.

Fashion Use: o Rotating hands, heads, sleeves, or other parts of the body or garments, etc.
o Copying and rotating one sleeve or object to create the second sleeve.

Reflect Tool

The **Reflect** tool is stacked beneath the Rotate tool. You can access it by clicking on the Rotate tool and sliding over to the Reflect tool, or by tearing off the Rotate/Reflect strip. Reflect allows you to mirror-image a selected object on the horizontal or vertical axis, or any specified angled line. You can rotate freeform by choosing the tool and dragging the selected image, or you may double-click on the tool to open a dialog that allows you to specify the rotation numerically.

The Reflect tool

To reflect an object using the dragging technique:
1. Select the object or objects.

2. Choose the **Reflect** tool. The cursor will change to a crosshair.

The Rotate/Reflect toolbar

3. Click on the object at the point you want to serve as your point of origin. A new crosshair will appear above the pivot point to indicate the point.

4. Drag your mouse on the document to form a line across which the object will be flipped. When the object is positioned correctly, click a second time.

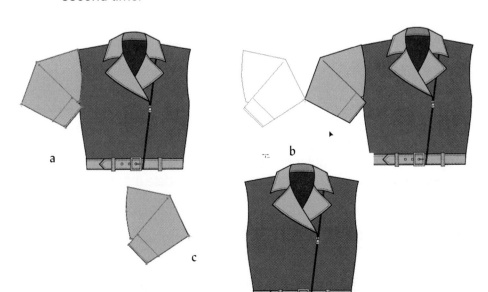

The left sleeve is selected (a) and the Reflect tool is chosen. The cursor is moved over the sleeve and clicked in the sleeve area. Then, the mouse is dragged and a ghosted version of the sleeve appears as dragging occurs (b). When the mouse is released you have a reflected version of the sleeve (c).

To reflect an object using the Reflect dialog:
1. Select the object or objects.

2. Double-click on the **Reflect** tool (or choose the *Object>Transform>Reflect* menu command). A dialog will open. Note that the point of origin on the object will automatically be set as the center point of the object. If you want this point to be placed elsewhere, click with your mouse at the desired position.

The Reflect dialog

3. Choose which of the three options you want for reflection: *Horizontal* (reflects using the X-axis), *Vertical* (reflects using the Y-axis), or a set *Angle* (typing in the angle). If you now click on the *Preview* check box, you can see the rotation prior to approving the type/amount. The *Options* area of the dialog allows you to specify if you want both the object and pattern to reflect, or if you want one or the other. This is very handy if your garment is filled with a print design in that you can have both the pattern and the garment reflect together. The **Copy** button allows you to create a reflection that is a copy of the original. This is helpful if you are creating and reflecting the alternate sleeve, half of a garment, etc.

Fashion Use:　　o Drawing half a garment or a portion of a garment, selecting all its objects, and creating the alternate half (use the Copy option in the *Reflect* dialog).

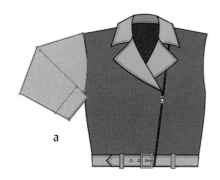 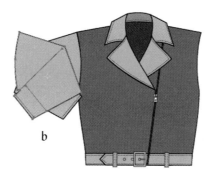 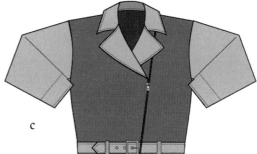

a　　　　　　　b　　　　　　　c

The left sleeve and detail stitching is selected (a). Double-click on the Reflect tool to open the dialog. Choose the Vertical option and click on Copy. A new reflected sleeve will appear and sit on top of the original (b). Using the Selection tool, drag the new sleeve to the right and position it on the right armhole (c).

Scale Tool (S)

The **Scale** tool allows you to resize selected object(s) by clicking anywhere on the document and dragging the mouse. Alternatively, you may want to use the *Scale* dialog where you can specify the percent of scaling. Objects scale relative to their center point unless otherwise directed (by moving the reference point). Both the stroke and pattern fill will scale if these options are chosen in the Scale dialog.

The Scale tool

To reflect an object using the dragging technique:
1. Select the object or objects.

2. Choose the **Scale** tool. The cursor will change to a crosshair.

3. The point of reference will be the center point of the object. If you want to change this point, click on the object where you want your new point of origin to be positioned. A new circular crosshair will appear to indicate the point.

4. Drag your mouse on the document to scale the object.
o The object will scale according to the direction of the movements you make with your mouse.
o If you hold the *Shift* key as you drag straight *up or down,* the object will stretch vertically.
o If you hold the *Shift* key as you drag straight to the right or left, the object will stretch horizontally.
o If you hold the *Shift* key as you drag diagonally, the object will scale proportionately.
o If you begin dragging (with or without the *Shift* key) and then press the *Option* key (Mac) or *Alt* key (Windows), you will create a scaled *copy* of the original object.

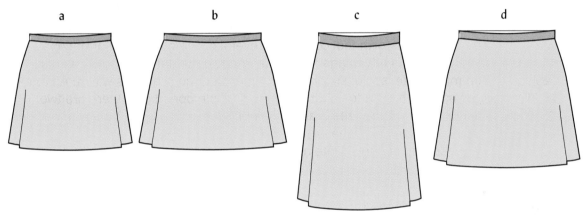

Original skirt (a), scaled horizontally only (b), scaled vertically only (c), and scaled proportionally (d).

To scale an object using the Scale dialog:
1. Select the object or objects.

2. Double-click on the **Scale** tool (or choose the *Object>Transform>Scale* menu command). A dialog will open. Note that the point of origin on the object will automatically be set as the center point of the object. If you want this point to be placed elsewhere, prior to double-clicking on the tool, select the tool once, then *Opt +click* (Mac) or *Alt+click* (Windows) with your mouse at the position you want the new reference point to be set.

The Scale dialog

3. Choose whether you want the scaling to be *Uniform* or *Non-Uniform* and type in the percent of scaling. Numbers over 100 will enlarge the object and numbers less than 100 will reduce the object. Click **OK** to complete the operation.
o *Uniform* scales objects equally in width and height.
o *Non-Uniform* allows you stretch the object vertically or horizontally.

o If you choose the *Scale Strokes and Effects* option, the stroke line thickness and any effects created will scale accordingly.

o If you want, you can scale the object and pattern fill in unison, or scale only the object or the pattern. This is very handy when scaling prints in garments.

o The *Preview* check box allows you to view the change before it takes effect.

o To create a scaled copy of the original, click on the **Copy** button instead of the **OK** button.

Fashion Use:
o Scaling textile prints inside garments to better illustrate the scale of print inside a garment.
o Scaling multiple garments to retain a consistent scale between them.
o Scaling garments to allow them to fit on one page.
o Reproportion garments to change from Standard sizing to Petite or Plus.

The Free Transform tool

Free Transform Tool (E)

The **Free Transform** tool combines several of the other transformation functions and is advantageous to use once you understand how it works. You may rotate, scale, shear, distort, and even move objects with it. Although it is handy to have a tool that performs multiple operations, there are two shortcomings of the Free Transform tool:

1. You cannot change the point of origin.
2. You cannot create a copy as you perform the transformation.

Thus, you can see why it is important to know and understand how all of Illustrator's tools work so you can choose when to use specific individual tools, and when to use the **Free Transform** tool. Learning the intricacies of this tool takes a little time, and a list of basic operations follows.

All operations presume that you have selected an object and then selected the **Free Transform** tool in the Toolbox.

The scaling cursor (left) and rotation cursor (right), used to manipulate objects with bounding boxes

o Place your cursor **outside the selected object** and drag with the mouse to *rotate* the selected object.

o Place your cursor **within an object** and drag with the mouse to *move* the selected object.

o Place your cursor on **a corner handle** of the bounding box (which will appear even if the View Bounding Box feature is turned off) and drag with the mouse to **resize** the object in any direction. If you hold down the *Shift* key as you drag your mouse, your object will be resized proportionately.

o Place your cursor **on a side handle** of the bounding box (which will appear even if the View Bounding Box feature is turned off) and drag with the mouse to *resize the object in and out.*

o Press and hold down the *Option/Alt* key while resizing the object and it will resize from the center of the object.

o Place your cursor **on a side handle** of the bounding box, press and hold the *Cmd/Ctrl* key, and drag with the mouse to *shear an object.* Adding the *Option (Mac)/Alt* (Windows) key while shearing skews the object from the center.

The following tools are not used as commonly as the Rotate, Reflect, and Scale tools; however, it is beneficial to know what they do.

Shear Tool (E)

The **Shear** tool skews or angles your object(s). The tool is found stacked under the **Scale** tool. To use the tool you must select the object(s) you want to shear, then click on the tool and drag the cursor on your document to skew the selected object(s); or you can double-click on the tool to use the *Shear* dialog and enter the angle of shearing as well as the axis on which to shear. The dialog offers you the same abilities to shear the object and/or pattern. Shearing will occur from the object's center unless you establish a new point of origin.

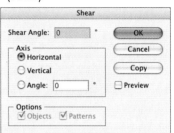

The Shear tool (above) and dialog (below)

Reshape Tool (E)

The **Reshape** tool (also stacked beneath the **Scale** tool) allows you to move anchor points in order to create controlled deformations of an object. It differs from the **Direct Selection** tool in that you are allowed to use what are known as focal points to control how the object will be reshaped. Focal points, once selected, operate as a unit and maintain their relationship among themselves when moved. See your Illustrator manual or Illustrator Help for more information.

The Reshape tool

Warp and Related Tools

A variety of distortion tools have now been placed in Illustrator's Toolbox for your use. These include the *Warp*, *Twirl*, *Pucker*, *Bloat*, *Scallop*, *Crystallize,* and *Wrinkle* tools. Refer to your Illustrator manual or the Help files for explanation on how to use these tools.

The various Distortion tools: Warp, Twirl, Pucker, Bloat, Scallop, Crystalize, and Wrinkle

Additional Comments on Transformation Tools

There are a few considerations that must be made when working with the *Transformation* tools. These are listed below.

Note the differences in the skirt width below, achieved by selecting specific points for transformations.

Transformation and the Direct Selection Tool

Transformations may be performed on an entire object or in some cases on a portion of the object. Use the **Direct Selection** tool to select chosen points to transform and then select the desired tool and perform the action.

Fashion Use:
- o Scaling a hand on a croquis to improve its size.
- o Scaling the flare of a skirt at the lower portions/hemline to increase/decrease its flare to better illustrate how softer fabrics drape differently (as shown in the illustration to the right).
- o Rotating a foot on a croquis to change the model's pose.

Preferences Settings

When you work with pattern fills in garments you want to ensure that the Preferences option for *Transform Pattern Tiles* is checked in the General Preferences window. If it is not, rotated sleeves will not rotate the pattern. To open Preferences, choose the *Illustrator>Preferences>General* (Macintosh) or the *Edit>Preferences* (Windows) option. Ensure that there is a check mark beside the *Transform Pattern Tiles* option.

Preferences Settings

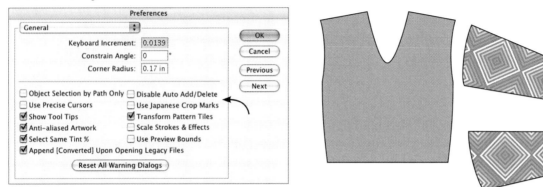

Ensure that the Transform Pattern Tiles option is checked in the General Preferences dialog. The sleeve examples above show you how the pattern rotates with the sleeve as a result of this preference being set.

Using the Tilde Key with Pattern Fill

If you want to transform a pattern fill without changing the object, you can hold down and press the **Tilde** key (~) on the keyboard as you perform the Rotate, Reflect, Scale, or Shear transformations. Note that you do not need to press the *Shift* key to use the tilde key. This is one idiosyncracy of Illustrator and its documentation. People refer to the key in its lowercase mode as the tilde key.

The original pattern appears on the left image. In each of the transformations (left to right: rotate, scale, rotate, and shear), the Tilde key was pressed as the operation was performed so that the transformation occured on the pattern fill only, and not on the object itself.

Using the Object>Transform Menu

You may choose to use the *Object>Transform* menu to evoke certain transformations in lieu of double-clicking on the tool in the Toolbox. A dialog will open ready for your use. Menu commands exist for Move, Rotate, Reflect, Scale, and Shear.

Using the Transform Again Menu Command (Cmd/Alt + D)
A command called *Transform Again* exists in the **Object** menu
(*Object>Transform>Transform Again*). This allows you to repeat
again and again a transformation just performed.

Fashion Use: o Setting and positioning buttons down the
front of a garment.
o Stacking heads to use when drawing a
fashion croquis (see Fashion Exercise
#8).

The Transform Again
menu command

Miscellaneous Special Function Tools

The next group of tools serve a variety of specialty functions
including gradient fills, sampling colors, spraying symbols, etc. Live
Paint Bucket and Live Paint Selection are two new tools first added
in version CS2. Only tools used in the design exercises in this book will be
discussed below. Consult Illustrator's Help files for explanation of the tools
not covered here.

Gradient Tool

Gradients are color fills or strokes of multiple colors that blend into each
other. They are used for shading and adding dimension to your fashion
drawings. In working with gradients you will use both the **Gradient** tool and
the *Gradient* panel. The **Gradient tool** allows you to control and adjust the
placement of a gradient within an object, while the **Gradient panel** allows
you to build and edit the gradient, which is then stored in the *Swatches* panel.
To learn more about gradient terminology and the creation and building of a
gradient, refer to Chapter 5, pages 138–140.

The Gradient tool

The **Gradient** tool allows you to control the placement of a gradient color
range within an object. The direction in which you move your mouse as you
click and drag within the selected object controls the angle and positioning of
the colors.

To Fill an Object with a Gradient:
1. Open the *Gradient* and *Swatch* panels to view them as you work.
Choose the *Window>Gradient* and *Window>Swatches* menu
commands or open and tear off the panels from the dock (CS3).

The Gradient swatch

2. Select an object that you would like to fill with
a gradient.

3. Click on the *Fill* icon in the lower Toolbox to
make it active.

4. Select a gradient swatch or build one using
the *Gradient* panel. The gradient will fill your
selected object. It will use the *Gradient Type*
(Radial or Linear) that was used when the
gradient was built.

The skirt is filled with a
linear gradient of green-to-
purple.

The Gradient panel
(above) and Fill (below)

Note: Gradient Colors

You may have up to 32 colors in a gradient.

To Experiment Using the Gradient tool:

1. Using the **Selection** tool, select the object filled with a gradient.

2. Choose the **Gradient** tool in the Toolbox.

3. Move your cursor over the selected object, position it within the object and *click+hold+drag* the mouse to reposition the gradient within the object. Release the mouse.

The position of your initial click will determine where the gradient starts, and the position at which you release the mouse determines where the gradient ends. You can control the span and angle of a gradient through the positioning of your mouse and the direction in which you drag to establish the distance.

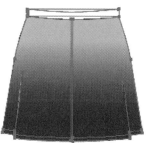

The yellow arrow in each skirt set above shows you the position of and angle on which the Gradient tool was dragged over the original skirt. The resultant gradient can be seen on the second skirt of each set.

For step-by-step instructions on how to build gradients, refer to the directions in Chapter 5, pages 138–140.

Eyedropper Tool (I)

The **Eyedropper** tool can be considered an editing tool as it allows you to sample and/or copy the various attributes of one object to another. These attributes include the stroke color and thickness, fill color or type (solid, gradient, pattern), transparency, and various filters such as drop-shadows, arrowheads, etc. Text attributes of characters or paragraphs may also be copied. Therefore, the **Eyedropper** tool is valuable in that one operation can be used to perform what would take several steps otherwise. It also ensures consistency in attributes between objects.

The Eyedropper tool

To sample the attributes of an object:

1. Click on the **Eyedropper** tool to select it in the Toolbox.

2. Ensure that no objects are selected.

3. Click on the object that you want to sample. You will see the stroke, fill, and other object attributes appear in the various panels. Nothing will change on the drawing as you are only sampling at this point.

To copy the attributes of one object to another:

1. Select the first object with the **Selection** tool. This is the object you want to bring the attributes to.

2. Click on the **Eyedropper** tool to select it in the Toolbox.

3. Click on the object that contains the properties you want. The stroke, fill type and color, and other object properties of the original object will change to those of the second object.

Fashion Use: o In fashion illustration, to copy skin tones from one body part to another.
 o In textile design, to copy color properties of one motif to the next.

Steps 1–3: (above) Using the Selection tool, click on the top, then with the Eyedropper tool active, click on the patterned square. The pattern will now appear in the top (below).

Paint Bucket Tool (K) (all versions of Illustrator prior to CS2)

The **Paint Bucket** tool works in conjunction with the **Eyedropper** tool. You will find it stacked beneath the **Eyedropper** tool. You can either tear off the panel or select the tool by clicking and holding on the **Eyedropper** and sliding over to the **Paint Bucket** tool and releasing.

The **Paint Bucket** tool allows you to copy the various properties of one object to another. These properties include the stroke, stroke weight, fill and fill type, transparency, etc. This is particularly handy in that one operation can be used to perform what would take several steps manually. It also ensures consistency in properties between objects.

To use the tool:

1. Click first on the **Eyedropper** tool to select it in the Toolbox.

2. Click on the object that contains the properties you want. The stroke, fill, and other object properties will change to those of the object you clicked on. Note that no objects are selected, yet the attributes of the object have been set in the various panels.

3. Choose the **Paint Bucket** tool in the Toolbox.

4. Position the tool over an object you want to change and click. You will see the attributes of these objects change. You can continue to click on additional objects with the Paint Bucket cursor to change their attributes as well.

The Paint Bucket tool

Note:

Eyedropper and Paint Bucket

The Eyedropper and Paint Bucket tools work in tandem with each other and are used to sample and copy attributes of one object to another.

Tip:

Eyedropper and Paint Bucket

When you are using either the Eyedropper or Paint Bucket tool, pressing and holding the Option key (Mac) or Alt key (Windows) allows you to toggle between the two tools as you work. This is handy for first sampling and then filling new objects with the attributes of another.

The Measure tool

The Measure tool is used to determine how long the pants are on the document. They measure 3.7037 inches.

Measure Tool

Although not directly considered an editing tool, the **Measure** tool comes in handy when you need to quickly determine the distances or angles between any two points. The tool is used in conjunction with the *Info* panel.

To use the tool:

1. Ensure that the *Info* panel is displayed by choosing the *Window>Info* menu command.

2. Select the **Measure** tool in the Toolbox. This is stacked beneath the **Eyedropper** tool.

3. *Click+release* on the first point of any object.

4. Click on the second point of any object and release.
OR
3. *Click+hold* on the first point of any object.

4. Drag your mouse to the second point, which can be on any object, and release the mouse.

5. View the *Info* panel and you will see the vertical and horizontal distances between the two points as well as the angle.

Fashion Use: o To measure distances between garment points.

The Live Paint Bucket tool

Live Paint Bucket (K) (versions CS2, CS3)

Live Paint is a new function that was introduced with Illustrator version CS2. It is truly unique in that it combines the intuitiveness of painting by hand with the vector/object world of Illustrator. You can use all of Illustrator's drawing power, but with Live Paint, all paths are treated as if they are on one layer; thus, the painting process becomes similar to working with hand drawing.
The general process is as follows:

1. Draw the objects you want to use in your painting.

2. Using the **Selection** tool, select all the objects involved in your drawing.

3. Create a **Live Paint Group** by choosing the *Object>Live Paint>Make* menu command.

4. Use the **Live Paint** tool in the Toolbox to paint areas of your image. You will see that the Live Paint tool treats all objects as if they are on the same layer and thus fills to boundaries Illustrator normally would not recognize since they cross layers and objects.

Live Paint groups contain paintable parts called *edges* and *faces*.
- An **edge** is the portion of a path between the intersection of the other paths.
- A **face** is the area enclosed by one or more edges. You can stroke edges and fill faces.

See Chapter 4, pages 93–95, for a more complete discussion of using Live Paint.

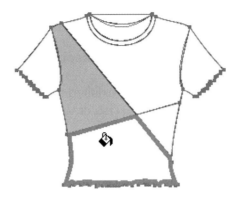

Moving the Live Paint tool over an area and filling it with color. No matter which layer the various objects are positioned on, Live Paint treats all objects as if they are on the same layer.

Live Paint Selection Tool (Shift + L)

The **Live Paint Selection Tool** works in conjunction with Live Paint. It is a unique selection tool that is specific to Live Paint Groups.

You can use the Live Paint Selection tool to select and then delete faces and edges. Deleting edges causes the fill to merge across any newly expanded faces.

The following explains the differences between the different selection tools:
- The **Live Paint Selection** tool acts on the faces and edges of a Live Paint group,
- The **Selection** tool acts on the *entire* Live Paint group, and
- The **Direct Selection** tool acts on the individual paths inside a Live Paint group.

Thus, if you want to apply different fills, gradients, etc., to the different faces within Live Paint Selection, you would use the Live Paint Selection tool to allow you to select specific faces and/or edges.

The Live Paint Selection tool

Crop Area Tool (Shift + O) (version CS3)

The **Crop Area** tool, new to CS3, allows you to mark off content for output in printing. Select the area you want to print using the tool, and then, when prepping to print, choose the Setup option in the Print dialog and change the pop-up menu of the *Crop Artwork to* option to Crop Area. Only the cropped area will print.

Setup

Crop Artwork to: [Crop Area]

The Crop Area tool

Scissor Tool (Shift + C)

The **Scissor** tool is used to cut, or create a break in an object's path so that you can divide one path into two or more paths. You may work with open or closed paths, but once you use the tool you will have an open path on each side of the dividing point(s). This tool is often considered an editing tool and was grouped with other editing tools in the Toolbox in earlier versions of Illustrator. You may either click on an existing anchor point or on any location on the path to create a breaking point. When you click on the middle of a segment you will create two new anchor points, which sit directly on top of each other. When you click on an existing anchor point, a new anchor point is

The Scissor tool
(located under the Eraser tool
in CS3)

The Scissor vs. Knife tool

The primary difference between the Scissor and Knife tools is how new objects result. The Scissor tool breaks an object into two separate open paths. The Knife tool breaks an object into two separate closed paths.

created directly beneath the point you clicked on. Each part of the object now has an anchor point positioned where you clicked. You do not need to have the object selected prior to using the **Scissor** tool.

To use the tool:

1. Optional: Using the **Selection** tool, click on an object to select it and thus display all the anchor points on the object.

2. Click on the **Scissor** tool in the Toolbox to select it.

3. Click on an existing anchor point or anywhere on a path to create a new point. This creates a break in the path.

4. Using the **Selection** tool, click and move the two objects away from each other. Or use the **Direct Selection** tool to edit the active point sitting on top of the nonactive point at the break.

5. Continue your editing/drawing of the object.

Fashion Use:
- o To isolate garment details to be edited, deleted, copied, and/or used elsewhere in a drawing.
- o To separate an armhole from the rest of a bodice.
- o To separate the hand from the arm at the wrist so that you may position it in front of the garment instead of behind.

The Scissor tool was used to cut the left skirt into two parts. The parts were then separated with the Selection tool. Note that each part is an open object.

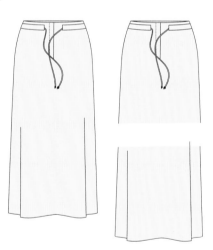

Knife Tool

The **Knife** tool is used to break one closed object/path into two *closed* objects. This differs from the **Scissor** tool in that you are working with closed objects, not open ones. After you have sliced with the knife you will have two closed objects, both of which share the same attributes.

The Knife Tool
(located under the Eraser tool in CS3)

To use the tool:

1. Optional: Using the **Selection** tool, click on an object to select it and display all the anchor points on the object.

2. Click on the **Knife** tool in the Toolbox to select it.

3. Drag the knife cursor over your object. If you want to divide the object with a straight line, press the *Option* key (Mac) or the *Alt* key (Windows) prior to dragging the knife cursor over the object.

4. If you selected the object prior to using the Knife tool, both new objects will be selected. Click away to deselect both objects.

5. Choose the **Selection** tool and select one of the objects to move it away from the other object.

Fashion Use: o To isolate garment details to be edited, deleted, copied, and/or used elsewhere in a drawing.
o To quickly divide a garment into two separate closed objects (e.g., color blocking a skirt).

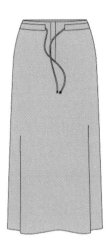
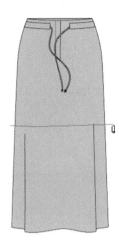

The Knife tool was used to cut the left skirt into two parts. The illustration to the left shows the tool in action. The parts were then separated with the Selection tool (right). Note that each part is a closed object.

Eraser Tool (Shift + E) (CS3)

An **Eraser** tool was added to CS3, and the original Eraser tool was renamed to **Path Eraser**. The new Eraser tool functions similar to the Knife tool, yet is different in that it allows you to divide vector artwork, and the areas that were under the tool are essentially erased or removed. You have control over the shape of the erasing tip (double-click on the tool). You can cut through all layers.

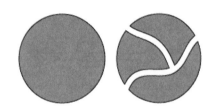

The Eraser tool in version CS3

Document Management Tools

The tools found in the lower portion of the Toolbox are used to manage the document you are working on. They allow you to pan, zoom in, and zoom out and to control the portion of the document that prints.

Hand Tool (H)

The **Hand** tool is used to allow you to navigate/pan or move the document around on the artboard. It is particularly helpful when you are zoomed into the document and need to move to a different spot.

To use the tool:
1. Select the **Hand** tool in the Toolbox.

The Hand tool

2. Ensure that you are in a zoomed-in view so that you cannot see all parts of the image; otherwise, you will not fully understand what the Hand tool does. If you look at the bottom and/or side of your document, you should see scroll bars.

Panning

Pressing and holding the spacebar down, and clicking with the mouse will switch you to the Hand tool and allow you to move or pan around the image. This is a handy shortcut to know, as it allows you to move around on an image without changing the tool you are working with in the Toolbox.

3. Position the hand icon in your document, then *click+hold+drag* the icon. Note that as you move the hand the document moves with you.

See page 21 for other methods of maneuvering around a page.

Page Tool

The **Page** tool is used to move or adjust the printable area of the page. This comes in handy if you have drawn objects that extend beyond the printable area (as indicated by a dotted-line box).

To use the tool:

1. Choose the **Page** tool in the Toolbox.

2. Zoom out to a level where you can see all the objects.

3. Click and hold the mouse and drag the *page cursor* on the screen. You will see a dotted box move with the cursor. This box defines the area that will print. Release the mouse when you have defined the proper area.

The Page tool

The dotted lines indicate the area that will print.

Zoom Tool (Z)

You can use the **Zoom** tool as a magnifying glass to zoom in or out on an image. This is just one of several ways to zoom in and out in Illustrator. The Zoom cursor will have a plus or minus sign in it to show you whether you are zooming in or out. The zoom/magnification level is displayed in several places in Illustrator: the title bar, the *Navigator* panel, and the lower left corner of the document.

To zoom into an image:

1. Choose the **Zoom** tool in the Toolbox. The cursor will become a magnifying glass with a plus sign in it.

2. Position the cursor over the area you want to zoom in.

3. Click and release with the mouse. Each time you click you will zoom in one level (as witnessed in the title bar, Navigator panel, etc.).
OR
3. *Click+drag* a box around the area you want to magnify and that area will fill the entire document.

To zoom out of an image:

1. Choose the **Zoom** tool in the Toolbox. Press and hold the *Option* key (Macintosh) or *Alt* key (Windows) and note that the cursor will become a magnifying glass with a minus sign in it.

2. Position the cursor over the area you want to zoom out of.

The Zoom tool (above) and the zoom-in and zoom-out cursors

3. Click with the mouse. Each time you click you will zoom out one level (as witnessed in the title bar, *Navigator* panel, etc.).

See page 20 for other methods of zooming in and out of an image.

Color Management Tools

The lower portion of the Toolbox contains tools/icons that allow you to control the color parameters of your objects.

Fill and Stroke (X)

One can manage the *fill* and *stroke* parameters of drawn objects either prior to drawing the object, or after the object is drawn as part of the editing process.

Fill and Stroke icons

The Fill and Stroke *icons* appear at the lower portion of the Toolbox. The *stroke* is represented by a square outline and the *fill* is represented by a solid square. To change the stroke or fill color, you simply click on the appropriate icon (Fill or Stroke), which brings it forward and makes it the active icon. Then you can either choose a color from the *Swatches* panel, or double-click on the icon to open the *Color Picker* and choose a color from there.

Swap Fill and Stroke

Two additional icons appear in the Fill and Stroke icon area. The first is the *Swap Fill and Stroke* icon (Shift+X on the keyboard). When you click on this, the fill and stroke colors exchange. The second icon is the *Default Fill and Stroke* (D on the keyboard), which will change the fill and stroke to the default colors of white fill and black stroke.

Default Fill and Stroke

Color, Gradient, and None

Directly below the Fill and Stroke icons are three color mode icons, which store either the default or the most recently used colors, gradient, and a None option. Click on any of these to change the active Fill or Stroke to the parameter as shown in that area.

Screen Display

You can control the display of your document/screen by hiding menu bars, the title bar, and/or scroll bars.

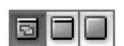

Screen Modes CS2 and earlier: Standard Screen (left), Full Screen with Menu Bars (center), and Full Screen (right)

Screen Modes

At the very bottom of the Toolbox are three *Screen Mode* icons or buttons. These three options control the view of the artwork, menu bars, title bar, and scroll bars. *They are as follows:*

Standard Screen Mode—This button allows you to view your artwork with a menu bar at top and scroll bars on the side.

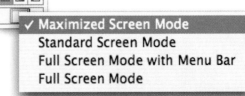

Screen Mode CS3 utilizes a pop-up menu to choose the mode.

Full Screen Mode with Menu Bars—This button allows you to display the artwork in full screen view with a menu bar but no title bar or scroll bars.

Full Screen Mode—This button allows you to view your artwork with no title bar, menu bar, or scroll bars.

The Symbol Sprayer tool

The Gradient Mesh tool

The Column Graph tool

The Blend tool

Additional Miscellaneous Tools

Several other tools exist in the Toolbox, but these will not be covered in depth in this manual. Consult Illustrator's built-in Help for details on how to use these tools and toolsets. *A quick overview of a few of the tools follows:*

Symbol Sprayer and related Tools—The Symbol Sprayer (and related tools) are used to spray multiple instances of the same symbol or image on your artwork. There are numerous symbol tools, found stacked beneath the sprayer.

Gradient Mesh Tool—This tool allows you to create objects with multiple gradients in varying directions.

Column Graph Tool and Related Tools—This toolset allows you to create graphs.

Blend Tool—The Blend tool creates shape and color blends between objects.

This completes the discussion of Illustrator's Toolbox. The next chapter focuses on the various menu commands found in the program. You will see that, at times, there is duplication between tools in the Toolbox and menu commands.

Illustrator's Menus

If you examine the Menu Bar, positioned at the top of the Illustrator screen, you will see menu options available for use. These are organized according to function. Each menu has numerous commands, some of which open a dialog (those ending with ...) and some of which have additional submenus (those ending with a black arrowhead). When you examine the menus, you will see that various items have keyboard shortcuts shown to the right of the command name. These begin with the *Command* (Apple) key on the Mac, and the *Ctrl* key on Windows. Some menu functions may be accessed through the panel menu functions, etc., but many are unique and found only in the main Menu Bar.

| Illustrator | File | Edit | Object | Type | Select | Filter | Effect | View | Window | Help |

| File | Edit | Object | Type | Select | Filter | Effect | View | Window | Help |

Illustrator's Menu Bar: Macintosh (upper), Windows (lower)

Once again, due to the depth of Illustrator, the discussion that follows in this chapter will provide only a brief overview of the menu commands that are commonly used in fashion design and in the exercises in this book. Refer to Illustrator's built-in Help for additional explanation on any menu commands not discussed, or not covered in the depth you want for other types of illustrative work.

Basic Maneuvering through the Menus

To use Illustrator's menus, click on the appropriate menu title in the Menu Bar. The full menu with submenus will open. Release the mouse and move down to the submenu function of your choice. If dots appear beside the command, there is yet another level of submenus to choose from and this will open once you click on the submenu. Move the mouse to the desired command and click and release. This activates the menu command.

If a menu command appears dimmed (or grayed out), this means that the menu is currently unavailable. Typically in this situation, it is necessary to perform a function in the program prior to selecting the menu. More often than not, this involves making a selection of an object or objects.

In the discussion that follows, each main menu and its commands will be covered, moving from left to right across the Menu Bar.

Edit	
Undo Rectangle	⌘Z
Redo	⇧⌘Z
Cut	⌘X
Copy	⌘C
Paste	⌘V
Paste in Front	⌘F
Paste in Back	⌘B
Clear	
Find and Replace...	
Find Next	
Check Spelling...	⌘I
Edit Custom Dictionary...	
Define Pattern...	
Edit Colors	▶
Edit Original	
Transparency Flattener Presets...	
Tracing Presets...	
Print Presets...	
SWF Presets...	
Adobe PDF Presets...	
Color Settings...	⇧⌘K
Assign Profile...	
Keyboard Shortcuts...	⌥⇧⌘K

Illustrator's Edit menu with dimmed items, keyboard shortcuts, and menu items ending in . . ., which indicates a dialog will open

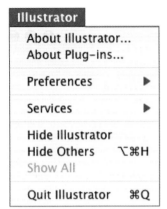

The Macintosh Illustrator menu

Illustrator Menu

The Illustrator menu is available to Macintosh OSX users. The first two commands, About Illustrator and About Plug-Ins, provide credits, serial number, and related information about the program and/or plug-ins.

Preferences

The Preferences command appears in the **Illustrator** menu on the Macintosh and in the **Edit** menu on Windows. It wizll be discussed at this point in time for both Macintosh and Windows platforms.

Preferences allow you to choose settings for various functions in the program such as the display, tools, units, exporting, etc. These typically go into effect immediately and will be remembered for future documents. When you choose a *Preference* option and open the *Preferences* dialog window, you can move from one Preference group to another by choosing the desired group from the pop-up menu, or you may click on the **Previous** and **Next** buttons to step through the various Preference groups.

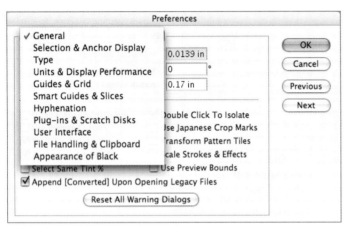

The Preferences pop-up menu shows the areas that can have custom Preferences set.

Most options are chosen by clicking on a check box to turn the function on. Some options require you to type in a number field. Work your way through the various options and click **OK** when you are through adjusting your settings.

Specific discussion of altering some Preferences settings will be covered more fully in the design exercises where a specific task requiring a preference change is used. The following list contains a brief discussion of the most commonly used Preferences settings.

General
- Precise Cursors turns crosshair and similar cursors on.
- Tool Tips allow the name of a tool to be displayed when you place your cursor over a tool.
- Anti-aliased Artwork allows the edges of vector objects to appear smoother on-screen. It has no effect on printing.
- Append [Converted] Upon Opening Legacy Files adds the word [Converted] to the filename of an earlier-version Illustrator file when opening it in a newer version.

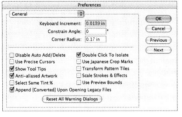

The General Preferences (above) and Selection and Type Preferences (below)

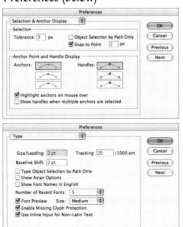

Selection and Anchor Point Display (CS3)
- Settings for selection of points and the display of anchor points.

Type (and Auto-Tracing, prior to CS2)
- Size/Leading controls the amount of space between lines of text.
- Number of Recent Fonts sets the number of recently used fonts that appear at the top of the Font menu when you use fonts and display the menu.
- Auto Trace settings (prior to version CS2 only) allow you to set the precision of auto-tracing (see Fashion Exercise #12).

Units and Display Performance

- General units set the display of your rulers and units. Most people prefer to work in Inches. Other options include Points, Picas, Millimeters, Centimeters, and Pixels.
- Stroke units control the measurement unit for the stroke applied to an object. Most people prefer to use Points, but other options include Picas, Millimeters, Centimeters, and Pixels.
- Type units control the measurement unit for the stroke applied to an object. Most people prefer to use Points, but other options include Inches, Millimeters, or Pixels.

The Units & Display Performance Preferences (above) and Guides & Grid Preferences (below)

Guides and Grids

- Choose the *Guide* color and style (lines vs. dots) for your guidelines, which are pulled out from the Rulers on the outer edge of your document, once displayed. Clicking on the colored square opens a *Color Picker* for your use.
- Choose the *Grid* color and style (lines vs. dots) for the grid whose display is accessed through the *View>Show Grid* menu command. You may also set the frequency of the grid and the number of subdivisions displayed. Fashion Exercise #2 uses the Grid.

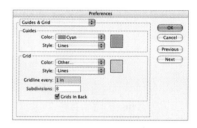

Plug-ins and Scratch Disk

- Illustrator uses RAM memory as you work. A chunk of your hard drive is used to store this information. If you have more than one hard drive, you can direct Illustrator to use a secondary scratch disk when it needs more memory.
- Choose the Grid color and style (lines vs. dots) for the grid whose display is accessed through the *View>Show Grid* menu command.

The Plug-ins & Scratch Disks Preferences (above) and File Handling & Clipboard Preferences (below)

File Handling and Clipboard

- Use *Low-Resolution Proxy for Linked EPS* files to keep file size small by displaying the linked file in a low-resolution manner.
- *Ask When Modified in Links* instructs Illustrator to warn you if a linked file has been changed or modified. These are files that have been placed in a linked manner. Fashion Exercises #10–#13 use linked files.
- If you have an image on the clipboard, it will be saved on the clipboard as a PDF file upon quitting Illustrator.

Hide Illustrator (Macintosh only)

You can choose to temporarily hide all of the Illustrator documents, panels, and tools by choosing the *Hide Illustrator* command from the **Illustrator** menu. To return to Illustrator, either press and hold the *Cmd/Alt* key (Mac/Windows) and then tap the *Tab* key repeatedly until you see the Illustrator icon appear. This keyboard shortcut allows you to toggle between open programs, and it is a very handy shortcut to know. You may also click on the Illustrator icon in the task bar to return to Illustrator.

Hide Others (Macintosh only)

This menu command allows you to hide all other applications.

Quit *Cmd/Ctrl+Q*

Use this command to quit and close the program. Many new users presume that closing all documents closes the program, when in actuality, only the documents are closed. If you have been working in Illustrator for a long time, it is wise to completely close the program and reopen it again to refresh memory. Software and computers, like humans, need a break now and then to refresh.

File Menu

The **File** menu contains commands that allow you to create, open, save, and manage your files.

New *Cmd/Ctrl+N*

This command allows you to create a new document. You may specify certain artboard settings as you do so, including document size, units, orientation, and color mode. If you type in a name for your document, don't presume that the file is saved. You must still use the *Save* or *Save As* command to actually save the file.

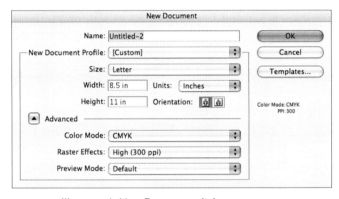

Illustrator's New Document dialog

New from Template

There are numerous templates available in Illustrator. These preset files offer you quick-start layouts for specific items such as brochures, CD covers, business cards, etc. Template files are found in Illustrator's template folder, which is found in the Illustrator folder. You can create template files yourself by saving as a template (see *Save as Template* description). Template files are saved in .ait format.

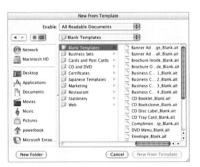

New from Template dialog

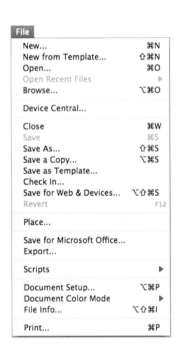

Illustrator's File menu (Mac CS3)

Open . . . *Cmd/Ctrl+O*

The *File>Open* command presents you with the *Open* dialog that allows you to locate files on your hard drive and open them.

Open Recent Files

This command allows you to view recently saved files and open them directly. This is very handy if you don't recall the exact name and/or location of the file you last saved.

Browse

The *File>Browse* command allows you to open Adobe's Bridge (CS2, CS3) or the *Browse* window (CS1). The Bridge is a control center for the entire Creative Suite, whereas the Browse window works within Illustrator CS1 itself. Use these to organize, browse, and locate files.

File Close and Save Commands

There are several commands in the *File* menu that provide control over closing and saving your files.

Close Cmd/Ctrl+W

Use this command to close your document. Understand that closing all documents does not mean that you have closed the program. You must use the *Illustrator>Quit Illustrator* (Mac) or *File>Quit (Windows)* command to close the program.

Save, Save As..., Save a Copy, Save as Template, Save for Web

Various save commands exist in Illustrator. The *Save* command opens a *Save* dialog that allows you to save your file and choose the location (on your hard drive) and format of the file (.ail, .pdf, etc.). Learn to use the keyboard shortcut (*Cmd/Ctrl+S*) to save your files often. Each time you use the menu or the command you are updating the saved version of your file. Get into the habit of saving and you will avoid the frustration of losing work if the computer crashes or Illustrator shuts down unexpectedly.

Close	⌘W
Save	⌘S
Save As...	⇧⌘S
Save a Copy...	⌥⌘S
Save as Template...	
Check In...	
Save for Web & Devices...	⌥⇧⌘S
Revert	F12

Various File menu commands pertaining to closing and saving files

File>Save—saves changes to the current file.

File>Save As . . .—saves changes to a new file.

File>Save a Copy—saves an identical copy of the file while leaving the original file open and active.

Save as Template—saves the file as an .AIT (Adobe Illustrator Template) file, which saves all the settings in the file. This allows you to open a file using this template format without altering or changing the template file.

Check In . . . (CS3) or Save a Version (CS2)—involves the turning on of Version Cue in Preferences and is designed to aid workgroups sharing files or to increase personal productivity. You must have the Creative Suite in order for this feature to be enabled.

Save for Web & Devices—opens a dialog that allows you to optimize an image for the Web, resulting in a file that is smaller in size and thus loads quickly on the Internet.

Save for Microsoft Office (CS2)—lets you create a PNG file that you can use in Microsoft Office applications. This menu option is located lower in the menu in CS3.

Revert

This command allows you to revert back to the last-saved version of the current file. Thus, if you performed a series of steps you no longer want to keep, you can use the *File>Revert* command to easily go back to the last-saved version of the file.

Place

The Place command allows you to *import* artwork into Illustrator. *There are two ways you can choose to import the file:*

The Place dialog

1. You may choose to link to the file you are placing, which means that the file is not embedded in the current file, and thus the file size remains smaller. You can edit certain aspects of the file (such as transformation functions), but you can't change the actual design of the linked image without going to the source program and editing it there. You can view your linked images through the *Links* panel (*Window>Link*).

2. You can embed files so that they become part of the Illustrator file, resulting in a larger file size. In some cases (depending on the type of file you import) you have greater editing capability of the imported file. You may place .tif, .jpg, .psd, and .pdf files.

Various export options shown in the Format pop-up

Export

Use the *File>Export* command to export files in a variety of formats. Use the *Format* (Mac) or *Save As Type* (Windows) pop-up menu to choose the format.

Scripts

This is an advanced feature that allows users to utilize scripts to automate tasks.

Document Setup

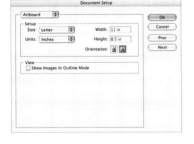

The Document Setup dialog

The *Document Setup* command opens the *Document Setup* dialog, which allows you to alter settings for the document including artboard, type, and transparency. You can click on the **Next** or **Previous** button to move through the setting options, or click on the pop-up menu in the upper left corner of the dialog to change from one setting group to another. Choose the settings you want for each group and click **OK** to finalize the changes.

Document Color Mode

This menu allows you to choose between RGB and CMYK color modes. If you know your project is going to be printed on a full-color press, use CMYK mode. Most raster effects in Illustrator can be applied only while you are in RGB mode.

File Info

File Info allows you to add information to be stored with your file. If you want to add copyright information to a file, this is the place to do so. See the Illustrator Help for more information on adding File Info.

Print

The *File>Print* command allows you to choose the print settings for your document and print the file. There are various submenus to choose from.

The Print dialog

Edit Menu

The **Edit** menu is comprised of standard editing commands used in the Windows and Macintosh worlds. In addition to the undo and clipboard functions, you will find specialized Illustrator functions as well.

Undo and Redo *Cmd/Ctrl+Z*
 Shift+Cmd/Ctrl+Z

The *Undo* command allows you to undo or cancel the last operation performed. The actual wording of the undo command may change to become more specific about the task just performed (e.g., Undo Rectangle). The *Redo* command allows you to undo an undo.

Clipboard Functions

The next group of commands pertain to the clipboard, which is an invisible holding tank for imagery, text, objects, etc. Only one item at a time can be held on the clipboard.

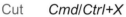

Note how the Undo command becomes more specific.

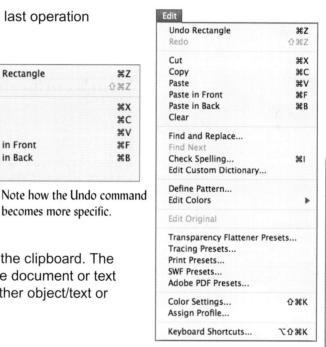

Illustrator's Edit menu (Mac)

Cut *Cmd/Ctrl+X*
 Allows you to take selected objects/
 text or other information and send it to the clipboard. The information is lifted or removed from the document or text field and sits on the clipboard until another object/text or other information replaces it.

Copy *Cmd/Ctrl+C*
 Allows you to take objects/text or other information and send a *copy* of it to the clipboard.

Paste *Cmd/Ctrl+V*
 Allows you to bring clipboard information into the document you are working on.

Paste in Front or Back
 Allows you to control the positioning of the object(s) you paste in (relative to the currently selected object). Prior to pasting in the object, you will need to choose an object on your document, then perform the desired command, *Paste in Front* or *Paste in Back*.

Clear
 Allows you to delete selected objects.

Spelling Function

This group of commands allow you to check the spelling of text used in Illustrator. You may use typical search and replace commands as well.

Various spelling and related functions

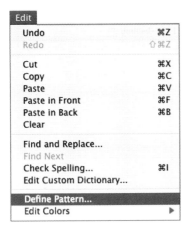

The Define Pattern command in the Edit menu.

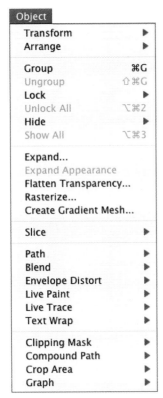

The Object menu

Define Pattern

The *Define Pattern* command is used when creating pattern fills. You will need to select objects and then choose the menu command. You will explore this more fully in the Textile Design section of this book.

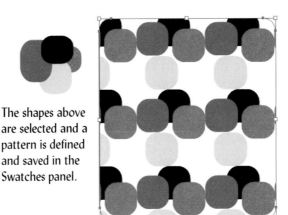

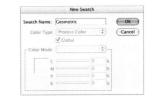

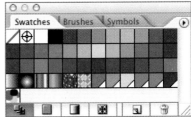

The shapes above are selected and a pattern is defined and saved in the Swatches panel.

Fashion Use: o Creating fabric prints to insert into garments.
o Drawing repetitive patterns quickly.

Edit Colors (CS3)

This menu command allows for color editing using the Live Color features found in Illustrator CS3. This will be discussed more fully in Chapter 5 on pages 133–137.

Presets, Color Settings, and Profiles

Presets are predefined settings for various actions or situations. This section of the **Edit** menu allows you to choose from the various presets that exist within Illustrator. You may define and add your own custom presets, color settings, or profile, and access them from the **Edit** menu. Consult Illustrator Help for further information.

Keyboard Shortcuts

Choosing this menu command opens a dialog, which allows you to edit the various keyboard shortcuts used in Illustrator. You may click on the pop-up menu to choose between Tools and Menu shortcuts. Changes are saved to a custom file that you may name and save.

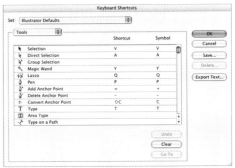

The Keyboard Shortcuts dialog allows you to customize shortcuts.

 Think 'D' for "duplicate"

The keyboard shortcut Cmd/Ctrl+D, for the Transform Again menu, allows you duplicate the last action. To remember this . . . think 'D' for duplicate.

Object Menu

The **Object** menu allows you to perform a variety of operations on selected objects in your document. Many of the functions performed by commands found in this menu can be accessed elsewhere in Illustrator.

Transform Again *Cmd/Ctrl+D*

This menu allows you to quickly repeat a transformation (such as scale or rotate), applying exactly the same parameters that were used in the first transformation. This is particularly handy in building drawings that

have repetitive objects. Take time to perform the initial transformation exactly as you want it, as the repeated transformations use precisely the same offset/moves, etc.

Draw the first two teeth of the zipper with the Line tool, then select these and Option/ Alt+Drag them to copy/move them to the new position. Then use the Transform Again menu command to repeat.

Fashion Use: o Stacking heads to aid in measuring and drawing a fashion croquis.
o Drawing the teeth of a zipper.
o Drawing fashion details such as pleats, buttonholes, zippers, etc.

Various Transform Commands

In addition to the *Transform Again* command, there are multiple transformation commands available for use through the **Object** menu. Transformations include operations such as moving, rotating, scaling, reflecting, and shearing. Many of these have Toolbox tool equivalents. Using the menu opens a dialog that allows you to specify settings. This is generally the same dialog you would access by double-clicking on the corresponding tool in the Toolbox. The *Transform* panel is yet another tool available to achieve transformations.

The Transform menu options

Several of the dialogs that open will share some common settings.
These are:

- Clicking on the **Copy** button will perform the transformation to a copy of the original and leave the original intact on your document.

The Transform panel contains some of the same settings as the Transform menu.

- If the object has a fill pattern and you want to move the pattern as well as the object, check the *Patterns* check box.

- Checking the *Preview* box will allow you to see the transformation prior to clicking the **OK** button to approve and finalize the change.

Move *Shift+Cmd/Ctrl+M*

The *Move* command allows you to move selected objects a specified amount. Positive numbers will move the object up (if vertical) and to the right (if horizontal). Negative numbers will move the object down (if vertical) or to the left (if horizontal). A positive number in Distance and Angle will move the object up; a positive distance and negative angle will move the object down.

In the example to the right, the original image (left) is moved 2 inches to the right and 2 inches down. Both the object and the pattern were moved.

Rotate

The *Rotate* command allows you to rotate selected objects a specified amount. You can use the **Rotate** tool in the Toolbox to open the same dialog, or you can use the various functions of the bounding box to rotate your artwork visually (as opposed to setting a specific amount as in this dialog).

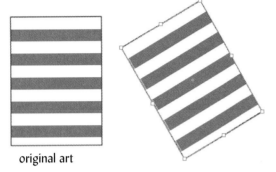

original art

In the example to the left, the original image (left) is rotated 30 degrees. Both the object and the pattern are rotated.

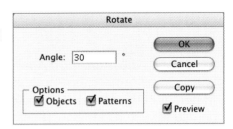

Fashion Use:

o Rotating sleeves on garments.
o Rotating limbs on a body to strike a pose.

Reflect

Reflect allows you to reflect or mirror selected objects on an *Axis* (Horizontal or Vertical) or by a specified *Angle*. You can use the **Reflect** tool in the Toolbox to open the same dialog.

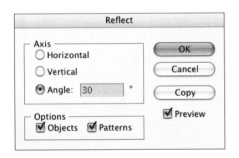

In the example to the right, the original image (left) is reflected 30 degrees. Both the object and the pattern are reflected.

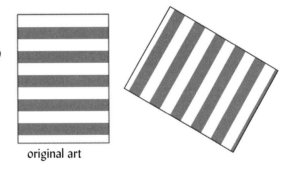

original art

Fashion Use:

o Creating the mirror image of a half-garment.
o Creating anything that must be perfectly symmetrical by drawing the first half, reflecting it, and then joining the two objects in the appropriate places.

Scale

Scale allows you to resize selected objects a specified percentage. You can use the **Scale** tool in the Toolbox to open the same dialog.

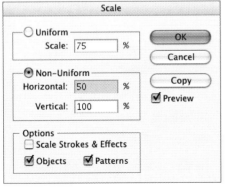

The Horizontal scale of the original image (left) is set to 50% to result in the graphic on the right.

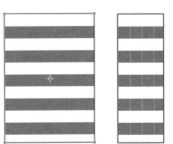

original art

Fashion Use:

o Scaling multiple garments to fit into a layout.
o Scaling the print of a fabric in a garment (scale Pattern only, not Object).

Shear

The *Shear* command causes an object to lean in a direction. You can set the angle of shearing. You may use the **Shear** tool (which is hidden beneath the Scale tool) in the Toolbox to open the same dialog.

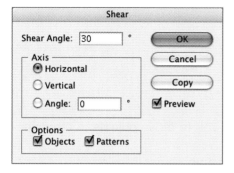

In the example to the right, a 30-degree angle is applied to the original image (left), resulting in the image on the right. Both the object and the pattern are reflected.

Arrange Commands

When objects are drawn on a single layer, they are arranged in a *stacking order*, with the most recently drawn object on top. This only becomes apparent when objects overlap, and sometimes it becomes necessary to rearrange their stacking order to achieve the desired effect.

Illustrator organizes *objects* and *layers* with stacking orders. A stacking order refers to the placement of objects, one above the other. *The following is true of stacking orders:*

- On a *given layer*, objects are stacked according to the *order in which they were drawn*, with the first drawn object at the bottom of the stack, and the last drawn object at the top of the stack. You can rearrange the order using the *Object>Arrange* menu commands.

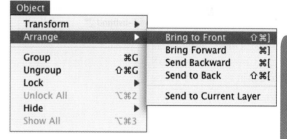

The Arrange menu

- Layers are also stacked and their position is controlled by their location in the *Layers* panel, with the lowest layer at the bottom of the list, and the uppermost layer at the top of the list. To reposition a layer, simply drag it up or down in the *Layers* panel. This is discussed more fully in the *Layers* panel discussion (see pages 119–124).

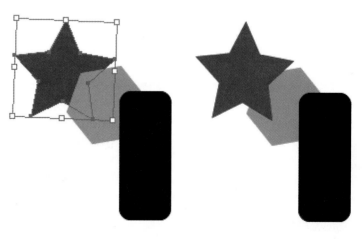

The *Arrange* commands allow you to move a selected object or objects forward and backward on the given layer. In all cases, you select the object(s) first, then apply the command. *Bring to Front* and *Send to Back* move the object all the way to the front or back, as

The shapes on the left image were drawn in the following order: star, hexagon, rectangle, and the stacking order reflects this. The star was then selected and the Object>Arrange>Bring to Front menu command was chosen, bringing the star to the front of the stacking order (as seen in the image on the right).

requested. *Bring Forward* and *Send Backward* move the object forward or backward one level only (among all the objects on the layer).

There are keyboard shortcuts for these menu commands and it pays to get to know them. They involve the square brackets on the keyboard. *These shortcuts are as follows:*

Bring to Front	*Shift+Cmd/Ctrl+]*
Bring Forward	*Cmd/Ctrl+]*
Send Backward	*Cmd/Ctrl+[*
Send to Back	*Shift+Cmd/Ctrl+[*

The *Send to Current Layer* command allows you to move objects to the layer of your choice. *To use this:*

1. Choose the **Selection** tool and click on an object to select it.
2. Click on the layer you want the object to move to.
3. Choose the *Object>Arrange>Send to Current Layer* menu command and the object will move to the layer that is currently selected.

You may achieve the same result using the *Layers* panel.

1. Choose the **Selection** tool and click on an object to select it.
2. In the *Layers* panel, drag the selected-art indicator located to the right of the layer name, to the layer you want the object to be moved to.

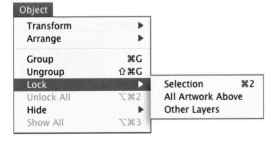

Moving an object from layer to layer using the selected-art indicator in the Layers panel

Fashion Use: o Working with the stacking order of multiple objects, such as facial features on a fashion illustration.
o Moving garment pieces forward and backward as necessary, e.g., moving the sleeve behind the bodice. The *Arrange* command frees you to draw the objects in any order as they can be easily moved forward or backward.

Group, Ungroup, Lock, and Hide/Show Commands

This set of menu commands help you manage multiple objects more effectively.

Group *Cmd/Ctrl+G*

The *Group* command allows you to select multiple objects and group them, temporarily creating a single object for use. Thus, when you click on any of the original objects in the group, only one bounding box appears around the entire group. This makes the group of objects easier to move, transform, etc. If you want to edit a single object or a single path in the group, you will now need to use the **Group Selection** tool, which allows you to select paths or anchor points within a group.

Group and Lock menu commands (above) and the Direct Selection tool (below)

Fashion Use: o Grouping multiple objects, such as facial features, on a fashion illustration.
o Grouping like objects such as buttons so that you may move or transform them easily.

Ungroup *Shift+Cmd/Ctrl+G*

The *Ungroup* command allows you to reverse the *Group* command and return grouped objects to independent objects. This command will appear dimmed until you have a grouped object selected.

Lock *Cmd/Ctrl+2*

The *Lock* command allows you to lock selected objects so that they may not be selected, edited, or moved. This gives you the freedom to lock only chosen items on a layer, as opposed to all the items on a layer (which is achieved by locking a layer). To lock objects, simply click on them and then choose the *Object>Lock* menu command. There are three submenus for the Lock command.

Selection—allows you to lock the selected objects.

Other Layers—allows you to lock all layers other than the layer that contains the selected object or group.

All Artwork Above—allows you to lock all objects that overlap the area of the selected object and that are on the same layer.

Fashion Use: o Lock selected items such as the lower facial features and continue to work on the upper facial features without the worry of changing what is already drawn.

Unlock All *Opt/Alt+Cmd/Ctrl+2*

The *Unlock All* command allows you to unlock all the objects in the document.

Hide *Cmd/Ctrl+3*

The *Hide* command allows you hide selected objects from view. This is different than hiding a layer, as you may choose to hide only some, and not all of the objects on a layer. To hide objects, simply click on them and then choose the *Object>Hide* menu command. There are three submenus for the *Hide* command.

Selection—allows you to hide the selected objects

Other Layers—allows you to hide all layers other than the layer that contains the selected object or group.

All Artwork Above—allows you to hide all objects that overlap the area of the selected object and that are on the same layer.

Show All *Opt/Alt+Cmd/Ctrl+3*

The *Show All* command allows you to view or show all objects on the document.

Expand

There are times when you want to divide a single object into multiple parts so that you can modify individual appearance, attributes, or other properties. For example, if you have a circle with a *stroke* of 5 and a colored *fill*, you can expand it to become two objects; one representing the shape of the original thick stroke, and the other representing the filled area.

To use this command:

1. Choose the **Selection** tool in the Toolbox.

2. Select the object you want to expand.

3. Choose the *Object>Expand* menu. A dialog will open. Choose the options you desire and click **OK**.

The star on the left is one object with a purple stroke of 5 points and a solid pink fill. Once expanded you have two separate objects; the outline of the star and the solid interior piece (center and right).

The Expand dialog

The single object will become two or more objects (depending on its shape and complexity). It is possible to break a gradient into multiple objects. This often facilitates printing and speeds up the process. You will need to ungroup the objects to select specific ones (or use the **Group Selection** tool).

The *Expand* dialog has several options, and those available to utilize will vary depending on the object that is selected. *Options include:*

Object—expands complex objects such as symbols and live blends.

Fill—expands fills to become a separate object.

Stroke—expands the strokes to become a separate object.

Gradient Mesh—expands gradients to a single mesh object.

Specify—allows you to input the number of objects you want the gradient to become once expanded.

Here a gradient-filled circle is expanded to 20 objects.

prior to expanding after expanding

Expand Appearance

This menu works in conjunction with objects that have *styles* applied to them. For example, the left circle below was drawn with the Pencil Artistic Effect. Once the object was selected and the *Expand Appearance* menu command was used, the circle expanded into multiple shapes.

Using the Expand Appearance menu to expand an object with a style into multiple objects

Flatten Transparency

This command was introduced in Illustrator version 10. It converts areas of overlapped objects into separate non-overlapping objects. The transparency is no longer editable. *To use this command:*

1. Choose the **Selection** tool in the Toolbox.

2. Select the objects that contain transparency in their overlap.

3. Choose the *Object>Flatten Transparency* menu. A dialog will open. Choose the options you desire and click **OK**.

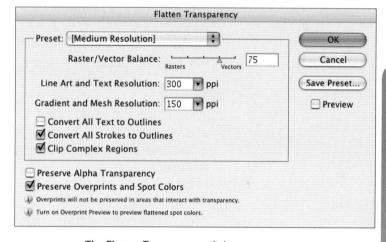

The Flatten Transparency dialog

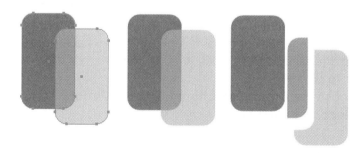

Two rectangles are drawn, with the upper object being set with a 67% transparency (left). The Flatten Transparency command is used to flatten the shapes to become separate objects (center). The shapes to the right show you the separate objects that are created.

Rasterize

This command converts a vector object image into a raster (bit-mapped) image. Once an image has been rasterized you can apply any raster filter to it. *To use this command:*

1. Choose the **Selection** tool in the Toolbox.

2. Select the object(s) to be rasterized.

Rasterizing and Filters

Numerous filters will only work on rasterized RGB images. Set the color mode to RGB using the File>Document Color Mode menu, and rasterize the object image using the Object>Rasterize menu or the Effect>Rasterize menu. The Effect result is reversible whereas the Object>Rasterize result is not.

3. Choose the *Object>Rasterize* menu command. A dialog will open. Choose the settings you desire and click **OK**. The image will rasterize and become a bit-mapped image. You can no longer edit its paths, but now you can apply raster filters to the object.

The vector art on the left was rasterized and then the Brush Stroke>Angled Stroke filter was applied to it (right).

Gradient Mesh

This tool allows you to convert standard objects into a mesh object with lines and intersecting points. This is done so that you can create an object that has multiple gradients arranged in various directions and locations, resulting in painterly effects. Consult Illustrator's Help files for instructions on how to use this feature.

Slice

The Slice command is used for prepping files for the Web. Essentially, it allows you to slice up an image into multiple pieces so that loading the image is sped up. Consult Illustrator's Help files for instructions on how to use this feature.

Path Functions

This section of the **Object** menu presents various commands that allow you to control how paths work with each other. *The following are commands found in the Path submenu:*

The Object>Path>Average menu

Average —This command allows you to select two or more anchor points (on the same path or on different paths), and average them along the Horizontal (X) axis, the Vertical (Y) axis, or both axes. *To do this:*

1. Choose the **Direct Selection** tool or the **Direct Selection Lasso** tool.

2. Select the two anchor points you want to average. You may *drag+select* around the points, or *Shift+click* on the two points.

3. Choose the *Object>Path>Average* menu command or press *Opt/Alt+Cmd/Ctrl+J* on the keyboard. The *Average* dialog will open.

4. You may choose to average the points on the X-axis, Y-axis, or both. Click **OK**.

Fashion Use: o Averaging points between the left and right sides of a garment prior to joining. This allows for drawing garments with perfect symmetry.

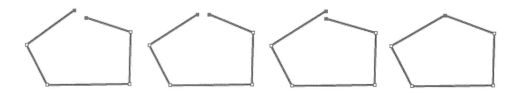

The Average command in the Context menu, opened by a right mouse button click (Windows) or Ctrl+Click (Mac)

In the example above, the left shape is the original image. Moving left to right, you can see the original image, average on horizontal axis, average on vertical axis, and average on both the horizontal and vertical axes.

Join —This command allows you to select two or more anchor points (on the same path or on different paths) and join them. If the points are one directly on top of the other (often achieved using the *Average* command), they will combine to become one anchor point. If they are not one directly on top of the other, a new segment will be added to join the two points.

To join two points that are one directly on top of the other:
1. Choose the **Direct Selection** tool or the **Direct Selection Lasso** tool.

2. Perform the *Average* command (*Object>Path>Average*) and the two points will be positioned, one directly on top of the other.

3. Choose the *Object>Path>Join* command, and the two objects should join at the selected anchor point, and no new segment will be added.

To join two points that are not one directly on top of the other:
1. Choose the **Direct Selection** tool or the **Direct Selection Lasso** tool.

2. *Drag+select* over the two points to select them.

3. Choose the *Object>Path>Join* command. Since the points are not one directly on top of the other, the *Join* dialog will open. Choose the *Corner* option if you want to join two corner points into one corner point with no direction lines. Choose the *Smooth* option if you are connecting a corner point and a smooth point to create a smooth point with one direction line. You may also choose the option if you want to connect two smooth points into a smooth point with two direction lines that are in tandem. A new segment will be drawn that will join the points.

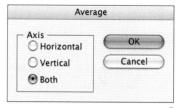

The Average dialog will open when two points are not one on top of the other.

Using Ctrl+Click or the Right Mouse Button to Speed Things
Once you have selected two anchor points to average or join, you can Ctrl+click (Mac) or right click (Windows) and select Average or Join from the Context menu that opens.

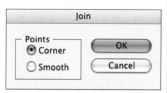

The Join dialog will open when two points are not one on top of the other.

The Join menu command

Fashion Use:

o Joining points at the center of the garment. This allows for drawing half garments, copy-reflecting the half, and then joining the two sides, resulting in garments with perfect symmetry.

In the example above, the left is the original image. Moving left to right, you can see the original image, averaging two points in both directions and then joining (center), and joining two points that are not one on top of the other, which results in a new segment being added (right).

Outline Stroke —This command converts a stroked path to a closed path/object that is the same width as the original stroke. This is helpful if you want to create a curved object that is consistently the same thickness throughout.

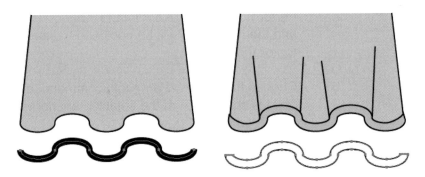

A Quick Trim! The curved path on the lower edge of the drawing on the left was copied and pasted to become a separate object. The stroke thickness was increased to '5', and then the stroke was outlined using the Outline Stroke menu command. The new object was filled with a new color and positioned back on the garment drawing. Minor repositioning of points was necessary at the sides of the drawing only.

Fashion Use:

o Creating quick trims on the edges of garments (copying the lower edge, thickening the stroke of this object, then outlining the stroke).

Offset Path —This command creates a copy of the selected closed path and offsets it a specified distance from the original. The results, in many cases, are superior to using the **Scale** tool, as the offsets retain a more parallel appearance. If a *negative* number is entered in the Offset field, the new object will be positioned inside the original object. If a *positive* number is entered, the new object will appear outside the original.

The Offset Path dialog

<p>Fashion Use: o Creating bevelled buttons.

 o Creating parallel lines on closed objects for top-

 stitching.</p>

The Offset Path command was used to create a bevelled button by offseting with a positive number to create a larger parallel circle. A gradient was used on the outer object to create depth. The top-stitching detail on the pocket was created by using a negative number in the offset dialog to create a new object inside the original. The stroke of the new object was then dashed using the Dashed line option in the Strokes panel.

Simplify —This is a handy feature, particularly for new Illustrator users, as in the beginning, one tends to draw with an excess of anchor points. Simplifying a path removes anchor points without significant change to the shape of the path. This results in smaller files, faster printing, etc. To use the function, select an object, then choose the *Object>Path>Simplify* command. A dialog will open and you can control the curve precision through the use of a slider. Turn on the *Show Original* option so that you can see the relationship between the old and the new versions of the object as you drag the slider. You can also see how many points the original image has versus the current one. Click **OK** when you are happy with the result.

Fashion Use: o Simplifying drawings that have an excess of

 anchor points.

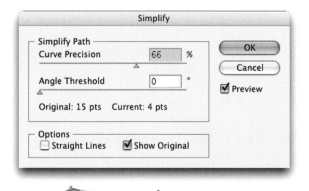
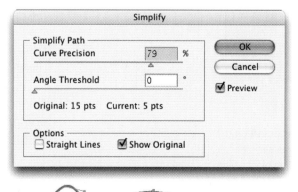

The Simplify command allows you to remove excess anchor points in a drawing. The two examples above show you the original (the dotted line) and the new path (the solid line) with varying curve precision settings.

The Add Anchor Point menu command

Add Anchor Point —This function inserts one anchor point midway between every two existing points. This is handy when you need the new point to be centered. To use the command simply select the segment or object (with the **Selection** tool) and choose the *Object>Path>Add Anchor Point* menu command. A new point will appear midway between each set of selected points. Using the **Direct Selection** tool to select only one segment of an object will allow a new point to be added only to the selected segment.

Fashion Use:
- o Creating a quick center point to pull a tip on a pocket.
- o Dividing a line evenly to add pleats, scallops, etc.

Creating a quick pocket! A rectangle was drawn (left) and the Add Anchor Point command was used to add new anchor points midway between the existing points. The new lower center point was then pulled down to create the tip of the pocket.

The red circle was drawn on top of the four squares, selected, and used as the dividing object. The Object>Path>Divide Objects Below command was used to split the objects as shown in the lower image (where the individual objects have been moved to better illustrate the division).

Divide Objects Below—This command is one of the Divide functions in Illustrator. The selected object acts as a "cookie cutter" to split or divide the objects that lay beneath it. Only one object at a time may be selected and utilized.

To use the command:

1. Draw/place an object over the objects you want to be divided. You may use an open or closed object, so a dividing line works well.

2. Choose the **Selection** tool and select the object to be used as the dividing object.

3. Choose the *Object>Path>Divide Objects Below* command. The objects below are now divided by the shape of the selected object and can be separated.

Fashion Use:
- o Inserting a quick neckline into a rectangle.
- o Drawing a line on top of the garment to splice it for design interest.

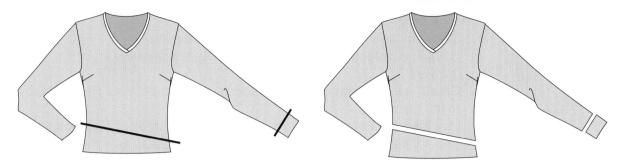

The garment on the left was spliced at the lower front and lower sleeve by drawing a dividing line in both places and utilizing the Object>Path>Divide Objects Below menu command. You must perform two separate operations (one for the body and one for the sleeve), as only one object can be used as the dividing object at any given time.

Blend

The *Blend* command automatically blends objects. It creates a multistep color and shape progression between two or more objects. You can control the automatic settings in the *Blend Options* dialog. This menu function differs from the **Blend** tool in the Toolbox in that the process happens automatically according to the settings in the *Blend Options* dialog. For the most part, this is a tool that can be used for effect. File size and printing time will increase when you use the blend functions. Refer to Illustrator Help to learn more about the function.

The Blend Options dialog and settings used for the star example to the left

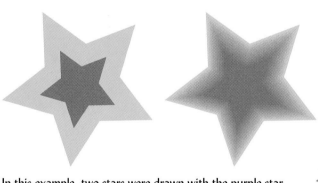

In this example, two stars were drawn with the purple star positioned on top of the yellow star. The Blend Options were set to specify 8 steps and the Blend command was used. The result was the center star with gradations of colors, which have been dragged apart in the image to the right.

Envelope Distort

An envelope is a special kind of container that is used in building distortions. This function will not be covered in this book. Refer to Illustrator's Help for further details.

Live Paint

Live Paint is a new function that was introduced with Illustrator version CS2. It is truly unique in that it combines the intuitiveness of painting by hand with the vector/object world of Illustrator. You can use all of Illustrator's drawing power, but with Live Paint, all paths are treated as if they are on one layer. Thus, the painting process becomes similar to working with hand drawing.

The general process is as follows:

1. Draw the objects you want to use in your painting.
2. Using the **Selection** tool, select all the objects involved in your drawing.
3. Create a **Live Paint Group** by choosing the *Object>Live Paint>Make* menu command.
4. Use the **Live Paint** tool in the Toolbox to paint areas of your image. You will see that the Live Paint tool treats all objects as if they are on the same layer and thus fills to boundaries Illustrator normally would not recognize since they cross layers and objects.

Live Paint groups contain paintable parts called *edges* and *faces*.
- An **edge** is the portion of a path between where it intersects with other paths.
- A **face** is the area enclosed by one or more edges. You can stroke edges and fill faces.

Let's take a drawing of a simple top to demonstrate how Live Paint works.
1. Draw a simple garment or load a predrawn style.

2. Using the **Pen** tool, add two lines to the drawing to divide the front into four parts.

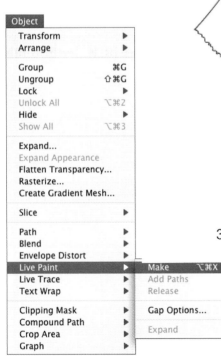

Step 1: Draw the garment. Step 2: Draw new dividing lines.

The Object>Live Paint>Make menu command

The Live Paint tool

3. Using the **Selection** tool, select all objects on the top and choose the *Object<Live Paint>Make* menu command. Note how you now have unique squares on the bounding box, which indicate that it is a *Live Paint Group*.

4. Set the *fill* and *stroke* colors according to your preference.

5. Choose the **Live Paint** tool in the Toolbox.

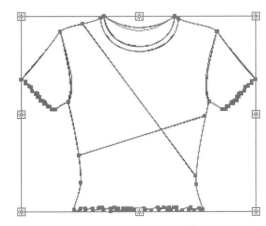

Step 3: Creating a Live Paint Group.

6. Move over to the drawing and move your cursor around. As you move it over areas of the drawing, you will see a red box outline the face of an enclosed area. Click to fill the area.

7. Repeat the filling process until you have filled the entire top with color in the

Step 6: Moving the Live Paint tool over an area and filling it with color.

appropriate fill areas. Note, as you work, how Illustrator is behaving in a new way; it is recognizing the outlines of areas as shapes, regardless of the layer they are on, or which object they belong to.

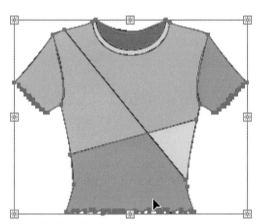

Step 7: Completing the painting process.

Once you have completed painting the image, use the **Selection** tool to click on the various objects to see what exists.

8. Now, using the **Direct Selection** tool, select the entire top. Then, choose the *Object>Live Paint>Expand* menu command. This will expand the image and break it into its various parts. If you take the **Selection** tool and click on various objects, you will see that you can pull them away from the garment. Note that the filled shapes do not have a stroke color at this point. You will need to add the stroke color if you want it.

For further information on the use of Live Paint, consult the Help files of Illustrator CS2/CS3.

Step 8: Expanding the Paint Group to individual objects, which can be pulled away from the top.

Live Trace

Live Trace is also a new function that was introduced with Illustrator version CS2. It also is a pretty amazing feature of the program, and replaces the *Auto-Trace* abilities of earlier versions of Illustrator. Fashion Exercise #13 walks you through the use of Live Trace. Use the sample file referred to there, or the one utilized here as an example.

The process of using Live Trace is as follows:

1. Load or Place a bit-map (raster) image (e.g., **flat001.tif** located in the *Fashion Exercises>Art* folder on the accompanying DVD). The *Control* panel will display slightly different options if you load a file versus placing a file. If a file is placed you will have the option to embed it, which will make it part of the image, and thus no link to the file will exist.

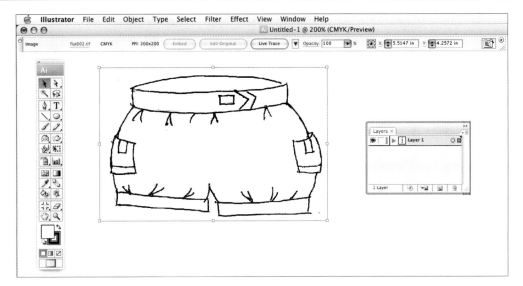

Step 1: An image is placed in Illustrator and then embedded (optional).

2. Using the **Selection** tool, select the image. The *Control* panel will change and display options pertaining to tracing. Note that all tracing objects are named "Tracing" in the *Layers* panel (look at the sublayers).

3. Click on the **Live Trace** button (or choose the *Object>Live Trace>Make* menu command). The *Control* panel will change and now display functions that pertain to Live Trace.

Steps 2 and 3: The Control panel, before and after clicking on the Live Trace option.

4. Choose the Preset of your choice for the *Preset* pop-up menu. In the case of the example here, *Hand Drawn Sketch* was the selected option. Experiment with other options and you will see the results immediately.

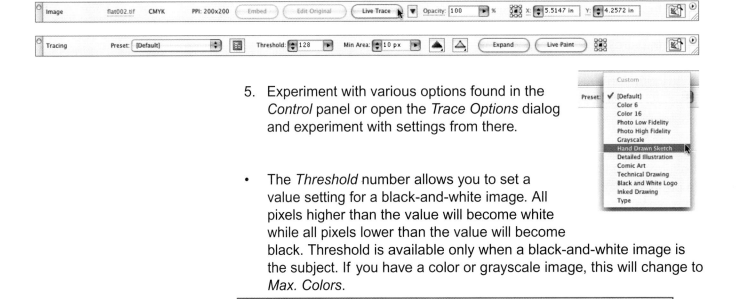

5. Experiment with various options found in the *Control* panel or open the *Trace Options* dialog and experiment with settings from there.

• The *Threshold* number allows you to set a value setting for a black-and-white image. All pixels higher than the value will become white while all pixels lower than the value will become black. Threshold is available only when a black-and-white image is the subject. If you have a color or grayscale image, this will change to *Max. Colors*.

Threshold: 190 Min Area: 4 px

• *Min Area* dictates the size of a feature that will be recognized. Thus, if it is set to 4, images smaller than 4 pixels wide by 200 pixels high will be ignored in the tracing.

- The black and white arrowheads allow you to change the view of the *Vector View* (black) or *Raster View* (white).

6. If you want to experiment further, click on the *Tracing Options* icon on the *Control* panel. This will open the *Tracing Options* dialog window. There are numerous options for you to experiment with.

Step 6: Click on the Tracing Options icon on the Control panel (above) to open the dialog shown below.

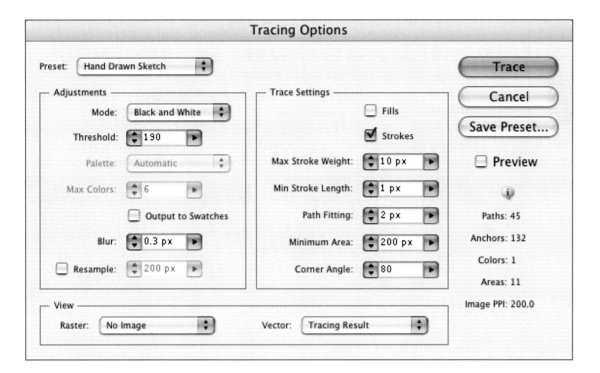

Tracing options

Preset—allows you to choose a tracing preset.

Mode—allows you to choose a color mode for the tracing result (i.e., Black and White, Grayscale, Color).

Threshold—allows you to set a value for generating a black-and-white tracing result from the original image. All pixels lighter than the threshold value are converted to white, all pixels darker than the threshold value are converted to black. This option will only be available when the *Mode* is set to Black and White.

Palette—allows you to choose a palette for generating a color or grayscale tracing from the original image. You will be able to use this option only when the *Mode* is set to Color or Grayscale.

Max Colors—allows you to set a maximum number of colors to use in a color or grayscale tracing result. (You must have a Color or Grayscale image).

Output to Swatches—if checked, creates a new swatch in the *Swatches* panel for each color in the tracing result.

Blur—performs a blur of the original image before generating the tracing result. Use this option if there is "noise" in the image or jagged edges in the tracing result.

Resample—resamples the original image to the set resolution before creating the tracing result. This option is useful when working with large images that require more memory to trace.

Note: **Paths vs Anchors**
As you change settings in the Tracing Options dialog, you can see the resulting number of paths and anchors in the lower right corner. Use this as a guide.

Live Trace performed on a fashion photograph. Mardell Wenger

Fills—results in filled regions in the tracing result.

Strokes—results in stroked paths in the tracing result.

Max Stroke Weight—allows you to set the maximum width of features in the original image that will become stroked. Features that are larger than the maximum width will become outlined in the tracing.

Min Stroke Length—allows you to set the minimum length of features in the original art that can be stroked.

Path Fitting—allows you to control the distance between the traced shape and the original pixel shape. Use lower values to create a tighter path fitting, and higher numbers to create a looser path fitting.

Minimum Area—allows you to control the smallest feature in the original image that will be traced. For example, a value of 8 will result in features smaller than 8 pixels wide by 8 pixels high being omitted from the tracing result.

Corner Angle—controls the sharpness of a turn/angle in the original image that is considered a corner anchor point in the tracing result.

Raster (in View Area)—allows you to choose how you want to display the bitmap part of the tracing object.

Vector (in View Area)—allows you to choose how you want to display the vector part of the tracing.

Preview check box—allows you to preview the changes that result when you change a setting in the dialog.

Anchor/Path/Color Information—allows you to watch the results as you make changes in the number of anchor points, paths, colors, and color areas. This appears in the lower right corner of the dialog.

Each time you change a setting, the original image will be retraced.

The Expand button is used to expand a tracing into a set of grouped objects.

6. Once you are happy with your settings and the image is traced, click on the **Expand** button in the *Control* panel. This will expand the tracing to a final vector file. The image will be composed of grouped objects. Illustrator won't necessarily understand that certain objects must be joined to complete a garment piece, so if you want to fill the garment, you will need to perform the joins manually (using the *Object>Path>Join* command), or you can use *Live Paint* to assist you.

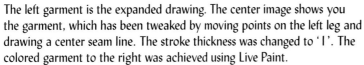

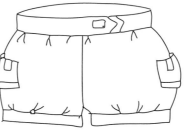

The left garment is the expanded drawing. The center image shows you the garment, which has been tweaked by moving points on the left leg and drawing a center seam line. The stroke thickness was changed to '1'. The colored garment to the right was achieved using Live Paint.

Text Wrap

The *Text Wrap* function allow you to take a text window and wrap it around an object. *The following is true of Text Wrap:*

- The object that the text wraps around is referred to as a *wrap object*.
- Illustrator wraps text around the opaque parts of bitmapped objects and ignores transparent parts.
- Wrapping is determined by the stacking order of objects and text, and by the layers.
- The wrap object must be directly above the text and on the same layer.
- If the object is grouped, the text needs to be included in the group in order for text wrap to work.

To use text wrap:

1. Create your objects and your text on the same layer.

2. Ensure that the object(s) you want to wrap is/are directly above the text.

3. Choose the **Selection** tool and click on the object(s) you want to wrap.

4. Choose the *Object>Text Wrap>Make* menu command.

The text will wrap around the object. When you want to release the text wrap, choose the *Object>Text Wrap>Release* menu command. There are two options you may set in the *Text Wrap Options* dialog (accessed by choosing the *Object>Text Wrap>Text Wrap Options* menu command). The *Offset* option allows you to control the distance between the edge of an object and the text. The *Invert Wrap* option wraps the text around the opposite side of an object.

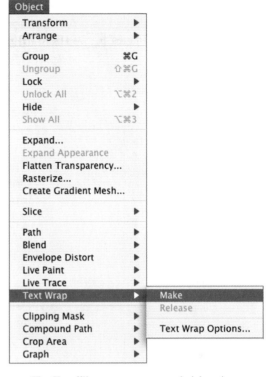

The Text Wrap menu commands (above) and the Options dialog (below)

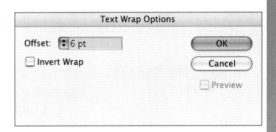

Text Wrap Options dialog

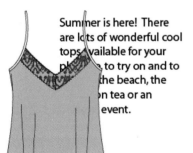

The example to the left shows you text prior to wrapping (far left) and after wrapping (near left). Above you see the stacking order of the objects in the Layers panel.

shoes · pumps · sling-backs ·
sneakers · mules
boots ·
moccasins·
loafers ·
spikes ·
walking
shoes ·
running
shoes ·
oxfords · sandals · shoes ·
pumps · sling-backs · sneakers ·

A second example of text wrap. Here the text wraps around a circle filled with a gradient.

Clipping Mask Cmd/Ctrl+7

A *Clipping Mask* allows you to combine two or more objects so that the artwork that lies beneath the top shape is only seen *through* the shape. *The following is true of Clipping Masks:*

- The clipping mask is an object whose shape masks the artwork beneath it
- A clipping mask and the objects that are masked are called a clipping set. This set is marked with a dotted line in the *Layers* panel.
- A clipping set is made by selecting two or more objects or from all the objects in a group or layer.
- Only vector objects can be clipping masks. Both vector and raster images can be masked.
- Masked objects are moved into the clipping mask's group in the *Layers* panel if they didn't already reside there.
- If you use a layer or group to create your clipping mask, the first object in the layer/group (the uppermost object in the stacking order) masks everything that is a subset of the layer/group.
- Once a clipping mask is created, the clipping mask object changes to have no stroke and no fill.
- If you want a semitransparent mask, use the *Transparency* panel to create an opacity mask.
- You can release a clipping mask by using the *Object>Clipping Mask>Release* menu.

The Clipping Mask menu command

Fashion Use:
- o Take an image of scanned fabric (in bit-mapped format) and place it inside a vector garment.
- o Mask text into a drawn object so that the text fills only the object.

To create a clipping mask:

1. Load or draw the images you want to use. If you are combining an image of a scanned fabric, place this into your document using the *File>Place* menu command.

2. If any of the objects are grouped, either ungroup them or add the image/object you want to be masked into the group.

3. Ensure that the object you want to become the clipping mask is on top of the object/image you want to be masked.

4. Choose the **Selection** tool, press the *Shift* key on the keyboard, and select both the clipping mask object and the object/image to be masked. Observe your *Layers* panel to see what is selected.

Steps 2-4: The objects are positioned in the document so that the image to be masked (the fabric) is beneath the masking object (the garment). Then, both objects are selected.

5. Choose the *Object>Clipping Mask>Make* menu command. The object/ image to be masked will now appear inside the masking object only. The original fill and stroke of the masking object will change to None.

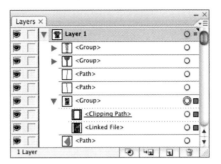

Step 5: Making a clipping mask. Note that the Layers panel displays the mask as a grouped item. Note that the Clipping Mask layer sits as a sublayer to the Group layer.

When a mask exists, the object/ image being masked still exists and is indicated by a hollow box. You can choose to release the mask at any point in time.

6. Using your **Selection** tool, select the masking object (in this case the body of the top). Click on the **Stroke** icon in the Toolbox, and change the stroke color to black. The body of the top will now have a black outline once again.

If you click on the top, you will see the invisible box that contains the masked image. You may release the mask by choosing the *Object>Clipping Mask>Release* menu.

Compound Path *Cmd/Ctrl+8*

Compound paths allow you to cut holes in an object and see through the holes to the underlying object. This is achieved by placing objects in such a manner that they overlap, or positioning one object inside another. When you create the compound mask, the areas where the objects overlap are "cut out" and you can see through to whatever is positioned underneath. *The following is true of Compound Paths:*

- When objects are defined as a compound path, all objects involved take on the paint style and attribute of the backmost object in the stacking order.
- Compound paths behave as grouped objects. In the *Layers* panel they appear as <Compound Path> items.
- You must use the **Direct Selection** or **Group Selection** tool to select a given part of a compound path.
- You may edit the shape of compound paths, but you may not alter the appearance attributes, graphic styles, or effects of individual components, as these changes will apply to the entire group.
- You can release a compound path by using the *Object>Compound Path>Release* menu.

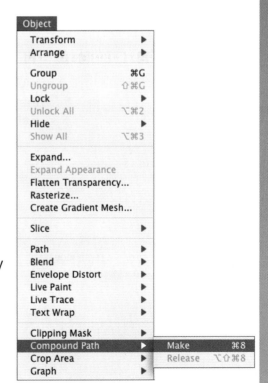

The Compound Path menu commands

To create a compound path:
1. Draw or load the initial objects to be used as the background. In the example that follows, a fashion drawing of a model wearing a t-shirt top was used.

2. Draw the object that you want to use as a "cut-out." Ensure that the object you want to cut out is on the top of the stacking order of objects. The example here shows a circle placed above the model's top.

3. Choose the **Selection** tool, press the *Shift* key on the keyboard, and select both the circle (the object to be cut out) and the top (the object you want to have the cut-out occur on).

4. Choose the *Object>Compound Path>Make* menu command. The object on the top (the circle) will now be cut out of the object below (the top) and you will be able to see through to the body of the model. Observe the *Layers* panel to see the compound path indicator on the layer.

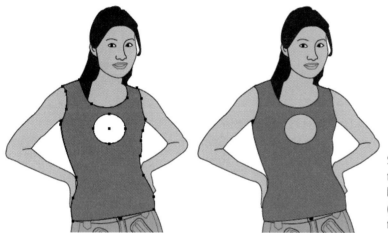

Steps 3–4: Select both objects involved, ensuring that the object you want the cut-out to occur on is beneath the object you are using to create the cut-out (far left). Use the compound path command to create the cut-out. You will now be able to see through the top to the body objects beneath it (near left).

5. If you want, you can experiment with moving the circle (using the **Group Selection** tool) or editing its shape (using the **Direct Selection** tool).

Step 5: Experimenting with moving and editing a compound path object.

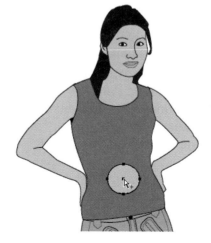

You can release the compound path by choosing the *Object>Compound Path>Release* menu command.

Crop Area

The Crop Area command allows you to crop an image so that crop marks appear on the document and printout, or, upon request, only the cropped area prints. The latter situation requires an additional change in the *Print* dialog. To crop, you create a rectangular object to define the cropping area, and place this above the artwork to be cropped.

To create a crop area:

1. Draw or load the drawing you want to work with.

2. Choose the **Rectangle** tool and drag a rectangle over the area of the artwork you want to crop to. It doesn't matter what *fill* and *stroke* you use. If necessary, reposition the rectangle using the **Selection** tool or, if the rectangle is the selected object, you can use the *arrow* keys on the keyboard to nudge the position of the rectangle.

3. Using the **Selection** tool, select both the rectangle and the objects beneath it.

4. Choose the *Object>Crop Area>Make* menu command. Crop marks will appear on the document. These will not print.

5. When you want to print, choose the *File>Print* menu and click on the *Setup* option. Then, choose *Crop Area* in the *Crop Artwork to:* pop-up. Click on **Print**. Only the cropped area will print.

Crop areas can be released using the *Object>Crop Area>Release* menu.

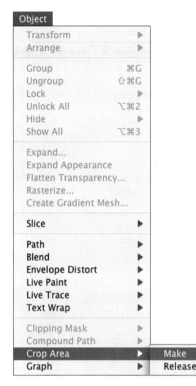

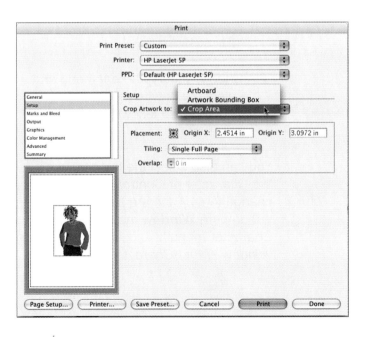

Draw a rectangle over the area you want to crop. Select the rectangle and the drawing below and choose the Object>Crop Area>Make menu command. Crop marks will appear on the drawing. When you go to print, you must select the Crop Area option in the print dialog in order to see the results on your printout.

Graph

The Graph function of Illustrator will not be covered in this book. Consult the Help files for details.

The Character panel

Type Menu

The **Type** menu contains functions that pertain to working with type and fonts in Illustrator. Many of the menu options can be accessed through the *Character* and *Paragraph* panels. Only certain functions will be covered in this book. Refer to Illustrator's Help files for details on functions not covered.

Font

The *Font* menu command allows you to access and select from the library of fonts installed on your computer.
To select a font prior to typing:

1. Choose the *Type>Font* menu and slide to the right. A long list of fonts will appear. Slide down and click on the font of your choice. This will now be the active font.

2. Choose a **Type** tool from the Toolbox.

3. Click on the screen where you want to start typing or drag a text box by *clicking+holding+dragging* a box over the area you want to type in. Commence typing.

To change a font after typing has occurred:

Selecting a font from the Type menu

1. Choose the **Type** tool in the Toolbox and double-click in a text box to select the text, or *click+hold+drag* over the text you want to change.

 The of the garment is 3" deep.

 OR
 Choose the **Selection** tool and click on a text window to select it.

 The neckline of the garment is 3" deep.

2. Choose the *Type>Font* menu and select the new font of your choice. The selected text will change to the new font.

You can also select the text and use the *Character* or *Control* panel to change fonts. Both are accessed through the **Window** menu. The Character menu is accessed through the *Window>Type>Character* menu.

Recent Fonts

The *Recent Fonts* menu command displays fonts that you have recently used in the document. This is a handy feature as you can quickly see a shorter list of fonts used recently and select one of the fonts for current use.

Recent Fonts displays a list of fonts used.

Size

This menu command allows you to adjust the size of the font. When you first select the menu, it will show the size of the default font or any current selection on the document.

To change a font size after typing has occurred:
1. Choose the **Type** tool in the Toolbox and double-click in a text box to select the text, or *click+hold+drag* over the text you want to change.
OR
 Choose the **Selection** tool and click on a text window to select it.

2. Choose the *Type>Size* menu and slide to the right. You will see a list of numbers appear. A check mark appears beside the current font size. Slide down to the font size of your choice. The selected text will change to the new font size.

The Font Size menu command

You can also use the *Character* panel to change a font's size. This is accessed through the *Window>Type>Character* menu and is often more convenient to use.

Create Outlines

Create Outlines allows you to change a font into a graphic. This is particularly handy if you want to fill the font with a gradient or if you want to hand alter the shape of your text. Many people choose to use outlined fonts when they plan to transfer the file to a printing bureau or to another user who may not have the same fonts on their computer. Realize that once outline fonts are created, you can no longer use the typical text editing tools, as the fonts are indeed graphic objects and no longer editable fonts.

To create an outline font:
1. Choose the **Type** tool in the Toolbox and type text on your document. Set the font style and size according to your taste.

2. Choose the **Selection** tool and click on the text to select it.

3. Choose the *Type>Create Outlines* menu command. Each letter of the type on the screen will change to an object using the current fill and stroke in the panel.

4. Experiment with stroke and fills.

The Create Outlines menu command (above). An example of converting an outlined font to a graphic and filling it with a gradient fill (left).

Context-Click

This is when you right-mouse-button click (Windows) or Control+click (Mac) to open a context menu.

Find Font

This is a handy function. *Find Font* allows you to identify all the fonts used on a document, according to font family. It also allows you to quickly locate the font, change it, etc. If you context-click (*Ctrl/Right Mouse Button+click*) on any of the fonts that appear in the dialog, it will show you the first few words of the text that uses the font.

The Find Font dialog

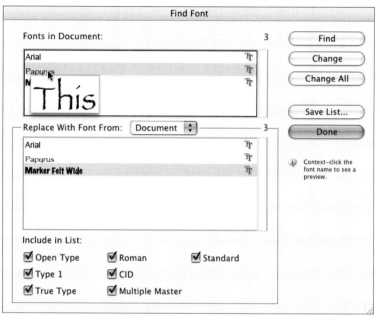

Change Case

This command allows you to change the case of the type. Choices include UPPERCASE, lowercase, Title Case, and Sentence case.

CLASSIC
classic
Classic
Classic

Examples of the various case options

The Change Case menu command

Type Orientation

This command allows you to change the orientation of the type. You may choose between horizontal and vertical.

Horizontal (above) and Vertical (left) Type Orientation

Select Menu

The **Select** menu contains functions that pertain to selections. Objects are typically selected so that they may be moved or edited.

As a quick review, *selections are made through any of the following ways:*

- **Layers panel**—You may select objects on a given layer or on a sublayer. Click on the colored circle to the right of the layer or sublayer name.

- **Tools in the Toolbox**—Use the Selection, Direct Selection, and Group Selection tools to select objects. The Lasso tool lets you draw a circle or lasso around the objects you want to select. The Magic Wand lets you select objects of the same color, stroke weight, stroke color, opacity, or blending mode.

- **Live Paint**—Live Paint lets you select faces (areas enclosed by paths) and/or edges (portions of paths between intersections) of Live Paint groups.

The **Select** menu commands allow you to quickly select or deselect all objects, or objects based on their position relative to other objects. You may also select objects that share similar attributes and you may save selections and load them later.

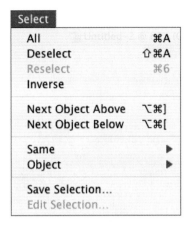

The Select menu

All *Cmd/Ctrl+A*

This command allows you to select all objects on the document. This is handy if you want to make global changes to the current object set, or if you want to move or transform all objects as a group (without making them a group).

Deselect *Shift+Cmd/Ctrl+A*

This command allows you to deselect all objects that are currently selected. You may also click away (by pressing the *Cmd/Ctrl* key on the keyboard and clicking away from any of the objects that are selected).

Reselect *Cmd/Ctrl+6*

This command allows you to repeat the last selection command. For example, if you had just selected all the pink objects using the *Select>Same>Fill Color* command, and now you want to select all the purple fill objects, you can select a purple-filled object and choose the *Reselect* command.

Inverse

The *Inverse* command allows you to select items and then invert the selection so that all nonselected items become the selected ones. Sometimes when there are numerous items to select, it is actually easier to select the items you don't want, and invert the selection.

Next Object Above *Opt/Alt+Cmd/Ctrl+]*
Next Object Below *Opt/Alt+Cmd/Ctrl+[*

These commands allow you to locate and actively select objects directly above or below the currently selected object.

> **Speed Tip**
> If you want to quickly switch from your current tool to the last-used Selection tool, without going over to the Toolbox with the mouse, press and hold the Cmd/Ctrl key on the keyboard to change the current tool to a Selection tool. Release the key when you want to return to the original tool. This is particularly useful when drawing with the Pen tool, as you can toggle back and forth between the Pen tool and the Selection tool.

Same

There are times when you want to select multiple objects that all share the same attributes or properties. This menu command and its various suboptions allow you to choose objects by their shared attributes with the currently selected object.

To use this option:

1. Select an object that has the attributes of the objects you want to select.

2. Choose the *Select>Same* menu command and the submenu of your choice. Options include *Blending Mode, Fill & Stroke, Fill Color, Opacity, Stroke Color, Stroke Weight, Style, Symbol Instance,* and *Link Block Series.* All objects with the same parameters chosen by your menu choice will be selected.

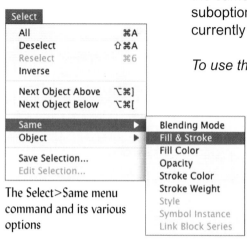

The Select>Same menu command and its various options

Fashion Use:
o In textile design, this command will allow quick building of multiple colorways through the global change of all objects that share the same stroke/ fill combination.
o Quick global changes of design lines (such as design details) that share the same stroke width.

Note: **Select Same**
The Select Same menu commands do not work with Live Paint Groups

Note: **Magic Wand**
The Magic Wand can select objects with the same color, stroke weight, stroke color, opacity, or blending mode.

Object

Whereas the *Same* menu commands allow you to select objects sharing the same attributes, the **Object** menu command allows you to select objects of the same type. Each of the suboptions has its own unique situation(s) in which the ability to select all of the same type of objects is beneficial. Global changes are quick and easy.

To use this option:

1. Select an object of any given type.

2. Choose the *Select>Object* menu command and the submenu of your choice. Options include *All on Same Layers, Direction Handles, Brush Strokes, Clipping Masks, Stray Points,* or *Text Objects*

Using the Stray Points function is a good way to clean up a document by removing all stray points created in the drawing process.

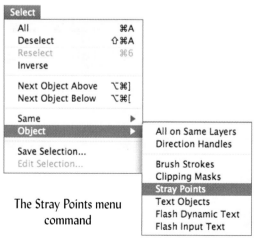

The Stray Points menu command

Save Selection and Edit Selection

The ability to save a selection of multiple objects is handy when the selection process was complicated and contains a variety of object types as well as objects with variable attributes.

To use this function:
1. Using the **Selection** tool, select one or more objects.

2. Choose *Select>Save Selection*. A dialog will open.

3. Type a name in the *Name* text box, and click **OK**.

The selection will be saved with the document. You can reload a saved selection in a document by choosing the selection name from the bottom of the *Select* menu. To delete or rename a selection, choose the *Select>Edit Selection* command.

Naming the selected object group

Selections may be named and saved, and will appear at the bottom of the Select menu.

You may edit the name of, or delete a saved selection by choosing the Select<Edit Selection command and either renaming or deleting it.

Choosing to edit a selection

Filter and Effect Menus

Filters and *Effects* in Illustrator are used to change the appearance of objects and images through distortion, texture, color changes, etc. The main difference between an *Effect* and a *Filter* is that Effects change only the appearance of an object (and not its underlying path) and thus are editable, whereas Filters change the underlying object/path, and thus are not editable after the filter has been applied (although you can undo). Upon examining the **Filter** and **Effect** menus, you will see that there are many parallel effects and filters. Sometimes settings used in one menu will automatically occur in the counterpart of the other menu.

Both the **Filter** and **Effect** menus are divided into two general sections. In both, the upper section is devoted primarily to vector images and is labeled Illustrator Filters or Illustrator Effects. The lower section of both menus is devoted to raster images and is labeled Photoshop Filters or Photoshop Effects. Vector filters and effects randomly distort an object's shape or modify its color. Bitmap filters and effects add painterly or artistic qualities to an image. Once used, recently-used filters or effects will appear at the top of the menu, making them available for quick use again.

The Filter and Effect menus

Targeting Objects

Prior to changing an *Appearance* attribute or applying a style or effect to an object, layer, or sublayer, it is necessary to target the object/layer/sublayer. This can be achieved by selecting the object with the usual selection methods (using the **Selection** tools), or you may click on the round circle icon in the Target and Appearance column of the layer or sublayer in the *Layers* panel.

Examine the *Layers* panel below and note the two columns to the right of the layer and sublayer names. These are the *Target and Appearance* column and the *Selection* column.

- o Shaded target icons indicate items that contain appearance attributes (see the circle object below, which has a drop shadow effect applied to it).
- o Targeted objects (i.e., actively selected objects) are indicated by a double ring around the target icon (see the rectangle object below, which is selected in the artwork).

You may select or target objects by using the **Selection** tool or by clicking on the appropriate well in the layer or sublayer that contains the object. See the discussion on the *Appearance* panel in Chapter 5 for further explanation on targeting objects (page 142).

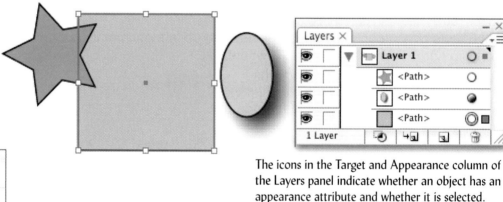

The icons in the Target and Appearance column of the Layers panel indicate whether an object has an appearance attribute and whether it is selected.

The Filter menu

Filter Menu

The following is true of Filters:
- o Filter commands change the actual object.
- o Vector filters are designed to be used with vector objects and are grouped in submenus in the top portion of the menu.
- o Raster filters are designed to be used on bitmap images and are categories at the bottom of the **Filter** menu. These are Artistic, Blur, Brush Strokes, Distort, Pixelate, Sharpen, Sketch, Stylize, Texture, and Video.
- o Some of the Raster filters work only on RGB or grayscale images. If you are using a CMYK or Bitmap (black/white) image, it is necessary to convert the image to RGB or Grayscale (using the *Image>Mode* menu) prior to using the filter.

To apply a Filter:
1. Target the object, image, layer, or sublayer.

2. Choose a filter from the submenu of the **Filter** menu. If a dialog opens, click on the *Preview* box and change settings in the dialog, examining the preview of how the effect will alter the appearance of the object.

3. Click on the **OK** button to apply the effect.

If you do not like the result of a filter, undo the action using the *Undo* command (*Edit>Undo*) to back up and undo the change. You may also use the *History* panel to back up to a prior point in time.

Effect Menu

The following is true of Effects:
o Effects change only the appearance of an object, and not its underlying path. Therefore, objects with effects are editable. For this reason, one can experiment more with effects.
o Objects with applied effects can be reshaped at any time and the effect will update.
o Effects can be applied to any kind of object, even editable text.
o Applied Effects are listed on the *Appearance* panel for each selected object.
o Effects applied to a targeted layer, sublayer, or group will be applied to all existing and future objects on that layer, sublayer, or group.
o Effects can be saved as a style.

To apply an Effect:
1. Target the object, layer, or sublayer.

2. Choose an effect from the submenu of the **Effect** menu. If a dialog opens, click on the *Preview* box and change settings in the dialog, examining the preview of how the effect will alter the appearance of the object.

3. Click on the **OK** button to apply the effect.

If you examine the *Appearance* panel, you will see an effect symbol (represented by a circle with the letter 'f' inside) to the right of a selected object (once it is selected).

The Effect menu

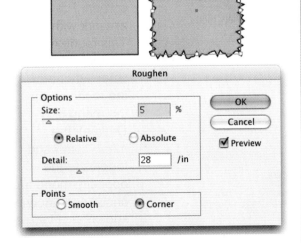

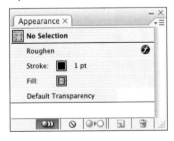

Right: The Roughen Effect was applied to a square (left example) to create a ragged-edge version (right example).

Left: The resulting Appearance panel

Editing an Effect using the
Appearance panel

To edit an Effect:
1. Target the layer, sublayer, or object in the *Layers* panel by clicking on the target icon in the *Layers* panel.

2. Double-click on the effect name in the *Appearance* panel.

3. Make your changes in the dialog that opens, and then click on **OK**.

Filters and/or Effects will be used in the Design exercises in the Presentation section of this book. Refer to Presentation Exercise #2 for a step-by-step example.

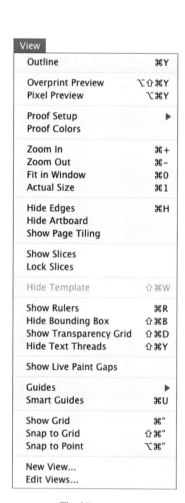

The View menu

View Menu
The **View** menu contains menu commands that control the view of the document and objects you are working on. Use of various options in this menu can facilitate and speed your work. Only menu commands used in the exercises of this book will be discussed.

Many of the menu commands found in the **View** menu are toggle menus, which means the name of the command will change to its counterpart name, once it is selected. For example, once the *Show Grid* menu command is selected, its name in the menu will change to *Hide Grid*. You toggle the function on or off.

Outline vs. Preview Display Modes
There are two display modes that control how you view your artwork:

Outline vs. Preview *Cmd/Ctrl+Y*
Outline mode displays your artwork as paths only, hiding the various object paint attributes. This mode speeds up the screen refresh when you are working with complex drawings. It is often handy when working with multiple overlapping objects, as the view simplifies what you see on screen. Preview mode displays your artwork with both paths and color fills. This mode represents how your image will look when printed. Once you have selected one of the modes from the menu (e.g., *Outline*), the menu command toggles to the opposite mode and makes it available for your choosing (it now becomes *Preview*). This is known as a toggle menu.

The two menus here show the toggle between Outline (left) and Preview (right) menu commands.

Overprint Preview

When this is turned on, you will see how spot color objects overprint underlying objects. Refer to the Illustrator Help files for more detail.

Pixel Preview

This mode turns on a 72 ppi (pixel-per-inch) raster display, which will display your images as they would be seen as Web graphics on the Internet.

Zoom Level Controls

There are four different methods of controlling the zoom level of the display of your artwork on the screen.

The Zoom Level menu commands

Zoom In *Cmd/Ctrl+=*

This command allows you to zoom in one level.

Zoom Out *Cmd/Ctrl+-*

This command allows you to zoom out one level.

Fit in Window *Cmd/Ctrl+0*

This command zooms to a level where the document fits in your display.

Actual Size *Cmd/Ctrl+1*

This command zooms to a level where you are viewing the actual size of the drawing.

Document Display

There are three different methods of controlling what you see on the document window. These are *Hide/Show* toggle menu commands.

The Document Display menu commands

Hide/Show Edges *Cmd/Ctrl+H*

This command allows you to hide the display of the edges of selected objects. When edges are hidden, you can select an object and edit it without the layer selection color showing in the display.

Hide/Show Artboard

The artboard is represented by a black outline on the document. This command allows you to turn the display of the artboard on and off. The illustration to the right shows artwork sitting on the artboard (which is represented by the black outline).

Hide/Show Page Tiling

When you work with documents that are larger than the paper you are planning to print on, you will need to tile the printouts so that you may tape them together to build the large document. You will not see the tiling until you set the paper size in the *Print* window to be the actual paper size, and set the Tiling option in the *Print Setup* to *Tile Full Pages*.

Setting up Page Tiling in the
Print dialog (right) and the
resultant tiling of pages (below)

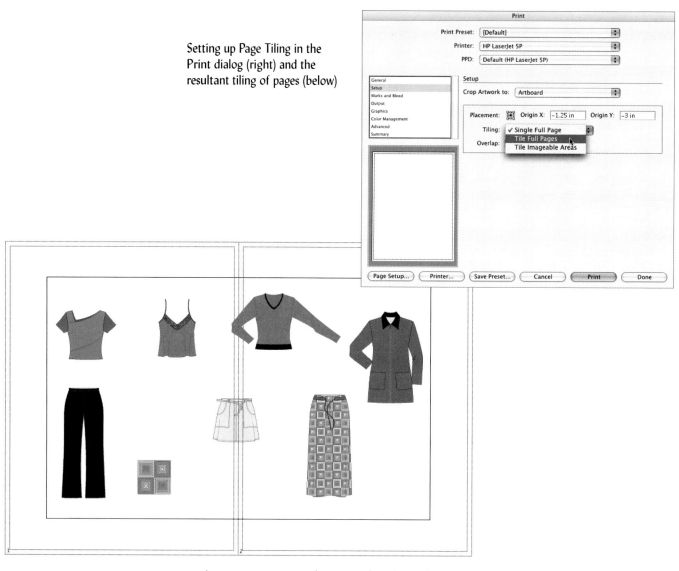

Other Screen Displays and Related Functions

Rulers are displayed on the left
and upper sides of the document
(below).

The following are additional **View** options in Illustrator that are commonly
used in creating fashion-related drawings:

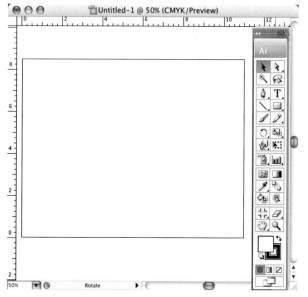

Hide/Show Rulers *Cmd/Ctrl+R*
Rulers can be displayed to use as measuring guides
as you work. The measuring denomination is set in
Preferences. At any point in time you can reset the '0'
point of the ruler. You need to view the rulers in order to
create guidelines.

Hide/Show Bounding Box
Shift+Cmd/Ctrl+B
This command allows
you to turn on or off the
bounding box, which is
a box that surrounds
selected objects and
allows you to quickly
perform transformations
to them.

A bounding box surrounds the
selected object.

Guides>Hide/Show or Guides>Lock

Guides are vertical or horizontal lines that you "pull" from the rulers and position on your document to assist you while you work. You can use a guide to assist in aligning objects, to mark a center point of a drawing, etc. Typically guides are locked and if you want to move a guide or remove it (by dragging it back over a ruler), you need to unlock the guide using the *View>Guide>Unlock* menu command.

Smart Guides

Smart Guides are temporary guides that help you align objects. When turned on, they appear when you draw, move, duplicate, or transform an object. See Illustrator Help for more details.

Hide/Show Grid *Cmd/Ctrl+"*

This command allows you to turn on or off the display of a grid as you work. You can control the setting of the Grid in Illustrator's Preferences. Fashion Exercise #2 uses Grids and Snap to Grid.

Snap to Grid *Shift+Cmd/Ctrl+"*

The *Snap to Grid* function causes your cursor to jump to grid intersections as you draw or move an object. It feels somewhat like you are working with a magnet. A check mark by the menu name indicates whether the grid snap is on or off. Fashion Exercise #2 uses Grids and Snap to Grid.

Snap to Point *Opt/Alt+Cmd/Ctrl+"*

The *Snap to Point* function causes your cursor to jump to anchor points as you draw or move an object. If you are moving an object, attempt to place your cursor on an anchor point and then drag the object to reposition it. The *Snap to Point* function will allow the dragged anchor point to snap to the anchor point of a new object once you are within a few pixels of it. A check mark by the menu name indicates whether the Snap to Point is on or off.

Hide and Lock Guides menu commands

Displaying the grid to facilitate drawing

Window Menu

The **Window** menu is primarily used to choose panels you want to have open and ready for use.

New Window

This menu command opens a duplicate window of the one you are currently working on. All changes made to your art occur in both the original and duplicate windows. This feature allows you to zoom in on one file and stay zoomed out on the other so that you can view your artwork at two different levels as you work.

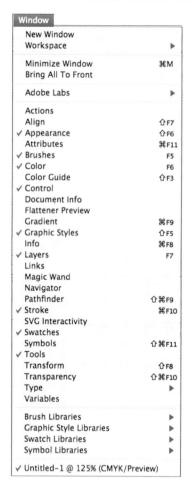

The Window menu

Workspace

A workspace in Illustrator is your arrangement of panels and tools. As you work on various types of projects in Illustrator, you may find that you have preferred layouts for different projects. For example, when you are drawing flats of garments you may want certain panels and tools readily available. You can set this layout up and save it for easy retrieval later.

To create a custom workspace:

1. The **Workspace** menu command allows you to organize the layout of your open panels and save this for future use.

2. Open the panels of your choice and position them on the document.

Saving a workspace

3. Tear off any tools that you want to use and position these as well.

4. Choose the *Window>Workspace>Save Workspace* menu command. A dialog will open.

5. Type in a name that identifies this workspace for you. Click on the **OK** button.

The Save Workspace dialog

The workspace will be saved and will now appear in the *Workspace* submenu.

To further manage your workspaces, choose the *Window>Workspace>Manage Workspace...* menu command. *Once this menu is open, you can do any of the following:*

- Rename a workspace by selecting it and editing the text
- Delete a workspace by selecting it and clicking on the **Delete** button.
- Duplicate a workspace by selecting it and clicking on the **New** button.

Remaining Menu Items

The remaining items listed on the **Window** menu are the names of panels that can be opened for use. The first time you select a panel it opens and a check mark appears beside its name. To close a panel from the menu, simply select its name again. A list of open documents will appear at the lower end of the panel.

This completes the discussion of the Menu Bar and menu functions in Illustrator.

Illustrator's Key Panels

Illustrator has numerous panels available for your use. These are accessed through the **Window** menu. In earlier versions of Illustrator the term palettes was used. This book covers all versions of Adobe's Creative Suite, but the term panel will be used. CS1 and CS2 users should understand that panel = palette.

A panel is a floating window that contains functions according to a theme. Panels allow you to modify images, or to monitor your work status. If a panel is open, a check mark appears beside the panel name in the **Window** menu. The choice of which panels to open will vary from user to user and from project to project. Any given panel window may contain multiple functions, each organized like a manila folder with a tab. There are numerous panels available for your use in Illustrator. The Toolbox is considered a panel, and is discussed in detail in Chapter 3. The most commonly used panels discussed in this chapter are the *Control, Layer, Navigator, Stroke, Color, Swatches, Color Guide (CS3), Gradient,* and *Appearance* panels. Of all of these, the *Layers* panel is the most commonly used, and critical to productive work in Illustrator. The *Control* panel differs slightly from other panels in Illustrator (and will be discussed on the next page). Refer to Illustrator's Help to read up on panels not covered in this book.

Note: Illustrator's Key Panels
The key panels used throughout this book are:
- o Toolbox
- o Control
- o Layer
- o Navigator
- o Stroke
- o Color
- o Swatches
- o Color Guide
- o Gradient
- o Appearance

Three panels docked together

The following is true of panels (other than the Control panel):
- o Each panel has a tab to indicate the name of the panel.
- o Panels can be docked or grouped so that several appear in a window together. Clicking on a panel tab brings the selected panel to the front of a group.
- o A panel can be torn away from the group by clicking and holding on its tab and dragging the panel away from the others. Likewise, you can group panels by dragging independent panels into a window that contains a group.
- o Many panels have menus accessed by clicking on the panel menu/options arrowhead on the upper right side of the panel. These menus contain commands pertinent to the function of the panel.
- o Some panels have double-arrow heads to the left of the panel name. If you click on this you can change the view of the panel: with options, without options, compressed to a panel title only.
- o Panels can be collapsed to the panel title only, by double-clicking on a tab. Double-clicking a second time returns the title to the full panel.
- o In Illustrator CS3, panels can be docked to the right side of the window. They can be collapsed to icon view or expanded to full view by clicking on the double arrows at the top of the panel area.

Click on the double arrowhead to alternate between panel views.

Panel Options Menu. Click on this to access additional options. CS2 above and CS3 below.

Expanding and collapsing the panels in the dock

o The layout and position of panels is remembered when you close Illustrator so that the next time you open the program, all will appear as you last left it.

Setting up a Workspace

As you continue to work with Illustrator, you will find you develop different approaches to projects according to the type of operations required and the functions you must perform. You may even find that you set up a different assortment of tools and panels to be available for use, project-to-project. It is for this reason that the concept of a *workspace* was developed. A workspace is a layout of panels and tools frozen in time, at the point at which you save the workspace. Thus, if you have a favorite set of panels and tool tearoffs that you like on your screen as you work, you can set these up and then save the workspace.

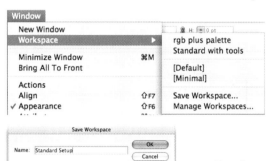

Saving a custom Workspace for future retrieval and use

To create a custom workspace:

1. Open a new document, using the *File>New* menu. Choose the page size, orientation, and color mode. Click **OK**.

2. Choose the panels you want to display, using the **Window** menu to open them. If a check mark appears beside the panel name, the panel is open.

3. Arrange the layout of the panels on the screen by moving them to the desired position.

4. Tear off any tools that you want handy and position them on the document.

5. Choose the *Window>Workspace>Save Workspace* menu command. A dialog will open. Type in the name of your workspace and click **OK**.

Control Panel (CS2, CS3)

A *Control* panel was added to Illustrator beginning with version CS2. This panel initially appears across the top of the screen directly beneath the Menu Bar, but it may be moved to the lower screen.

The *Control* panel works in conjunction with selections and displays the various settings/attributes of the currently selected object. You can view the current settings for the following: fill and stroke color, stroke width, brush tip, opacity setting, fonts, style (if used), etc. In addition, you can determine the specific location and size of an object. If you like, you can easily edit any of the settings directly from the panel simply by altering the numbers. The *Control* panel differs from other panels in Illustrator in that it doesn't have a panel menu and commands.

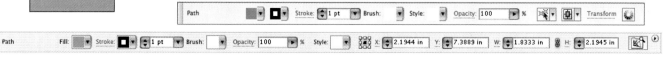

The Control panel here (CS3 above, and CS2 below) shows the various settings and options available that pertain to the selected orange rectangle object.

Layers Panel

The *Layers* panel is essential to working efficiently in Illustrator, and is the most commonly used panel. As you work on a drawing, you may utilize layers to separate objects from each other. This is particularly helpful when objects are stacked directly on top of each other. The editing process then becomes simpler as you can easily select the object of your choice to work on.

A layer is like a sheet of transparent film upon which you can add colored objects. One can see through the background of one layer to the layers beneath it, and you can stack layers in a specific order to build a drawing. For example, if you are creating a fashion illustration, it would make sense to place the facial features on a layer above the layer that holds the head. That way you can easily select and edit the eyes, nose, and/or lips without worrying about accidentally altering the head.

Top-level Layers
Access sublayers, path, and text objects
by clicking on the arrowhead of a layer.

eye →

lock →

template →

Access to Layer
panel menu

Make/
Release
Clipping
Mask

Create New
Sublayer

Create New
Layer

Delete Selection

New Layer...
New Sublayer...
Duplicate "Layer 1"
Delete Selection

Options for "Layer 1"...

Make Clipping Mask
Enter Isolation Mode
Exit Isolation Mode

Locate Object

Merge Selected
Flatten Artwork
Collect in New Layer

Release to Layers (Sequence)
Release to Layers (Build)
Reverse Order

Template
Hide All Layers
Outline All Layers
Lock All Layers

Paste Remembers Layers

Panel Options...

The Layers panel menu

There are several terms that you need to become familiar with when working with layers. *These are:*

top-level layer—is a layer that is not nested within another layer.

sublayer—is a layer that is nested within another layer. It is shown in the *Layers* panel indented inward from the top-level layer.

stacking order—the order in which objects and/or layers are positioned. Objects can be stacked on a single layer, and layers are stacked, one on top of the other. One always looks down from the top layer through all the layers to the bottom layer. It is possible to change the stacking order of objects (using the *Object>Arrange* menu command) and of layers (by dragging the layer to a new position in the *Layer* panel).

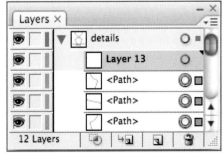

Top-level layer and sublayers are displayed above in CS2. A new sublayer was just created.

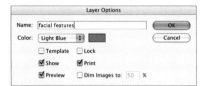

The Layer Options dialog

Viewing the objects on a layer

Layer Options—are specific settings chosen for a given layer. These are set in the *Layer Options* dialog, which is most easily accessed by double-clicking on a layer's name.

Objects on Layers—As you draw, each object drawn on a given layer can be seen in the *Layers* panel by opening up the layer, then the sublayer (if applicable), and then the objects list. You click on the triangle beside the layer name to see the list of objects.

The study of layers can be quite lengthy as there is much power to be learned and harnessed within Illustrator. If you want to become fully adept with layers, consult Adobe's Help files. The discussion below will cover the most important topics concerning layers.

Layers may be:

o **created** by choosing *New Layer* from the *Layers* panel pop-up menu (*click+hold* on arrowhead and slide over to the option), or by clicking on the **Create New Layer** button at the bottom of the *Layers* panel.

o **named** by typing a name in the dialog that opens when you choose *New Layer* from the *Layers* panel pop-up menu, or by double-clicking on a layer name to open the *Layer Options* dialog.

o **duplicated** by using the *Duplicate Layer* option in the *Layers* panel menu.

o **deleted** by choosing *Delete* from the panel pop-up menu or clicking on the **Delete** button at the bottom right of the panel.

o **stacked** in an order of your choice. This happens naturally, with the last created layer appearing on top, or through conscious effort by clicking on a layer prior to creating a new layer (in which case the new layer appears directly above the active layer).

o **reordered** or repositioned in a new stacking order, achieved through *clicking+dragging* on the layer and moving it to a new position.

o made **visible** or **invisible** by clicking on the "eye" icon in the Edit well column.

o made **active** for drawing or editing by clicking on the layer, which highlights to let you know it is the active layer.

o **locked**, and therefore protected from change or editing (by clicking on the box in the second layer well column, which toggles on/off a lock).

o **printed independently** by displaying the layer you want to print and hiding other layers, or by choosing this layer to print and other layers to not print in the *Layer Options* dialog for each layer.

o turned into a **template layer** using the *Layer Option* dialog, which creates a dimmed layer, typically used for tracing.

o viewed in **Outline** mode, achieved by clicking on the eye while holding down the *Cmd/Ctrl* key on the keyboard. It is possible to view some layers in *Outline* mode while viewing others in *Preview* mode.

o **merged** using the *Merged Selected Layer* option in the *Layers* panel menu.

When you are working on a project, you should click on the layer you want to place the next drawn object on. This is the most efficient way to work. If you accidentally place the object on the wrong layer, however, you can move it to the proper layer at any point in time. This process is explained on page 123.

Below are step-by-step instructions on the main operations performed when using the *Layers* panel.

To create a new layer:

1. Choose *New Layer* from the *Layers* panel pop-up menu or click on the **Create New Layer** button at the bottom of the *Layers* panel. If you choose to use the pop-up menu, the *Layer Options* dialog will open and allow you to name the layer and set options for it. If you choose to use the **Create New Layer** button at the bottom of the *Layers* panel, the layer will automatically be assigned a numbered layer name (e.g., Layer 2). If you want to rename the layer, you must double-click on the layer name to open the *Layer Options* dialog.

Steps 1 and 2: Using the Layers panel menu to create a new layer for the second layer and naming it in the Layer Options dialog.

2. Name your layer in the dialog window that opens if you used the pop-up menu to create the layer in step 1. If you used the **Create New Layers** button to create a new layer, you will need to double-click on the layer name and open the *Layer Options* dialog to rename the layer.

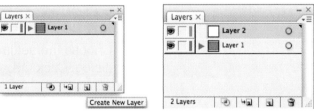

Step 1: Alternate approach to creating a new layer, using the Create New Layer button at the bottom of the panel. Note that the layer is not named.

3. Choose the settings you want for your layer in the *Layer Options* dialog and click **OK**. Your choice of selection color for the layer determines what color selected objects will become once selected, which allows you to easily know which layer the object is on. You may choose to set print, dimming, lock, template, and preview options for the layer. Some of the settings will be discussed below. If you want to position a new layer in

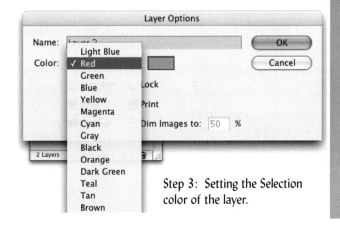

Step 3: Setting the Selection color of the layer.

a specific spot in the stacking order, click on the layer you want to appear directly below the layer you are about to create. Then when you create the new layer, it will be positioned just above that layer.

Creating a Sublayer

A sublayer is a layer that is nestled within another layer. It is accessed by clicking on the arrowhead that appears on the left side of the layer's name. *To create a sublayer:*

1. Click on the layer that you want to have as the top-level layer. If there are objects on this layer you will see a black triangle appear to the left of the layer name.

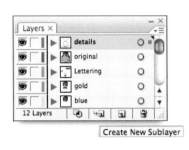

Creating a sublayer using the Create New Sublayer button (above) and the resulting Layers panel (below).

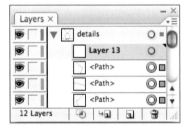

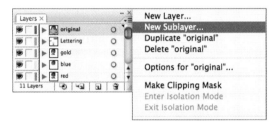

Creating a sublayer using the New Sublayer menu command found in the Layers panel menu

2. Choose *New Sublayer* from the *Layers* panel pop-up menu or click on the **Create New Sublayer** button at the bottom of the *Layers* panel. If you choose to use the pop-up menu, the *Layer Options* dialog will open and allow you to name the layer and set options for it. If you choose to use the **Create New Sublayer** button at the bottom of the *Layers* panel, the layer will automatically be assigned the next available numbered layer name (e.g., Layer 5). If you want to rename the layer, you must double-click on the layer name to open the *Layer Options* dialog.

3. Name your sublayer in the dialog window that opens if you used the pop-up menu to create the sublayer in step 1. If you used the **Create New Sublayer** button to create a new layer, you will need to double-click on the layer name to open the *Layer Options* dialog to rename the layer.

4. Choose the settings you want for your layer in the *Layer Options* dialog. Click **OK**.

To access the sublayer you will need to click on the arrowhead on the top-level layer. Clicking on this arrowhead the first time opens the list of sublayers. Clicking on it a second time closes the list.

Note: Once a sublayer is created and is viewable in the list of layers, you may drag the top-level layer into the sublayers list to turn it into a sublayer.

Changing a Layer's Stacking Order

Layers are ordered as follows: top-to-bottom in the list in the panel = front-to-back or top-to-bottom in the illustration. *To change the stacking order:*

1. *Click+hold* on the layer's name and drag the mouse up or down in the panel area. As you drag the layer's name you will see a hand cursor and double arrowhead appear and move with the mouse. When you are between layers the arrowheads appear.

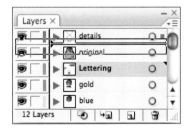

Changing the stacking order of layers by dragging a layer to a new position. Observe the double arrowhead that appears as you drag a layer from place to place.

2. Release the mouse when you get to the location where you want the layer to be positioned. It needs to be just above or just below another layer and you should see the double arrowhead on the left side of the layer name area.

Note: You can change stacking order within layers and sublayers. You can also change a top-level layer into a sublayer by dragging it into the sublayer area of a layer (which is essentially changing its stacking order).

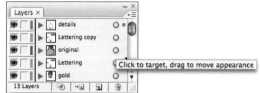

Moving Layers
As you move layers, keep your cursor to the left of the layer panel as you drag a layer from place to place. This helps prevent a layer from being dragged accidentally onto another layer and thus becoming a sublayer of that layer.

Quick Selection of Objects on a Layer:

If you want to quickly see what objects are on a given layer, perform the following steps:

1. Move your cursor over the hollow circle icon that appears to the right of the layer's name. You should see the words *Click to target, drag to move appearance* appear.

2. Click on the circle with the mouse and all the objects on the layer should be selected and highlighted in the designated layer color.

Selecting objects on a given layer

Moving Objects from One Layer to Another:

Method A

1. Select any object or group (and note that the object's current layer is highlighted in the panel).

2. Drag the *Selected Art indicator* (the little colored square to the right of the layer name) up or down (noting that the cursor turns into a pointing hand).

3. Release the mouse button.

Moving an object from layer to layer by dragging the colored square (which represents the selected object) to a new layer

Method B

1. Select any object or group (and note that the object's current layer is highlighted in the panel).

2. Choose *Edit/Cut* from the menus (or press *Cmd/Ctrl+X* on the keyboard).

3. Click on the layer where you want to place the object, and choose *Edit/Paste* from the menus (or press *Cmd/Ctrl+V* on the keyboard).

Merging Layers:

There will be times when you want to combine objects from multiple layers onto a single layer. *To do this:*

1. Click on the first layer. It will highlight.

2. Press the *Shift* key on the keyboard and click on the second layer. It will also highlight.

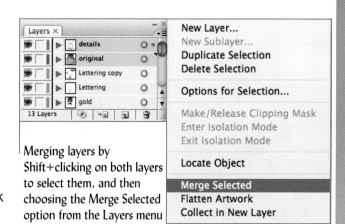

Merging layers by Shift+clicking on both layers to select them, and then choosing the Merge Selected option from the Layers menu

Flattening multiple layers to become one

3. Click on the arrowhead to access the *Layers* panel pop-up menu and choose the *Merge Selected* option. The two layers will become one and take the layer name that was selected last.

Flattening Layers:

There will be times when you want to combine all layers of a project into a single layer, which will reduce file size. *To do this:*

1. Click on the arrowhead to access the *Layers* panel pop-up menu and choose the *Flatten Artwork* option.

The hidden artwork warning dialog

2. If you have hidden artwork, a warning dialog will open asking if you want to discard hidden artwork. Choose the desired response. All layers will merge into one (with the name of the layer that was selected as active).

Paste Remembers Layers:

Typically when you use the clipboard with layers, all objects selected and copied from multiple layers will paste back into the document on a single layer. If you want the objects to remember their independent layers, you must turn on this option in the *Layers* panel pop-up menu. *To do this:*

1. Click on the arrowhead to access the *Layers* panel pop-up menu and choose the *Paste Remembers Layers* option. A check mark will then appear by the option, and this function will remain active until you select the menu option again, which turns it off (and removes the check mark).

Now when you select objects on multiple layers and use the clipboard's *Paste* function (*Edit>Paste*), all objects will paste in their original layers. The original named layers will appear in the *Layers* panel.

Additional layer functions can be found in the *Layers* panel menu. Consult Adobe's built-in Help for instructions on anything not covered here.

Turning on the Paste Remembers Layers function by selecting the option in the Layers menu

The Navigator panel allows you to see what portion of the image is currently displayed in your document window.

Navigator Panel

The *Navigator* panel allows you to see what portion of the document you are viewing on the screen. This is particularly helpful if you are zoomed in, as you can see where you are in relation to the full image. A red box in the panel shows you the *Proxy Preview Area*. If you click inside this area, you can drag the hand cursor that appears and move the Proxy Preview area around on the document, thus controlling what portion of the image appears in your view on-screen. You may also control the magnification or zoom level

by moving the magnification slider at the bottom of the panel or by typing in a new number in the number field in the lower left corner of the window.

Panel options exist and may be accessed by clicking on the panel menu arrowhead in the upper right corner of the window.

Working with the Navigator panel to zoom and pan images on your document

Stroke Panel

The *Stroke* panel allows you to control the color, width, and alignment of a stroke path. It also allows you to change a solid line to a dashed line, a function that is commonly used to create top-stitching in garment illustration. The basic stroke width and color adjustments can also be made in the *Control* panel, but in order to perform more advanced stroke functions you will need to become familiar with the *Stroke* panel.

To open the panel, choose the *Window>Stroke* menu command or press *Cmd/Ctrl+F10* on the keyboard. When the panel opens, you can choose to view the additional panel options by choosing *Show Options* from the panel menu. This is the only menu command found in the panel menu. When options are requested, the panel window will enlarge.

The Stroke panel without options (above) and with options (below)

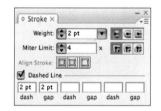

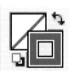

The Stroke icon in the Toolbox

To edit or set up the stroke parameters, you need to have the *Stroke icon* be active in the Toolbox. You can then change its width, color, alignment, continuity (dashed vs. solid), etc. Exercise #2 in the Basic Drawing Exercises section covers changing a stroke's thickness, color, and continuity. Various fashion drawing exercises will use a dashed line to draw top-stitching. Consult Adobe's Help files for further explanation on how to use additional stroke options, such as Caps and Joins.

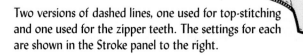

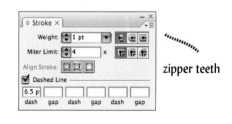

zipper teeth

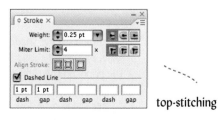

top-stitching

Two versions of dashed lines, one used for top-stitching and one used for the zipper teeth. The settings for each are shown in the Stroke panel to the right.

Color Panel

The *Color* panel displays a strip of colors, called a *Color Spectrum*, used to select, edit, or mix colors. You may click on either the *Fill* or *Stroke* icon in the Toolbox, and then select/create the color you want as the current working color. On examination of the panel, you will see the None option appear to the left and the default black and white colors appear along the right side of the panel window. In the panel menu you may choose the color mode (e.g., RGB vs. CMYK). If you choose to *Show Options,* the panel will expand to display color sliders. You can move these sliders to mix custom colors. Once you have created a color, you can drag it to the *Swatches* panel for storage.

To choose/create a custom color:

1. Ensure that you are displaying the *Color* panel options if you want to view the color sliders and the formula of the color you are going to select. Click on the arrowhead in the upper right corner of the panel to access the *Show Options* menu command.

Panel Tip
Double-click on the panel name to collapse the panel. Double-click again to expand it.

The Color Spectrum of the Color panel (above). The full panel with options displayed (below).

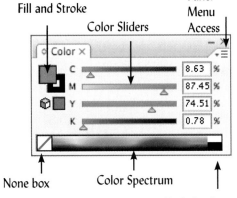

Fill and Stroke
Color Sliders
Panel Menu Access
None box
Color Spectrum
Default white and black boxes

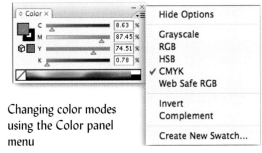

Changing color modes using the Color panel menu

2. Choose or change the Color mode, as desired, by selecting the color mode of choice from the panel menu (click on the arrowhead in the upper right corner of the panel to view the menu).

3. Click on the *Stroke* or *Fill* icon in the *Color* panel. This will bring the icon forward, indicating that it is the active attribute.

4. *Click+hold+drag* your cursor over the Color Spectrum and note it has changed to an eyedropper. As you move the eyedropper around the color strip, the color changes in the *Stroke/Fill* icon. Once you release the mouse button, the color remains and will become the current color for the *stroke/fill.* If you want to mix the color manually or edit the color slightly, move the individual color sliders (e.g., CMYK) to the left or right as shown in the example below.

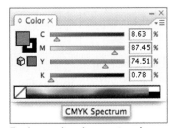

Explore colors by moving the eyedropper icon over the Color Spectrum bar.

Documenting Color Formulas
Record color formulas to quickly reproduce the color later in a different project, or drag an object using the color from one document to the next.

Creating a deeper shade of yellow. The panel on the left shows the original yellow. The panel on the right shows how the black slider was moved to the right to create a deeper shade of yellow. This technique is commonly used for adding shading in fashion drawings.

Swatches Panel

The *Swatches* panel stores colors, patterns, and gradients. In CS3 you also can view color groups. When you first open Illustrator, you will see a default set of swatches, which includes an assortment of colors, patterns, and gradients. Across the bottom of the panel are a series of buttons that allow you to customize the view of the panel or to copy or delete colors. The panel menu allows you to access various commands that provide the ability to create, duplicate, merge, and delete swatches as well as sort and view them in differing ways. You can also save a swatch set/library or load existing saved libraries by utilizing the appropriate menu command from the *Swatches* panel.

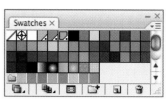

The Swatch panel of CS3

Through the use of the button strip at the bottom of the *Swatches* panel, you can access or save swatch libraries, choose to view only colors, patterns, or gradients, view swatch options, or edit color groups. You can also create new swatches or color groups and delete existing swatches. The **Swatch Option** button will toggle to become an **Edit Color Group** button when a color group is selected in the panel.

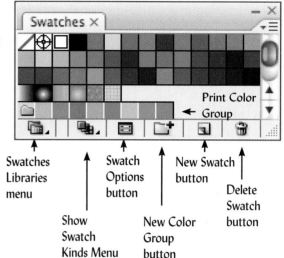

Swatches Libraries menu

Show Swatch Kinds Menu

Swatch Options button

New Color Group button

New Swatch button

Delete Swatch button

Print Color Group

If, when viewing the solid colors in a panel, you see swatches with a white triangle in the lower right corner, you should understand that the white triangle indicates that the color is a *spot* color. Spot colors in the printing industry are colors that are printed "as is," meaning no mixing of colors occurs. Colors that do not contain the white triangle are *process* colors, which means that in printing, the color is achieved by mixing Cyan, Magenta, Yellow, and Black (four-color process printing). Illustrator's panels allow you to choose the appropriate color type. If you are planning to print the project on a press, make sure you use the appropriate color mode in the panel (i.e., the mode that corresponds to the type of printing you plan to do, spot vs. process colors).

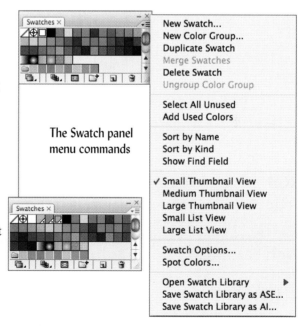

The Swatch panel menu commands

Spot vs. Process Colors. Spot colors are those that have a white triangle in the lower right corner.

Swatch Options

Double-clicking on a swatch in the panel, choosing the *New Swatch* option from the panel menu, or clicking on the **New Swatch** button at the bottom of the panel will open the *New Swatch* dialog. This contains various options to utilize as you work.

Creating a new swatch using the panel menu command

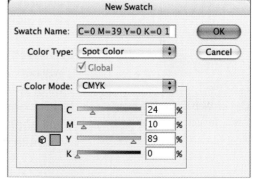

The following describes the components and options of the dialog:

Swatch Name—You can name your swatch in this field. Then, when you hold your cursor over a color in the *Swatches* panel, you will see the name of the swatch. When naming colors, it becomes imperative that you use unique names in order to quickly identify and use colors efficiently. Then, as you design a garment or textile print, you can easily confirm that you are using the same color. Global color changes will be quick and simple.

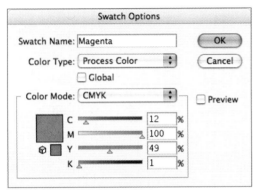

You can name the color of your swatch in the dialog. Then, when you place your cursor over the color in the Swatches panel, the name will appear.

Note: You may also turn on the Global function (see below) or use the **Eyedropper** tool to select a color from an object already drawn.

Choose Process or Spot Color as your Color type using the pop-up menu.

Color Type—Choose between *Process* color (commercial press printing with Cyan, Magenta, Yellow, and Black) or *Spot* color (printing with the pre-mixed color only). Spot colors appear with a white triangle in their lower right corner in the panel.

Global—Turning this on by clicking on the check box. Making a process color global allows all objects that contain the color to change globally when one is edited or changed. This can be very handy when working with changing color in garments (with multiple pieces) and when working with textile design.

Grayscale
RGB
HSB
✓ CMYK
Web Safe RGB

Color Mode options

Color Mode—choose between the various color modes including Grayscale, CMYK, RGB, HSB, or Web-Safe RGB. If you plan to print your project on a full-color press, use CMYK.

Preview—If you turn this on by clicking on the check box in the dialog, you will be able to see the color change in the Toolbox and on the object, if one is currently selected. The *Preview* check box does not appear in the dialog if you are creating a new swatch. You will see it only when you are editing a swatch.

The Preview check box

The Out of Web Color Warning icon, as it appears in the Swatches panel

Out of Web Color Warning—If this icon appears in the dialog, you are being warned that the current color is not Web safe. The closest Web-safe color will appear in the small square that sits directly beneath the current color box. Clicking on either the Warning icon or the small square will change the current color to a Web-safe color. Note how the color formula changes.

Color Sliders—You may move any of the color sliders to alter the current color. Note how the color formula changes as you do this.

Color Formula—The percentage of each color component of a color (e.g., RGB or CMYK) displays. Also, you can mix colors by typing in the color formula. Pantone books generally provide the color formulas for colors based on the CMYK color mode.

Color Sliders, which may be dragged back and forth to mix new colors

To view a specific swatch type only:
1. Click on the appropriate swatch-type button at the bottom of the panel (All, Color, Gradient, Pattern, Color Group). Only swatches of the selected type will be displayed in the panel.

Clicking on one of the swatch type buttons at the bottom of the panel will customize the view of the panel to show only those type of swatches. The example to the right shows the pattern swatches only.

To add a swatch:
1. Click on the **New Swatch** button at the bottom of the *Swatches* panel. The *New Swatch* dialog will open and the color that is currently selected in the active *Fill* or *Stroke* icon area of the panel will then appear in the dialog.

OR

1. Choose the *New Swatch* command from the *Swatches* panel menu. A dialog will open showing the currently selected fill or stroke color.

Using the New Swatch button to add a swatch to the panel

2. Click **OK** to use the color, or choose the type of color (Process or Spot), color mode (e.g., RGB, CMYK, etc.), and alter the color by moving the sliders. Name the color if you like, then click **OK** to finalize the process. The new swatch will appear in the panel.

OR

1. *Click+hold* on the *Fill* or *Stroke* icon in the Toolbox and drag it over to the *Swatches* panel and release the mouse. The color will then position itself in the next available color swatch in the panel.

Creating a new swatch using the panel menu command

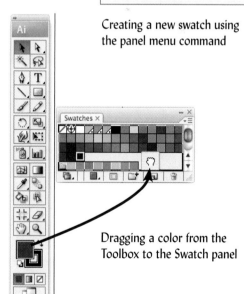

To duplicate a swatch:
1. Click on the swatch to select it.

2. Choose the *Duplicate Swatch* command from the *Swatches* panel menu. A new swatch will appear at the end of the panel.

Dragging a color from the Toolbox to the Swatch panel

Duplicating a swatch and then changing its value is a common operation performed in fashion illustration. This allows you to more effectively illustrate the back side of fabric or shadow the depth of folds or other details.

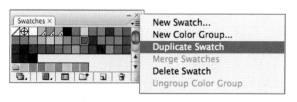

Duplicating a swatch using the panel menu

Deleting Swatches

If you want to delete an entire row or consecutive group of swatches, click on the first swatch, press and hold the Shift key on the keyboard, and then click on the last swatch in the group. All the swatches between and including the first and last swatches will be selected.

To name a swatch or change its color:

1. Double-click on the swatch to select it. The *Swatch Options* dialog will open.

2. Type in the new name and/ or adjust its color by moving the color sliders accordingly.

Naming swatches is commonly done to allow you to correctly identify colors used when there are several similar ones in a palette.

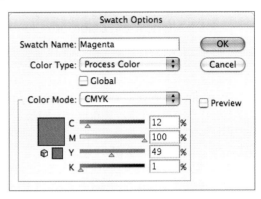

Naming a swatch in the Swatch Options dialog

To reposition swatches:

1. *Click+hold* on the swatch you want to move and drag it to a new position.

2. Release the mouse button and all swatches will shuffle as necessary.

Repositioning swatches by dragging them from one position to another in the panel. In the above, a burgundy swatch is dragged from the first row to the end of the panel.

To delete a swatch:

1. Click on the swatch you want to remove from the panel. If you want to remove multiple swatches, press the *Cmd/Ctrl* key on the keyboard as you click on each swatch and add it to the selected group.

2. Click once on the **Delete** button at the bottom of the panel or choose *Delete Swatch* from the *Swatches* panel menu.

3. A dialog will open, asking if you want to delete the swatch(es). Click on the **Yes** button.

Deleting a swatch by selecting it and using the Delete Swatch menu command

To save a Color Group (CS3):

1. Select the swatches you want in the group by pressing the *Cmd/Ctrl* key and clicking on the swatches to select them.

2. Click on the **New Color Group** button at the bottom of the panel. A dialog will open. Name the group if you like, and click **OK**. The color group will appear in the panel.

The Delete Swatch warning dialog

Creating a new Color Group

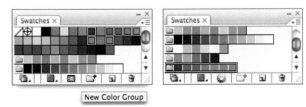

To save a swatch library:

1. Organize your swatches in the panel by naming them, repositioning them, etc.

2. Choose the *Save Swatch Library* from the *Swatches* panel menu. When the dialog opens, type in a name for your library and click on

Save. The swatch library should save in the Swatches folder found in the ***Presets*** folder of your ***Illustrator*** folder on your hard drive. If the file requester that opens does not direct it there, you may want to manually direct the file there to retain consistency with other saved libraries.

OR

Click on the **Swatch Libraries menu** button and choose the Save option.

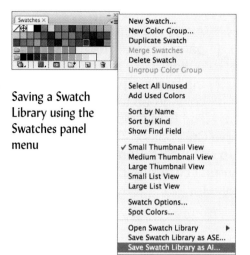

Saving a Swatch Library using the Swatches panel menu

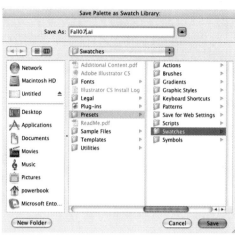

You would want to build a custom swatch library if you are working with specific colors for a given collection or season. For example, once you create and mix the colors of your upcoming Fall collection, you would want to save them as a means of archiving the data and to allow for quick retrieval.

Color Guide Panel (CS3)

Version CS3 of Illustrator introduced numerous color features that are truly wonderful and easily utilized in garment and textile design. The *Color Guide* panel allows you to create and build custom groups of colors that may be saved and utilized in the *Swatches* panel. Now you can let Illustrator suggest color harmonies, based on one initial color, or you can ask Illustrator to extract colors from existing artwork. Color groups are easily created and saved. In addition, you can quickly perform color swaps between color groups.

The Color Guide panel

The *Color Guide* panel works in conjunction with the active stroke or fill color in the Toolbox and with the *Swatches* panel. The current color becomes the *base* color that appears in the upper left corner of the *Color Guide* panel. A color harmony appears to the right of this color. The arrowhead in the upper right corner of the panel opens the panel menu.

The color magenta was selected in the Swatches panel and it became the current fill color in the Toolbox and the base color in the Color Guide panel. To view color harmonies, click on the down arrow of the color strip. This will open a window that displays the various Harmony Rules.

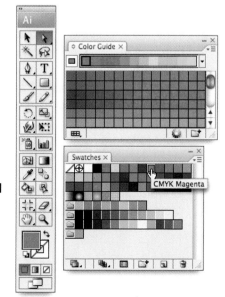

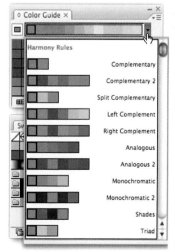

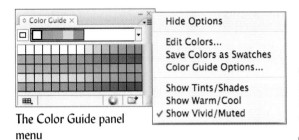

The Color Guide panel menu

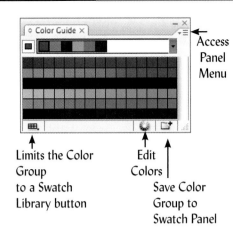

Access Panel Menu

Limits the Color Group to a Swatch Library button

Edit Colors

Save Color Group to Swatch Panel

Along the bottom of the panel you will see three buttons. The button in the lower left limits the color group to colors in a specific library. The **Edit Colors** button opens the Live Color dialog. The **Save Color Group to Swatch Panel** button saves the current color group to the *Swatches* panel.

Color Group

A *Color Group* is a collection of colors grouped together in such a way that they can be saved and retrieved easily. It is a valuable tool for designers and apparel manufacturers who have chosen their colors for a given season and need to have them easily available for projects. Once you build the group in the *Live Color* dialog, it becomes part of your *Swatches* panel, ready for use.

The Sunflower color group is one of three color groups in the Swatches panel above. Double-clicking on the icon of the group will open the Live Color dialog.

The following is true of Color Groups:

o A color group is a combination of two or more colors that you determine work visually together.

o Color groups can contain spot, process, or global colors.

o As color groups are created in the *Color Guide* panel, they are also shown in the *Swatches* panel.

o Color groups are created using either the *Live Color* dialog (*Edit>Edit Colors> Recolor Artwork*) or the panel menu of the Color Guide panel (*Edit Colors*).

o Color groups may be created by pulling them from a color library, such as Pantone, or by specifying a specific library for use. Alternatively, you can build your color group by manually mixing the RGB or CMYK color formulas. See Exercise #1 in the Presentation Techniques section of the book, page 341.

o If you need inspiration, you can build a color group by choosing one color and applying a harmony rule to that color. Traditional color theories such as complementary, analogous, etc., are built into the harmony guides.

o Color Groups can be extracted from existing vector artwork. Currently, you cannot extract colors from raster (bit-mapped) files. To extract colors, simply select the objects you want colors pulled from. If you want to use a raster image as an inspiration, you can apply the *Live Trace* function to convert the raster image to vector, and then extract the colors from the selected objects on the vectorized image.

o Double-clicking on the icon of the color group in the *Swatches* panel opens the *Live Color* dialog so that you may edit the group.

Live Color Dialog

The *Live Color* dialog allows you to adjust, assign, reduce, or convert the colors in your artwork.

The dialog can be accessed in the following ways:

o Selecting the *Edit>Edit Colors>Recolor Artwork* menu command.

o Selecting the *Edit>Edit Colors>Recolor with Presets* menu command.

o Clicking on the *Edit Colors* button at the bottom of the *Color Guide* panel. If an object is selected, the button is called *Edit* or *Apply* Colors.

o Double-clicking on a color group's icon in the *Swatches* panel.

Live Color dialog

Edit Button

Click on this when you want to change the color mode, adjust color values or brightness, experiment with color harmonies, alter the number of colors, save color groups, or preview the chosen colors on selected artwork. You can edit the brightness, saturation, luminosity, or temperature of a single color or a group of colors in the group.

Assign Button

This button is available only when you have one or more objects selected on your artwork. Click on this when you want to recolor an existing group of objects. You have control over which new colors replace existing old colors. Recoloring can be used when you need to limit, reduce, or convert your colors for printing. In fashion it is used to create multiple colorways of garments or textile designs.

Edit and Assign Buttons of the Live Color dialog

Additional Buttons and Functions of the Live Color Dialog

The following are functions of the Live Color dialog:
Active Colors—are displayed in the upper left corner.

Color Group Name—can be assigned by typing in the field next to the Active Colors

Get Color from Selected Art Button—will be active if an object or objects are selected on the artwork. This button lets you sample colors from the art that is selected in your document and build a color group from them.

Save Changes to a Color Group Button—allows you to save changes to the current color group, should you choose.

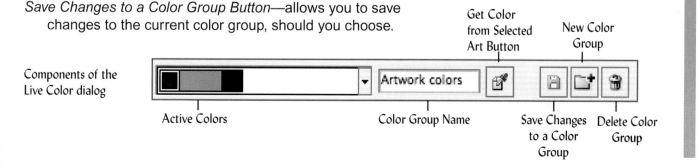

Components of the Live Color dialog

Get Color from Selected Art Button

New Color Group

Active Colors

Color Group Name

Save Changes to a Color Group

Delete Color Group

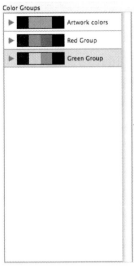

Color Group Storage

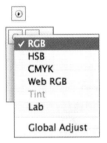

Color Modes
accessed through
the Color Mode
button

New Color Group Button—allows you to create
a new color group.

Delete Color Group Button—allows you to
delete an existing color group, and when you
do so, it will disappear from the *Swatches*
panel as well.

Color Group Storage—the area of the dialog
that stores the various color groups.

Color Wheel and Options—are various buttons
that allow you to choose the display mode of
the color wheel (smooth, segmented, or color
bars), control the brightness (center slider),
Add and *Subtract Colors from a Color Group*, and
Lock/Unlock a color harmony.

Current Color and Color Sliders—show the current
color and its formula in the current color mode.

Color Mode Button—allows you to change the color
mode.

*Limit Color Group to Colors in a Swatch Library
Button*—allows you to limit the colors you can
work with to a selected swatch library.

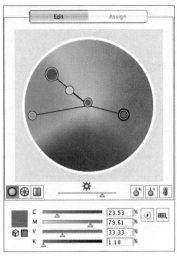

Color Wheel options

Slider for Brightness

Add Color, Remove
Color, Unlink
Harmony Groups

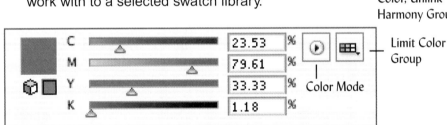

Limit Color
Group

Color Mode

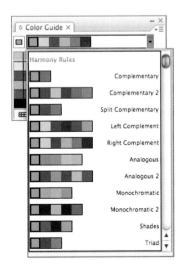

Choosing a color harmony from
the Color Guide panel

Working with Color Harmonies

You can create a color harmony from the *Color Guide* panel itself, or from the
Live Color dialog.

Using the Color Guide Panel

1. Choose a color as your current color from the *Swatches* panel or the
 Color Picker. This color will appear as the Active Color in the panel.

2. Click on the down arrow of the *Harmony Rules* strip. This will open a
 pop-up that displays the various harmony rules. Note that the scroll
 bar indicates that there are additional harmonies to be viewed. Slide
 down and select a harmony. This will appear in the strip at the top of
 the panel.

3. If you want to save this color group, click on the **Save Color Group to
 Swatch Panel** button at the bottom of the panel.

Using the Color Guide Panel

1. Choose a color as your current color from the *Swatches* panel or the *Color Picker*. This color will appear as the active color in the *Color Guide* panel.

2. Open the *Live Color* dialog by using one of the methods described on page 133. The Active Colors will appear in the upper left corner of the dialog.

3. Click on the *Harmony Rules* down-arrow to the right of the *Active Colors* strip. This will open a pop-up that displays the various harmony rules. Note that the scroll bar indicates that there are additional harmonies to be viewed. Slide down and select a harmony. This will appear in the strip at the top of the panel.

4. Select a harmony of your choice. The color harmony will appear in the *Active Colors* strip and the name color group will appear to the right of this in the *Color Group* field. Note that the color wheel now displays the colors in the group in their corresponding positions.

5. Name the color group by typing a name in the *Color Group* field.

6. Click on the **New Color Group** button. The colors will become a group and be placed in the group storage area.

7. Click **OK** to close the dialog. Note that the color group also appears in the *Swatches* panel.

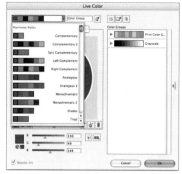

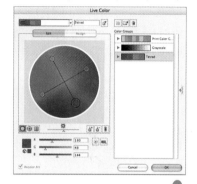

Choosing a color harmony (above) and viewing it in the panel (below)

Creating a Color Group from Colors in Your Artwork

Live Color allows you to create a color group from the colors of objects selected on the document. *To do this:*

1. Load or create a file that contains artwork from which you want to extract colors.

2. Using the **Selection** tool, select the objects on your document that contain the colors you want to use to create a color group.

3. Click on the **Edit or Apply Colors** button in the lower strip of the *Color Guide* panel, or choose *Edit Colors* from the panel menu. The *Live Color* dialog will open.

4. Click on the **Get Colors from Selected Art** button. The colors will appear in the strip with the color group name of Artwork colors. Change the name of the *Color Group* if you like.

5. Click on the **New Color Group** button. The colors will become a group and be placed in the group storage area.

Step 3: Choosing the Get Color from Selected Art button.

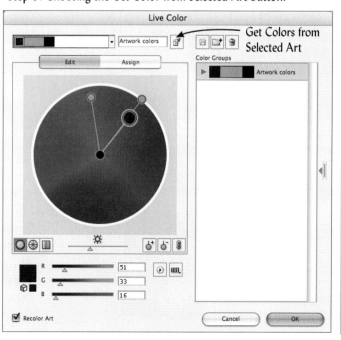

Get Colors from Selected Art

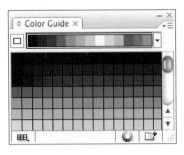

Sunflower Color Group

6. Click **OK** to close the dialog. Note that the color group also appears in the *Swatches* panel.

Working with Raster Images to Extract Color

One can only extract colors from vector art images. If you want to create a color group from a raster image (e.g., a Photoshop image), you can perform the **Live Trace** function on the image to create a vector version, and then extract a color group from that. The example below shows a sunflower image that was traced with *Live Trace* and then expanded. Then, *Live Color* was applied to create the sunflower color group.

Use Live Trace to trace the raster sunflower (immediate right) to become a vector image (far right), and then use Live Color to extract the colors to create a color group.

Raster image of sunflower

Vector image of sunflower created through Live Trace

Using Assign to Recolor Artwork

The **Assign** button of the *Live Color* dialog allows you to recolor artwork with supported color harmonies or with any color group in your *Swatches* panel. This can be used to create multiple colorways of one garment or textile design. The example below will walk you through the steps of creating three colorways of one dress design.

In Preparation

To prepare, set up multiple copies of the garment to be recolored, and prepare your panels as follows:

1. Load the artwork you want to use as your basis for creating multiple colorways. This example here uses a dress that is composed of three colors, plus a shadow color used to display the back inside of the dress.

2. Create two additional copies of the dress. If you plan to stack your dresses, you might want to place each on a separate layer after they are stacked, so that you can easily select one dress without selecting portions of the other.

3. Prepare three color harmonies. In the case of the example here, each of the base colors was kept at approximately the same color value, and color harmonies were created. This resulted in color groups that were added to the *Swatches* panel using the **Save Color Group to Swatch Panel** button.

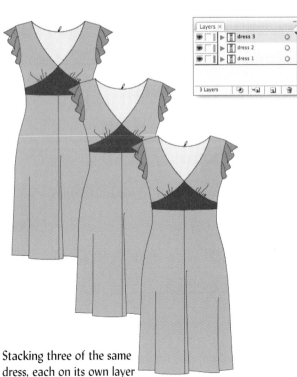

Stacking three of the same dress, each on its own layer

Swatches panel with three color groups, one for each dress

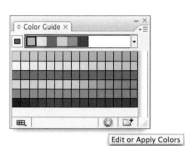

Edit or Apply Colors

Performing the Recoloring

1. Position your *Swatches* and *Color Guide* panels so that they are near your artwork.

2. Select all objects of the first dress to be recolored.

3. Open the *Live Color* dialog by clicking on the **Edit or Apply Colors** button at the bottom of the *Swatches* panel. Note that the name of this button has changed slightly to include "Apply" as artwork is selected on the document. The *Live Color* dialog will open.

4. Click on the **Assign** button. The dialog display will change. You can now see the current colors of the artwork and the three color groups.

5. Click on the color group you want to use for the current dress. Note that colors in the dress change on your document.

6. Click on the menu arrow of **New** to experiment with the various ways in which the colors can be mapped.

7. Click on the **randomly change color order** button to experiment with colors.

Randomly change color order

8. If you prefer, manually drag the colors back and forth to position the color swaps. When you are pleased with the recoloring, click **OK** to finalize and close the dialog. You may be prompted to save the changes to the color group. The dress is now colored.

9. Repeat the process for the third dress.

Live Color has more options for you to explore, but these will not be covered in this book. If you would like to learn more about *Live Color* and the new color editing abilities of Illustrator CS3, consult the Help files in the program.

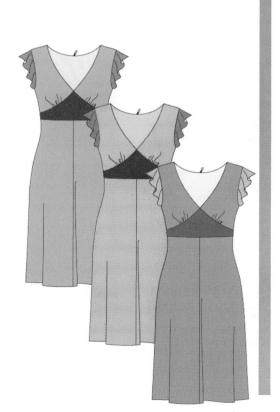

Gradient Panel

The *Gradient* panel allows you to build custom color gradations that can be used to add visual interest and/or depth to your drawings. Essentially, colors used in a gradient blend into each other. You may blend two or more colors and you can control the speed and angle at which the blending occurs. You may choose to view panel options, using the *Gradient* panel menu to access/expand the panel to view the additional options.

Gradients used to create highlighted hair (above) and the panel (below)

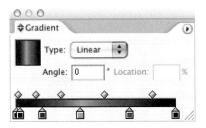

Gradient Terminology

Endpoint — is the point or slider that defines the left or right end of a gradient.

Midpoint — is the diamond-shape point that sits between two endpoints or two stop points. You may slide this point away from the middle position if you like. This controls how fast a blend occurs between two colors.

Stop — is the point at which a gradient changes from one color to another. Stop points are identified by filled squares that sit below the gradient bar.

Intermediate Colors — are colors or stops that exist between the two endpoints.

Overview of the Gradient Panel

Type – There are two types of gradients: radial and linear. Radial gradients extend from the center of an object outward, and Linear gradients extend from side-to-side or top-to-bottom.

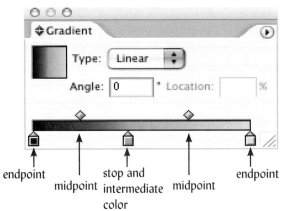

endpoint stop and endpoint
midpoint intermediate midpoint
 color

Angle – The Angle function works with the Linear gradient and allows you to specify the angle of a gradient within a shape.

Location – The *Location* function will not be active until you have three or more Gradient Sliders. It allows you to precisely set the position of the internal sliders along the gradient bar. Click on an internal Gradient Slider and type in the desired position (between the numbers of 0, representing the left side of the bar, and 100, representing the right side of the bar).

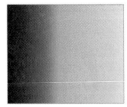 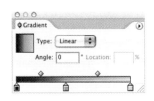

Linear gradient (above) and Radial gradient (below) and their respective panels

Gradient Sliders – These are the filled square shapes (topped with a pointer or diamond shape) that appear at the bottom of the panel under the Gradient Strip. A gradient requires at least two sliders (to define each of the colors at either end of the gradient spectrum), but you may add additional sliders between the outer sliders.

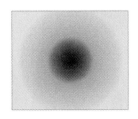 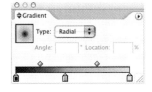

Components of the Gradient panel

Setting up to Create/Edit a Gradient

1. Open your *Colors* panel if it is not already open (*Window>Colors*). You will need this to choose colors for the gradient.

The Gradient panel without options displayed (above) and with options (below)

2. Double-click on the **Gradient** tool in the Toolbox (or choose the *Window>Gradient* menu command, or press *Cmd/Crtl+F9* on the keyboard). This will open the *Gradient* panel.

3. Ensure that the *Gradient Options* are displayed. If necessary, click on the *Options* triangle in the upper right corner of the *Gradient* panel to turn on the options.

4. Click on the Gradient swatch in the *Gradient* panel. When you do this the Gradient bar will become active and you will see sliders and stops on the gradient bar in the panel.

Below: Moving the sliders affects how the color blend displays.

5. Perform any of the gradient operations that follow.

Gradient Operations

To change the color of a gradient slider:
- Click on the slider to select it, and then click on a new color in the *Color* panel.

To add additional gradient sliders or stop points:
- Drag a color from the *Color* or *Swatches* panel to a position beneath the gradient bar.

OR

 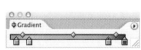

- Click beneath the *Gradient* bar (which creates a stop point) and then, while this is active, choose a new color from the *Colors* panel.

The Gradient tool

To remove an intermediate color:
- Click on the color square and drag it off the panel.

To change the speed of blending of a color blend:
- Click on the slider and drag it to the left or right.

The top circle shows the original starting point of the center and lower examples. The center circle shows the gradient created using the Gradient tool and dragging the mouse the distance and angle of the black line. The lower circle shows how the gradient looks inside the circle when the mouse is dragged over an area larger than the circle.

To add a gradient to your Swatches Panel:
- Once you have built the gradient, click on the **gradient swatch** in your *Gradient* panel and drag it to your *Swatches* panel.

Using the Gradient Tool to Fill a Single Object

The *Gradient* tool in the Toolbox is used to control the direction and placement of a gradient within an object or over several selected objects.

To use the tool on a single object:
1. Select an object.

2. Fill it with a gradient by clicking on the fill icon in the panel to select it, and then choosing a gradient swatch from the

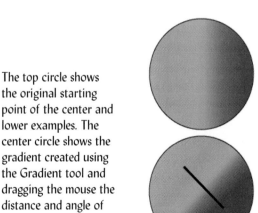

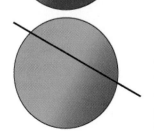

Swatches panel.

3. Click on the **Gradient** tool to select it.

4. Choose the gradient fill type (radial vs. linear) in the *Gradient* panel if you want to change the current setting.

5. With the object still selected, *click+hold+drag* across the object in the direction you want the gradient to move. The positioning of your beginning click and ending release of the mouse will control where the gradient starts and ends and the angle of the blend. If you start or end the dragging operation inside the object, Illustrator will continue to fill the object with the solid color of that end of the gradient.

To use the tool on multiple objects:
1. Select several objects by dragging around them with the **Selection** tool or by *shift+clicking* on the multiple objects.

2. Fill them with a gradient by clicking on and selecting the fill icon in the panel, and then choosing a gradient swatch from the *Swatches* panel.

3. Click on the **Gradient** tool to select it.

4. Choose the gradient fill type (radial vs. linear) in the *Gradient* panel if you want to change the current setting.

5. With the objects still selected, drag across them in the direction you want the gradient to move. The positioning of your beginning click and ending release of the mouse will control where the gradient starts and ends. If you start or end the dragging operation inside an object, Illustrator will continue to fill the object with the solid color of that end of the gradient.

Fashion Use:
 o Adding shadows to clothing.
 o Creating depth to hair and skin areas of an illustration.
 o Use open paths with a gradient fill and no stroke to create shadows in clothing.

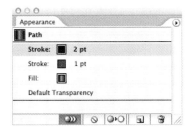

The Appearance panel

Appearance Panel

Attributes beyond the basic fill and stroke that have been applied to an object are called *appearance attributes*. These attributes allow you to edit objects in a completely different way, experimenting with a variety of techniques that can easily be edited or removed. Appearances allow you to apply *multiple* fills and strokes to the same object, and you may apply a different blending mode, opacity level, or *Effect* menu options to each stroke and fill. Bear in mind that all appearance attributes do **not** change the underlying path of the object, only the *appearance* of the path.

The *Appearance* panel allows you to quickly view your added attributes as

they exist on an object, group, or layer. Objects' fills and strokes are listed in
a stacking order, top-to-bottom, in the panel that correlates to the front-to-back stacking order of objects in the drawing. If *Effects* are used, they are listed from top to bottom, in the order they were applied to the specific path/object. Since version CS2/CS3 of Illustrator provides a *Control* panel, you may choose to edit certain attributes (such as *stroke* and *fill*) from there.

Attributes that can be applied to a path include:
- fills
- strokes
- transparency settings
- blending modes
- brush strokes
- Effect menu items

Attributes can be reedited, restacked, or even removed at any point in time. It is possible to create multiple fills and strokes within the same object. This is the basis for creating unique effects. As an example, try creating a second narrower stroke on top of a wide stroke.

Once you start working with multiple attributes, you may want to create a *Style*, which is essentially a combination of attributes. Styles are created, named, and stored using the *Styles* panel. Even though a style is stored in the *Styles* panel, it can only be edited using the *Appearance* panel. Using options from the **Effects** menu allows you to change an object's appearance without changing its actual path. Effects include such things as Drop Shadow, Inner and Outer Glow, Feather, etc.

To create multiple fills and strokes:
1. Open the *Appearance* panel (*Window>Appearance*).

2. Using the **Selection** tool, select one or more objects or groups, or target a layer in the *Layers* panel by clicking on the appropriate target column.

3. Select *Add New Fill* or *Add New Stroke* from the *Appearance* panel menu. Alternatively, you can select an existing fill or stroke in the *Appearance* panel, and click the **Duplicate Selected Item** button at the bottom of the panel.

4. Set the color and other properties for the

Selecting an object and choosing the Add New Stroke command from the Appearance panel menu

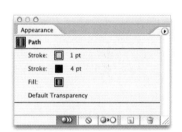

A second stroke of yellow with a thickness of 1 is added on top of the black stroke (thickness 4).

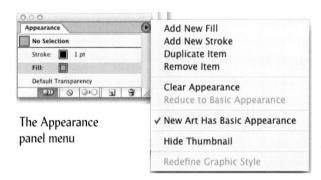

The Appearance panel menu

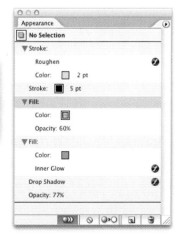

The Appearance attributes of the rectangle above

newly created fill or stroke. It may be necessary to adjust the position of the new fill or stroke in the *Appearance* panel to ensure that both can be seen. This is achieved by dragging the new appearance attribute up or down in the panel.

A scribble appearance (Effects>Stylize>Scribble) has been added to various strokes on the skirt and bust area of the woman on the left. The woman on the right shows you the original drawing.

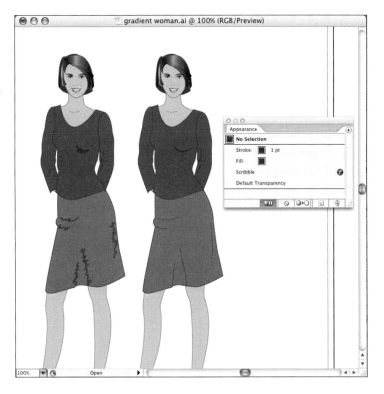

Fashion Use:

o Adding drop shadows to objects that can be easily removed later, if desired.

o Creating special effects for buttons, stitching, and other drawings by layering multiple strokes on top of each other.

o Allowing experimentations in drawing that are not permanent and can be easily removed.

What is Targeting?

Targeting is the process of selecting an object, group, or layer in the *Layers* panel so that you can set an appearance or apply an effect or style. The *Target and appearance column* is located to the right of the name of the layer, group, or object. *The type of target icon communicates two things;*

1. Whether the item contains any appearance attributes, and
2. Whether the item is currently targeted for editing.

The following target icons assist in communicating information:

indicates a non-targeted item with appearance attributes

indicates a targeted item with appearance attributes

Indicates a non-targeted item with no appearance attributes beyond a single fill and stroke

Indicates a targeted item with no appearance attributes beyond a single fill and stroke

The example to the right shows you a targeted sublayer that has appearance attributes.

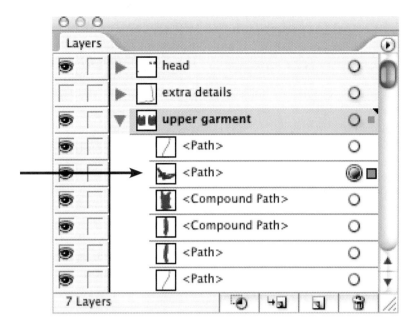

Pathfinder Panel

The *Pathfinder* panel contains ten buttons/tools that allow you to combine and divide two or more intersecting objects. This allows you to efficiently build complex shapes, which are often called compound paths.

The basic approach to working with compound paths and the *Pathfinder* tools is to create shapes and combine them in various ways.

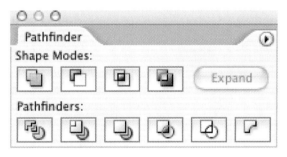

The Pathfinder panel with the Shape Modes tools (upper row) and the Pathfinders Effect tools (lower row)

Basic Premises of Pathfinder Panel Functions

- The Pathfinder panel is divided into two parts: the Shape Modes and the Pathfinders Effect functions.
- Pathfinder panel tools work only with objects (vector images), not bit-mapped images.
- Pathfinder panel functions involve two or more selected objects.
- The order in which things are drawn is important, as is the stacking order of objects, so the *Object>Arrange* menu becomes an important tool in working with Pathfinder functions.
- Compound paths/shapes that are created using the *Shape Modes* are considered to be "live" in that you can create them, and come back and edit them later. The original shape still exists, but not all parts of it are visible. The invisible parts of the compound object receive a fill and stroke of None.
- When compound objects are created, they appear to be grouped and the lower object moves to the level of the upper object in the stacking order.
- To break a compound path/shape back up into its components, choose *Release Compound Shape* from the *Pathfinder* panel menu.
- The **Expand** button in the *Pathfinder* panel is used to convert a compound shape created with a *Shape Modes* tool into an editable

The Pathfinder panel menu

single object. It will remove the invisible paths and should be used only when you are sure you don't want to edit the original shape further.

- The *Pathfinders Effect* options, found in the second row of the panel, perform more complex transformations than the *Shape Modes* tools, which generally deal with overlapping objects.
- Compound paths that are created using the *Pathfinders Effect* tools are not considered to be live, and any excess paths are deleted immediately upon using a Pathfinders Effect function.
- When two objects are combined using the *Pathfinder* panel, the object on the bottom assumes the fill and stroke attributes of the object on the top. The *Crop* and *Subtract From Shape Area* are the exceptions to this general rule.
- The *Pathfinder* panel has a panel menu that allows you to trap colors, repeat functions, set Options, and Make, Release, or Expand a Compound Shape.

The Shape Modes Tools

Shape Modes:

The top row of the *Pathfinder* panel contains the **Shape Modes** buttons/tools, which allow you to control the interaction between the objects or components of a compound shape. *Tools include:*

Add to Shape Area—used to join selected objects into one object (which assumes the fill and stroke of the topmost object). This function was called Unite in earlier versions of Illustrator.

Subtract from Shape Area—used to cut out the area of the uppermost selected object from the underlying selected objects.

Intersect Shape Areas—uses the area of the topmost selected object to clip the underlying selected shapes as a mask would.

Exclude Overlapping Shape Areas—uses the area of the uppermost selected object to invert the underlying geometry, turning filled regions into holes and vice versa. When the top object sits completely inside the lower object, the function is similar to the *Subtract from Shape Area* function.

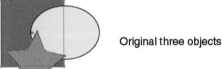

Original three objects

In the example to the right, three shapes were drawn: a square, circle, and star. Note the stacking order of these.

For each of the examples of Pathfinder Shape Modes, only the square and the star were selected before applying the Shape Mode to make the compound shape.

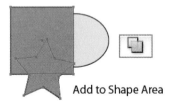

Add to Shape Area

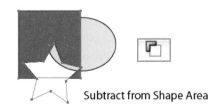

Subtract from Shape Area

Note: This illustration shows you the hidden portions of each object, which are viewable because the square and star objects are selected. This file, Pathfinder.ai, is found in the Examples folder on your Art DVD.

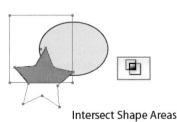

Intersect Shape Areas

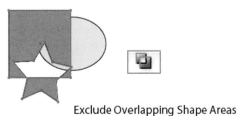

Exclude Overlapping Shape Areas

The Pathfinders Effect Tools

The lower row of the *Pathfinder* panel contains the **Pathfinders Effect** buttons/tools, which allow you to control the interaction between the objects or components of a compound shape. *Tools include:*

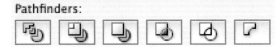

Pathfinders:

Divide—used when you want the uppermost selected object to cut the lower selected objects along the outer edge of the top object's path. You need to move the various shapes to see the new separated objects that result.

Trim—used to cut out and delete the parts of the lower selected object(s) that are hidden by the topmost selected object. You need to move the upper object in order to fully see how this works. The stroke of the affected objects is removed, but objects of the same color are not merged.

Merge—used to cut out and delete the parts of the lower selected object that are hidden by the topmost selected object. The stroke of the affected objects is removed and objects of the same color are merged. You need to move the upper object in order to fully see how this works.

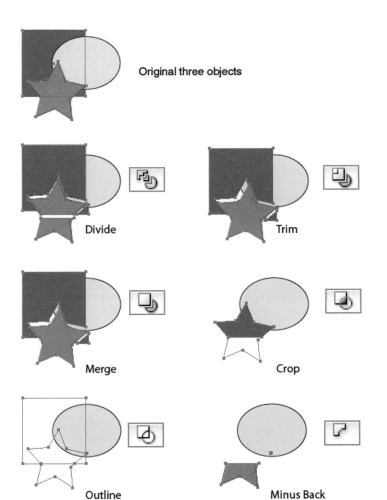

Original three objects

Divide

Trim

Merge

Crop

Outline

Minus Back

In the example to the left, three shapes were drawn: a square, circle, and star. Note the stacking order of these.

For each of the examples of Pathfinder Effect modes, only the square and the star were selected before applying the Pathfinder Effect to perform the operation.

Note:
Objects have been moved slightly to facilitate your understanding of each operation. In most cases, the hidden portions of objects are removed in the operation. This file, Pathfinder2.ai, is found in the Examples folder on your Art DVD.

Crop—used to remove any parts of selected objects that extend beyond the bounds of the topmost selected object.

Outline—used to turn all selected objects into unfilled open paths (or outlines). Intersections of the selected objects define the places where new paths begin and end.

Minus Back—used to retain portions of the topmost selected object where no overlap with lower selected objects occurs.

Fashion Use:
- o *Add to Shape* can be used to join arms and legs to a torso when objects are drawn separately (see Fashion Exercise #9).
- o *Subtract from Shape Area* can be used to create grommets. Place a smaller circle inside a larger one and use *Subtract from Shape Area* to cut out the inner circle (see Drawing Exercise #8).
- o *Divide* can be used to create snapshots of garments. Place a hollow rectangle over the section of the garment you want to snapshot, perform the function, and remove extraneous objects outside the rectangle (see Presentation Techniques Exercise #4).

This completes the discussion of Illustrator panels commonly used in fashion design. Other panels exist and should be explored. Consult Illustrator's Help files for further information.

Basic Drawing Exercises

This chapter includes a series of exercises that will teach you basic drawing skills, general to all types of design. These skills become the building blocks for fashion exercises later in the book. As you work your way through each exercise, attempt to understand the steps and be able to repeat them without referring to the instructions. The goal is to understand the concepts covered so that you may apply them to all types of drawing later.

A skirt drawn with top-stitching created using the Dashed Line option in the Stroke panel (Exercise #2)

Basic Drawing Exercises

The neckline bow drawing created in Exercise #4

Adding details to the bow using layers in Exercise #5

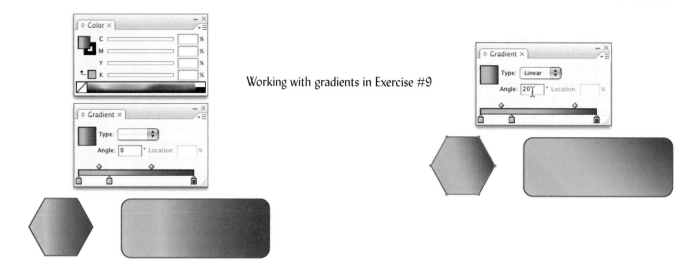

Working with gradients in Exercise #9

Couture

Placing a color gradient in text using a
clipping mask in Exercise #10

Transferring swatches from one document to
another in Exercise #11

Exercise #1: Setting up a Document

Goal

The goal of this exercise is to teach you how to set up a typical document, including the choice of panels and stroke and fill attributes.

Illustrator Tools and Functions

- ◆ *File>New* menu
- ◆ Various menu commands found in the **Window** menu, used to open the desired panels for display and use.

Step-by-Step

Setting up

When you first open Illustrator, it does not open with a document window, so you must create a document prior to starting work. The following steps will walk you through the setup of a standard-sized document, choosing to display the most commonly used panels and specifying the typical stroke/fill setup.

1. Create a new document. Choose the *File>New* menu or press the *Cmd+N* (Macintosh) / *Ctrl+N* (Windows) keys on the keyboard.

2. Type in a file name. In the New Document area, choose your paper size. *Letter* is suitable to most projects. Select the *Portrait* or *Landscape* Orientation.

3. Choose the *CMYK* setting if you are planning to take your project to press printing. Otherwise, you may use either *CMYK* or *RGB* as your Color Mode. Click **OK**.

The document will open. Although there is a filename, the document is not saved. You must perform a *File>Save As* operation to do this.

Opening Panels for Use

Ensure that the following panels (which are the most commonly used panels) are open and available for use. These may be turned on by selecting the panel name in the **Window** menu.

Control—This panel allows you quick access to the various options related to selected objects. It is typically positioned at the top of the document, but may be moved to the bottom.

Swatches—This panel contains selected color, gradient, and pattern swatches. You may customize the panel or use the defaults.

Note: Earlier Versions of Illustrator

Earlier versions of Illustrator (e.g., version 8) opened an Untitled document when the program was opened. The instructions here refer to versions 10, CS1, CS2, and CS3. Use File>Document Setup to alter your settings.

Note: Naming vs. Saving a File

Naming a file in the New Document dialog does not save the file. You must perform a separate File>Save As operation to save the file.

Selecting various panels to be displayed, using the Window menu

The various panels commonly used in Illustrator

The New Document

Saving a Workspace

You may save your document setup as a workspace by choosing Window>Workspace>Save Workspace. When the dialog opens, name your workspace and save it for later retrieval (Creative Suite versions).

Colors—Use this panel to select colors for your object's stroke and/or fill from a broad range of colors.

Colors Guide—Use this panel to assist you in creating color combinations, saving color groups, etc.

Navigator—This panel shows you what portion of the document you are viewing (indicated by the red box) and the zoom level. You may click on the red box and drag it to a new position to view other parts of the document. You may also change the zoom level by clicking and dragging the slider at the bottom of the window.

Layers—Use this panel to create layers, which allow you to view, hide, and lock objects for better work management of multiple objects. Layers should be named and used according to theme/function.

Stroke—You may use this panel to change the stroke weight, miter setting, and continuity (solid vs. dashed line).

Appearance—This panel provides information on the selected object in a drawing. Information on the stroke, fill, transparency, etc., is provided.

Artboard vs. Printable Area vs. Scratch Area

The artboard is the document size you specify and thus the area you want to print. The area outside the artboard is called the *scratch area*. Since most printers aren't capable of printing to the edge of the paper, the printable area may differ from the artboard. To view the printable area, choose the *View>Show Page Tiling* menu. A dotted line will appear inside the document to show you the area that will print.

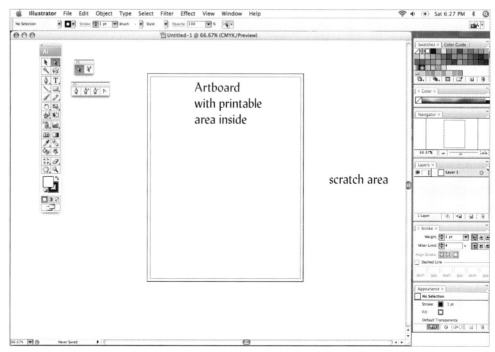

Exercise #2: Working with Fill and Stroke Settings

Goal
This exercise explores the process of setting an object's *fill* and *stroke*, prior to drawing the object, and editing these attributes after the drawing has been completed.

Illustrator Tools and Functions
- **Pen** tool
- **Selection** tool
- *Stroke* and *Fill* icons in the Toolbox
- *Stroke*, *Swatches*, and *Control* panels
- *Color Picker*

The Pen tool generally appears as the top tool of the stacked Pen tool set in the Toolbox.

Step-by-Step

Tearing off the Pen Tool Panel
The **Pen** is the primary drawing tool in Illustrator. You will use this and several variants of it often, so it is a wise practice to tear off the Pen tool strip. There are several pen-related tools found in the Toolbox. The **Pen** tool itself generally is visible, and the related Pen tools are stacked/hidden beneath it.

1. Click and hold down on the **Pen** tool in the Toolbox.

2. Slide/drag your mouse to the right, across all the tools, and rest it on top of the *Tearoff bar*. You will see the word "tearoff" appear on the screen as your mouse sits over the bar. Release the mouse button, and you will see the **Pen** tool strip appear on your screen. You may move this to the desired position on your document.

3. Choose a *fill* color and *stroke* weight and color prior to drawing an object, or edit the stroke or fills of existing objects (which are currently selected).

Tearing the Pen tool strip away from the Toolbox

To Set the Stroke Color:
1. Turn on the *Swatches* and *Color* panels if they are not already visible (*Window>Swatches* and *Window>Color*).

2. Click on the *Stroke* icon in the Toolbox (which will bring it forward, ahead of the Fill icon), then click on a color in the *Color* or *Swatches* panel.

The Stroke icon is the square outline in the lower right corner of the Stroke/Fill icon area of the Toolbox. Clicking on this icon selects it and brings it to the front, which indicates that the stroke color is ready for editing if desired.

3. Alternately, you can simply double-click on the *Stroke* icon in the Toolbox to open the *Color Picker* window and choose your color from there (bypassing the need to use the *Swatches* panel). Click **OK** when you have chosen a color. **Note**: Earlier versions of Illustrator did not support this method.

The Color Picker dialog

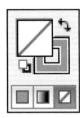

The Fill icon is the solid shape that appears in the upper left corner of the Stroke/Fill icon area in the Toolbox. Clicking on this icon selects it and brings it to the front, which indicates that the fill color is ready for editing if desired.

To Set the Fill Color:

1. Click on the *Fill* icon in the Toolbox (which will bring it forward), and then click on a color in the *Color* or *Swatches* panel. One often chooses to draw with a *fill* of None as this allows you to see through the inside of an object while you are working. You can later turn this into a solid fill. The *None* icon (indicated by a diagonal red line) can be found beneath the *Fill* and *Stroke* icons in the Toolbox or in the *Swatches* panel. Click on this icon to set a *fill* of None.

2. Alternately, you can simply double-click on the *Fill* icon in the Toolbox to open the *Color Picker* dialog and choose your color from there. Click **OK** when you have chosen a color. **Note**: Earlier versions of Illustrator did not support this method.

The Pen tool icon. The 'x' indicates that the Pen is ready to commence with the drawing of a new object.

Drawing Several Polygon Shapes

Now, using the **Pen** tool, draw several multisided objects on the screen.

1. Choose the **Pen** tool in the Toolbox or the Pen tool strip (if torn off).

2. Move your mouse over to the document and note how the **Pen** cursor has a small 'x' beside it. This means the Pen is ready to start a new object.

3. Click and release your mouse repetitively on the screen, moving between clicks. This will draw a polygon.

4. Close the polygon by placing your cursor over the first point on the object. You will see a small circle appear beside the Pen cursor. This indicates that you are over the beginning point of the object. If you click, you will close the object by placing the end point directly on top of the beginning point.

Placing the Pen cursor over the beginning point displays the circle icon, which indicates that you are about to close the object.

5. Closing the object tells Illustrator that you are through with the drawing of it, and your cursor will return to the Pen cursor with the 'x', ready to draw again. If you choose not to close the object, then press and hold the *Cmd* key (Mac) or the *Ctrl* key (Windows) and click away to end the object currently being drawn.

6. Change the *fill* and/or *stroke* color and draw a second object. Repeat the process until you have drawn four objects.

Note that all the objects are formed of multiple straight line segments. This results from the process you used to set anchor points (clicking and releasing). In Exercise #3 you will learn how to draw curved line segments.

Editing Fill and Stroke Color

Illustrator *Control* panel (CS2 and CS3) makes editing fill and stroke colors of objects incredibly simple. Instructions for this and the traditional approach will be given below.

In CS2/CS3:

1. Ensure that the *Control* panel is displayed (*Window>Control*).

2. Choose the **Selection** tool in the Toolbox. Click on an object to select it. The paths of the object will highlight in the color chosen for the layer and all anchor points will be solid to indicate that the entire object (including all anchor points and segments) is selected. If you look at the *Control* panel you will see the various options related to the object.

The stroke and fill of the above objects have been altered from the original.

3. Click on the *Fill* or *Stroke* option and slide to a new color. When you release the mouse the new color will now be an attribute of your object.

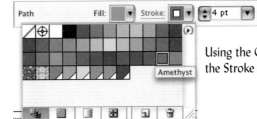

Using the Control panel to change the Stroke color of an object

In all versions of Illustrator:

1. Display the *Stroke* panel if it is not already in view (*Window>Stroke*).

2. Choose the **Selection** tool in the Toolbox. Click on an object to select it. The paths of the object will highlight in the color chosen for the layer and all anchor points will be solid to indicate that the entire object (including all anchor points and segments) is selected.

3. Change the *fill* color by clicking on the **Fill** icon in the Toolbox and then clicking on a new color in the *Swatches* or *Color* panel.

4. Change the *stroke* color by clicking on the **Stroke** icon in the Toolbox and then clicking on a new color in the *Swatches* or *Color* panel. Note how the stroke and fill of the object change.

5. Experiment with exchanging the stroke and fill colors of an object by clicking on the **Swap Fill and Stroke** icon in the toolbox. This is the curved double arrowhead that appears to the right of, and slightly above the *Stroke* and *Fill* icons.

Changing the Stroke Weight

If you want to change the thickness of a stroke, you can do so using the *Stroke* panel. Version CS2/CS3 users can also use the *Control* panel.

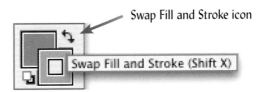

Swap Fill and Stroke icon

1. Ensure that the *Stroke* panel is displayed (*Window>Stroke* menu).

2. Choose the **Selection** tool in the Toolbox. Click on the object you want to change.

3. Click and hold on the down arrow to the right side of the stroke *Weight* field. A pop-up list will appear. Slide down to the number of

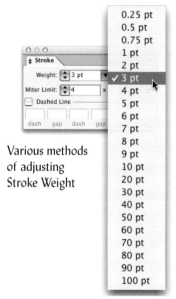

Various methods
of adjusting
Stroke Weight

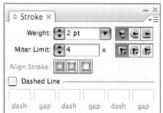

Clicking on the Show Options
arrowhead (above) to display
Stroke Options (below)

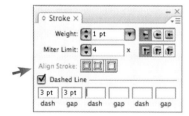

Setting up a dashed line. You
may use any series of numbers to
create your dashed line. If you fill
in the first dash and gap only, the
sequence will repeat automatically.

A polygon with the dashed line
stroke

your choice for the weight of the stroke.
Release the mouse.

OR

Click and release on the up or down
arrow to the left side of the stroke
Weight field. Each time you click and release, the
number will increase or decrease appropriately
(depending on which arrow you were clicking on).

OR

Place your cursor inside the weight field and type a
number. Press the *Tab* or *Return/Enter* key on the
keyboard to complete the change.

Borrowing the Fill and Stroke from Another Object

If you want an object to use the same *fill* and *stroke* as
another object, you may use the **Eyedropper** tool to
achieve this.

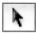

1. Choose the **Selection** tool in the Toolbox. Click on the object you
 want to change.

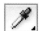

2. Choose the **Eyedropper** tool in the Toolbox. Click on the object
 from which you want to borrow the *fill* and *stroke* combination. Your
 first object will now take on the same stroke and fill attributes as
 the second one.

Creating a Dashed Line

Dashed lines are used for many reasons. In fashion design they are used
primarily to communicate top-stitching on clothing. *To set up or edit a stroke
to become a dashed line:*

1. Choose the **Selection** tool in the Toolbox. Click on the object you want
 to change.

2. Click on the arrowhead in the upper right
 corner of the *Stroke* panel to show the
 options.

3. Click on the *Dashed Line check box* to
 place a check in the box. This turns the
 dashed mode on.

4. Type 3 in the first dash field and in the
 first gap fields. This indicates the width
 (in points) that you desire the dashes and
 gaps to be. The pattern will repeat.

A skirt drawn with top-stitching
created using the Dashed Line
option in the Stroke panel

If you have selected an image, its stroke will now
become a dashed line. If you have not yet drawn
the image, drawing at this point will result in an object with a dashed stroke.

Exercise #3: Drawing Straight and Curved Segments

Goal

The goal of this exercise is to teach you how to draw segments in Illustrator using the **Pen** tool. You will draw a variety of line types including straight and curved lines.

Illustrator Tools and Functions

- *Fill* and *Stroke* icons in the Toolbox
- **Pen** tool
- Various panels: *Colors, Swatches, Appearance, Stroke*

Step-by-Step
Setting up

1. Create a document as per the general instructions in *Exercise #1*. Ensure that the following panels are open and available for use: *Control* (CS2/CS3), *Appearance, Color, Navigator, Stroke, Swatches*, and *Tools*. These may be turned on by selecting the panel name in the **Window** menu. If you created a custom *Workspace* for the setup of panels, choose the workspace (*Window>Workspace>your save name*).

Setting a black stroke and a fill of None

2. Set the *fill* to None and the *stroke* to black. (See Exercise #2.)

3. Choose the **Pen** tool by clicking on it in the Toolbox or pressing **P** on the keyboard.

Overview of Drawing Straight and Curved Segments with the Pen Tool

Drawing objects in Illustrator involves the creation and setting of anchor points, which define the beginning and end points of line segments. The manner in which you set an anchor point and how you move your mouse dictates the type of segment you build. In general, lines are created by clicking and releasing the mouse as you set anchor points. Curves are created not only by clicking the mouse to set a point, but by dragging the mouse as part of the point-setting process. Thus, if you *click+hold+drag* the mouse, you are telling Illustrator that you want to create a curve.

Direction Lines – A single antenna or pair of antennae that project from an anchor point and thus define the arc of the curve of the segment it is attached to.

A curved segment may have curve control on one end only, or on both ends. Direction lines extend from an anchor point; the length of the arm plus its angle control the arc of the curve. Symmetrical curves are best achieved by having a curve direction line on each end of the segment.

If you examine a drawing using the **Direct Selection** tool to select segments and anchor points to highlight them, you will often see that anchor points that join two curved segments generally have direction lines extending from the anchor point in both directions; one to control the segment drawn prior to setting the anchor point, and one to control the next segment drawn immediately after setting the anchor point.

Keep in mind that every segment has the following attributes:
- Beginning and end points called **anchor** points.
- Optional **direction lines** that extend from the anchor point and result in a curve. Moving the line's angle and/or length controls the arc of the curve.

Type of Anchor Points

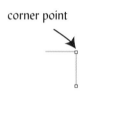

corner point

Corner Point—joins two straight segments. It is represented by a small square on the screen. This initially is created by *clicking+releasing* the mouse button as you set anchor points. It can also be created through the editing process, using the **Convert Anchor Point** tool.

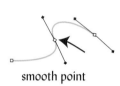

smooth point

Smooth Point — joins two curved segments. It is represented by a square on the screen with two direction lines extending from it, one for each curved segment. This is initially created by *clicking+holding+dragging* the mouse button as you set anchor points. It can also be created through the editing process, using the **Convert Anchor Point** tool.

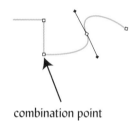

combination point

Combination Point—joins a straight and a curved segment. It is represented by a square on the screen with a direction line extending from the curved segment side. This is initially created by *clicking+holding+dragging* the mouse button as you set one of the two anchor points and by *clicking+releasing* as you set the other point. It can also be created through the editing process, using the **Convert Anchor Point** tool.

In the following drawing exercises, the numbers in each illustration generally relate to the drawing order and process of setting anchor points. You can follow the sequence and perform the appropriate action (e.g., *click+release* or *click+drag*, etc.). Use a *fill* of None and a black *stroke*.

Creating Straight Lines between Anchor Points

1. *Click+release* once on the lower left corner of the document. This sets an anchor point that appears as a small solid square (1).

2. Move your mouse to the right and up a little and *click+release* again (2). This sets a second anchor point, and a line appears between the two anchor points. This line is a path. **Note**: The first anchor point is now indicated by a hollow square and the second anchor point is a solid square. This means that the second point is active or selected and the first point is inactive. This will become an important element of knowledge.

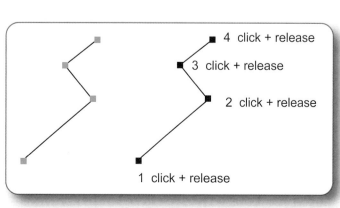

4 click + release

3 click + release

2 click + release

1 click + release

3. Continue to move your mouse and set anchor points 3 and 4 as shown in the illustration to the left. *Click+release* as you set each point.

4. To finish the object, either choose a different tool, or press the *Cmd* key (Mac) or *Ctrl* key (Windows) and click away from the object.

Creating a Perfectly Vertical Line

You will be drawing lines while holding down the *Shift* key on the keyboard, which constrains your anchor points to perfectly horizontal, vertical, or diagonal positions (180-, 90-, and 45-degree angles), depending on how you move the mouse.

1. With the **Pen** tool, click in the lower left corner of your document (1).

2. Press down and hold the *Shift* key. Now move your mouse directly above the last point drawn and *click+release* (2). Note how the anchor point jumps to its position directly above the first point. The result is a perfectly straight line.

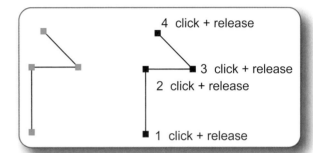

3. With the *Shift* key still depressed, move your cursor to the right and click again (3). You will get a perfectly horizontal line.

4. With the *Shift* key still depressed, move your cursor diagonally to the upper left and click again (4). You will get a perfectly diagonal, 45-degree angle line.

5. *Click away* to complete the object.

Creating a Curved Segment (whose arc is controlled at one end only)

The drawing of curved segments in Illustrator involves a different mouse action. Rather than *click+release*, you will *click+hold+drag*. The dragging action communicates that you want a curve and allows you to create a *direction line*. This direction line controls the arc of the curve through its angle and its length. When you drag the mouse you are creating the direction line, and setting its position and length.

The following short exercises will allow you to see how the dragging movement of the mouse controls the curve. As you try each curve, *click+release* and/or *click+hold+drag* to set the appropriate anchor points. Follow the numbered sequence and instructions. Drag the mouse when instructed, following the dotted line as the suggested distance to move the mouse from the prior point.

Curve 1
1. With the **Pen** tool, *click+release* in a different area of your document (1) to begin the object.

2. Move your mouse to the right and upwards and *click+hold* (2).

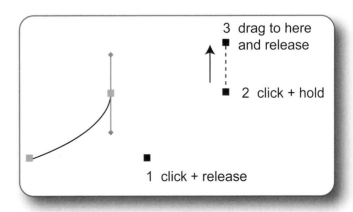

3. Drag the mouse to position 3 and release. Note how you now have two direction lines extending from the second point. The lower direction line controls the curve between points 1 and 2, and the second direction line will control the curve of the next segment you create with the next click of the mouse.

Adding the next segment:

4. Move your mouse to position 4 and *click+release*.

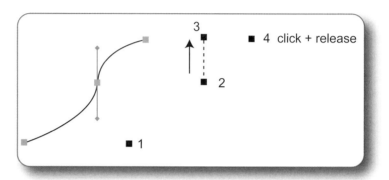

Note how the second segment is also a curve. The point that joins the two segments is a *smooth anchor point*, as it joins two curves. *Click away* to end the object.

Creating a Combination Point at Position 2
We are now going to repeat the same exercise as above, but perform slightly different actions to achieve a curve segment followed by a straight segment.

1. Repeat steps 1 through 3 of the above exercise. Once you have created the first segment, move your cursor directly over point 2 and click. Note how this action removes the second direction line.

The action of clicking on a *smooth* anchor point immediately after its creation turns the point into a *combination* point, allowing the next segment you draw to be a straight line (if you *click+release*) or a curved segment, with the curve control at the far end (if you *click+drag+release*).

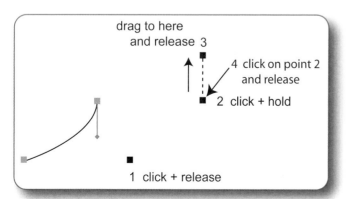

2. Move your mouse to the upper right and *click+release* (5), and you will see that your next segment will be a straight line.

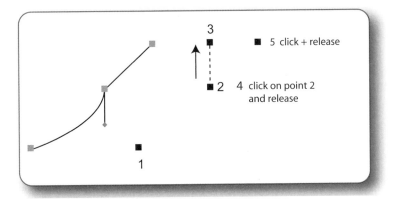

Controlling the Curve

Follow the numbered sequence in each of the following exercises and note the effect of where you drag the mouse on the resultant curve.

As you draw, note once again how the most recently drawn points are the active points (solid) and all other points are inactive (hollow).

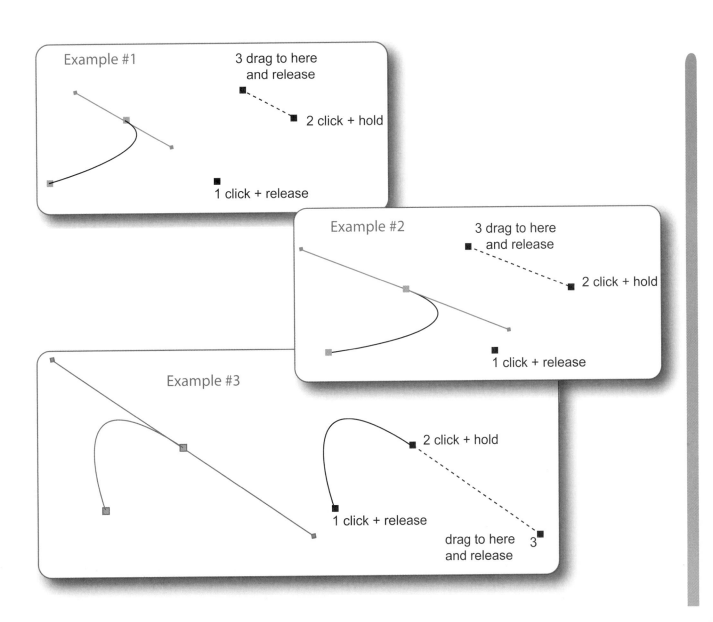

Creating a Curved Segment (whose arc is controlled at both ends)

To create two curved segments, you will follow the sequence below.
Note that how you drag the mouse controls the arc of the curve. The first segment is a curve controlled at the far end of it. The second segment is a curve that can be controlled from both anchor points.

Note: Again, if you examine the last anchor point set, you will see that two direction lines extend from the point. One direction line controls the curve just drawn, and the second direction line sets up the initial curve of the next segment to be drawn.

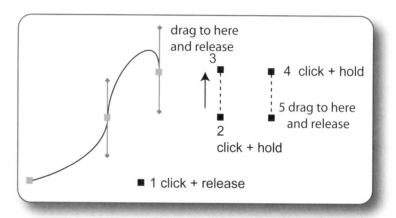

Ending the Path

To end the path, you may click on any other tool in the Toolbox, or press the *Cmd* (Mac)/*Ctrl* (Windows) key and *click away* from the path.

You now have created an *open path*. It is considered open as the beginning and end points are different.

The Anatomy of the Shapes Just Drawn

Now that you have drawn your first shapes, let's examine their components by their technical names.

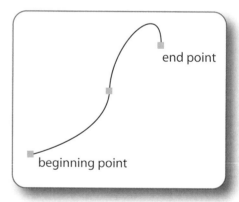

> *Anchor Point* — the end point of a curved or straight segment.
>
> *Direction Line* — the line that extends from the anchor point of a curve.
>
> *Control Point*— diamond point at the end of a direction line.
>
> *End Point* — the beginning and end points of an open path.

In addition, the various anchor points in our drawing have different names according to what type of segments they join.

> *Corner Point* —an anchor point that joins two lines.
>
> *Smooth Point*—an anchor point that joins two curved segments.
>
> *Combination Point*—an anchor point that joins a straight segment and a curved segment.

Further Exercises

Experiment with the drawing of lines and curves. Try drawing your name, exploring the steps in drawing required to create the proper curved and straight segments to create your name.

Student Gallery:
Names
Mesa College Fashion Students

Exercise #4: Adding, Deleting, and Changing the Types of Anchor Points Using the Grid and Snap to Grid as Aids to Drawing

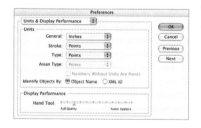

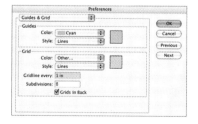

The neckline and bow tie drawings to be created in this exercise.

Goal
In this exercise you will experiment with the addition, removal, and conversion of anchor points. The grid will be used to facilitate the drawing process.

Illustrator Tools and Functions
- ♦ **Circle** and **Rectangle** Shape tools
- ♦ Various **Pen** tools including the Pen, Add Anchor Point, Delete Anchor Point, and Convert Anchor Point tools
- ♦ Grid (*View>Show Grid*)
- ♦ Grid (*View>Snap to Grid*)
- ♦ **Eyedropper** tool

Quick Overview
In this exercise you will begin by displaying the grid, and then you will draw two simple geometric shapes: a circle and rectangle. The circle will be turned into a neckline through the removal of anchor points and the conversion of *smooth* anchor points to *corner* points. The rectangle will become a bow tie through the process of inserting new points, moving them, and converting the *corner* points to *smooth* points. Illustrative fold lines and a wrap for the bow tie will be added.

Review the three types of anchor points; Corner, Smooth, and Combination (see page 144). Note that the anchor point type is dictated by the types of segments it joins.

Step-by-Step
Setting up

1. Ensure that your Preferences Units are set to *Inches*. Choose the *Illustrator>Preferences>Units and Display Performance* (Mac) / *Edit>Preferences>Units and Display Performance* (Windows) menu command. Set the General option to *Inches* by clicking on the arrow and selecting Inches from the list. Leave the Stroke and Type options set at *Points*. Click **OK**.

2. Click on the *Preferences* drop-down menu in the upper left corner of the window and slide down to the *Guides and Grid* option. The options in the window will change. The subdivisions should be set to 8. If your setting is different, change this to 8 and click **OK** to close the Preferences window.

3. Create a new file using the *File>New* menu command. Type *Anchor Point Experiments* as the file name. In the New Document Profile area, set the Size to *Letter* and the Orientation to *Portrait*. You may choose RGB or CMYK as your color mode. Click **OK** and the document will appear on the screen.

Steps 1 and 2: Setting up the Preferences.

4. Immediately save the file. Since you typed a name in Step 3, you simply need to choose the *File>Save As* menu and click **OK** to save the file.

5. Ensure that the Toolbox and the following panels are open: *Control, Colors, Swatches, Stroke, Appearance, Layers*. If they are not, open them using the **Window** menu.

6. Display the grid by choosing the *View>Show Grid* menu command. We will treat each grid square as one inch of the garment.

Drawing the Geometric Shapes

1. Tear off the **Shape** tools by *clicking+holding* on the top shape tool (most likely the Rectangle tool, as this is the default tool) and dragging over to the right to the tearoff strip. When you see the word *Tearoff* appear, release the mouse and the tools will tear off into a separate panel.

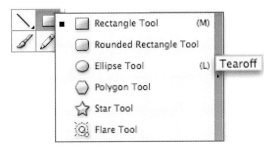

Step 1: Tearing off the Shapes tool set.

2. Set the *fill* to None and the *stroke* to black. (See Exercise #2.)

3. Choose the **Circle** tool, and move over to the document. *Click+hold+drag* to create a circle approximately two inches in diameter (use the grid as a guide for measuring). If you press and hold the *Shift* key as you drag, you will be able to draw a perfect circle. Release the mouse to create the shape. You might want to zoom in a bit to see the grid better (using the *Navigator* panel or other means of zooming).

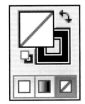

Step 2: Setting a black Stroke and a Fill of None.

4. Choose the **Rectangle** tool, and move over to the document. *Click+release* the mouse. A Rectangle dialog will open. Type 3 for the width and 2 for the height. Click **OK**. A rectangle will appear.

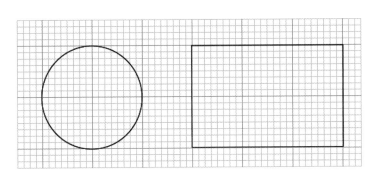

Steps 3 and 4: Drawing the circle (for the neckline portion of this exercise) and rectangle shape (for the bow tie portion of the exercise).

5. Using the **Selection** tool, move the rectangle off the document into the scratch area.

Turning the Circle into a Neckline

1. Tear off the **Pen** tools by clicking on the **Pen** tool and dragging over to the Tearoff bar. Release the mouse and the tools will tear off.

Step 1: Tearing off the Pen tool set.

Selection tool

Delete Anchor Point tool

2. Choose the **Selection** tool and click on the circle to select it and view the anchor points. You will see the bounding box surrounding the circle plus the handles on the bounding box. If you do not see the bounding box, choose the *View>Show Bounding Box* menu command.

3. Choose the **Delete Anchor Point** tool. You will see a Pen cursor with a *minus sign* appear. Move the cursor over the anchor point at the top of the circle. Click on the anchor point and it will disappear. The top curve of the circle will adjust. There are now three anchor points on the shape, and each anchor point is a smooth point. You can confirm this by using the **Direct Selection** tool to select each point and observe the direction lines that extend to either side of the anchor point.

Steps 2 and 3: Selecting the circle shape and then deleting the upper anchor point. The resulting shape contains three anchor points, all smooth points.

Convert Anchor Point tool

Add Anchor Point tool

4. Choose the **Convert Anchor Point** tool. *Click+release* on each of the upper side points. This will convert the smooth points to combination points (joining a straight and a curved segment).

5. Choose the **Add Anchor Point** tool. You will see a cursor with a plus sign appear. Move this directly over the center of the upper straight segment of the shape. *Click+release* to add an anchor point in the center of the segment. You will need to ensure that the tip of the Pen cursor is on the segment or you will get an error message when you click. This will add a point to the center of the upper segment. The point will be selected (solid blue). Do not click away to deselect it.

6. Press and release the *down arrow* key on the keyboard a few times to nudge the point downwards. Move it down two grid squares. If you accidentally deselected the point, choose the **Direct Selection** tool to select the point and then move the point down.

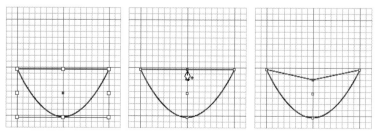

Steps 4-6: Converting the smooth points to combination points (left), then adding an anchor point (center) and nudging it downwards (right).

7. Choose the **Convert Anchor Point** tool. *Click+hold+drag* on the new
 point just added and drag to the right. This will change the anchor
 point from a corner point to a combination point (joining two curves).
 If you hold the *Shift* key as you drag to the right you will constrain
 the movement and achieve a nice balanced curve. You have now
 completed drawing a neckline template that can be used as the
 negative space of a neckline. If you like, choose a fill color for the
 object.

Convert Anchor Point tool

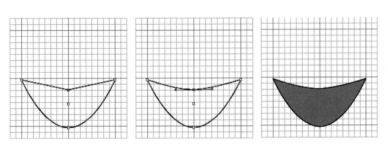

Step 7: Converting the center corner
point to a smooth point and filling the
object with a color.

8. Using the **Rectangle** tool, draw a rectangle that measures four inches
 square (use the grid as a guide for measuring). Change its *fill* to
 white. Using the **Add Anchor Point** tool, insert three points, one for
 each side of the neck and one at the center neck, and then move the
 center point down (using the **Direct Selection** tool). Use the **Convert
 Anchor Point** tool to convert the center point to a *smooth* point.
 Then, position the neckline template on top of the new rectangular
 shape. Use the **Direct Selection** tool to widen the curve at
 the center front of the neckline. Achieve this by dragging
 the ends of the *Direction Lines* outward.

Direct Selection tool

Remember to use the
Control palette to facilitate
anchor point manipulation/
conversion.

Step 8: Adding a fill to the body of the garment, adding and adjusting anchor points, and
moving the neckline template over the body. Adjust the shape to the neckline template to
create a flatter curve in the center area of the neckline.

9. Save the file.

This completes the simple neckline drawing.

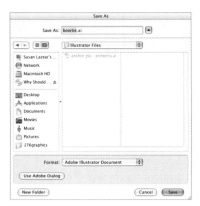

The Save As dialog

File Saving Maintenance

You will now turn your attention to the rectangle drawn earlier. At this point, it would be wise to save the file with a new name and remove the neckline objects.

1. Choose the *File>Save as . . .* menu command. When the dialog opens, type in **bowtie** for the file name and choose **Save**.

2. Choose the **Selection** tool, and click on the neckline and body objects to select them. Press the *Delete/Backspace* key (Mac/Windows) to delete both objects.

3. Save the file again by choosing the *File>Save* command. This will update the saved file.

Turning the Rectangle into a Bow Tie: Drawing the Outer Shape

1. Using the **Selection** tool, drag the original rectangle back onto the document. Zoom into the document to magnify the object somewhat.

Selection tool

2. Turn *Grid Snap* on by choosing the *Snap to Grid* function in the **View** menu.

Snap to Grid in View menu

3. Using the **Selection** tool, move your rectangle so that the outer edges align to a heavy gridline (the demarcation line). You will note that the shape snaps to the gridlines as you move the shape.

Add Anchor Point tool

4. Choose the **Add Anchor Point** tool, and add two points to both the upper and lower lines of the rectangle. Position these points two grid squares away from center. You will find that it is easy to add the points directly on a grid intersection, as the snap function aids this.

Steps 2–4: Using Snap to Grid to move the rectangle to align with the grid lines, then using the Add Anchor Point tool to add anchor points to the rectangle straddling the center of the rectangle, on the upper and lower lines of the rectangle.

Direct Selection tool

5. Choose the **Direct Selection** tool and move each of the new points inward two grid squares on the rectangle. The points will snap to the grid intersections as *grid snap* is active.

Step 5: Moving the new points inward two grid squares using the Direct Selection tool.

Convert Anchor Point tool

6. Choose the **Convert Anchor Point** tool. *Click+hold+drag* on each of the outer corner points of the rectangle to convert the *corner* points to *smooth* points. Experiment with the direction of your drag and

observe how the curve is forming. You will find that the *grid snap* will assist you. Start with the upper right corner point and move around the rectangle in a clockwise manner, dragging your mouse diagonally at each point, moving in a clockwise manner as you work your way around the rectangle. This will give you a nice balanced drawing.

Step 6: Using the Convert Anchor Point tool to change corner points to smooth points, thus creating the outer curve of the bow.

Adding Illustrative Detail to the Bow Tie

We now want to add some illustrative gather lines. This will be achieved by drawing open path objects within the body of the bow tie.

1. Choose the **Pen** tool. Ensure that you have a black stroke and no fill. Temporarily turn Grid Snap off, as it will inhibit your drawing. Choose the *View>Snap to Grid* menu command, which will toggle the snap function off.

2. With the **Pen**, draw several open paths to illustrate the released fullness of a bow tie as it radiates out from the center of the bow tie. Experiment with your paths to draw straight and curved segments as desired. See the illustration below as an example. As you complete each object, press the *Cmd/Ctrl* key (Mac/Windows) and click away to end the object. This is a shortcut for ending objects. As you draw objects, the most recently drawn object will be the forwardmost object.

Steps 1 and 2: Turning Snap to Grid off and using the Pen tool to draw illustrative gather lines.

3. You now want to add the center wrap to the bow tie. Choose the **Rounded Rectangle** shape tool. Turn *Snap to Grid* back on by choosing the *View>Snap to Grid* menu command. Move your cursor over to the drawing and draw a curved rectangle over the center area of the bow. Since the wrap was the most recently drawn object, it will sit on top of all the other objects (the bow and the illustrative gathering lines).

Step 3: Using the Rounded Rectangle tool to draw the wrap.

Rounded Rectangle tool

Coloring the Bow Tie

1. It is now time to add some color to the bow tie. Begin by turning the display of the grid off (choose *View>Hide Grid*).

2. Using the **Selection** tool, click on the outer bow. Click on the *Fill* icon in the Toolbox to bring it to the front. Currently, the *fill* is None. Go to the *Swatches* panel and choose a color for the fill. The bow will fill with color. Repeat the process for the bow wrap, choosing the same *fill* color from the *Swatches* panel.

Steps 1 and 2: Filling the bow and wrap with color.

3. To add a little depth to your drawing, you will add a *fill* to all the open paths used to draw the illustrative gather lines. You will set up the fill of these to become a slightly darker shade of the bow color. Using the **Selection** tool, click on one of the illustrative fold lines to select it.

Eyedropper tool

4. Choose the **Eyedropper** tool, and then click on the outer bow so that the object uses the same fill and stroke properties as the bow. This is the purpose of the **Eyedropper** tool.

5. Move your cursor to the *Fill* icon in the Toolbox. Double-click on the Fill icon to open the *Color Picker*. Lower the value of the color by dragging the small circle in the middle of the color range to a deeper shade of the color. As you move the circle you will be able to see the original and new colors in the upper right corner of the *Color Picker*. Click **OK** to finalize the color change. You will see a fill appear on the open object you have selected. This will add a little depth to the foldline.

Step 5: Using the Color Picker to choose a deeper shade of the bow color.

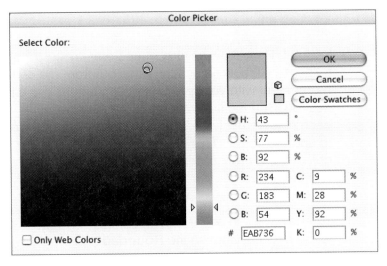

6. Using the **Selection** tool, select all the other gather lines. Press and hold the *Shift* key down as you select each gather line so you can select multiple objects.

7. Choose the **Eyedropper** tool. Now click on the foldline that has the new fill. Each of the illustrative lines will now fill with the deeper value of the bow color. Click away (press the *Cmd/Ctrl* key and click outside of the objects) to see the overall effect. You may want to alter the shape of some of your illustrative lines. Use the **Direct Selection** tool to do this and select the various anchor points and adjust by moving them or altering the *Direction lines*.

8. Save the file. The next exercise will use this file.

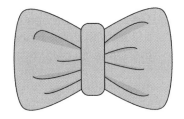

Steps 6 and 7: Selecting all open paths to be shaded and using the Eyedropper tool to apply the same fill and stroke to all selected paths.

Exercise #5: Grouping Objects

Goal
This exercise will teach you how to select multiple objects and group them so they may be treated as a single object for the purposes of moving and editing. You will use the bow tie file created in the last exercise.

Illustrator Tools and Functions
♦ **Selection** tool
♦ *Object>Group* menu command
♦ **Group Selection** tool

Quick Overview
In this exercise you will begin by loading the bow tie file created in the last exercise. Using the **Selection** tool, you will select all the detail objects drawn to illustrate the fabric being cinched in by the wrap rectangle. You will group the selected objects so that they become a unit. You will then experiment with the group by changing stroke weight, color, etc.

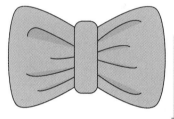

The bow tie created in Exercise #4

Step-by-Step
Loading the Initial File
1. Load the **bowtie.ai** file created in Exercise #4.

Selecting and Grouping Objects
1. Choose the **Selection** tool. Press and hold the *Shift* key on the keyboard, and select one-by-one all the illustrative detail paths/objects created in the last exercise. If you accidentally select the body of the bow tie or the wrap, click on it a second time to deselect it. All detail lines should be visibly selected. Note that as you select additional objects the bounding box grows to surround all the selected objects.

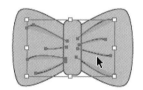

Step 1: Choose the Selection tool, press the Shift key, and click+select all the detail objects.

2. Choose the *Object>Group* menu command. All the objects will become grouped. Now, if you click away and then click again with the **Selection** tool, all the detail lines will select as a group.

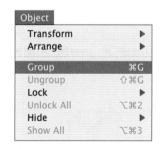

Step 2: Choose the Object>Group command from the Object menu.

Editing the Objects in the Group
1. Choose the **Selection** tool if it is not already active.

2. Click on any object in the group of objects and all detail paths will become highlighted and thus active.

3. Perform the following edits to the group:
 • Change the *Weight* of the *stroke* to .5 in the *Control* panel (CS2/CS3). To do this, click to the right of the Stroke Weight number and when the pop-up menu appears, slide down to .5, then release the mouse button. If you have an earlier version

Selection tool

Changing the
Stroke weight
using the
Control panel or
Stroke panel

of Illustrator, expand the *Stroke* panel to show all options (click
on the arrowhead in the upper right corner of the panel), and
set the new stroke weight from there.

The weight of the stroke lines is changed from 1 point (left) to .5 point (right).

- Change the color of the *stroke* to a
 deep shade of the bow color. This
 shade needs to be darker than the
 shadow shade you created in the last
 exercise. With the group selected,
 double-click on the *Stroke* icon in the
 Toolbox. The *Color Picker* will open.
 Since the current stroke color is black,
 you will need to click in the yellow
 area of the color strip, then choose
 a deep shade. Click **OK** to finalize
 the color change, and note that the
 stroke color of the bow details has
 changed.

The color of the stroke lines is
changed from black to a deep shade
of yellow (below).

Using the Group Selection Tool

The **Group Selection** tool allows you to
select a single object from within a group.
This can be very handy when you want to
edit an object without performing the *Ungroup* function.

Group Selection tool

Four of the objects have been changed
to have a stroke weight of 2 points (as
opposed to .5 point).

1. Choose the **Group Selection** tool. This is hidden under the **Direction
 Selection** tool. You can *click+hold* on the **Direct Selection** tool and
 slide over to the **Group Selection** tool, or you may tear off the **Direct
 Selection** tool strip/panel and then choose the **Group Selection** tool
 from that.

2. Click on any of the objects within the group of details. Note that only
 your chosen object selects (as opposed to the entire group).

3. Change the *Weight* of the stroke for this object by choosing a new
 weight in the Control panel or the Stroke panel.

4. Alter the weight of additional detail lines to create greater variety in
 the drawing.

5. Save the file as **bowtie2.ai.**

Exercise #6: Working with Layers

Goal

This exercise will illustrate the value of working with layers. You will learn how to set up new layers and utilize layer functions such as viewing and locking. In addition, you will learn how to move objects from one layer to another.

The Layers panel, utilizing three layers, layer visibility, and locks

Illustrator Tools and Functions

- ◆ **Selection** tool
- ◆ Layers
- ◆ Moving objects from one layer to another

Quick Overview

In this exercise you will begin by loading the bow tie file created in Exercise #4, and edited in Exercise #5. You will create two new layers, one for the details of the bow and the other for a drawing of a ribbon to extend from the bottom of the bow. The detail lines and rectangular band will be moved to the *Details* layer. You will learn how to move a layer from one position to another and will do so with the *Ribbon* layer so that it lays beneath the bow layer.

Step-by-Step

Loading the Initial File

1. Load the **bowtie2.ai** file created in Exercise #4.

2. Immediately save the file as **bowtie3.ai**. Use the *Save As . . .* command found in the *File* menu.

Setting up Layers

Layers are one of the greatest strengths of Illustrator. They allow you to organize objects by theme and/or by arrangement in a stacking order. Consider each layer to be a sheet of transparent film. You can see through each layer to the one beneath it, except in areas where opaque objects are drawn. The uppermost layer in the *Layers* panel sits on top of all other layers. Remember that within a layer, objects also stack, bottom to top, with the most recently drawn object sitting on top. You may move objects forward and backward using the *Object>Arrange* menu. If you examine the bow tie file you just loaded, you will see that there is one layer and it is most likely called *Layer 1* (unless you already renamed it). At this point we will rename the layer and set up two additional layers for our drawing.

Step 1: Double-click on Layer 1 and when the Layer Options dialog opens, rename it Bow.

1. Double-click on the words *Layer 1* in the *Layers* panel, and when the dialog opens, change the layer name to *Bow*. Notice that the layer color is currently Light Blue. This means that when objects are selected on this layer they will be highlighted in a light blue color. Click **OK** to close the dialog.

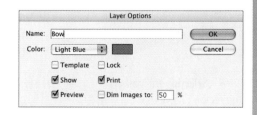

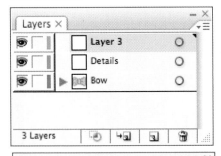

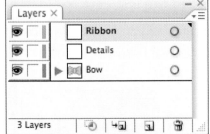

The process of setting up the layers for this exercise

2. Create a new layer by clicking on the *Layers* panel menu arrowhead in the upper right side of the panel. Choose *New Layer*. When the dialog window opens, name the layer *Details* and choose a color for the selections. Choose Red. Click **OK**.

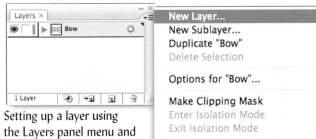

Setting up a layer using the Layers panel menu and dialog

3. Now try an alternative approach to creating layers. Click on the **Create New Layer** button in the lower right corner of the *Layers* panel. When you click on the button, a new numbered layer appears in the *Layers* panel. You will need to double-click on the layer name to open the *Layer Options* dialog. Name the layer *Ribbon*. Use green as your selection color. Click **OK**.

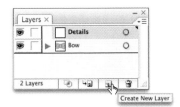

Setting up a layer using the Create New Layer button and then renaming the layer

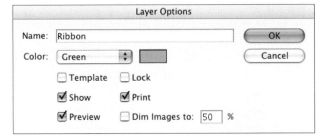

You have now set up all the layers required for this exercise.

Moving Objects from One Layer to Another

In order to better organize the objects used in the file, the details of the bow (the gathers and wrap) will be moved from the *Bow* layer to the *Details* layer. *To do this:*

1. Choose the **Selection** tool.

2. Click on any of the gather objects to select the group. These objects were grouped in the last exercise and should still be a group unless you performed the *Ungroup* command on them. You want to select all the gather lines, which should be a one-step operation if grouping is still active.

Step 2–3: Selecting the gathers and the rectangular wrap.

3. Press and hold the *Shift* key on the keyboard and click on the rectangular wrap of the bow to select it. The *Shift* key allows you to add objects to a selection.

4. If you observe the *Layers* panel at this point in time, you will see that there is a small solid blue square to the right side of the *Bow* layer indicating that there are selected objects. Move your cursor over this square and observe that the cursor changes to a white hand. *Click+hold+drag* the square up onto the *Details* layer. Once you are on top of the layer, release the mouse. You will now see a solid red square on this layer, which shows you that there are selected objects on the layer. You have successfully moved objects from one layer to the other.

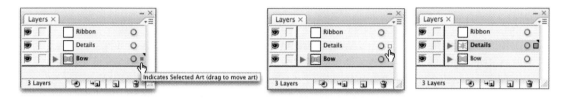

Step 4: Moving objects from one layer to another by dragging the colored square (which appears when objects are selected on a layer) to a new layer.

Selectively Viewing Objects on Layers

You can cross-check what is on a given layer by turning its view off and on. *To do this:*

1. Click on the *Eye icon* in the edit column of the *Details* layer to turn the view of the layer off. You will see the details disappear on the drawing. To redisplay what was hidden, click where the eye icon was. The icon will display again, as will the objects.

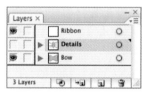

2. Repeat the process with the *Bow* layer to view only the objects on the *Details* layer.

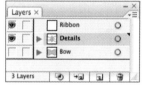

3. If you click on the arrowhead on the *Details* layer to open the view of the sublayers, you will see an expanded view of the layer and all the individual objects drawn on the layer. You will see the grouped objects and may click on this arrowhead to display the various objects within the group. If you prefer, you can select an object using the *Layers* panel. Simply click on a sublayer to select it. You may change the object's properties or delete it once it is selected.

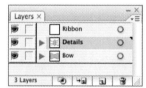

Steps 1 and 2: Experimenting with the view of what is on each layer.

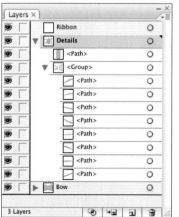

Selectively Locking Objects on Layers

There are times when it is very helpful to lock a layer and the objects on it so that they cannot be selected, moved, or edited. This is particularly handy when you have multiple objects sitting on top of each other.

Step 3: Viewing the various objects on the Details layer. You may click on a sublayer to select it and make it ready for editing.

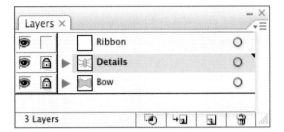

Step 3: Locking the Details and
Bow layers.

To do this:

1. Click on the second column of the edit columns of the *Details* layer to turn on a padlock. This will lock the layer and all objects on it.

2. To unlock the layer, simply click on the padlock to toggle it off, leaving objects available for editing.

3. Lock both the *Details* and *Bow* layers so that you cannot edit objects.

Rearranging Layers and Drawing Ribbon Objects on the Ribbon Layer
At this point, you will draw two ribbons that extend from the bow. These objects will be drawn on the *Ribbon* layer. Since this is currently the upper layer, it will be necessary to move it beneath the *Bow* layer so that the ribbons will extend from under the bow.
To rearrange the stacking order of the layers:

1. Click on the *Ribbon* layer to select it. It will be highlighted.

2. Press and hold the mouse down and drag the layer down. You will see a white hand cursor as you do this. On the left side of the layer name you will see a black arrowhead marker that shows you the position of your layer (among the other layers) as you move it. Be careful not to drag your mouse to the right, or you will make the *Ribbon* layer become a sublayer of one of the other layers. When you see that the arrowhead is beneath the *Bow* layer, release the mouse and the *Ribbon* layer will now appear beneath the *Bow* layer.

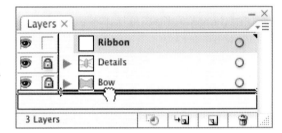

Repositioning the Ribbon layer by dragging it
downward under the Bow layer

The Eyedropper tool

The Pen tool

3. Choose the **Eyedropper** tool and click on the bow. Even though the layer is locked you can still sample the fill and stroke of an object. You now should have a yellow fill and black stroke active in your Toolbox.

4. Choose the **Pen** tool. Now move over the drawing and draw two ribbon objects that extend downward from the bow. This will be simple to do, as the *Bow* and *Details* layers are locked so you cannot accidentally select objects or draw on these layers.

Consider the following:

- Experiment with different shapes of ribbons, moving your trial attempts off to the side as you try a new one.

- Use the bounding box (*View>Show Bounding Box*) to rescale and rotate objects as you work. Once an object is selected, move your cursor around the bounding box and observe how the cursor icon changes according to where you are in relation to the bounding box. Learn to recognize the rotation and scaling icons and use these functions to quickly edit a drawing.

- Draw a new object to show the foldback/underside of the ribbon. You can start this object by using the **Direct Selection** tool to select the bottom of the ribbon, and copy and paste this segment back into the document. Then, use the various **Pen** tools to add and delete anchor points as needed and to draw the rest of the object. Use a darker shade of the bow color to create a shaded effect.

5. Save your file when the drawing is complete.

The Pen tools

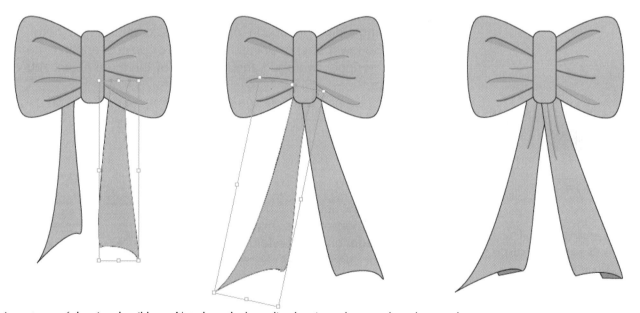

Various stages of drawing the ribbons. Note how the bounding box is used to rescale and rotate the ribbons. Additional objects are drawn to illustrate gather lines and the underside of the ribbon.

This completes the layer exercise.

Exercise #7: Using Join and Average

Goal

This exercise will teach you how to use the *Join* and *Average* functions found in the **Object** menu.

Illustrator Tools and Functions

- ◆ **Selection** tool
- ◆ **Pen** tool
- ◆ *Average* and *Join* commands, found in the **Object** menu
- ◆ *Align points* functions found in the **Control** panel

Quick Overview

In this exercise you will begin by drawing two open shapes of differing sizes. You will then create copies of these and perform average and join commands. *The basic steps are as follows:*

- ◆ Draw two half rectangles using the **Pen** tool, making one object slightly bigger than the other.
- ◆ Select both boxes and make two copies of them. Position these copies elsewhere on the document.
- ◆ Select the upper anchor points of each set of objects and average them using a different option for each (horizontal, vertical, both).
- ◆ Select the lower anchor points of one set of objects and join them.
- ◆ Select the upper averaged anchor points of the three object sets and join them.

Review the discussion of the *Average* and *Join* commands found on pages 88 and 89.

Step-by-Step

Setting up

Step 1: Creating the new document.

1. Create a new document using the *File>New* menu. Name this file **joinaverage**, choose *Letter* size, *Portrait* orientation, and the CMYK color mode. Click **OK**. The document will appear. Save the file.

2. Ensure that the *Control* panel is in view (*Window>Control*, CS2/CS3 version).

Drawing the Objects and Creating Copies

1. Using the *Control* panel (or the *Stroke* and *Color* panels), set the *fill* to None and the *stroke* to black. Choose a stroke *Weight* of 1.

2. Choose the **Pen** tool. Draw two open objects on the document, with the open ends facing each other. Make one object larger than the other. If you want to keep the lines straight, press the *Shift* key as you click and release, setting anchor points. If necessary, use the **Selection** tool to move the objects in position so that they look like the illustration to the left.

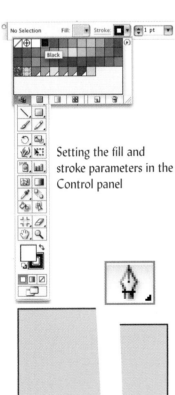

Setting the fill and stroke parameters in the Control panel

Step 2: Drawing two open objects with the open ends facing each other.

3. Using the **Selection** tool, select both objects and *Opt/Alt+drag* them to create two additional copies on the document. If you press the *Shift* key after you start the dragging process, the copies of the objects will align vertically with the originals. The timing is important in that you must start the *Opt/Alt+drag* first, then press the *Shift* key.

Step 3: Creating copies of the original set of objects.

Using the Average Command

1. Using the **Direct Selection** tool, drag a box around the upper end points of each object to select both points.

Step 1: Using the Direct Selection tool to select the upper inner points of each shape for averaging.

2. Choose the *Object>Path>Average* menu command (or press *Opt/Alt+Cmd/Ctrl+J* on the keyboard). The *Average* dialog will open.

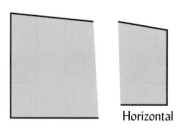
Horizontal

3. Choose the **Horizontal** option in the dialog, and click **OK.** The two upper points will average horizontally.

4. Repeat the process with the two additional sets of objects, choosing the **Vertical** and **Both** options in the *Average* dialog.

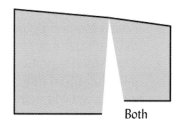
Vertical

Using the Join Command

1. Using the **Direct Selection** tool, select the lower anchor points of the top object set.

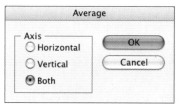
Both

Averaging, Steps 2–4: Results of using the various options in the Average dialog.

2. Choose the *Object>Path>Join* menu command (or press *Cmd/Ctrl+J* on the keyboard). A segment will be drawn between the two selected points.

3. Using the **Direct Selection** tool, select the upper anchor points of each object set and perform the *Join* command. You will see a line segment form between the horizontal and vertical averaged points. When you join the averaged anchor points, a *Join* dialog will open asking you if you want to use a *Corner* or *Smooth* point for the join. Choose *Corner* and click **OK.**

Steps 1 and 2: Selecting the lower anchor points of the two objects and joining them, which results in a line segment being drawn between the object.

Note: Various functions/buttons in the Control panel can be used to align anchor points and facilitate the averaging and joining process.

Point and Align Point controls in the Control panel

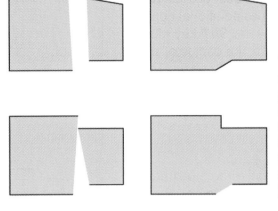

The examples to the left show you the results of each join of the upper anchor points of each object set. Note that an extra line segment was drawn when points were averaged horizontally or vertically. In the lower object set, the anchor points that were averaged in both directions were converted to a corner anchor point in joining.

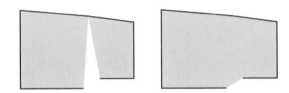

Note:

Join Function in the Control Panel

A Connect selected end points option exists in the Control panel. This will add a new segment between the anchor points involved, but it is handy to know that this function exists.

Troubleshooting

Occasionally, Illustrator gets "fussy" about joining points. The following guidelines will assist you in understanding why certain problems arise.

- Anchor points that are to be joined must be on open paths.
- Anchor points that are to be joined must be on the same layer.
- If selected anchor points are grouped, they must be in the same group.
- If two selected points are not on the same path, they cannot be on text paths or inside graphs.
- If two anchor points sit directly one above the other, the process of selecting them may actually cancel one of the selections out, so sometimes it is helpful to move the two points just slightly apart.

The warning dialog that may appear when Illustrator is having problems joining two points

To join, you must select two open endpoints. If they are not on the same path, they cannot be on text paths nor inside graphs, and if both of them are grouped, they must be in the same group.

☐ Don't Show Again (OK)

Exercise #8: Working with Pathfinder

Creating grommets

Goal

In this exercise, you will learn how to use some of Illustrator's Pathfinder options to speed up the drawing process and facilitate better drawings.

Illustrator Tools and Functions

- ◆ **Pen** and **Shape** drawing tools
- ◆ **Selection** tool
- ◆ *Pathfinder* panel functions
- ◆ *Average* and *Join* commands, found in the **Object** menu

Designing unique necklines

Quick Overview

In this series of mini exercises you will draw shapes and experiment with various *Pathfinder* panel functions to explore various ways in which Pathfinder functions can be used to speed and facilitate the drawing process.

Review the discussion of the *Pathfinder* panel and its functions found on pages 143 through 146.

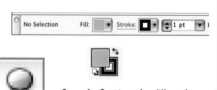
Developing interesting motifs

Step-by-Step
Setting up

1. Create a new document by using the *File>New* menu or pressing *Cmd/Ctrl+N* on the keyboard. Name this file **pathfinderexercise**, choose *Letter* size, *Portrait* orientation, and the CMYK color mode. Click **OK**. The document will appear. Save the file.

2. Ensure that the *Control* panel is in view (*Window>Control*, CS2/CS3 versions).

3. Open the *Pathfinder* panel using the *Window>Pathfinder* menu command.

Drawing a Grommet Using Subtract from Shape

1. Using the *Control* panel, set the *fill* to gray and the *stroke* to black. Choose a stroke *Weight* of 1.

2. Choose the **Ellipse** Shape tool.

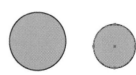
Step 1: Setting the fill and stroke.

3. *Click+release* on the document. A dialog will open. Set the Width and Height of the ellipse to 1 inch. Click **OK**.

4. Create a second ellipse/circle measuring 0.75 inch in width and height. Click **OK**.

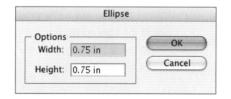

Steps 2–4: Drawing two ellipses of different sizes.

Steps 5–8: Superimposing the two circles in Outline mode (left) and then Preview mode (right).

5. Switch the **View** mode to *Outline* by choosing the *View>Outline* menu.

6. Using the **Selection** tool, position the smaller circle inside the larger circle so that the 'x' centers of the two circles align.

7. Switch the **View** mode to *Preview* by choosing the *View>Preview* menu command.

8. Using the **Selection** tool, select both circles.

9. Click on the **Subtract from Shape Area** button in the Pathfinder panel. The inner circle will be cut out from the outer circle, resulting in a transparent center. At this point you still have two circles.

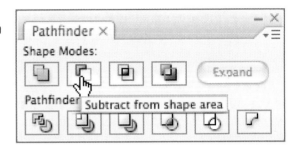

Step 9: Applying the Subtract from shape area Pathfinder function.

10. Click on the **Expand** button in the *Pathfinder* panel. This will remove the invisible shape (the center circle) and leave one object that is now your grommet. If you like, change the color of the fill.

Step 10: Expanding the compound shape.

The expanded compound shape (left) and recolored (right)

Creating a Unique Neckline Using Trim

1. Load the file called **topex8.ai**. This is found in the **Drawing Exercises** folder on the Art DVD. You will see a bodice and an oval. The width of the oval is the same width as the neckline of the top.

2. Using the **Selection** tool, select the oval.

3. Choose the *Filter>Distort>Zig Zag . . .* menu command. A dialog will open.

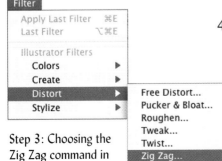

Step 3: Choosing the Zig Zag command in the Filter menu.

4. Click on the *Preview* check box. Set the Size to *11*, the mode to *Absolute*, the Ridges to *9,* and the Points to *Smooth*. Click **OK**. The oval will now appear with a zig zag edging. Using the **Filter** menu causes the zig zag operation to actually change the edge of the oval, which is necessary for the Pathfinder functions to work properly.

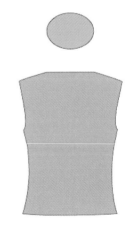

5. Switch to **Outline** view (*View>Outline*). Using the **Selection** tool, move the oval down until the center of the oval sits on top of the top neckline of the garment. This will center the oval on the upper neck edge of the garment. Switch back to **Preview** view (*View>Preview*).

6. Open the *Align* panel by choosing the *Window>Align* menu command.

7. Using the **Selection** tool, select both the oval and the bodice objects. Click on the **Horizontal Align Center** button in the *Align* panel. This is the second button in the upper row. The bodice and oval will now be aligned at the center points, which will guarantee that the neckline you are about to cut out will be centered.

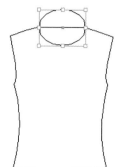

Steps 4–5: Creating the zig zag shape and positioning it over the neckline.

8. With both objects still selected, click on the **Trim** button in the *Pathfinder* panel. The hidden parts of the bodice will be deleted and the stroke will disappear from both objects.

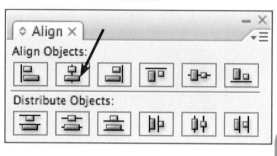

9. Choose the **Direct Selection** tool and click on the zig zag oval and move it up. You will now see the bodice with its cutout. Click on the bodice object, then click on the *Stroke* icon in the Toolbox and choose black as the stroke color (or use the *Control* panel to change the stroke color).

Step 7: Aligning the bodice and the zig zag oval along their horizontal center points.

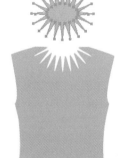

You now have created a top with a cutout neckline.

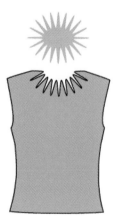

Steps 8 and 9: Moving the zig zag object up and adding a stroke to the bodice object.

Building a Compound Motif Shape Using Divide

1. Create a new document or load the **pathfinderexercise.ai** file created earlier.

2. Choose a black *stroke* and a colored *fill*.

3. Choose the **Star Shape** tool in the Toolbox. Draw a series of stars on the document, similar to the illustration here. Allow stars to rotate as you draw, to add interest to your design. Click away to end the drawing process.

4. Change the *fill* to a different color and set the *stroke* to None.

Step 3: Creating the star shapes.

Steps 4–5: Drawing a circle over the stars, allowing stars to protrude over the edge.

Group Selection tool

5. Select the **Ellipse Shape** tool in the Toolbox. Now, draw a circle over the stars, but do not cover up all parts of the stars. If you want your ellipse to be perfectly round, press and hold the *Shift* key on the keyboard as you draw the ellipse. This constrains the proportions.

6. Using the **Selection** tool, select all the objects.

7. Choose the **Divide** button in the *Pathfinder* panel. The circle will be divided wherever objects overlap it below. All the objects will now be grouped as a unit.

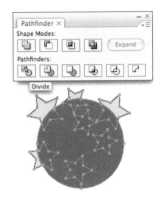

Step 7: Using the Divide Pathfinders Effect to separate all objects where they overlap.

8. Choose the **Group Selection** tool. Now, selectively remove the inner stars from the circle. If it helps you to see, move to *Outline* view (*View>Outline*), or zoom in to see the objects more clearly. The portions of the stars that were inside the circle should now be removed from the drawing, leaving cutout star shapes.

9. If you want, you can change the stars that extend beyond the circle to have the fill color of the circle and no stroke.

You have now created a compound shape that can be used creatively in design.

Steps 8 and 9: Using the Group Selection tool to remove stars (and portions of them) from inside the circle, and changing the fill and stroke color of the outer stars.

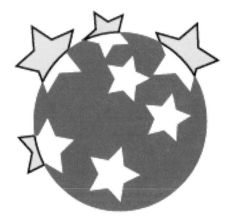

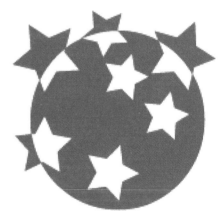

Exercise #9: Creating and Working with Gradients

Goal

This exercise will teach you how to build a gradient color spread and apply it to an object.

Illustrator Tools and Functions

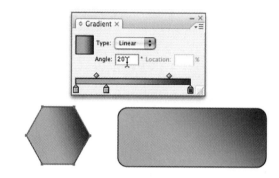

- ◆ **Gradient** tool
- ◆ *Gradient* panel
- ◆ *Color* panel
- ◆ *Swatches* panel
- ◆ **Shape** tools

Quick Overview

In this exercise you will build and experiment with gradient features in Illustrator. *The steps are as follows:*

- ◆ Build a two-color gradient and experiment with sliders in the *Gradient* panel.
- ◆ Apply the gradient as a fill to a drawn object.
- ◆ Store the gradient in the *Swatches* panel.
- ◆ Add a third color to the gradient.
- ◆ Store the new gradient in the *Swatches* panel.

Review the discussion of gradients found on pages 138 through 140.

Step-by-Step

Setting up

1. Create a new document by using the *File>New* menu or pressing *Cmd/Ctrl+N* on the keyboard. Name this file **gradientexercise** and choose the *Letter* size with a *Portrait* orientation, and the CMYK color mode. Click **OK**. The document will appear. Save the file.

2. Ensure that the following panels are open and in view: *Color, Swatches, Gradient*. These are found in the **Window** menu. You may also turn on the *Control* panel (*Window>Control*, CS2/CS3 versions).

Opening the Gradient Panel
Double-clicking on the Gradient tool will open the Gradient panel.

The panels to be used in this exercise

Building a Two-Color Gradient

1. Click on the color strip at the bottom of the *Gradient* panel to make it active. You will see *Endpoints* and a *Midpoint* in the lower strip of the panel. If your starting gradient is black and white, you will likely have to reset the color mode of the gradient to RGB or CMYK as you work through the next few steps.

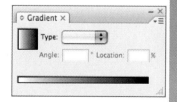

The Gradient panel

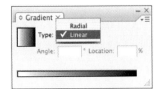

Step 2: Choosing a Linear type of gradient.

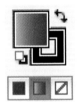

The Gradient displayed in the Fill area of the Toolbox

2. From the **Type** drop-down menu/list, choose the *Linear* option.

3. Click on the left endpoint/slider. If, when you click on this endpoint, the *Colors* panel shifts to a Grayscale palette, you will need to change the color mode of the panel to CMYK or RGB. This is achieved by choosing the desired mode from the *Color* panel menu.

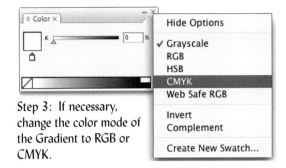

Step 3: If necessary, change the color mode of the Gradient to RGB or CMYK.

4. With the left slider selected, click on a color in the *Color* panel. This will assign the new color for the left end of the gradient fill.

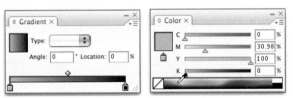

Step 4: Choosing a new color for the left slider.

5. Click on the right endpoint/slider and reset the *Color* panel to RGB or CMYK if necessary. With this slider selected, click on a different color in the *Color* panel. Choose a color that contrasts with the first color so that the gradient is easily seen. The fill can be previewed in the gradient slider bar along the bottom of the panel. If you look at the *fill* color in the Toolbox you will see the new gradient there.

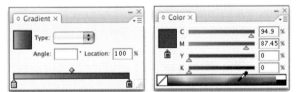

Step 5: Choosing a new color for the right slider.

6. Choose a **Shape** tool and draw one or more shapes on the screen. Since the gradient was the current *Fill*, your shape will fill with the gradient color spread.

Step 6: Two shapes filled with the gradient color spread.

7. Use the **Selection** tool and select both shapes.

8. Click on the diamond-shaped midpoint and drag it to the left and then to the right on the slider bar. Note how the position of this midpoint changes the rate at which the first color merges into the second. You will see the changes in the *Gradient* panel and on the fills of both selected objects. Experiment until you find a gradient change rate that appeals to you. Note that the location of the diamond slider is displayed as a percentage in the *Location* field in the *Gradient* panel.

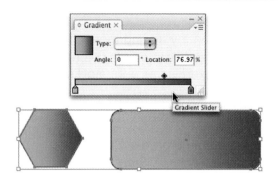

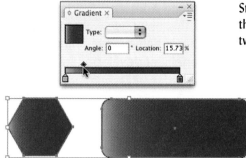

Step 7: Experimenting with the rate of gradation between two colors.

Transferring the Gradient to the Swatches Panel

There are three ways to transfer the new gradient to the *Swatches* panel. As you perform each of the options below, change the gradient slightly by moving the midpoint slider. *The three options of creating a gradient swatch are:*

1. *Using the New Swatch Menu*—With the gradient active in the *Fill* of the Toolbox, choose *New Swatch* from the *Swatches* panel. A dialog will open. Type a descriptive name for the gradient and click **OK**. The swatch will now appear in the *Swatches* panel.

OR

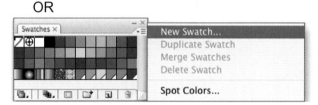

Creating a gradient swatch using the Swatches panel

2. *Dragging the Swatch from One Panel to Another*—Drag the gradient from the *Gradient* panel to the *Swatches* panel. You will need to name this gradient as a separate operation. Double-click on the gradient swatch to open the *Swatch Options* dialog. Type a name and click **OK**.

OR

Creating a gradient swatch by dragging the swatch from one panel to another

3. *Dragging the Swatch from the Toolbox to the Swatches Panel*—Drag the gradient from the *Fill* icon of the Toolbox to the *Swatches* panel. You will need to name this gradient as a separate operation. Double-click on the gradient swatch to open the *Swatch Options* dialog. Type a name and click **OK**.

Creating a gradient swatch by dragging the swatch from the Toolbox to the Swatches panel

Adding Additional Colors to the Gradient

At this point, we will make a multicolored gradient by adding more colors to it. This is achieved by introducing what is known as *intermediate* colors. Use the panel just developed in the prior steps of this exercise as your starting point.

1. Ensure that the *Gradient* panel and the *Color* panel are displayed.

2. Using your mouse, click directly beneath the gradient bar at the position where you want to add the new color. A *Stop* point will appear.

Step 2: Adding an intermediate stop point. You can see the original panel (left) and the new panel (right).

3. Choose a color from the *Color* panel and click on it. This will move the color into the new intermediate color *Stop* and change the gradient accordingly. Note that now there are two diamond *Midpoint* markers. If you like, apply this new gradient to the objects you drew earlier in the exercise.

4. Experiment with the rate of color change in the gradient by dragging the diamond-shape midpoints around. Experiment also with the *Angle* and *Location* settings.

Step 3: Changing the new intermediate color to green by clicking on the green color in the Color panel.

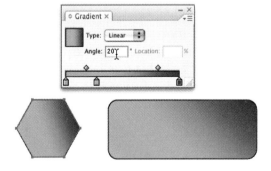

Step 4: Experimenting with the Angle setting. The object on the left uses a 30-degree angle and the object on the right uses a 45-degree angle.

Exercise #10: Working with Clipping Masks

Goal
In this exercise you will learn how to use a clipping mask to combine a gradient fill with type.

Couture

Placing a color gradient in text using a clipping mask

Illustrator Tools and Functions
♦ *Gradient* panel
♦ **Type** tool
♦ ***Rectangle*** *shape tool*
♦ *Object>Arrange* menu
♦ *Make* and *Release* functions of the *Clipping Mask* (**Object** menu)

Quick Overview
The fill options with type are limited, so using a clipping mask allows you to expand your text capabilities. *You will perform the following steps:*
♦ Create text using the **Type** tool.
♦ Draw a rectangle and fill it with a gradient.
♦ Position the text on top of the rectangle.
♦ Create a Clipping Mask that will fill the text with the gradient color.

Review the discussion of clipping masks found on pages 100 through 101.

Step-by-Step
Setting up
1. Create a new document using the *File>New* menu. Name this file **clippingmask**, choose the *Letter* size with a *Portrait* orientation, and the CMYK color mode. Click **OK**. The document will appear. Save the file.

2. Ensure that the following *Control, Layers,* and *Gradient* panels are open. You may also open the *Type>Character* panel, although many of its functions are found in the *Control* panel. If you want to build a new custom gradient, open the *Color* and *Swatches* panels.

Creating Text
1. Set your *fill* to black and your *stroke* to None.

2. Choose the **Type** tool. In the *Control* panel, set the font size to at least 36 and choose a heavy-looking font. The font used in the illustrations here was a bold version of Arial set to size 48.

Steps 1-3: Using the Type tool to type text.

3. Click on the screen where you want to type and type the word(s) you want. Press the *Cmd/Ctrl* key on the keyboard and click away when you are done. This will finish the text.

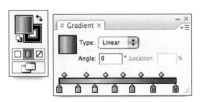

The chosen gradient

Creating the Gradient Rectangle Shape

1. Click on the *Fill* icon in the Toolbox to make it active (if it is not currently active).

2. Choose a gradient from the *Swatches* panel or build a custom gradient per the instructions from the last exercise.

3. Choose the **Rectangle** shape tool. Draw a rectangle that is slightly larger than your text. Since this was drawn after the text was created it will sit higher in the stacking order of objects on your document. You will change this shortly.

Step 3: Drawing the gradient-fill rectangle.

Creating the Clipping Mask

1. Using the **Selection** tool, position the gradient rectangle over the text.

2. With the rectangle still selected, choose the *Object>Arrange>Send to Back* menu command. This will reposition the rectangle so that it is behind the text in the stacking order.

Steps 1 and 2: Positioning the objects and sending the rectangle to the back of the stacking order.

3. Using the **Selection** tool, drag a box around both the rectangle and the text so that both objects are selected.

4. Choose the *Object>Clipping Mask>Make* menu command. The mask is made and the gradient is cropped so that it only

Step 4: Creating the mask.

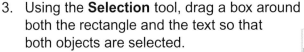

appears through the upper object, the mask. You will notice that the objects are grouped, and that the fill in the panel has turned into a question mark. Click away to deselect all objects.

The Clipping Mask menu command (above) and the Layers panel showing the grouped objects (below)

5. Observe the *Layers* panel and click on the down arrows of the layer to view all objects within the layer.

6. Choose the **Direct Selection** tool, and click on the text. Only the text will be selected.

7. Click on the *Stroke* icon in the Toolbox. Change the color of the stroke to black. You may

Step 7: Changing the stroke color to black.

also use the *Control* panel to change the stroke color. The text will be outlined in black.

Both the text and gradient rectangle objects still exist, and you can release the mask at any point in time.

Exercise #11: Transferring Swatches between Documents

Goal

In this exercise, you will learn how to transfer swatches (color, gradient, or pattern) from one document to another.

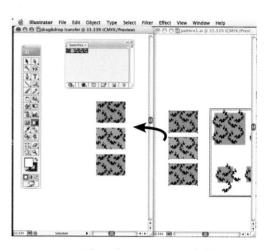

Illustrator Tools and Functions

- ◆ **Selection** tool
- ◆ *Edit>Copy* and *Edit>Paste* commands
- ◆ Drag and Drop functions between documents
- ◆ Importing of *Swatches* panels using the *Window>Swatch>Other Library* menu command

Transferring prints and thus swatches between documents

Quick Overview

You will learn three methods of transferring swatches from one file to another. *These are:*

1. *Copy and Paste*: Objects that utilize the swatches you want may be copied to the clipboard and pasted into the new file.

2. *Drag and Drop:* Objects that utilize the swatches you want may be dragged from one file to another. The receiving file will add the new transferred swatches to its panel.

3. *Windows>Swatches>Other Library:* Use this menu command to import colors, gradients, and patterns from one Illustrator file to another.

In the examples below, you will be transferring three pattern swatches from a file called **pattern1.ai** (found on the Art DVD) to different documents.

Step-by-Step

Method #1: Transferring Swatches via the Clipboard

In this example we will transfer objects filled with patterns from the **pattern1.ai** file to a new document using the *Clipboard* as a transfer tool.

1. Open the **pattern1.ai** file. This is found in the *Textile Design Exercises* folder on the Art DVD. Ensure that the *Swatches* panel is displayed (*Window/Swatches*).

The Swatch panel of the pattern1.ai file

2. Create a new document using the *File>New* menu. Name this file **transferclipboard**, and choose the *Letter* size with a *Portrait* orientation and the CMYK color mode. Click **OK**. The document will appear. Save the file.

3. Reposition and resize both documents so that you can see both files at the same time. If you are using Windows, choose the *Window>Tile* menu to perform this task. Click on the **pattern1.ai** file to make it the active document.

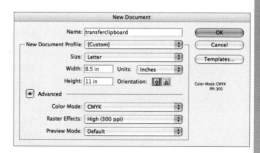

Step 2: The New File dialog.

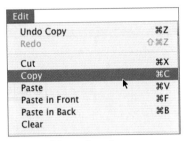

Copy and Paste functions found in the Edit menu

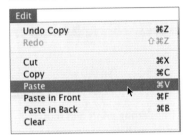

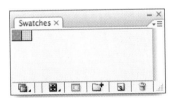

The Swatches panel of the new file, before (above) and after (below) the transfer

4. Using the **Rectangle** tool, create three simple rectangles, choosing a different squiggle pattern swatch for the fill of each. Zoom in if you want to view the rectangles.

5. Using the **Selection** tool, drag a box around the three rectangles to select them.

6. Choose the *Edit>Copy* menu command to copy the swatches to the clipboard.

7. Move to the **transferclipboard.ai** file. Clicking on the document will achieve this. Ensure that the *Swatches* panel is open. Click on the **Show Pattern Swatches** button at the bottom of the panel to view the pattern swatches only.

8. Choose the *Edit>Paste* menu and watch the pattern swatches appear in the *Swatches* panel of this file.

9. Save the **transferclipboard.ai** file.

Step 4: Creating the rectangles with pattern fills.

Steps 5-8: Copying the rectangles from the pattern1.ai file and pasting them into the transferclipboard.ai file.

Method #2: Transferring Swatches Using Drag and Drop Between Documents

In this example we will transfer three pattern swatches from the **pattern1.ai** file to a new document using the *Drag and Drop* method of transferring objects and thus information. Drag and Drop may be used between documents within a program, and even between programs (such as Illustrator and Photoshop).

1. Open your **pattern1.ai** file (if not already open). This is found in the *Textile Design Exercises* folder on the Art DVD. Ensure that the *Swatches* panel is displayed (*Window/ Swatches*).

2. Create a new document using the *File>New* menu. Name this file **drag&drop transfer.ai**, and choose the *Letter* size with a *Portrait* orientation and the CMYK color mode. Click **OK**. The document will appear. Save the file.

Step 2: The New File dialog.

Step 3: Resizing and repositioning the two documents.

3. Reposition and resize both documents so that you can see both files at the same time. If you are using Windows, choose the *Window>Tile* menu to perform this task.

4. Using the **Rectangle** tool, create three simple rectangles, choosing a different squiggle pattern swatch for the fill of each.

5. Click on an object in the **pattern1.ai** document and drag it to the **drag&droptransfer.ai** window. The object will copy onto the new document and the pattern will appear in the *Swatches* panel. Repeat the process with the other two swatches. If you do not want the objects on the screen, you may delete them now, as the panel has incorporated the pattern swatches.

6. Save the **drag&droptransfer.ai** file. The *Swatches* panel will now include the pattern swatches.

Steps 4-5: Creating rectangles filled with a pattern and dragging these to the new document.

Method #3: Using the Swatch Import Command

In the example below, we will be transferring pattern swatches from an unopened file (**pattern1.ai**) to the *Swatches* panel in an open document. This process does not require that the file be open or that any artwork (containing the desired swatches) be available.

1. Create a new document using the *File>New* menu. Name this file **transferimport**, and choose the *Letter* size with a *Portrait* orientation and the CMYK color mode. Click **OK**. The document will appear. Save the file.

Step 1: The New File dialog.

2. Choose the *Window>Swatch Libraries>Other Library* menu. A file requestor will open. Locate and choose the **pattern1.ai** file (found in the *Textile Design* folder on the Art DVD) and click **Open**. You will now see two swatch panels on the screen, one for the original file and the other from the **pattern1.ai** file. Note that the *pattern1* panel is not a fully operational panel in that it lacks the icons at the bottom of the window and the panel menu options are different from those of a fully functional *Swatches* panel. Note also that the *pattern1* panel displays all swatches (color, pattern, and gradient). In the example here, only the pattern swatches are displayed in the *Swatches* panel.

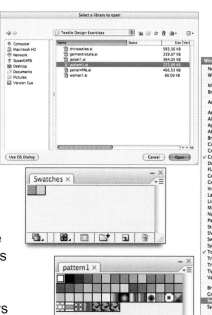

Step 2: Opening the pattern1 panel, a panel created and stored with another file.

Step 3: Transferring swatches from the pattern1 panel to the Swatch panel.

3. You are now ready to move the squiggle pattern swatches from the *pattern1* panel to the *Swatches* panel. This is achieved by simply clicking on the squiggle swatches in the *pattern1* panel. As you click on each swatch, a white box will surround the swatch and copy it into the main *Swatches* panel.

Note: Once you have *utilized* swatches in your artwork, you can remove unused swatches in the panel by choosing the *Select All Unused Swatches* option in the *Swatches* panel menu and then choosing the *Delete Swatch* option.

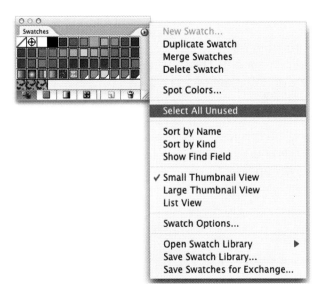

The process of deleting unused swatches:
1. Choose Select All Unused from the panel menu (left).
2. Click on the Trashcan icon in the lower panel (above).
The resulting panel (below).

Fashion Drawing Exercises

This chapter includes a series of exercises that focus on the drawing of fashion flats, the building of a fashion croquis, and the drawing of fashion illustrations. You will learn how to use Illustrator's tools and menu items to achieve these specific tasks.

Exercise #5:
Drawing Flats
on a Basic Croquis

Valery Ketenjian

The exercises are divided into groups based on the type of fashion drawings: technical garment flats, the creation of a croquis template, illustrative poses, and techniques utilizing Illustrator's masks.

Exercises include:

Drawing Fashion Flats

Exercise #1 Drawing a Basic Tank Top Utilizing Straight and Curved Segments as You Draw

Exercise #2 Drawing a Basic T-Shirt Body Utilizing a Grid, Pen, and Pen Editing Tools

Exercise #3 Adding Sleeves and a Neckband to an Existing Garment Body

Exercise #4 Drawing Symmetrical Garments Using Guidelines, Grid, and the Reflect Tool

Exercise #5 Drawing Flats on a Basic Croquis

Exercise #6 Working with the SnapFashun Library of Flats

Exercise #7 Working with Predrawn Flats

Developing a Croquis

Exercise #8 Developing and Drawing a Fashion Croquis

Exercise #9 Working with a Jointed Croquis

Drawing Fashion Illustrations

Exercise #10 Tracing a Hand-Drawn Fashion Illustration

Exercise #11 Creating a Posed Fashion Figure from a Fashion Photo

Exercise #12 Creating a Screen Capture for Use in Illustrator

Exercise #13 Automatically Tracing a Scanned Photo, Drawing, or Clip Art

Additional Techniques

Exercise #14 Using Clipping Masks to Lay Scanned Fabric in Vector Images

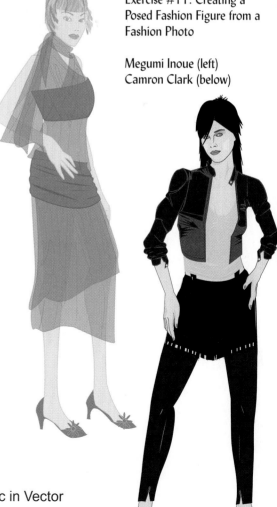

Exercise #11: Creating a Posed Fashion Figure from a Fashion Photo

Megumi Inoue (left)
Camron Clark (below)

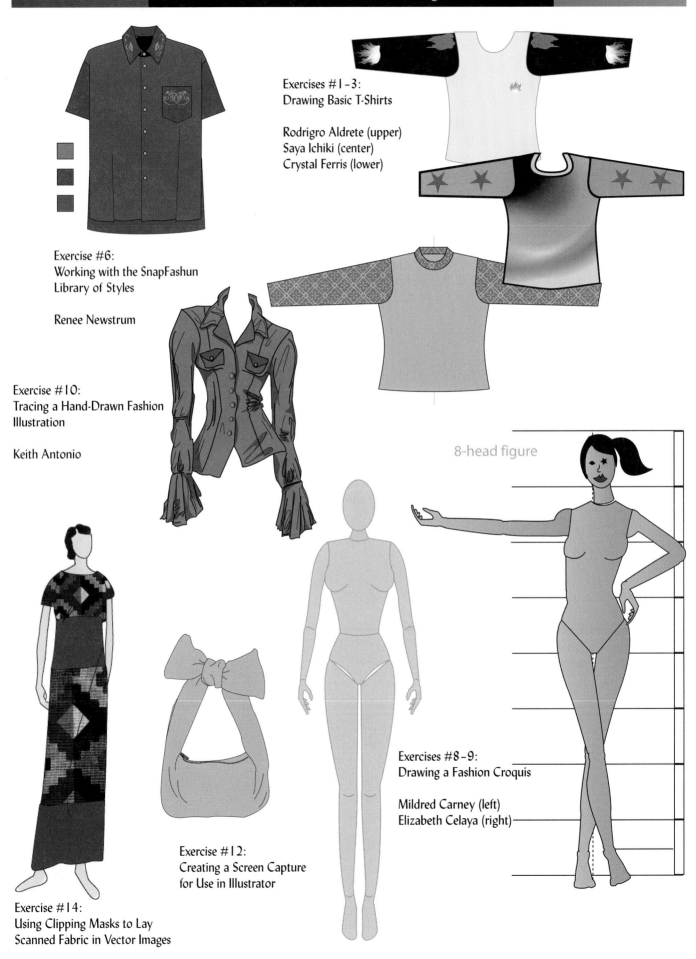

Exercises #1–3:
Drawing Basic T-Shirts

Rodrigro Aldrete (upper)
Saya Ichiki (center)
Crystal Ferris (lower)

Exercise #6:
Working with the SnapFashun
Library of Styles

Renee Newstrum

Exercise #10:
Tracing a Hand-Drawn Fashion
Illustration

Keith Antonio

8-head figure

Exercises #8–9:
Drawing a Fashion Croquis

Mildred Carney (left)
Elizabeth Celaya (right)

Exercise #12:
Creating a Screen Capture
for Use in Illustrator

Exercise #14:
Using Clipping Masks to Lay
Scanned Fabric in Vector Images

Exercise 1: Drawing a Basic Tank Top Utilizing Straight and Curved Segments as You Draw

Goal

This exercise focuses on the drawing of a simple tank top garment using a combination of straight and curved segments. Perfect symmetry is not the primary focus. Rather, we will concentrate on the process of creating appropriate straight and curved paths.

Illustrator Tools and Functions

◆ **Pen** tool
◆ **Selection** tool
◆ Various menu commands found in the *Window* menu
◆ Layers

The simple cropped tank top created in this exercise

Quick Overview of the Process

The approach in this exercise is to draw the tank top, segment by segment, thinking, in advance of drawing, what each segment in the garment needs to be (straight vs. curved). The manner in which you set the anchor points and move your mouse as you draw plays a direct role in the type of path/line you create. Do not worry if your garment is not perfectly symmetrical, left-to-right. The purpose of this exercise is to learn how to anticipate and then draw the appropriate line/path. *The general approach is as follows:*

◆ Set up individual layers for guidelines and garment drawing.
◆ Create a center guideline to use as a visual marker.
◆ Draw the tank top by setting points and creating straight and curved segments in the proper location.

Review the concepts in Chapter 1 if necessary.

Step-by-Step

Setting up

1. Ensure that your Units are set to **Inches**. Choose the *Illustrator>Preferences>Units and Display Performance (Mac)* or *Edit>Preferences>Units and Display Performance (Windows)* menu command. Set the General option to *Inches* by clicking on the pop-up arrow and selecting *Inches* from the list. Leave the Stroke and Type options set at *Points*. Click **OK**.

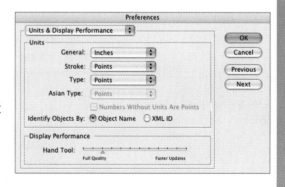

2. Create a new file using the *File>New* menu command. The New Document dialog opens. Type *Tank Top* as the file name. In the New Document Profile area, set the Size to *Letter* and the Orientation to *Portrait*. You may choose RGB or CMYK as your color mode. Click **OK** and the document will appear on the screen.

Macintosh Preferences setup (above) and Document setup (below)

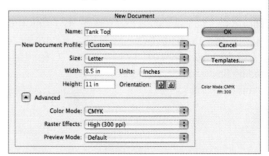

3. Immediately save the file. Choose the *File>Save As* menu and maneuver your way to a location where you want to save the file. Click **Save**.

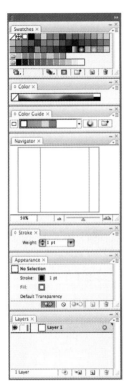

Panels used in this exercise

4. Ensure that the Toolbox and the following panels are open: *Colors, Swatches, Stroke, Appearance, Layers*. If they are not, open them using the *Window* menu.

5. Double-click on the name of *Layer 1* in the *Layers* panel. A dialog will open. Rename the layer to *guidelines*. Use light blue as the layer color. Click **OK**.

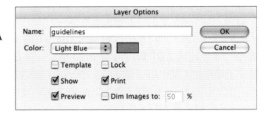

6. Create a new layer by clicking and holding on the arrowhead in the upper right corner of the *Layers* panel and choosing the *New Layer* menu option. Name this layer *tank top* and set the Color as red. Click **OK**. The layer will appear in your *Layers* panel.

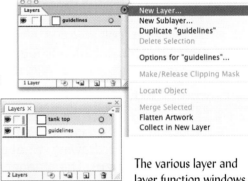

The various layer and layer function windows

Drawing the Center Guideline

1. Turn on the display of the Ruler by choosing the *View>Show Rulers* menu command.

2. Click on the *guidelines* layer to select it.

3. Set the *fill* to None and choose a blue color for your *stroke.* Ensure that the stroke *Weight* is set to 1 in the *Stroke* panel or on the *Control* panel (CS2/CS3).

Step 3: Setting a fill of None and a blue stroke.

4. Choose the **Pen** tool in the Toolbox. Move your cursor to the upper center of the document and click once to set an anchor point. This is the upper endpoint of your vertical guideline.

Steps 4–5: Drawing the vertical guideline on the document.

5. Press the *Shift* key on the keyboard and move your cursor down and directly below the first point. Click with the **Pen** again to set the endpoint of the line. Holding the *Shift* key down will constrain the line to keep it perfectly straight. This completes the drawing of your center guideline.

Step 6: Locking the guideline layer.

6. Click on the *Lock option box* of the guidelines layer to toggle the lock on. This will prevent further drawing on this layer.

Drawing the Right Side of the Tank Top

1. Click on the *tank top* layer to select it and make it the active layer.

Step 1: Selecting the tank top layer.

> ## Note:
> ## Hide or Show the Bounding Box?
> When you draw with Illustrator, you can choose to show or hide the bounding box. Use the View>Show/Hide Bounding Box menu command to turn this on or off.

Step 2: Changing the stroke to black.

2. Leave the *fill* set at None. Change the *stroke* color to black.

3. Begin at the center neck of the tank top. Move your cursor to an area at the top of the page, directly above the center guideline. Click and release to set an anchor point.

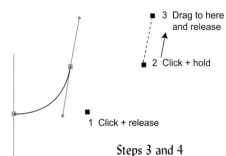

3 Drag to here and release

2 Click + hold

1 Click + release

Steps 3 and 4

4. Move to the right and up slightly to the position where you want to set the neckline/upper shoulder point. Since you want the neckline to be a curved line, you will *click+drag* when you set this next point, which will allow you to create a curve with a direction line and control point at the end of the neck curve. You will have best results if you drag upward and release. Note that two direction lines extend from the new anchor point. One line controls the curve of the segment you just completed, and the second direction line will control the curve of the next segment. Currently, the anchor point you just drew is a **smooth** anchor point since it is set up to connect two curves.

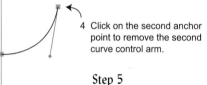

4 Click on the second anchor point to remove the second curve control arm.

Step 5

5. The next segment you want to draw is a straight line (for the shoulder seam), so you should remove the direction line that will control the curve at the beginning of the segment. To do this, simply click on the second anchor point and the second direction line will disappear. If by chance you happened to click away from the drawing, you will not be able to use this technique to change the anchor point to a combination point. In this case, use the **Convert Anchor Point** tool to change the type of anchor point after you finish drawing the garment or drag the *control point* of the direction line directly on top of the anchor point to remove the curve.

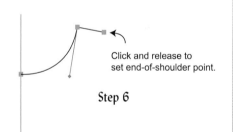

Click and release to set end-of-shoulder point.

Step 6

6. Move your cursor to position it where the shoulder seam should end. Click once to set an anchor point and create the straight line segment.

7. Move your cursor to position it where the mid-armhole point should be placed (approximately 2/3 of the depth of the armhole and inward slightly). Click once and release to set the anchor point. This will create a straight line.

8. Position your cursor where the underarm point should be placed. Since you want this segment to be a curve, *click+drag* the mouse to set the point and drag directly to the right to create the lower armhole curve. You want the curve to be relatively flat where it meets the side seam, so try to drag your mouse horizontally. Once you have created a proper curve (you may use the *Shift* key to assist you), release the mouse to complete the action.

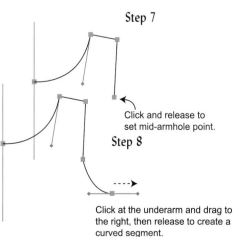

Step 7

Click and release to set mid-armhole point.

Step 8

Click at the underarm and drag to the right, then release to create a curved segment.

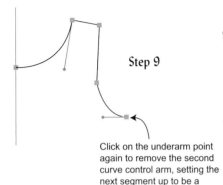

Step 9

Click on the underarm point again to remove the second curve control arm, setting the next segment up to be a straight line.

9. The next segment (the side seam) needs to be straight, so you should remove the second direction line created in the last step. To do this, click once again on the underarm anchor point. The second direction line is removed.

10. You are now ready to draw the side seam. This will be a straight line and you want it to be positioned directly below the lower armhole point. Press the *Shift* key on the keyboard and move your mouse to the lower side seam point of the tank top. Click once and release to set the point. The *Shift* key is a constrainer key and will force your side seam to be perfectly straight.

11. Your next point will be the lower center hem point of the tank top. Use the *Shift* key once again and move your mouse horizontally to the center front of the top. Click to set the anchor point.

12. Save the file to update it.

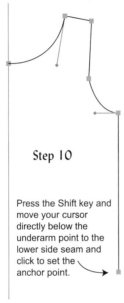

Step 10

Press the Shift key and move your cursor directly below the underarm point to the lower side seam and click to set the anchor point.

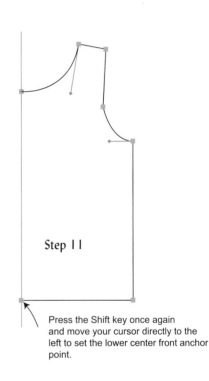

Step 11

Press the Shift key once again and move your cursor directly to the left to set the lower center front anchor point.

Note:

Guides

A Vertical guide could be used instead of drawing a vertical line object. This is achieved by dragging a guide off the vertical ruler.

Drawing the Left Side of the Tank Top

You have now built the right half of the tank top. The left side is built in a similar way, but the manner in which certain anchor points are set will vary slightly as you are creating the straight lines and curves, coming from a different direction. Use the right side of the tank top as a visual guide to assist you in placing all points of the left side of the garment.

The steps are as follows:

1. Press the *Shift* key once again, move your mouse horizontally to the left to the position of the lower side seam point, and *click+release* to set the anchor point.

2. You now want to set the left lower armhole point. Hold down the *Shift* key once again and position your cursor directly above the lower side seam point and directly across from the opposite

armhole point. *Click+release* with the mouse to create the straight line segment.

3. You are ready to set the point that defines the top part of the lower armhole curve. Move your cursor inward, mirroring the same amount as the right top armhole. You are preparing to draw the lower armhole curve, so you will need to *click+drag* to create the curve. Whereas on the right side you dragged to the right to create the armhole curve, you will drag *up* on this side of the tank top. This is because you are drawing and setting points in a clockwise manner around the garment and the curve of this lower armhole is controlled by the endpoint of the curve as opposed to the beginning point (as is the case on the other side of the top). As you drag the mouse to shape the curve, try to match the opposite armhole curve. It will be difficult to be "perfect," so don't worry if you are bit off in your accuracy. Once you have released the mouse the lower armhole curve is set.

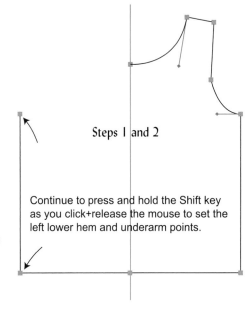

Steps 1 and 2

Continue to press and hold the Shift key as you click+release the mouse to set the left lower hem and underarm points.

Drag to here and release.

Click and hold

Step 3

Click again on the mid-arm anchor point to remove the second curve control arm.

Step 4

4. The next segment (the upper armhole) is a straight segment, so you will want to remove the second direction line that occurred naturally in the creation of the last anchor point. Move your mouse directly over the anchor point and click to remove the direction line that will affect the next segment you draw.

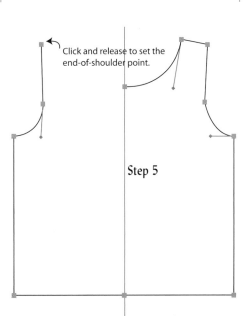

Click and release to set the end-of-shoulder point.

Step 5

5. Move your mouse to the position of the lower shoulder seam point. *Click+release* to create the straight upper armhole segment.

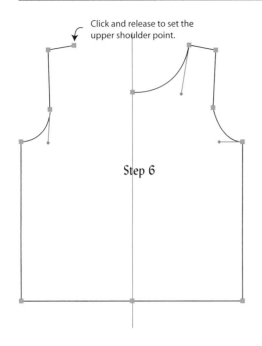

Click and release to set the upper shoulder point.

Step 6

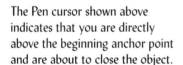

The Pen cursor shown above indicates that you are directly above the beginning anchor point and are about to close the object.

6. The next segment is the shoulder seam, which is a straight segment. Position your mouse where the end of your shoulder seam should be located to mirror the left side of the tank top. *Click+release* to create the shoulder seam.

7. The last segment you need to draw is the left neckline. The creation of this curve segment will close the path so that you have a closed object. Position your mouse over the beginning center neck point. When you are directly over the point, the cursor should change to a Pen with a circle. *Click+drag* to the right to create a curve that matches the right neckline curve. Release the mouse. Notice that the direction line extends to the left even though you dragged to the right. This is normal. You have now closed the path/object.

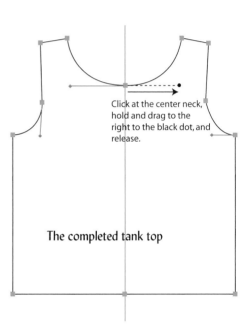

Click at the center neck, hold and drag to the right to the black dot, and release.

The completed tank top

Editing Points

If your tank top is not perfectly symmetrical you can now come back and edit curves and points as necessary to achieve a greater symmetry between the two sides. The **Direct Selection** tool is used for this process.

To Edit the Position of Points:
o Using the **Direct Selection** tool, click on a point to select it and use the arrow keys found on your keyboard to nudge the points up, down, or sideways. Alternatively, you may click on a point and drag it to a new position. Nudging provides a gentler approach to moving points.

To Reshape Curves:
o Use the **Direct Selection** tool to select the anchor point attached to the curve. Once the point is selected, the direction lines and control points should become visible.

The Direct Selection tool, used to select chosen points for editing

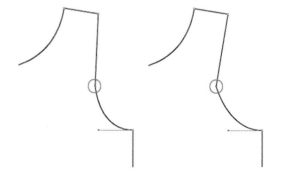

Nudging points using the Direction Selection tool and the arrow keys on the keyboard. The original mid-armhole point (left) is moved inward slightly through nudging (right).

Click+hold on a control point and drag it to a new position. Observe how the curve is changed. Lengthening the direction line changes the depth of the arc and changing the position of the control point changes the angle of the curve.

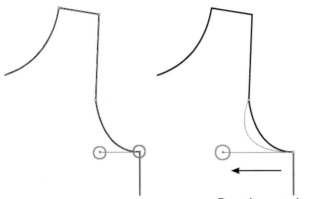

Using the Direct Selection tool, click on a smooth or combination anchor point (i.e., an anchor point that controls a curve) and view the direction line and control point that appear. Click on the control point and move it to lengthen the direction line. Note how the curve is changed.

Drag the control point to the left to change the curve.

Assigning a Fill Color

Once you are satisfied with the shape of the tank top, you may change the fill to a color.

1. Choose the **Selection** tool and click on the garment to select it. There is no fill in the garment, so you will need to click on the outline or stroke to select the object.

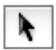

The Selection tool, used to select an entire object

2. Double-click on the *Fill* icon in the Toolbox. This will open the *Color Picker* dialog.

3. Choose a new color in the *Color Picker.* Achieve this by dragging your cursor over the various colors in the window. You will see the current chosen color appear in the rectangular box in the upper right-center of the window. Click **OK** when you are happy with your color choice.

4. The tank top will fill with a color and the *Fill* icon in the Toolbox will reflect this color.

5. Save the file again to update it.

Steps 2–4: Choosing a new fill color.

No fill on the tank top (left) and red fill on the tank top (right)

This completes the first exercise.

Amy Nguyen

Keith Antonio

Kristen Sandy

Mildred Carney

Gretchen Kauffman

Variations on a Theme: Cynthia Martinez

Exercise #2: Drawing a Basic T-Shirt Body Utilizing a Grid, Pen, and Pen Editing Tools

Goal
To draw a basic T-shirt utilizing a rectangle shape, a grid, and the various Pen tools. To insert the proper garment points necessary to create a neckline, armholes, etc.

Illustrator Tools and Functions
♦ **Rectangle** tool
♦ *Layers* panel
♦ Grid (*View>Show Grid*)
♦ Various **Pen** tools, (e.g., Pen, Add Anchor Point, Delete Anchor Point, Convert Anchor Point)

The various Pen tools (left to right): Pen, Add Anchor Point, Delete Anchor Point, and Convert Anchor Point.

Quick Overview of the Process
In this exercise you will start with a basic rectangle and insert points in the appropriate place to mark key garment points for a basic T-shirt. Once the points are in place you will move them around as necessary and then convert certain lines between anchor points into curves, as dictated by the location of the segment on the T-shirt. *The basic steps are as follows:*
♦ Set up a grid to use in drawing a T-shirt to scale using actual garment measurements.
♦ Create a Rectangle as your starting point.
♦ Insert key anchor points as garment points for the T-shirt using the grid as a counting/measuring device.
♦ Edit the points as necessary to achieve the right combination of straight and curved lines.
Note: This drawing is done on a single layer, so multiple layers will not be used.

Note: Drawing Approach
The approach taken here to draw the T-shirt body is similar to pattern drafting.

T-Shirt Dimensions
The diagram to the right lays out a drawing with dimensions that are to be used in this exercise. These dimensions represent the actual scale of a T-shirt, approximately medium size.

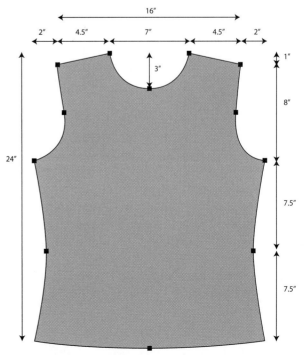

Step-by-Step
Setting up

1. Ensure that your Preferences Units are set to **Inches**. Choose the *Illustrator>Preferences>Units and Display Performance* (Mac) / *Edit>Preferences>Units and Display Performance* (Windows) menu command. Set the General option to *Inches* by clicking on the pop-up arrow and selecting *Inches* from the list. Leave the Stroke and Type options set at *Points*.

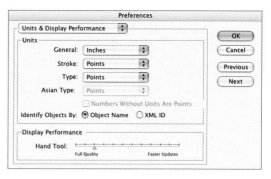

Steps 1 and 2: Setting Preferences for the Units and Grid.

2. Click on the *Preferences* pop-up menu in the upper left corner of the window and slide down to the *Guides & Grid* option. The options in the window will change. Set Gridline every to be *1 inch* and Subdivisions to be *4* (the default is 8, so you must change it). Use gray as your grid color. Click **OK** to set both of these preferences.

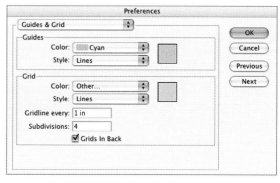

3. Create a new file using the *File>New* menu command. In the dialog that opens, type *Basic T-Shirt* as the file name, and set the Size to *Letter* and the Orientation to *Portrait*. You may choose RGB or CMYK as your color mode. Click **OK** and the document will appear on the screen.

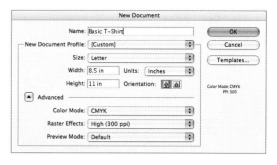

4. Immediately save the file. Choose the *File>Save As* menu, and maneuver your way to a location where you want to save the file. Click **Save**.

5. Ensure that the Toolbox and the following panels are open: *Colors, Swatches, Stroke, Appearance, Layers*. If they are not, open them using the **Window** menu.

6. Display the grid by choosing the *View>Show Grid* menu command. Each small grid square will equal one inch of the garment.

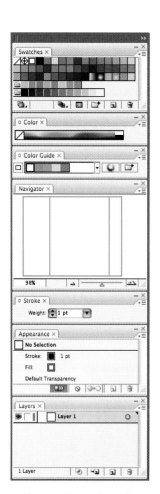

Commonly used panels

Note:

Grid Scale

In this exercise, each square of the grid equals 1" of the garment.

Creating the Rectangle and Setting Key Points

1. In the Toolbox, set the *fill* color to None and choose black for your *stroke* color.

Step 1: Setting a fill of None and a black stroke.

2. Select the **Rectangle** tool in the Toolbox, and then click once in the middle of the screen. A dialog will open. Set the width to 5 inches (20 inches of garment divided by 4 squares per inch, our scale) and the height to 6 inches (24 inches of garment length divided by 4). Click on **OK**. A rectangle will appear on the screen. Note that there is a center mark inside the rectangle.

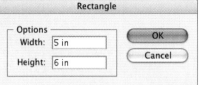

Step 2: Creating the rectangle.

3. Using the **Selection** tool, click on the center mark of the rectangle and reposition it so that the upper edge of the rectangle is on a grid line, and the center of the rectangle is centered on a major (heavier) grid line on the screen.

The rectangle is created and positioned on the gridded document so that the edges of the rectangle are directly on top of grid lines. This will facilitate counting units later.

Inserting Anchor Points to Mark Garment Key Points

Refer to the diagram/schematic on page 203 for measurements used throughout this exercise. You will use these measurements when inserting points on the rectangle.

1. Tear off the *Pen Tools* toolbar. Click and hold on the **Pen** tool in the Toolbox, and drag and move over to the right until you reach the *tearoff strip*. With your cursor positioned above the tearoff strip, continue to drag and the tools toolbar will tear off. Release the mouse button.

The tearoff strip of the Pen tools

2. Choose the **Add Anchor Point** tool. When you use this tool, make sure you click directly above and on the line where you want to insert the point.

The Add Anchor Point tool

Note: Refer to the illustration on page 203 as you perform steps 3 through 8 below.

3. *Insert Center Points:* Insert a point at the center top and center bottom of the rectangle. These represent the center front points of the T-shirt.

4. *Insert Neckline Points*: Insert a point 3.5 inches on either side of center front.

5. If you like, turn on *Grid Snap* now, as you will be working in even inches for the next few steps. Choose the *View>Snap to Grid* menu

 Grid Snap
One can use Grid Snap (turned on using the View>Snap to Grid menu) to easily move points full inch amounts. Grid Snap ensures that the anchor points snap to the intersection of grid lines. You must remember to turn this function off if you want to move a point between grid lines (as in the case of the mid-armhole point and the center hem point).

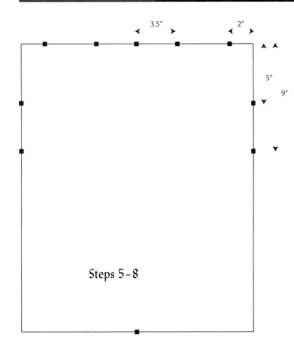

Steps 5-8

command. A check mark will appear beside *Snap to Grid,* which indicates the function is on. Now, when you place points, they will easily snap into place on the intersections of the grid lines.

Hide Grid	⌘"
✓ Snap to Grid	⇧⌘"
✓ Snap to Point	⌥⌘"

6. *Insert Shoulder/Armhole Points*: Insert points 2 inches in from each of the outer top corners. These represent the armhole inset of the T-shirt.

7. *Insert Lower Armhole Points*: Insert points on both of the side seams, 9 inches down from the top corners.

8. *Insert Mid-Armhole Points:* Insert points on both of the side seams, 5 inches down from the top corners.

Delete Anchor Point tool

Removing Unneeded Points

1. Now, change to the **Delete Anchor Point** tool.

2. Remove the outer top corner point on each side of the T-shirt. The armhole will angle inward from the mid-armhole point.

Moving Points to Proper Positions

1. Choose the **Direct Selection** tool.

Step 2: Removing Unneeded Points: right side complete, left side still to be performed.

Direct Selection tool

2. To create a rounded neckline, lower the center front neck by clicking on the center front point and dragging it down 3 inches.

3. Create the shoulder slope by clicking on each shoulder/armhole point, and moving each down 1 inch.

4. Create a graceful fitted armhole by clicking on the mid-armhole point and moving it 2-1/2" inward. (You will need to turn Grid Snap **off,** as it is currently on, and you want to use 1/2" increment movements.)

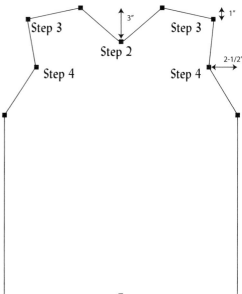

Exercise #3: Adding Sleeves and a Neckband to an Existing Garment Body

Goal
To add sleeves to the T-shirt body created in Exercise #2, utilizing the existing armhole.

Illustrator Tools and Functions
♦ **Scale** tool
♦ **Selection** and **Direct Selection** tools
♦ **Scissor** tool
♦ **Reflect** tool
♦ **Eyedropper** tool
♦ *Color* panel

Quick Overview of the Process
In this exercise you will use the body of the T-shirt created in the last exercise and "borrow" the armhole to begin building a sleeve. Initially you will need to scale the T-shirt down so that the final garment with sleeves can easily fit on the page. Once the first sleeve is drawn you will *copy+reflect* it to create the second sleeve. You will then change the fill colors of the body and sleeves and add a neckband

To summarize, the steps are as follows:
♦ Scale the T-shirt body down so the garment with sleeves will fit on the document.
♦ Select, then copy the armhole to the clipboard and paste it back in.
♦ Remove unwanted segments from the new object.
♦ Build the sleeve using the body armhole as the starting segment.
♦ Change the color *fill* of the body and the sleeves of the T-shirt.
♦ Create the second sleeve using the **Reflect** tool.
♦ Create a neckband.

Step-by-Step
Scaling the T-Shirt
The T-shirt created in Exercise #2 is rather large, so it will be necessary to scale it to 50% to create space on the page to build the sleeves. When an object is resized the grid does not scale with it. Thus, once the garment is resized to 50%, the new scale of the garment-to-grid is two inches per grid square.

1. If you closed the file last exercise, open it now.

2. Using the **Selection** tool, select the T-shirt body. If you did not create a fill on the object, you will need to click on a path (outer line of the shirt) to select it, OR, using the **Selection** tool, drag a box around the body. The entire object will become selected.

3. Double-click on the **Scale** tool. A dialog window will open.

4. In the *Uniform* portion of the dialog, type *50* into the *Scale* box. If you like, click on the *Preview* check box to preview the results. Click **OK**. Your T-shirt will scale to half its size.

The Selection tool (above) and the Scale tool (below)

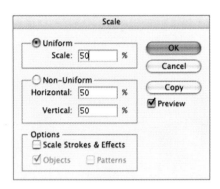

Step 3: The Scale dialog is used to scale the garment uniformly.

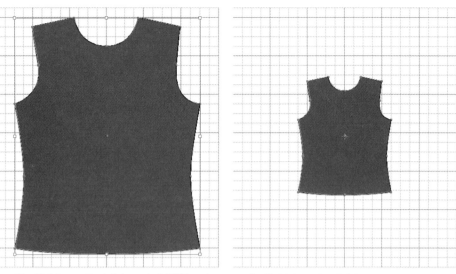

The T-shirt on the left is scaled 50% to become the T-shirt on the right.

The Direct Selection tool, used to select specific points and segments of an object

The Selection tool, used to select an entire object

Copying the Armhole

1. Using the **Direct Selection** tool, drag a box around the armhole of the right side of the T-shirt (you will actually include part of the shoulder seam and underarm seam). You will see that all the lines of the armhole plus the shoulder and upper side seam become selected.

2. Choose the *Edit>Copy* menu. Then choose *Edit>Paste*. You will see an object containing the armhole, shoulder, and side seams appear.

3. Using the **Selection** tool, move the new object off to one side. Click on the object so all points are displayed.

Note: If you selected only the segments of the armhole and no part of the shoulder seam, you would get the selection shown in the illustration to the right, which would save steps in this exercise. However, we will proceed with the first selection option so that you may learn how to work with the **Scissors** tool.

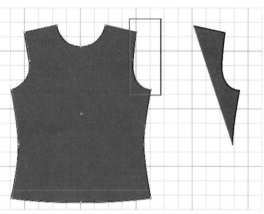

Steps 1–3: In the example above, the entire armhole was selected (as indicated by the box, used here for illustrative purposes only). In the example below, only the two segments of the armhole were selected (achieved by selecting the center area of the armhole). The resulting copied armhole contains only armhole segments.

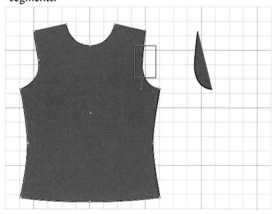

Removing Unwanted Segments

1. Choose the **Scissors** tool in the Toolbox.

2. Working with the copy of your armhole, click on the shoulder/armhole point and on the underarm point. This will break the original object into three separate objects (which is the function of the Scissors). You can confirm that you have three separate objects by selecting them with the **Selection** tool in the next step.

3. Using the **Selection** tool, click on the shoulder seam and confirm that it is the only object selected. Press the *delete/backspace* key (Mac/Windows) on the keyboard. Click on the side seam and press *delete/backspace* on the keyboard. You now have a copy of the armhole.

The Scissors tool is used to break objects into multiple objects, at the anchor points clicked on by the tool.

The Selection tool

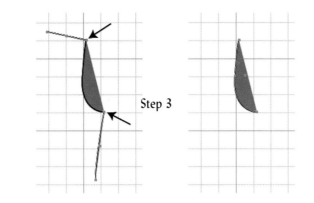

Steps 2–3: Using the Scissors tool, click on the upper and lower armhole points. This will break the object at these points, resulting in three separate objects. Using the Selection tool, click on the shoulder seam and the armhole seam and delete these segments by pressing the delete key (Mac) or the backspace key (Windows).

Adding to the Armhole to Build the Sleeve

1. Using the **Selection** tool, move the armhole close to the armhole of the garment. Leave this object selected so you can see the points.

2. Choose the **Pen** tool, and move your cursor directly on top of the shoulder point of the sleeve's armhole. The pen cursor should have a diagonal slash beside it. Click and release to establish that you are continuing the object. Using the shoulder line of the T-shirt as a slope guide, move the cursor and click at what will be the upper-wrist point of the sleeve. This line should follow the angle of the shoulder seam. You can "eye" the length of the upper sleeve line or visually measure it to be equal to approximately 23 inches in length (or a little over 11 squares using the grid). Click to set the point.

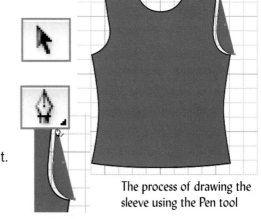

The process of drawing the sleeve using the Pen tool

Step 2

3. Move the cursor to establish the lower wrist point of the sleeve. Click to establish the point. On the actual T-shirt, the wrist opening would be 8" (and therefore 4" when folded

in half). Since we scaled our garment to 50%, each grid square now represents two inches, so move this point perpendicular to the upper line of the sleeve until it is about two grid squares in length.

4. Move the cursor to the underarm of the sleeve curve. You will see that the little circle appears by the pen cursor to let you know you are about to complete the object. Click to finish the object.

Completing the sleeve. Note the small circle that appears beside the Pen tool when you are directly above the starting anchor point (left). This indicates that you are about to close the object as you click the mouse.

Step 4

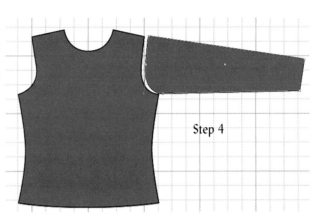

Step 4

Adding or Changing a Colored Fill to the T-Shirt and Sleeve.

1. If your *Color* panel is not open, choose the *Window>Color* menu.

2. Using the **Selection** tool, click inside the T-shirt (if there is an existing fill) or on the outer edge of the T-shirt (if there is no fill). This will select the object.

The original fill color and the new body and sleeve fills

3. Click once on the *Fill* icon in the Toolbox to select it, which will bring it forward if it was behind the *Stroke* icon.

4. Go over to the *Color* panel and *click+hold+drag* your cursor around on the colored strip bar until you find a color that you like. Note that the cursor changes to an Eyedropper and the color in the *Fill* icon in the Toolbox changes to represent the color under the cursor as you drag around. When you find a color you like, release the mouse button and your *Fill* icon and T-shirt will now change colors.

5. Using the **Selection** tool, click on the sleeve (or the outer edge of the sleeve if you have no fill).

6. Since the *Fill* icon is still selected, move your cursor over to the *Color* panel and click on a different color to use for your sleeve.

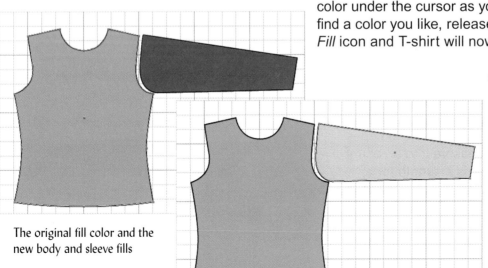

The original fill color and the new body and sleeve fills

Testing the Sleeve Length

At this point in time, you might want to test that the sleeve length is accurate and in proportion to the body of the garment. One way to do this is to temporarily rotate the sleeve, extending it downward, and then look at it in relation to the body.

The Selection tool

1. Using the **Selection** tool, click on the sleeve to select it.

2. Click once on the **Rotate** tool. Note that the cursor changes to a crosshair.

The Rotate tool

3. Move your cursor over to the sleeve and click on the upper sleeve anchor point to set this point as the pivot point. Note that the anchor point now has a circle icon above it, which indicates that it is the pivot point.

4. Click anywhere on the screen and drag your mouse down. The sleeve will begin to rotate. Continue the movement until the sleeve is vertical. Release your mouse button. Examine the length and determine if it is appropriate. Once you have made this determination, undo the rotation action by choosing the *Edit>Undo* menu (or pressing *Cmd/Ctrl+Z* on the keyboard).

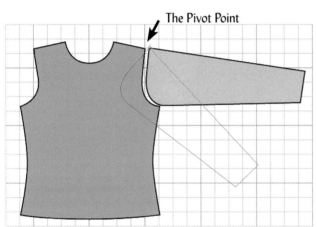

The Pivot Point

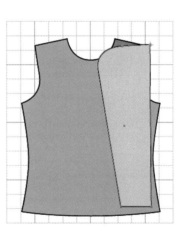

Steps 2-4

5. If necessary, use your **Direct Selection** tool, click on the hem of the sleeve, and adjust the length by moving inward or outward. Repeat the rotation test if you want to check the length again.

6. Once the sleeve is back in its original position, use the **Selection** tool and nudge it into the armhole using the *arrow keys* on the keyboard.

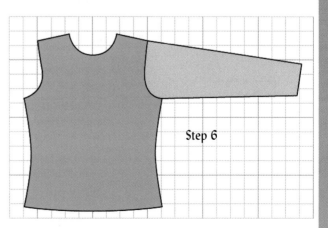

Step 6

Creating the Second Sleeve

If your **Reflect** tool is not visible, you can either click and hold on the **Rotate** tool to access and drag over to it, or you can tear both tools off the Toolbox. To do this, *click+hold* on the **Rotate** tool. You will see the **Reflect** tool appear. Drag your mouse over to the vertical Tearoff bar

Tearing off the Rotate and
Reflect tools

The Reflect tool

Step 2: Using the Copy button to
copy and reflect an object in one
step.

Note:

Reflection
Alternative
 Alternatively, you could
choose to copy and paste the
sleeve and then reflect it.

on the right. Release the mouse when you get there. The panel will tear off. Click on the title bar of the panel to drag it to a good position for working.

1. Using the **Selection** tool, click on the sleeve. Since there is a fill now, you can click anywhere inside the sleeve.

2. With the sleeve still selected, double-click on the **Reflect** tool to open the Reflect dialog. Ensure that *Vertical* is selected, and click on Copy. This will make a second copy of the sleeve in a reflected manner.

3. Using the **Selection** tool, position the sleeve on the garment. Save the file to update it.

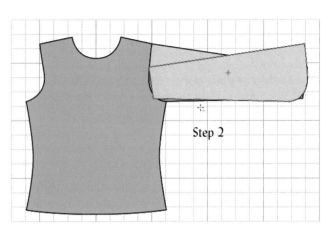

Step 2

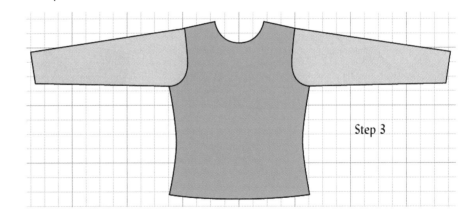

Step 3

Drawing the Front Neckband

You can build a neckband for the T-shirt utilizing the original neckline as your starting point. *The steps are as follows:*

The Direct Selection tool

Using Copy and Paste clipboard functions

1. Using the **Direct Selection** tool, click on the left neckline curve. Hold the *Shift* key and click on the right neckline curve. This will select both sides of the curve but not the anchor points. Alternatively, you may simply click on the center neck anchor point (which selects only the segments, and the fill will be slightly different).

2. Use the *Copy* and *Paste* menu functions to create a duplicate of the neckline (*Edit>Copy* and *Edit>Paste*). Note that when you paste in your neckline you do not get any part of the shoulder seams. This is because you only

Steps 1–2: Selecting the neck objects (above) and using the clipboard to create a copy.

selected the neck curve segments and not the shoulder anchor points. Had you selected the entire neckline by dragging your mouse around it and selected both curves and all anchor points, you would have included the shoulder seams in the selection. Thus, the importance of understanding how making proper selections can save time in design. Use the **Selection** tool to drag the neckline copy above the body of the garment.

Step 3

3. Choose the **Pen** tool. Move your cursor over the anchor point on the right side of the new neckline curve. Note how the cursor now has a slash line (/) to the right of it, which indicates that you are directly above an anchor point and ready to join an existing path. Click and you will join onto the path of the neckline curve.

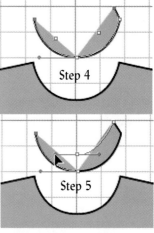
Step 4

4. Move the pen cursor up and to the left slightly, positioning it where the upper height of the right band would be. Click to set the new anchor point.

Step 5

5. Move the pen cursor to the center, just above the center neck point, and *click+hold* to set the upper center neckband point. *Drag* the mouse directly to the left (horizontally) to establish the curve (achieved through the dragging process). Release the mouse.

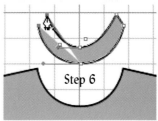

6. Move the pen cursor up and over to the left and set the left upper neckband point by clicking and releasing the mouse.

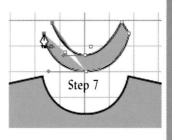
Step 6

7. You are ready to close the neckband object. Move the cursor over the left neckband curve. When you are directly above the anchor point you will see a hollow square appear by the pen cursor. This indicates that you are above the beginning point of the path. Click with the mouse to close the object.

8. If you like, change the fill color of the neckband by selecting it with the **Selection** tool and changing the *Fill* icon in the Toolbox using the *Color* panel (as discussed in the previous section of this exercise).

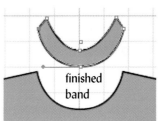
Step 7

9. Use the **Selection** tool to move the neckband down on top of the T-shirt neckline.

finished band

The front neckband is complete.

Drawing the Back Neckline

Add accuracy and finesse to your drawing by including the back neckband and an inside view of the back T-shirt itself.

Step 2

Step 3

The steps are as follows:

1. Using the **Selection** tool, select the front neckband as the active object. This will set the proper *fill* and *stroke* in the Toolbox. Press and hold the *Cmd/Ctrl* key and click away to deselect the neckband. The stroke and fill colors will remain ready for use with the next object.

2. Choose the **Rectangle** shape tool in the Toolbox. Move your cursor over to the T-shirt and draw a rectangle on top of the neckband, matching the upper corners of the rectangle over the upper corners of the front band. Leave the object selected.

3. Now choose the *Object>Arrange>Send to Back* menu command. This will send the rectangle to the back of the stacking order of objects and thus behind the front T-shirt and band.

4. To create the back body of the T-shirt, it is only necessary to draw a small rectangle. To select the T-shirt body color, use the **Selection** tool and click on the T-shirt body. The proper colors will appear in the *Stroke* and *Fill* icons in the panel. Click away to deselect the T-shirt.

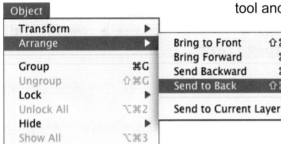

5. Choose the **Rectangle** tool once again, and draw a rectangle that overlaps the back and front neckbands. It will sit on top of all other objects as it was the most recently drawn object.

Step 5

6. While the new rectangle is still active, choose the *Object>Arrange>Send to Back* menu command. This will send the new rectangle behind all other objects. *Cmd/Ctrl+click away* to deselect the object.

Adding the Final Finesse

The final touch for the T-shirt will be to deepen the values of the color fill of the back neckband and T-shirt. This will add an illusion of depth to the garment.

1. Using the **Selection** tool, select the back neckband. The neckband's *fill* and *stroke* color will appear in the Toolbox.

Step 6

2. Double-click on the *Fill* icon to open the *Color Picker*. A circle in the color area indicates where the fill color is in the spectrum. Move this circle down to lower the value of the color somewhat. Click **OK** when you find the right color. The back neckband will appear deeper in color.

Using the Color Picker to select a lower value of the original color

3. Repeat for the back T-shirt body rectangle.

4. Save the file to update it.

This completes the T-shirt exercises.

Steps 2 and 3

Exercise #4: Drawing Symmetrical Garments Using Guidelines, Grid, and the Reflect Tool

Goal

In this exercise, a half garment created as an open path will be built. It will then be copied and reflected to create the opposite side of the garment. The two open-object pieces will then be joined, resulting in a closed single object. This method of drawing ensures perfectly symmetrical garments. Illustrator's built-in Rulers and Guides will be utilized.

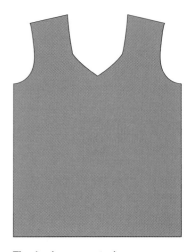

The final symmetrical garment

Illustrator Tools and Functions

- ◆ Rulers and Guides
- ◆ Grid (optional)
- ◆ Various **Pen** tools
- ◆ Various **Selection** tools
- ◆ **Reflect** tool
- ◆ *Average* and *Join* menu commands

Note: A single layer is used in this exercise.

Quick Overview of the Process

In this exercise you will:

- ◆ Set up rulers and create a vertical center guideline.
- ◆ Draw a half garment using the various Pen tools.
- ◆ Copy/Reflect the half garment to create the alternate side.
- ◆ Use the *Average* and *Join* menu commands to join the two open objects into one closed object.

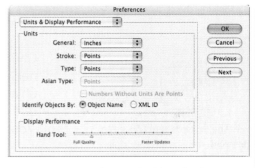

Setting the Units Preferences

Step-by-Step

Setting up

1. Ensure that your Preferences Units are set to **Inches**. Choose the *Illustrator>Preferences>Units and Display Performance* (Mac) / *Edit>Preferences>Units and Display Performance* (Windows) menu command and choose *Inches* for the setting of General. Click **OK**.

2. Create a new file, naming it **SymGarment,** and save it (per previous exercises). Turn on rulers (*View>Show Rulers*).

3. Create a guideline by *clicking+holding* on the vertical ruler on the left side of the document and dragging your cursor to the center of the screen. A guideline will follow your cursor. Position the guide around the 4" mark of your document.

A Guideline is dragged off of the vertical ruler and positioned in the center of the document.

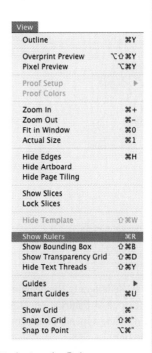

Displaying the Rulers

4. Ensure that the guidelines are unlocked (which means you can move them if you want). Go to the *View>Guides>Lock Guides* command and if it is checked, highlight it again to uncheck the command (and therefore unlock the guide).

Drawing the Half Garment

1. Set the *fill* to None and choose black as a *stroke* color. Set the stroke *Weight* to 1 point.

Step 1: Setting the fill and stroke options.

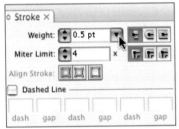

Step 2: Setting the stroke weight.

2. Using the **Pen** tools, create a right half garment, using the vertical guideline as your vertical center line. If you like, you may follow the steps and proportions of drawing the basic T-shirt in Exercise 2.

Alternatively . . .

1. Load the T-shirt you built in Exercise #2. For simplicity, remove all objects except the body, and remove the *fill* color by changing the *fill* to *None*.

2. If you completed the full garment, use the **Selection** tool to select the garment so you can see all the anchor points. You will need to click on the black outline of the garment (as there is no fill).

Step 3: The Scissors tool is used to break a path/object into multiple paths/objects.

3. Choose the **Scissors** tool and click on the center point at the neckline and lower hem of the T-shirt. This will break the single closed object into two open paths/objects. One side of the T-shirt will remain selected (the left side in the example here).

4. Choose the **Selection** tool and click on the outline of the left half of the T-shirt. Press the *Delete/Backspace* key (Mac/Windows) on the keyboard to remove this side of the T-shirt.

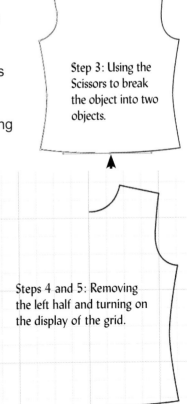

Step 3: Using the Scissors to break the object into two objects.

5. Turn on the display of the grid by choosing the *View>Show Grid* menu command. Ensure that the center of the garment sits on top of a grid line.

Step 6: Redesigning the neckline of the original T-shirt style. The new neckline appears on the image to the right.

6. Change the neckline slightly. In the example to the left, the neckline of the image on the right side was created by lowering the center front of the original neckline, adding a point in the center of the curve, and reshaping the entire neckline. Use the **Selection** tool and the **Add Anchor Point** tool to achieve this.

Steps 4 and 5: Removing the left half and turning on the display of the grid.

Creating the Second Side of the Garment

1. Using the **Selection** tool, click on the right side of the garment to select it. Click on the outline of the garment, as it is not filled.

The Selection tool

2. Double-click on the **Reflect** tool (which is often stacked beneath the **Rotate** tool in the toolbox). A dialog will open.

3. Click on the *Vertical* radio button (which indicates you want to reflect the object on the vertical axis), and then click on the **Copy** button (which indicates you want to flip a copy of the original and thus keep the original). A second object in a mirrored position will appear on your document.

The Reflect tool (above) and the Reflect dialog (below)

4. Using the **Selection** tool, click on the center front neckline point of the new piece, and drag the piece to the left until your cursor and the center front anchor point of the left front are superimposed on the center point of the right front. You can tell when they are precisely superimposed, as the selection cursor turns white.

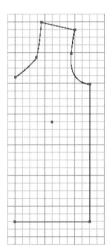 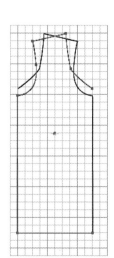 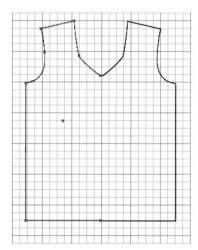

Steps 1–4: The right side of the garment (left) is selected and copy+reflected using the Reflect dialog. A new left side appears directly on top of the right side (center) and is selected. Using the Direct Selection tool, click on the center point of the object and drag it to the left, aligning the center neck and center bottom points (right).

Joining the Left and Right Front Pieces

At this point, the two open objects are ready to be joined. There are two menu commands that facilitate this process: *Average* and *Join*, found in the *Object>Path* menu. You do not always need to use the *Average* function, but you do need to use *Join*. Average is sometimes necessary to get the two points you are trying to join directly on top of each other (or close to it). There are times when Illustrator seems to argue with you about joining, and will give you warning messages concerning the need to select endpoints of two objects. Sometimes it is helpful to move the two objects you are trying

to join slightly away from each other so you can see the points you are selecting and understand what is going on. Refer to pages 88–89 in Chapter 4 for the discussion on *Average* and *Join* and when to use both.

In the following steps *Average* will be included in the process, although your drawing may not necessarily require that it be used (depending on the positions of the two anchor points you are trying to join).

The Average (above) and Join (below) menus

1. Using the **Direct Selection** tool, drag a selection box around the two center neck points, or zoom in and *Shift+click* on the two pertinent points. If your points are laying directly one on top of the other, it is a bit harder to see if you are aligned properly, as one point is laying directly on top of the second point.

2. Choose the *Object>Path>Average* command. When the dialog opens, choose the *Both* radio button and click **OK**. The two selected anchor points will average both horizontally and vertically and will now be superimposed. The points will be selected and you will want to leave them selected for the next step, so do not click away.

3. Now choose the *Object>Path>Join* menu command. A dialog will open. Given the neckline style, you will want to choose the *Corner* radio button, as the two lines meet at an angle and do not curve. Click **OK**. The two points will now become one.

4. Repeat steps 1 through 3 at the center hem of the garment. Again, if it is helpful, use the **Direct Selection** tool and move the points just slightly back from each other so that you may see them easily.

5. Choose the **Selection** tool and select the top. Change the fill color to a color of your choice.

6. Save the file.

You now have a closed object of a perfectly symmetrical garment.

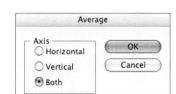

The Average and Join dialogs

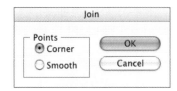

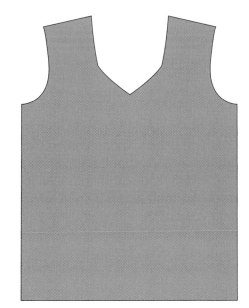

Exercise #5: Drawing Flats on a Basic Croquis

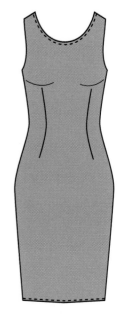

Goal

In this exercise a garment flat will be created using an eight-head croquis as a template/guide for body proportions.

Illustrator Tools and Functions

- Various **Pen** tools, (e.g., Pen, Add Anchor Point, Delete Anchor Point, Convert Anchor Point)
- Layers, including a *Template* layer
- **Reflect** tool
- *Average* and *Join* menu commands
- Dashed Stroke

The finished flat of a basic fitted dress

Quick Overview of the Process

You will begin by using the **Pen** tool to quickly place and set the key points of your garment, building a half garment. Then, using the various editing tools, you will tweak the curves and lines of the drawing to improve the shape and proportions. Finally, you will copy and flip the half drawing and join the two pieces. *To summarize the steps:*

- Load a file of an eight-head croquis.
- Set up layers.
- Use the **Pen** tool to set anchor points for various key points of the garment, building a half garment.
- Edit the points as necessary to achieve the right combination of straight and curved lines.
- Select the half garment and reflect copy it.
- Join the two sides.
- Add detailing such as top-stitching, etc.

Step-by-Step

Setting up

1. Load the Eight Head Croquis file using the *File>Open* menu. The file is called **8headcroquistempl.ai** and can be found in the *Croquis* folder, which sits inside the *Fashion Exercises* folder on the accompanying DVD.

2. Immediately save the file with a new name, e.g., **dress1**. Make sure that you save the file to a folder on your hard drive (as opposed to attempting to save it to the DVD, which is not possible).

3. Notice that all the paths on the drawing are gray, and that the croquis and guideline layers are locked. These have been set up as template layers, which will not print nor export. Observe the *template icon* beside these layers in the *Layers* panel.

4. Create a new layer using the *New Layer* menu option of the *Layers* panel. This is accessed by clicking on the panel menu button (the half triangle in the upper right corner of the *Layers*

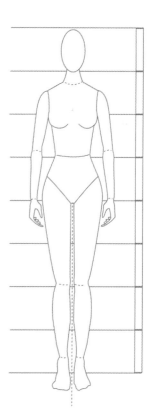

8headcroquistempl.ai

The template icon indicates that a layer cannot be drawn on nor printed.

Step 4: Creating a new layer from the Layers panel.

Center Guide

If you like, you can drag a vertical guide from the Ruler and position it in the center of the body to aid your drawing.

The Pen tool

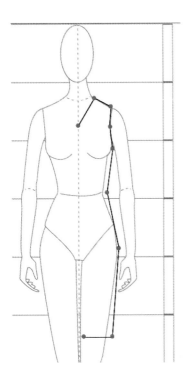

Step 3: Setting Corner anchor points around the perimeter of the garment.

panel). Name this layer *dress* and choose a selection color of *Green*. Click **OK**. The layer will appear in your panel.

5. Click on the *dress* layer to make it the active layer, in anticipation of drawing.

Step 4 (above): Setting up the layer. Step 5 (below): Selecting the dress layer as the active layer.

Garment Analysis

Analyze the garment you want to draw if you are using a fashion illustration, photograph, or actual garment. Determine where the various garment key points fall.

- Look at how deep the neckline is in relation to the chest height and Adam's apple of the person's neck.
- Look at where the armholes sit in relation to the person's arm joint.
- Look at the length of the garment in relation to the person's knee.
- Analyze the width of the garment at various points, as it would lay flat. This analysis should consider the ease factors of the garment, both functional and style-wise.

Building the Basic Outline of the Half Dress

1. Choose a black *stroke* of 1, and no *fill*.

2. Click on the **Pen** tool.

3. Beginning at the center of the garment, draw a half garment. Start at the neck, setting *corner anchor points* and straight lines only. You will curve the segments later. At the moment, you are defining and placing the key points of the garment and pattern. Using the illustration to the left as a guide, click and release the mouse to place points in the following places:

Step 1: Setting the fill and stroke for drawing.

- Center front neck
- Shoulder/neckline
- Shoulder/armhole
- Mid-armhole (upper chest width)
- Underarm (placed somewhat lower than the body's armhole)
- Waist point (including ease)
- Hip point (including some ease)
- Side Hem point
- Center Front Hem point (ideally place this point just slightly lower than the side seam point of the hem)

The illustration to the left shows you where all the anchor points have been placed. These are shown in red. Straight segments exist between all the anchor points.

4. Choose the **Convert Anchor Point** tool and convert the following *corner* points to *smooth* points by clicking and dragging on the appropriate points:

- Center front (drag straight to the right)
- Mid-armhole (drag down following the angle of the upper armhole)
- Waist (drag straight down)
- Hip (drag down following the angle of the side seam)
- Center Hem (drag straight to the left)

Convert Anchor Point tool

Step 4: Converting Corner points into Smooth points.

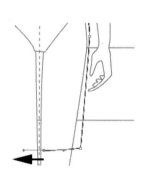

Using the Convert Anchor Point tool, click and drag on the various corner points to turn them into smooth or combination points. The arrows above indicate which direction to drag your mouse.

5. Using the **Convert Anchor Point** tool and the **Direct Selection** tool, correct any shapes/points that need to be altered. You may need to nudge points up or down, left or right, or you may need to alter the length of the direction lines created to make your adjustments.

6. Add a fill to the open path drawing. Do this by clicking on the outline of the dress object with the **Selection** tool, and then double-clicking on the *Fill* icon in the Toolbox. When the *Color Picker* opens, choose a color to use in your fill.

Reflecting and Joining the Half Garments

1. With the Selection tool still active, click on the half dress. Since the object has a fill, you can click anywhere inside the object.

2. Double-click on the **Reflect** tool in the Toolbox. The Reflect dialog window will open.

Step 6: Adding a colored fill to the dress object.

The Reflect tool

3. Click on the *Vertical* radio button. Click on the **Copy** button. The right dress will copy and flip.

4. Using your **Selection** tool, drag the left dress to its position, aligning the center front points of the neckline. Pressing and holding the *Shift* key as you drag will allow you to move the half dress more accurately.

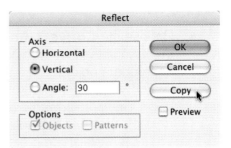

Step 3: Setting up to perform a copy+reflect of the half garment.

Joining the Pieces

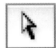

The Direct Selection tool

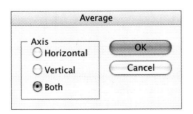

Average both the horizontal and vertical axes in the Average dialog.

1. Click on the **Direct Selection** tool.

2. *Drag+select* over the center front neckline points of both the left and right pieces. This is most easily achieved by dragging a box around the points.

3. Choose the *Object>Paths>Average* menu. When the window opens, choose the *Both* option, then click **OK**. The two center front points will average their position on both the horizontal and vertical axes and will lay directly one on top of the other.

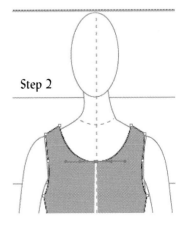

Step 2

4. Choose the *Object>Path>Join* menu. If the Join dialog opens, choose the *Smooth* option and click **OK**. This will create direction lines extending from the center front point and thus give you control over the curves on each side of the center.

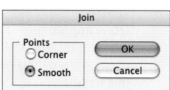

5. Repeat the *Average* and *Join* process on the two center points at the hem of the garment. The illustration to the right shows the joined dress.

Step 4: Joining the points using the Smooth option.

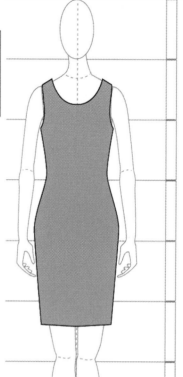

Adding Design Details (bust curve and body dart)

1. Create a new layer called *details*. Ensure that this layer sits on top of all the other layers. Click on the layer to make it active.

2. Choose the **Selection** tool.

3. Click on the dress to select it. This jumps you to the *dress* layer. Set the *fill* to *None* so that you can see through the dress to the body.

Step 4: Selecting the details layer.

After the Join has taken place at the center front neck and hem

4. Click on the *details* layer to select it.

5. Choose the **Pen** tool. Set the *stroke Weight* to .5 in the *Stroke* panel as this is to be a subtle detail (*Window>Stroke*).

6. If the dress is selected, deselect it by *clicking away*. Add the shape of the bust curve by drawing a curved line over the curve of the bust (or slightly lower). You will need to click away to complete one object before you draw the next.

7. Change the *stroke Weight* to 1 point as the dart detail is more important.

8. Using your **Pen** tool, draw a body dart extending from just beneath the bust apex through the waist and into the upper hip area.

Note: You could have added these details prior to reflecting the garment. Sometimes, however, it is nice to allow for some asymmetry.

Adding Top-Stitching
Top stitching may be added at any point in time, but if it appears symmetrically, it is best to add it prior to reflecting the garment.

1. Continue on the *details* layer.

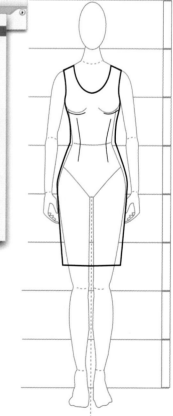

Steps 6-8: The bust curve and body darts are drawn on the details layer.

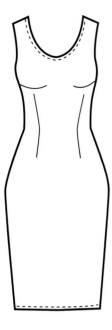

The final dress

2. Ensure that the **Pen** tool is still active and that you have a black *stroke* of 1 and no *fill*.

3. Draw appropriate segments where the top-stitching should occur on the garment (e.g., the hem and neckline in this case).

Step 4: Setting the Dashed Line option.

4. Choose the Selection tool, and using the *Shift+click* process, select all the segments that are to be used as top-stitching. In the *Stroke* panel, check the **Dashed Line** check box, and set the first *dash* and *gap* to 3. All the segments will now become dashed lines.

Tips on Adding Top-Stitching

If you use the **Direct Selection** tool to select the part of the garment you want to top-stitch, you can copy and paste the line to the *details* layer and apply the dashed line to the new line. The best way to select only the lines you need is to select the inner points of the line, but not the end points. Use the *copy* and *paste* functions (of the **Edit** menu) to create a duplicate. Then, click on the Dashed Line option of the *Stroke* panel. Position the line on your garment and adjust endpoints as necessary.

The neckline (left) and hem (right) are copied and pasted into the document. The Dashed Line option in the Stroke panel is then turned on. The new top-stitching lines are then moved into position and the endpoints of the segments are adjusted accordingly.

The upper bodice of the dress is selected, then copied and pasted into the dress layer of the document. The value of the dress color is lowered, and then the center points of the piece are nudged upwards. The piece is then positioned directly above the front dress and sent to the back using the Object>Arrange>Send to Back menu.

Tips on Adding the Back of the Garment

Use the **Direct Selection** tool to select the front neckline and shoulder seams of the garment (and include the top-stitching to save time). Use the *copy* and *paste* functions of the **Edit** menu to create a duplicate. Make sure you paste onto the *dress* layer. Change the *fill* color to a deeper value. Use the **Direct Selection** tool to raise the center neckline point of both the garment and the top-stitching. Choose the **Selection** tool and drag the back piece directly over the dress. Align all points. Choose the *Object>Arrange>Send to Back* menu command to position the back garment behind the front.

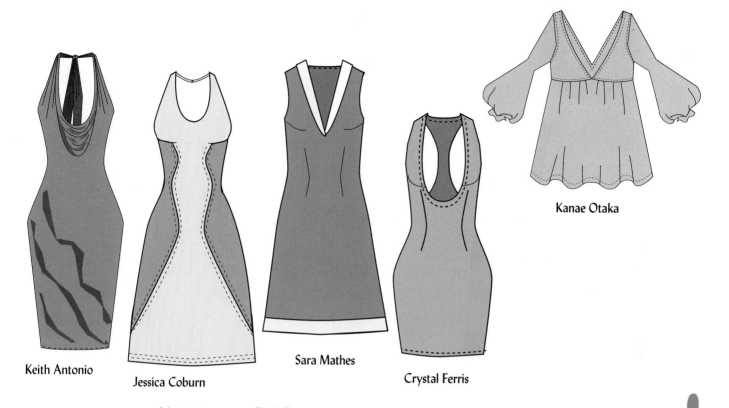

Keith Antonio

Jessica Coburn

Sara Mathes

Crystal Ferris

Kanae Otaka

Variations on a Shift Dress

Student Gallery: Fashion Flats
Mesa College Fashion Students

Sammy Song

Megumi Inoue

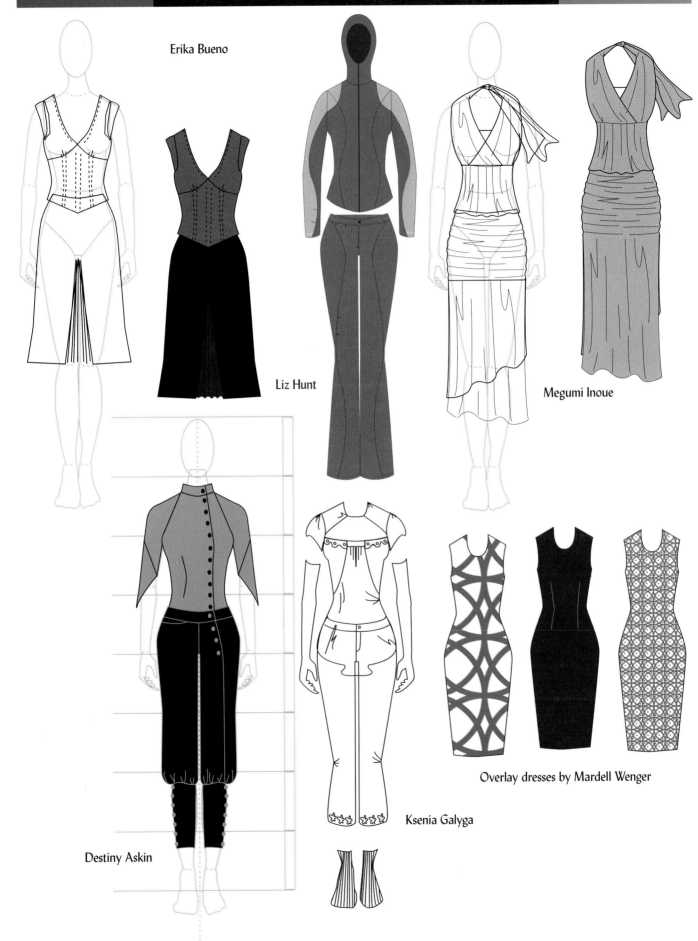

Erika Bueno

Liz Hunt

Megumi Inoue

Destiny Askin

Ksenia Galyga

Overlay dresses by Mardell Wenger

Exercise #6: Working with the SnapFashun Library of Flats

SnapFashun is a library of fashion drawings of clothing flats available in Illustrator format. It is developed for the apparel industry, designers, and educational institutions by Bill Glazer Associates in Los Angeles (www. snapfashun.com). Libraries are available for Womenswear, Menswear, Historical Garments, as well as Store Fixtures.

If you do not own **SnapFashun** you will not be able to complete this exercise. However, it would be advisable to read through the pages here to see how the library works and how one can use it to facilitate the drawing of fashion designs.

Once SnapFashun is installed on your computer, you will have an additional menu item in the **Window** menu called *Show Snapfashun Library*. Use this menu to access the libraries.

A SnapFashun garment

Goal
To utilize the SnapFashun library of clothing illustrations and to understand how this tool can facilitate fashion design.

Illustrator Tools and Functions
♦ *Window>Show SnapFashun Library* menu command
♦ Functions specific to **SnapFashun**

Quick Overview of the Process
In this exercise you will learn how to open and utilize the **SnapFashun** library of designs through the *Window>Show SnapFashun Library* menu command. You will learn how to open specific style libraries, preview individual styles, and drag desired designs into the Illustrator document ready for use.

The SnapFashun library menu

Step-by-Step
Opening Style Libraries
1. In Illustrator, open the **SnapFashun** library by choosing the *Window>Show SnapFashun Library* menu command. A new panel called *SnapFashun* will appear.

The SnapFashun library panel

2. To open a SnapFashun library, click on the **Open** button. If you have already opened some libraries, they will be visible in the panel and each will have a tab with the library title. You will then need to click on the SnapFashun tab first, and then click on the **Open** button. A file requestor window will open. You will most likely need to direct the file requestor to the **SnapFashun** folder, which should be located inside your **Illustrator** folder on your hard drive. On the Macintosh, this is generally in the **Applications** folder. In Windows, it is generally in the **Adobe** folder found in the **Program Files** folder.

SnapFashun
Contact
Information
SnapFashun/BGA
8581 Santa Monica Blvd.,
#515, Los Angeles, CA
90069-4120
Fax: 323-882-6712
SnapFashun inquiries
sales@snapfashun.com
www.snapfashun.com
(310) 659-5956

You will need to choose the Collection Suite and subsequent folders to get the library of your choice (e.g., *Application>Illustrator>Collection Suite>Women's Library>Items*).

3. Click on the collection suite of your choice (Kid's, Men's, or Women's) and then on either *Details* or *Styles* and finally the library of your choice (e.g., Jackets). A library window will open.

Using the Open dialog to locate the SnapFashun library of your choice

Alternatively: You may also load a style library by clicking on the arrow to the right of the panel and choosing the **Open** option.

Once libraries are open, they will appear as separate panels docked to the main *SnapFashun* panel. Each separate library can be torn off to become a separate panel. You may rejoin panels by dragging them into the panel window of other panels.

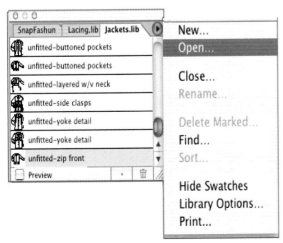

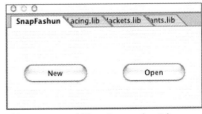

Various panel libraries, each with its own tab

To View and Load styles

1. Click on a library tab to make the library active (e.g., Blouses.lib). A list of styles will appear. You may enlarge the panel to view more styles.

2. Click on the **Preview** checkbox in the lower left corner of the window. This will enlarge the window so that you see a drawing of the selected style.

3. View styles by clicking on their names in turn.

4. When you find a style that you want to retrieve, place your cursor over the image of the style and *click+hold+drag* it over onto your Illustrator document.

The design is now ready for editing, as desired.

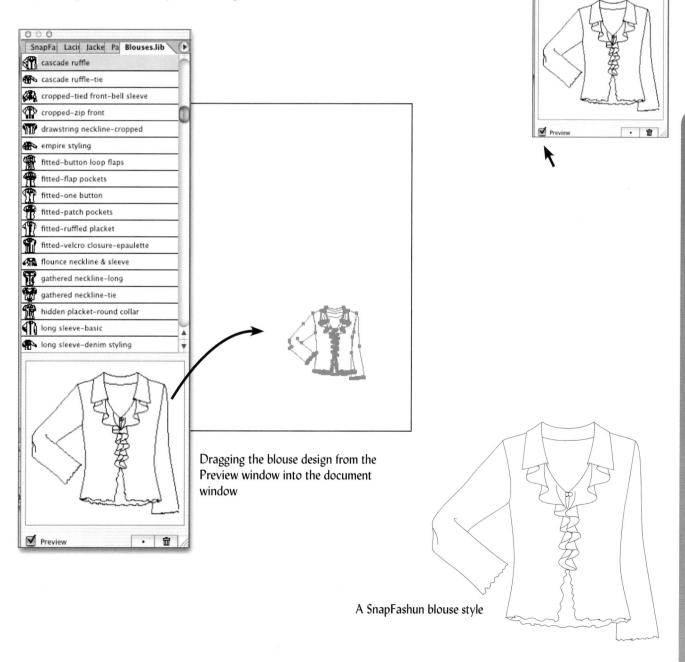

Dragging the blouse design from the Preview window into the document window

A SnapFashun blouse style

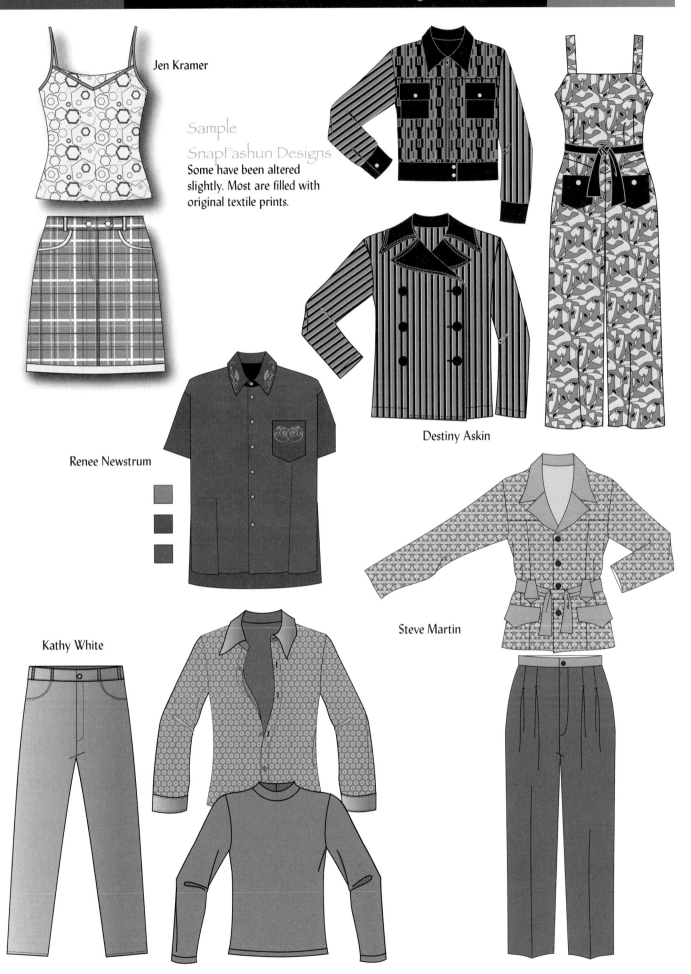

Jen Kramer

Sample
SnapFashun Designs
Some have been altered
slightly. Most are filled with
original textile prints.

Destiny Askin

Renee Newstrum

Steve Martin

Kathy White

Exercise #7: Working with Predrawn Flats

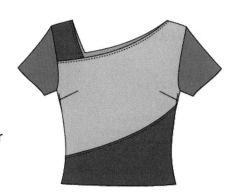

There are occasions when you will use predrawn flats as starting points for your own design. These may be available for purchase (as in the case of **SnapFashun**), or you may be sharing drawings with fellow workers or students. Regardless of the source, it is wise to load and analyze the drawings to determine the approach taken by the artist when creating the objects. If necessary, you may want to alter the objects slightly to have greater flexibility in design for current and future projects. Typically, you are looking at the drawings to determine whether garment pieces were drawn as finished objects, layers were utilized effectively, and design details are drawn and organized in flexible ways.

The final top you will create in this exercise

Goal

To learn how to analyze flats drawn by others and, if necessary, alter them to better utilize them efficiently in your work.

Illustrator Tools and Functions

- ◆ **Selection** tools
- ◆ **Pen** tools
- ◆ Layers
- ◆ *Join* menu command
- ◆ *Object>Group* and *Object>UnGroup* menu commands
- ◆ **Scissors** tool

Quick Overview of the Process

In this exercise, we will load a drawing of a garment, and analyze it for the use of layers and the way objects were drawn. We will then alter some of the objects to provide greater flexibility in design.

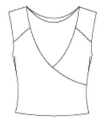

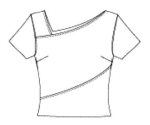

The two tops that can be used for this exercise

Step-by-Step

Loading a Predrawn Garment Flat and Analyzing It

1. Load the drawing of two tops. The file is called **tops.ai** and is in the *Edit Flats* folder found in the *Fashion Exercises* folder on the accompanying DVD.

2. Save the file with a new name on your hard drive. Name it **tops2.ai.**

3. Ensure that your *Layers* panel is displayed (*Window>Layers*). Observe and understand that there are two layers in this file, one for each top. For now, turn off the *top 2* layer, as this exercise deals with the top on the *top 1* layer. To turn the layer off, click on the eye icon of the layer.

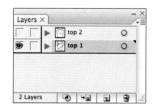

Step 3: Turning off the layer that displays the second top.

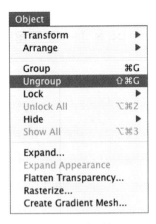

Step 4: Observing the Ungroup command in the Object menu (above), or the Group sublayer in the Layers panel (below).

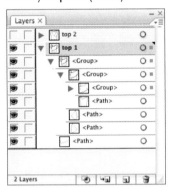

4. Choose the **Selection** tool and click on the top. You will see that all objects become selected. This should tell you that there are grouped objects. *You can confirm this in two ways:*

a. By choosing the *Object>Ungroup* menu. The fact that an Ungroup command is active (and not dimmed) tells you that a group exists.

OR

b. Click on the arrowhead to the left of the layer name to expand the *Layers* panel so that you can see the first level of grouped objects. Clicking on the arrowhead of this group sublayer will open further sublayers of groups and objects.

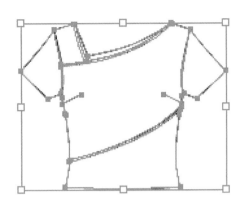

You may choose to ungroup the objects and then work with the **Selection** tool in the next step, or you may leave the objects grouped and work with the **Group Selection** tool. Either approach will work. The instructions that follow will leave the objects grouped and use the **Group Selection** tool. Close all the sublayers at this time to simplify the view of the *Layers* panel.

Determining What Objects Exist

At this point, you want to analyze the garment to determine what objects exist and how flexible the objects are for future drawing or filling the garment with color. *There are two ways to make this determination:*

The Group Selection tool

1. *Using the Group Selection Tool to Select and Observe the Objects*
Choose the **Group Selection** tool (which is buried under the **Direct Selection** tool) and click on the various paths to determine what objects exist. You can look at what is highlighted as you select various objects. By observing if the path is open or closed, you can get a sense for how it will fill. The illustration below shows you the various objects in the top. The main bodice and sleeves are closed objects. The back neckline and diagonal lines are open objects. Choose the **Group Selection** tool and click on various paths to view the objects that exist.

Step 1: Testing to determine what objects exist on the drawing. Observe which are open and which are closed paths.

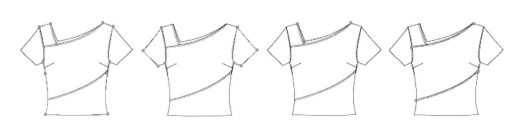

2. *Performing a Test Fill*

Choose the **Group Selection** tool, and click on the outer path of an object. You will see that the objects in these tops have a black *stroke* and no *fill*, and thus to select an object, you must click directly on its path. Once an object is selected, change the *fill* to a color. Examining how an object fills will help you understand the object and how it is drawn. The example below shows you that the sleeves fill properly, as does the body of the top. However, the paths that illustrate the back neckline do not fill properly to illustrate a colored version of the top.

Viewing the fill and stroke of an object in the top

Step 2: Testing the fill on various objects in the original drawing.

You may also choose to view the drawing in *Outline* view, which will show you all paths in the drawing in an unfilled mode. The top-stitching on the garment will appear as a solid line and you will be able to see the overlap of object pieces, such as the sleeve and body.

Planning the Restructuring of the Objects in the Drawing

The goal in working with the objects in this drawing is to create a garment with the greatest flexibility. Since the design caters to color-splicing, this will be one of the tasks to be performed. *For maximum design flexibility, the following needs to be done:*

Viewing the objects in Outline view

- ◆ Move the top-stitching and dart lines to a *top details* layer.
- ◆ Create separate objects for the upper and lower spliced areas of the top.
- ◆ Redraw the back garment so that it fills properly and position the object behind the bodice by creating and moving a layer for it.
- ◆ Fill the various objects to test the results.

Moving the Top-Stitching and Darts

1. If any of the objects have a colored fill, change the *fill* back to *none*. This will make working on the objects a little easier.

2. Ensure that the *top1* layer is the active layer. Using the *Layers* panel menu, create a new layer and name it *top1 details*. Make the color of the layer green. This layer will appear directly above the *top1* layer.

3. Choose the **Group Selection** tool. Press down the *Shift* key on the keyboard, and click on the three top-stitching lines (the dashed lines) and the two dart lines to select them. Note that a little red square appears on the *top1* layer.

Step 3: Selecting the top-stitching and darts.

4. Click on the little red square and drag it up over the *top1 details* layer. The top-stitching and darts objects have now been moved.

5. Click on the eye of the *top1 details* layer to hide the objects on the layer from view. This will simplify making selections in the next operation.

Steps 3 and 4: Moving the top-stitching and darts to the top details layer.

Setting up the Color Blocked Layer and Pieces

1. Click on the *top1* layer to make it the active layer. Using the *Layers* panel menu, create another new layer and call it *block pieces.* Make the color of the layer blue. This layer will appear directly above the *top1* layer and beneath the *top 1 details* layer.

2. Choose the **Group Selection** tool or the **Direct Selection** tool. Select the body of the top by clicking on the outer path of it. Note that a little red square appears on the right-hand side of the layer.

3. Press and hold the *Opt/Alt* key on your keyboard, and drag the red square up onto the *block pieces* layer. This creates a copy of the bodice on the *block pieces* layer.

Steps 1–3: Moving a copy of the body of the top to the block pieces layer.

4. *Shift+click* on the two diagonal seam lines to select them. This will move you to the *top1* layer and you will see the little red square. Drag the square to the *block pieces* layer.

5. Click on the eye icon on the *top1* layer to hide it from view. You are now left with the bodice outline, and the two diagonal lines on the *block pieces* layer.

Steps 4–5: Moving a copy of the body of the top to the block pieces layer and turning off the view of the top1 layer.

Redefining the Objects

The next several steps involve breaking the bodice into separate objects at the points where the diagonal lines intersect it. You will then join endpoints to create a shoulder and lower bodice object. These will sit directly above the base top.

1. Choose the **Group Selection** or the **Direct Selection** tool, and click on the body of the top to select it. It will highlight in blue. This will allow you to see the paths on the object.

2. Choose the **Scissors** tool.

The Scissors tool

3. Zoom in, if necessary, and click on the path of the body object, where the diagonal lines meet the body. When you use the **Scissors** tool and click where no points exist, a new point is added and the object is broken at that point into two objects (see locations a, b, and c on the illustration). When you use the **Scissors** tool and click on an existing

point (point d on the illustration), the bodice object will be broken into two objects and no new point will be added. The result of this operation is that you now have separated the body at the points at which the diagonal lines intersect it.

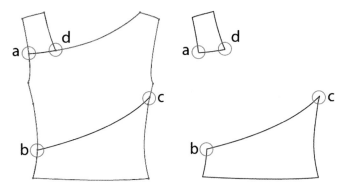

4. Choose the **Direct Selection** tool. Click on the objects in the center of the bodice and press the *delete/backspace* key to delete them. You should have only the upper shoulder piece and the lower bodice piece remaining, as in the illustration.

Steps 3 and 4: Using the Scissors to break objects into parts and removing the unwanted segments.

Creating the New Objects

You now will use the *Join* command to join the endpoints of the various objects to turn the upper shoulder piece and the lower body piece into closed objects.

1. Choose the **Direct Selection** tool. Click on the paths of the objects to determine where a path begins and ends. This will help you see what needs to be joined.

2. Drag a box around the points at position d to select the endpoints of the two objects that meet there.

Steps 3 and 4: Using the Scissors to break objects into parts and removing the unwanted segments.

3. Choose the *Object>Path>Join* menu command. The *Join* dialog will open. Choose the *Corner* option and click **OK**. The two paths will be joined.

4. Repeat the operation for the joins at positions a, b, and c. This will result in two closed objects, one for the upper bodice piece and the other for the lower bodice piece.

The Join menu command and the Join dialog

Redrawing the Back Piece

In order to properly fill the object that represents the back of the top, it is necessary to redraw it slightly.

1. Turn on the view of the *top1* layer by clicking on the eye well to the left of the layer name.

2. Click on the *top1* layer to make it the active layer. Using the *Layers* panel menu, create another new layer and call it *back*. Make the color of the layer pink. This layer will appear directly above the *top1* layer. Drag the *back* layer beneath the *top1* layer in the *Layers* panel. If you accidentally make this layer a sublayer of the *top 1* layer (by dragging down and to the right), undo the operation and repeat the dragging process, dragging down and to the left. Click on the *top1* layer to make it the active layer.

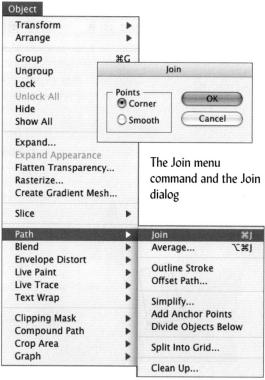

3. Using the **Direct Selection** tool, click on the back neckline piece to select it. Drag the little red square on the *top1* layer down to the *back* layer. Click on the eye icons on the *top1* layer and the block pieces layer to turn the view of them off.

4. Choose the **Pen** tool. Move the pen cursor to the end anchor point of the right side of the back. When you are positioned directly over the anchor point, you will see the little cursor on the **Pen** tool change to a diagonal slash line (/). Click on the endpoint, and this will begin the new drawing.

5. Move the **Pen** cursor to the lower right, and click with the mouse. This draws the next segment. Press the *Cmd/Ctrl* key on the keyboard and click away. This ends the path.

6. Now, move the **Pen** cursor over to the end point at the left side of the neckline and position it directly over the endpoint. When you see the diagonal slash line, click with the mouse to join the path.

7. Move your cursor down and to the left and click with the mouse to set the anchor point and create the next segment. Press the *Cmd/Ctrl* key on the keyboard, and click away. This ends the path. You now have an open path that, when filled, will fill properly with regards to the back section of the top. If you like, click on the eye icon of the *top1* layer to view how the back drawing relates to the top of the garment.

Steps 4–7: Using the Pen tool to add to the back neckline to create an object that fills properly.

Filling the Objects
At this point, you can now turn on the display of all objects and fill them in to see how all objects work with each other.

1. Turn on the view of all layers involving the top by clicking on the eye icon beside each layer name.

2. Choose the **Group Selection** or the **Direct Selection** tool.

3. Click on each object in turn, and change the fill to a color of your choice. When you fill the back, choose a slightly darker value of the color you use for the front of the garment, as this better illustrates a shaded area. (Note: It might be easier to turn the layers on in turn, adding the fill color to each object as you go.)

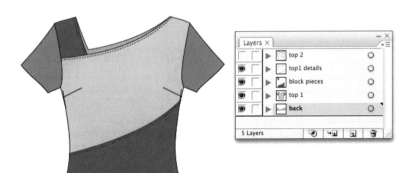

The final top drawing with multiple objects

You have now created a drawing with objects that are very flexible for use in redrawing and redesigning a garment. Experiment with the second top in the file to sharpen your skills.

Exercise #8: Developing and Drawing a Fashion Croquis

Goal
To develop and draw a basic women's 9-head fashion croquis in Illustrator.

Illustrator Tools and Functions
- **Ellipse** tool
- **Pen** tools
- **Selection** tools
- **Rotate** tools
- *Opt/Alt+Drag* (to create copies of objects)
- *Object>Transform Again* menu command
- Layers

Quick Overview of the Process
In this exercise you will learn how to develop a fashion croquis. You will begin by drawing an ellipse for the head and repeat this shape vertically to create a measuring template. You will then draw the croquis using the oval head and proportion chart on page 240 as a measuring guide. *The steps are as follows:*
- Set up guidelines and layers.
- Draw an ellipse.
- Stack 9 heads vertically using the *Option/Alt+drag* function to build duplicates of the head in conjunction with the *Object>Transform Again* menu command.
- Copy and rotate a head to set up width guides.
- Use the **Pen** tool to draw a half-croquis on its own layer.
- Use the **Reflect** tool to copy and reflect the half-croquis and then join the two halves in the appropriate places.

Overview of Body Proportions
The fashion croquis is a fashion figure drawn with specific body proportions and used as a template for drawing clothing. A croquis generally assumes a simple pose so that clothing is easily read. Of course, the more animated the stance of the croquis, the more fluid the clothing becomes.

Croquis are developed using standard body proportions, or they can be exaggerated to create a high fashion model height. Measurements of proportion are generally calculated by the number of heads (or head heights) the pose is drawn in. Because body proportions are easily measured in relation to one's head length, this is a easy system to use.

When one exaggerates the standard body proportions to create a fashion pose, the extra length is generally added in the legs. An average body measures 7-1/2 heads tall from the top of the head to the bottom of the foot in a standard forward-facing pose. The heel of the foot will be slightly less than the 7-1/2 heads. For fashion's sake, croquis measuring 8, 9, and even 10 heads tall are created.

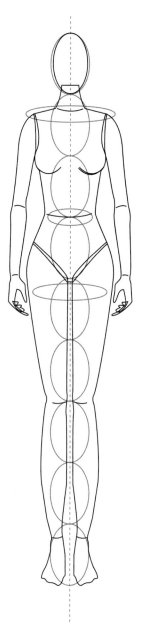

The 9-head fashion croquis

Guide of Women's Croquis Lengths at Key Body Points

	7-1/2-Head Croquis	8-Head Croquis	9-Head Croquis extra long legs	9-Head Croquis more proportioned
Head	1	1	1	1
Shoulder	1-1/4 to 1-1/3	1-1/4 to 1-1/3	1-1/4 to 1-1/3	1-2/3
Full Bust	2	2	2	2
Waist & just above elbow	3	3	3	3-1/2
Full Hip/Crotch & wrist level	4	4	4-1/8	4-1/2
Knee	5-1/3 +	5-2/3	6	6-1/2
Full Calf				7
Ankle	7-1/4	7-2/3	8-3/4	8-2/3
Bottom of Foot	7-1/2	8	9-1/4	9

Note: The numbers in the chart represent the vertical positioning of the various body parts in terms of heads.

If you begin by measuring the length of a single head, and then draw a column of heads, stacked one on top of the other, you can use this and some standard body proportions to easily draw an accurate figure. The above chart shows you the general length/depth measurements.

In addition to the chart, understand that the upper arm is generally just a bit longer than the lower arm, and the armhole depth is typically 1/2 head tall.

There are several **width** guides you can use to assist in drawing the fashion figure. These utilize a single head-height as a measuring device and work with all the various fashion croquis (7-1/2, 8, 9).

Guide of Women's Croquis Widths at Key Body Points

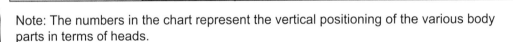

Shoulder Width	1-1/2 heads
Waist Width	3/4 head
Hip Width	1-1/4 heads

Step-by-Step
Setting up
Begin by considering the size of a typical sheet of paper. This would be 11 inches tall. To allow a little space for margins, it would be wise to make the fashion pose no longer than 10 inches. Working with a measurement of one inch per head height allows you to easily build the 9-head croquis on the drawing page.

Step 2: Setting up the Guide layer.

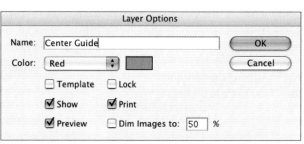

1. Create a new document in *Portrait* mode, and save it as **Croquis.ai**.

2. In the *Layers* panel, double-click on *Layer 1* and rename it *Center Guide.* Choose *Red* as your layer color. Click **OK**.

3. Set the *fill* to *None*, and choose a light blue as your *stroke* color Set the stroke *Weight* to 1. If you like, you may specify a dashed line by choosing the dashed option in the *Stroke* panel (you may need to view the *Stroke* options in the panel menu to see this part of the menu). Set the first dash and gap to 3.

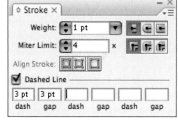

Step 3: Setting a Dashed Line.

4. On this layer, and using your **Pen** tool, draw a vertical line down the center of the page. If you click at the top of the page to place the first anchor point, then hold the *Shift* key down and click at the bottom of the page to set the second anchor point, you will create a straight dashed line.

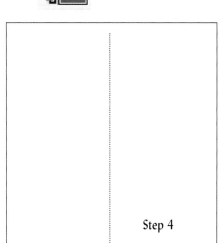

Step 4

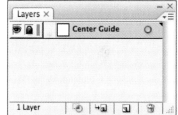

Step 5: Locking the Guide layer.

5. Lock this layer so that you don't move the dotted center guide (click on the lock well).

Creating the Head and Building the Stacked 9-head Guide
1. Create a new layer and call it *Heads*. Choose *Yellow* as the layer color. Click on this layer to make it the active layer.

2. Change the *stroke* color to light gray. Turn the dashed line option off.

Step 2: Setting the stroke color to light gray.

3. Choose the **Ellipse** shape tool. You may need to click and hold on the **Rectangle** shape tool until the pop-up menu of additional shapes appears. Slide over to the **Ellipse** tool and release the mouse button.

Step 3: Choosing the Ellipse tool.

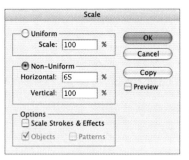

Step 5: Altering the horizontal scale of the circle to an oval.

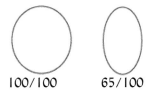

100/100 65/100

Step 9: Performing a copy+drag of the original oval. Note the white cursor, which indicates that the upper anchor point of the copy oval is directly above the lower anchor point of the original oval.

The Object>Transform> Transform Again menu command

Step 4: Setting the ellipse size.

4. Click once on the document and release the mouse. A dialog will open. Set the width and height to 1 inch. Click **OK**. A circle will appear on the screen.

5. Double-click on the **Scale** tool in the toolbox. A dialog will open. Type 65 in the Horizontal field and leave the Vertical field at 100. Click **OK**. This will create an oval shape suitable for a head. (You may use other percentages if you prefer to shape the oval differently.)

6. Turn the *Bounding Box* off by choosing the *View>Hide Bounding Box* menu command (if indeed it is turned on). This will make the next few steps simpler as you do not want to resize the oval and you will be working with the outer anchor points of the shape.

7. Choose the **Selection** tool and move the oval to the top of the document and position it, centering it over the vertical guideline. Position the center dot of the oval over the center line.

Step 7: Positioning the oval over the center guideline.

8. Ensure that you can see all the points on the oval. If necessary, click on the shape to select it.

9. Press and hold the *Option/Alt* key on the keyboard. Position your cursor over the top center anchor point of the oval and click on this point, then drag the oval straight down. This *Opt/Alt+copy* mode will create a copy of the oval, and as you drag it down, align the top anchor point of the copied oval on top of the lower point of the original oval. You can tell when the points superimposed as the cursor will turn white. When this happens, let go of the mouse to set the position of the second head. (Note: you will actually see two cursors; one lets you know you are copying and the other is your regular cursor, which assumes a new shape when it is on top of an anchor point.) Do NOT perform any further actions at this point as the success of step #10 relies on repeating the last operation performed.

Note: You may also use the *Shift* key to assist in aligning the heads vertically. As you start *Opt/Alt* dragging the original oval, a copy of the oval will appear. With the mouse button still down, press and hold the *Shift* key on the keyboard. This will constrain or force the copy to be positioned on the same vertical axis, directly below the original.

10. Now choose the *Object>Transform>Transform Again* menu or press the *Cmd/Ctrl+D* keys on the keyboard. This repeats the last transformation of dragging the second oval into place. A third head will appear.

Step 10: Stacking nine heads in a vertical strip.

Repeat the *Transform Again* process until you have the nine heads in place. These should all be centered over the vertical line and touch end-to-end. If your heads are not aligned perfectly, then delete the copies of the head and repeat the process again (starting with step 9), attempting to perfectly align the first copy of the head prior to using the *Transform Again* function.

Creating Croquis Width Guides for the Shoulder, Waist, and Hips

In croquis development, the length of a single head can be used as a guide to determine the **width** of the shoulders, waist, and hips on a body. We will use previously created heads as our starting point. Use the chart on page 240 as a guide for the width measurements.

The Rotate tool and dialog

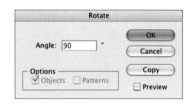

1. Using the **Selection** tool, *drag+select* around the top three heads of the vertical stack of heads. Make sure you do not select any additional heads. Now use the *Opt/Alt+drag* function to create a copy of the three heads and drag them over to one side.

2. Double-click on the **Rotate** tool. A dialog window will open. Type 90 in the field for the degrees to rotate. Click **OK**, and the heads will turn sideways. We will use each of these to build the width of the shoulders, waist, and hips. Separate the heads and line them up vertically at this point.

3. **Shoulder Width**: Select the top head, and then double-click on the **Scale** tool in the toolbox. A dialog will open. Click on the Non-Uniform option. Type 150 in the *Horizontal* field and leave the *Vertical* field at 100. Click **OK**. The head will widen to 1-1/2 heads, which is the width of the shoulder.

4. **Waist Width**: Select the second head/oval. Double-click on the **Scale** tool and this time type 75 in the *Horizontal* field and click **OK**. This will create a head that is 3/4 width, which represents the waist width.

5. **Hip Width**: Repeat the process for the third head, typing 125 in the *Horizontal* field to create a head that is 1-1/4 the size of the standard oval. This will become the width at the hips.

6. We now need to position the heads on the 9-head tall stack. *Position the center of each width guideline head in place as follows:*

 • The center of the shoulder width head should be at 1-1/4 heads down.

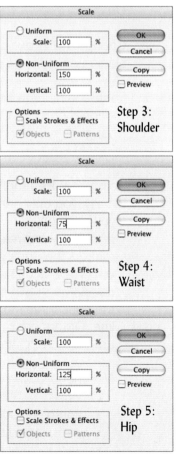

The Scale tool

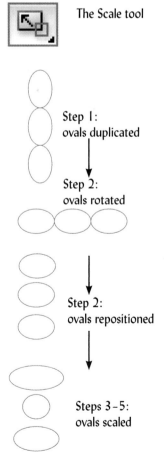

Step 1:
ovals duplicated

Step 2:
ovals rotated

Step 2:
ovals repositioned

Steps 3–5:
ovals scaled

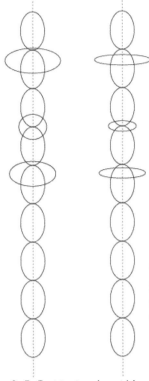

Steps 6-7: Positioning the width guide heads.

- The center of the waist width head should be at 3 heads down.
- The center of the hip width head should be at 4-1/8 heads down.

7. If you want, you can use the **Delete Point** tool to remove the upper and lower points of each oval, thus creating a flatter oval that will be easier to utilize in drawing the fashion figure.

The Delete Anchor Point tool

8. Using the tool, select one of the heads and copy it to the clipboard using the *Edit/Copy* menu command. The clipboard will serve as a storage tank and hold the head in memory until you need it in the next section.

The shoulder, waist, and hip width ovals are positioned on the 9-head stack per step 6. The Delete Anchor Point tool is used to remove the upper and lower points in the ovals to create a flatter shape (as shown in the drawing on the right).

9. Lock the *Heads* layer.

Step 9: Locking the Heads layer.

Drawing the Half Croquis

1. Create a new layer and name it *Croquis*.

2. Change the *stroke* color to black. Leave the *fill* as None.

3. Paste the head from the clipboard onto the *Croquis* layer. Change the *stroke* of this object

Step 1: Setting up the Croquis layer.

to black. Position this head over the top head of your *Heads* layer.

4. Using your **Pen** tool, begin to draw the various parts of the croquis. Initially, you only need to draw the right half of the torso and limbs, as you can copy/reflect this to create the left side. Always think in terms of objects and relate these to body parts. For example, you will need to draw the arms and legs as separate objects. The torso should be its own object. Details should be added separately. Some of these should be drawn prior to copying and reflecting the half body (e.g., the bust curve, fingers, and curve details that don't cross the center line. Others are best drawn after the half body is reflected and joins are made (e.g., the waist and neck curve lines).

Use the following list as a guide:
 Objects:
- torso, including neck
- arm, including hand (but not the fingers)
- leg, including foot

 Details:
- bust curve
- waist curve
- additional fingers
- neck indent curve
- elbow and wrist curve
- knee and ankle curve

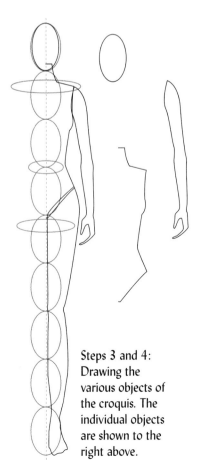

Steps 3 and 4: Drawing the various objects of the croquis. The individual objects are shown to the right above.

Copy/Reflecting the Half

1. Turn off the display of the *Heads* layer by clicking on the eye icon on the layer in the *Layers* panel. This will simplify the display and make the next several steps easier to complete.

2. Choose the **Selection** tool in the Toolbox.

3. Choose the *Select>All* menu command. All objects will become selected. Press the *Shift* key and, using the **Selection** tool, click on the head to deselect it. (Remember to click on the outer path of the head, as it is not filled.)

4. Double-click on the **Reflect** tool in the Toolbox. A dialog will open. Click on the **Copy** button. The selected objects will copy and reflect and sit directly above the original half.

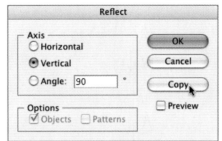

Step 4: Reflecting the right side of the croquis.

5. Press the left arrow key to start nudging the half body to the left. You might want to zoom in to ensure that you are aligning the two sides as close to center as possible.

6. Use the *Average* and *Join* commands (*Object>Path* menu) to join the torso at the neck and crotch. See Drawing Exercise #7 and Fashion Exercise #4 for a review on how to use these functions if necessary.

Final Details

You are nearly done. A few steps remain.

1. Change the *Fill* of the body objects (head, torso, limbs, and fingers) to a white or flesh color. Using the **Selection** tool, select these objects and change the fill color to a white or flesh color.

Step 1 before (left), after (right): Adding a flesh fill to the objects makes the fingers look correct.

2. If the head sits behind the torso, select it using the **Selection** tool and choose the *Object>Arrange>Bring to Front* menu command.

Step 2 before (left), after (right): Use the Object>Arrange>Bring to Front menu to position the head correctly.

3. Using the **Pen** tool, and a black *stroke* with no *fill*, draw in the waist and neck curves.

4. Save the file.

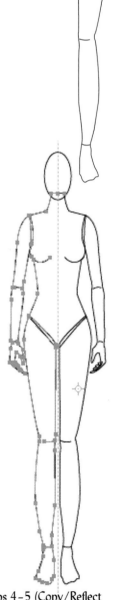

Step 4 (prior page): Details added to the basic croquis parts.

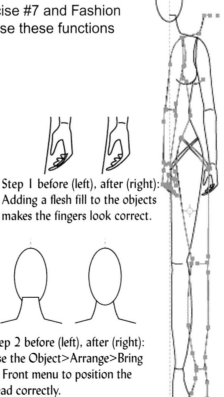

Steps 4–5 (Copy/Reflect section):
Creating and positioning the left side of the croquis.

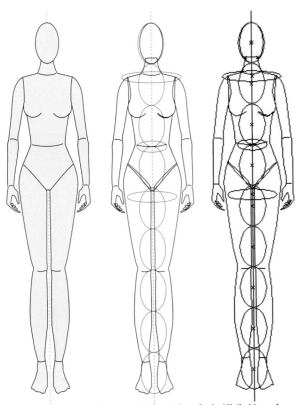

The final croquis in Preview View with a flesh fill (left) and no fill (center). The croquis in Outline View (right).

Student Gallery: Sample Croquis

Mesa College Fashion Students

Cynthia Martinez

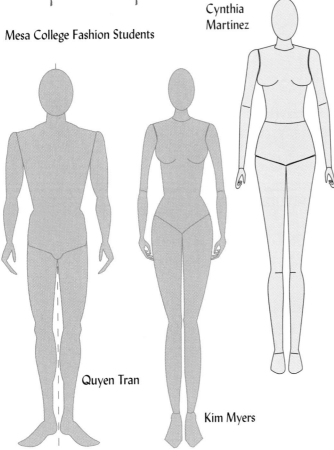

Quyen Tran

Kim Myers

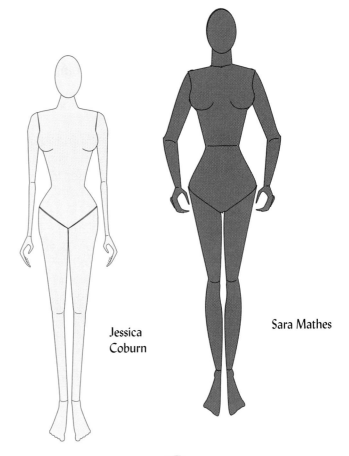

Jessica Coburn

Sara Mathes

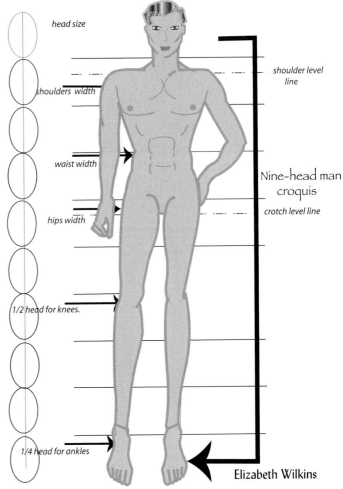

head size

shoulders width

waist width

hips width

1/2 head for knees.

1/4 head for ankles

shoulder level line

Nine-head man croquis

crotch level line

Elizabeth Wilkins

Exercise #9: Working with a Jointed Croquis

Goal
To use a jointed croquis to develop various fashion poses.

Tools/Functions to be Utilized
- **Rotate** tool ('R' on keyboard)
- **Selection** tool ('V' on the keyboard)
- **Direct Selection** tool ('A' on the keyboard)
- *Pathfinder>Add to Shape Area*

Overview of Body Proportions
Creating and utilizing a jointed croquis with limbs and joints allows you greater flexibility in design. Through the use of selections and rotations you can create a variety of poses. Then, using the *Pathfinder>Add to Shape Area* function, you can quickly join shapes to build a non-jointed croquis.

If you build your own master croquis, use the **Ellipse** tool to create circle joints at any point where the body bends, i.e., the shoulder, elbow, wrist, waist, hip, knee, and ankle. Build objects for the upper and lower torso, arms, and legs.

The Master Jointed Croquis drawing

Quick Overview of the Process
In this exercise, you will use a croquis that has already been developed. *The steps are as follows:*
- Load the croquis file and then analyze the objects on the various layers to understand the prep work in the file.
- Select and rotate the various limbs to create a new pose.
- Tweak positioning of the various limbs and joints.
- Use the *Pathfinder>Add to Shape Area* function to build final body parts that may be used as part of the fashion drawing.

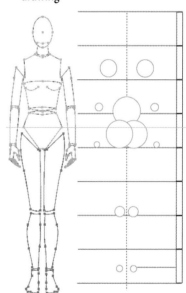

Moving the croquis to the side so you can see the "balls" of rotation

Step-by-Step
Understanding the Drawing and Layer Setup
1. Load the master jointed croquis file, an 8-head croquis. The file is called **masterjointedcroquis.ai** and can be found in the *Croquis* folder, which sits inside the *Fashion Exercises* folder on the accompanying DVD.

2. Save the file with a new name so that you do not overwrite the original file (*File>Save As*). Name it **croquisbend.ai**.

3. Observe and understand the objects located on each layer by using the eye icon to turn layers on and off. If you click and hold on the eye of the top layer and then drag down the column, you can quickly turn the eyes off. Note how the balled joints are red circles, and the head, torso, and limbs are black. Note also that some of the body guidelines (like the curve of the elbow) are grouped to the appropriate limb.

Use the eye icon to turn the layers visibility on and off so that you can see what is on each layer.

Step 2: Setting up the Layers panel for the arms' rotations.

The Rotate tool (above) and cursors (below)

 Crosshair

 Arrowhead

Shift+Click
To select multiple anchor points you may also press and hold the Shift key as you click on the various points you want to select.

4. View all layers, but ensure that the guidelines layer is locked.

Building a Pose

1. Let's build a pose where the croquis has one bent arm, one slightly angled arm, and a slightly bent knee. We will be using the **Selection** tool and the **Rotate** tool, so tear the tool panels for the **Rotate** tool off the Toolbox. Place it near your croquis to have the tool handy while you work.

2. We will start with altering the position of the arms, so lock all layers except the *arms* and *joint* layers. Click on the *arms* layer to make it the active layer.

3. Choose the **Selection** tool in the Toolbox (or press 'V' on the keyboard).

4. *Drag+select* around the entire left arm except for the joint at the shoulder, since you are using the **Selection** tool (as opposed to the *Direct Selection* tool). Note: You only need to drag over a portion of each object to select it.

5. Choose the **Rotate** tool in the toolbox (or press 'R' on the keyboard). Note that the cursor changes to a crosshair.

6. Click once on the underarm point of the arm (the point closest to the torso) and release. This tells the computer that you want this point to be the pivot point of the rotation. Note that the cursor changes to a black arrowhead.

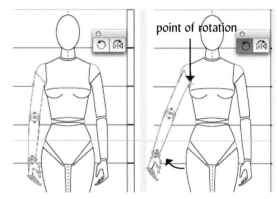

Above left—Select the left arm, but not the shoulder joint, Step 4.
Above right—Then choose the Rotation tool, and set the point of rotation as the underarm point, then rotate the arm outwards, Steps 5–7.

7. Now *click+hold* in the wrist area and drag the mouse out (to the left). As you do so, the arm will rotate on the pivot point you set. If you did not drag enough, repeat the dragging process, as the cursor is still the arrowhead, which tells you that you can rotate further.

8. Repeat the process for the right arm, dragging out slightly further to allow for a bent elbow. Click away when you are done to deselect the objects.

9. Using the **Selection** tool ('V') select the lower right arm and hand. Do not select the elbow joint, as we want to have the arm rotate around this. You should have three objects selected (the hand, wrist joint, and lower arm).

10. Choose the **Rotate** tool ('R') and click on the inner point of the elbow area to set the pivot point. Now rotate the arm inwards. Note how the elbow joint does not move, as the object was not selected. Since you essentially lengthened the arm in this rotation, use the *up arrow* key on the keyboard to nudge the arm up slightly.

11. Lock the *arms* layer and unlock the *legs* layer.

12. Using the **Selection** tool, select the left leg (all parts except the hip joint).

13. Using the **Rotate** tool, set the pivot point at the upper inner leg and rotate the leg outward. When you are through, use the left arrow key on the keyboard to nudge the leg outward so that it aligns better with the hip joint.

14. Using the **Selection** tool, select the lower left leg (the lower leg, ankle joint, and foot).

15. Using the **Rotate** tool, set the pivot point at the inner knee point and rotate the lower leg outwards.

16. Select the foot and ankle joint only and rotate these inward around the ankle joint. Choose the center of the ankle joint circle as the point of rotation. Use the *arrow keys* on the keyboard to nudge the lower leg, if necessary, to shorten it.

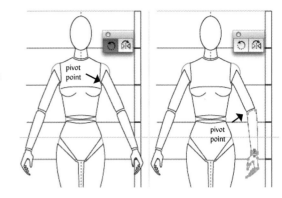

Above left—Select the right arm, but not the shoulder joint, and rotate it outward, Step 8.
Above right—Select the lower arm, wrist, and hand and rotate them back inward slightly, Steps 9-10.

Step 11: Prepping layers for rotating the legs.

Performing leg rotations

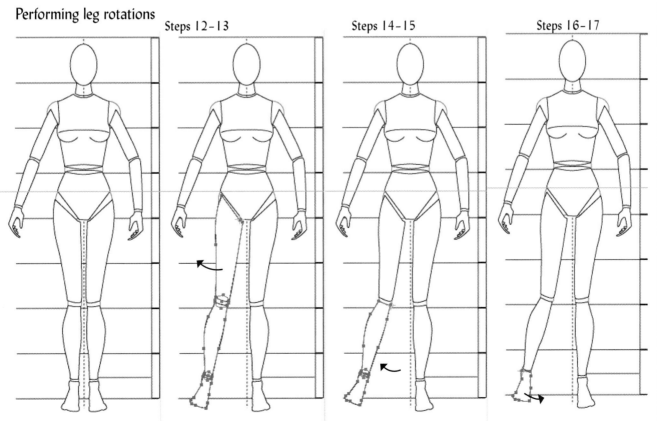

| Steps 12-13 | Steps 14-15 | Steps 16-17 |

18. When you are through, look at the length of the legs to determine if they are of the proper proportions. If necessary, select the appropriate parts (the lower leg, ankle joint, or foot) and nudge them accordingly. You may also want to unlock the *joints* layer and nudge the joint circles on the body to make all parts join smoothly.

The rotations of the pose are complete.

Tweaking Object Positions

The *Pathfinder* function will be used in the next step to join multiple objects and remove the inner lines. Prior to doing this, it is helpful to examine how all limbs and joints intersect. You may need to tweak or move some of these objects in order to achieve the smoothest transition possible.

Adjusting the original shoulder joints and the arms position (left) for a smoother transition (right) when limbs are joined with the Pathfinder function

Using Pathfinder to Join the Limb Parts

We now want to join all the sections of each body limb into one object, as opposed to several. To do this, we will use an option in the *Pathfinder* panel called *Add to shape area*, which allows you to merge parts in different ways.

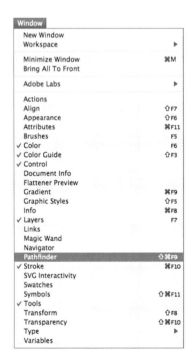

Step 1: Choose the Window>Pathfinder menu command to open the Patherfinder panel.

 Add to shape area function of the Pathfinder panel

1. Choose the *Window>Pathfinders* option to open the panel. Position it on your screen.

2. Using the **Selection** tool, select all parts of one leg (the upper leg, knee joint, lower leg, ankle joint, and foot). Do not include the hip joint.
 Note: Depending on how you rotated and tweaked the various objects, your choice of objects to join may vary.

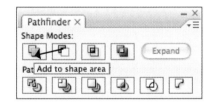

3. Click on the *Add to shape area* icon in the *Shape Modes* portion of the panel. All parts of the leg will now become one object.

4. Repeat the process for the other leg.

5. Unlock the arms layer (and lock the legs layer) and repeat the pathfinder process for each arm.

6. Save the file.

Steps 2-3: Selecting the lower leg objects (left). Add to shape area Pathfinder is applied to create the joined leg on right.

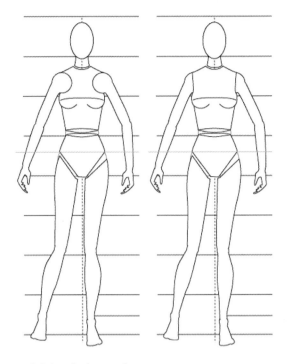

Joining the legs and arms.
Note that the arm joins include the shoulder joint. You will need to move the torso layer above the arms and legs layers.

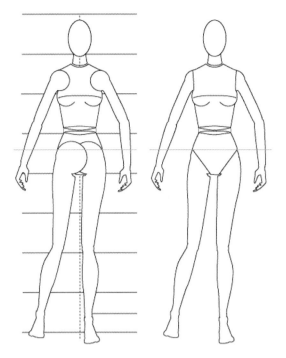

Adding the hip joints to the legs using the Add to shape area Pathfinder. You will need to move the torso layer above the arms and legs layers.

Tips in Joining Objects

- If you want to join all parts of the torso, you will need to edit the torso so that the different parts overlap somewhat, as the *Add to shape area* tool works only with parts that are overlapped.

- As you join shapes, check to see if objects have been grouped (as in the case with the waist curve markings that are joined to the torso).

- Once objects are joined, you can see the original object shapes when in *Outline* view.

- You may need to tweak and edit the curves of certain objects to allow for a nice smooth join between pieces. It is often necessary to alter the curve of the joint pieces.

- When joining the torso pieces, you may find it necessary to redraw the bust curve lines.

- There are certain objects that you do not want to join with Pathfinder. The fingers on the hands would be an example, as you want to keep the separate digits on the fingers.

The completed jointed croquis

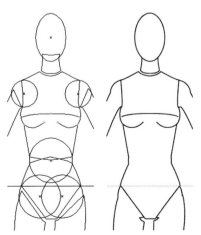

Using Outline view to see all paths in the object

Joining Decisions

You might want to move the breast curves to their own layer prior to joining objects with Pathfinder as this will prevent them from becoming part of the body.

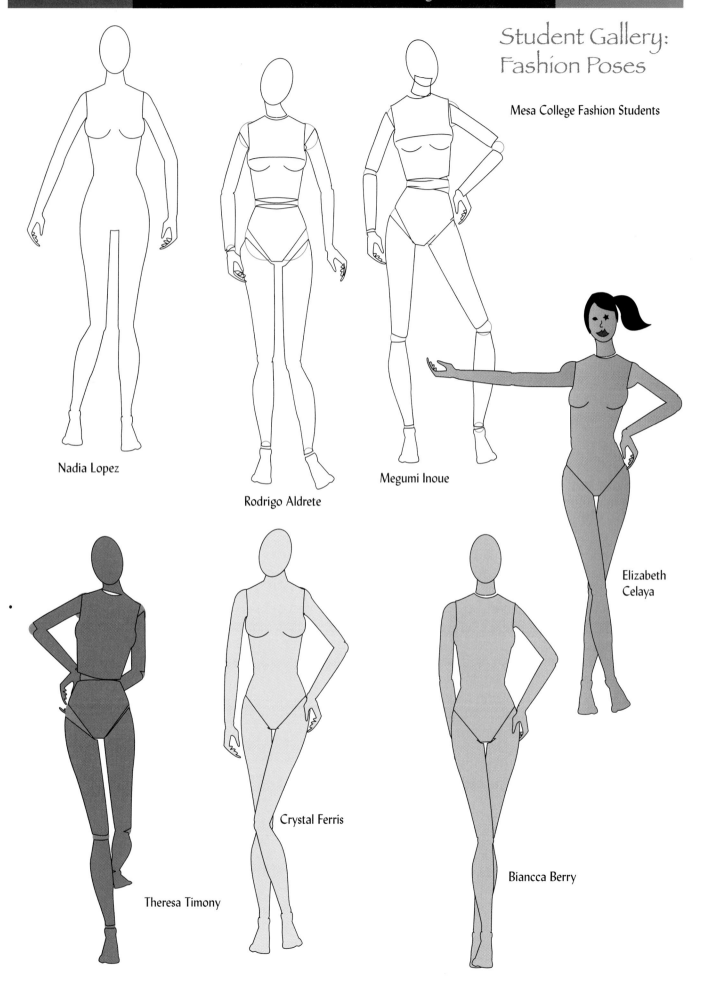

Student Gallery:
Fashion Poses

Mesa College Fashion Students

Nadia Lopez

Rodrigo Aldrete

Megumi Inoue

Elizabeth
Celaya

Theresa Timony

Crystal Ferris

Biancca Berry

Exercises 10–13: Fashion Illlustration

Fashion Illustration and an Overview of Tracing

This section of the book deals with the process of creating fashion illustrations. Once you have learned how to use the various tools and functions in Illustrator and developed a sense of body proportions, you will be able to draw illustrations from scratch. You will use *Layers* as a mechanism to keep yourself organized, and you might even use a predeveloped croquis (where time and energy were given to build a pose with proper proportions).

Exercise #9 introduced a jointed croquis, which can be used as a basis for developing poses in creating fashion illustrations. Once you establish the pose, you can draw clothing on the body. Building fluidity into the drawing comes with observation and practice, and with learning how to analyze fashion drawings and translate hand techniques to computer.

There will always be occasions when you want to take a hand drawing or a scanned image and translate it into an Illustrator vector format. Exercise #10 shows you how to work with a scanned image of a hand illustration and translate it to vector format. Exercise #11 will teach you how to take a fashion photograph and translate it to a fashion pose and clothing in an object-oriented way. Exercise #12 will walk you through the process of performing screen captures of images you want to use as inspiration or a starting point for further design. Exercise #13 covers the automated techniques of tracing, employing Live Trace (version CS2/CS3) or Auto Trace (versions prior to CS2). In all cases, you will learn techniques to assist you in working with pixelated raster images. Just as many artists trace a pose as a starting point or as a means to keep the drawing in proportion, you will trace a scanned image. Layers will be employed to keep you organized.

Monica Mitchell

In general, there are two approaches to tracing images:

1. Place the image and create a template layer. Then, working on a separate layer, manually trace the drawing with the **Pen** and editing tools. These techniques are covered in Exercise #10 (with a scanned image of a hand-drawn illustration) and Exercise #11 (with a fashion photograph).

2. Load or place the image and use automated tracing functions such as the **Live Trace** function (CS2/CS3) or the **Auto Trace** tool (versions prior to CS2). Both of these tools automatically trace the image. You have some level of control over the process and, once the image is traced, you may edit the paths.

You can either open or place a file that you want to trace. The differences between *open/paste* and *place* are as follows:

♦ If you *open* the source file (*File>Open*) or *paste* an image into Illustrator from the clipboard, the source image becomes embedded and thus part of the Illustrator file. These files will be larger in size.

♦ If you *place* the source file in Illustrator (*File>Place*), you are creating a reference or link to that file, which allows you to keep the size of

Kane Otaka

Mai Nguyen

the current file smaller. If you edit the original file, it will be updated in your Illustrator file the next time you open it. If you delete the source file from your hard drive, Illustrator will give you warning errors the next time you open the Illustrator file. You must always include the linked file with the Illustrator file when you transport or move files.

Tracing an image by hand is achieved with the various drawing and editing tools in Illustrator. You can use the **Pen** tool to quickly set anchor points and establish lines and curves. Then, you can tweak the design using the various editing tools.

With the introduction of the **Live Trace** tool in version CS2, the success of automated tracing improved greatly over the **Auto Trace** function of prior versions. *Live Trace* introduces increased Illustrator intelligence to the process and provides various presets that you can choose from to achieve the best result. Prior to version CS2, a tool called *Auto Trace* allowed you to quickly transform a raster (bit-mapped) image into a vector image. Both tools create editable paths by tracing the outline of what they find on an image. The quality of the results relates directly to the quality of the source image, which determines how easily an outline can be read by the software.

The exercises that follow will teach you various techniques involved in creating fashion illustrations through tracing.

Nadia Lopez

Letiti Benti

Kristen Matoba

Hanah Salas

Exercise #10: Tracing a Hand-Drawn Fashion Illustration

Goal

In this exercise, you will load a file of a scanned fashion illustration. You will then set up layers so that you may trace the fashion pose and the garment pieces.

Illustrator Tools and Functions

- ◆ **Pen** and **Selection** tools
- ◆ Layers, utilizing a template layer, sublayers, locks, and viewing on/off
- ◆ **Eyedropper** tool
- ◆ Varying *stroke Weights* (*Stroke* panel)
- ◆ Stacking order between layers and of objects on a single layer
- ◆ Open paths

Overview of the Process

You will begin this exercise by scanning a hand drawing, or by loading a file of a scanned image of a hand-drawn fashion illustration. Analyze the image, breaking it down into the various objects that will need to be drawn to create a vector version of the file. Examine the pose to determine which body parts and garment pieces you will need to draw as separate objects (e.g., head, neck, sleeves, collar, bodice, etc.) When you look at the garment, consider the pattern pieces that would be required to sew the garment as this will aid you in determining what objects to draw. Once you have finished the analysis, you will set up layers for the various components of the drawing (e.g., body, jacket body, sleeves, etc.), and turn the original art layer into a template layer. Then, you will commence building the drawing by tracing the various parts of the body and jacket to build the needed objects.

Illustration by Keith Antonio

Step-by-Step

Scanning a Fashion Sketch

1. Take a fashion sketch or photograph and scan it using your scanning software or Photoshop. Save the file as a .tif, .jpg, or .psd file.

2. If you are using Photoshop, use the *Image>Image Size* menu to control the size of the scanned drawing so that it is no larger than 8 x 10 inches. The resolution is not critical, but the higher the resolution, the larger the file size, and the larger your Illustrator file will be as long as the original art is embedded in the file. The sample file we will use in this exercise is approximately 3-1/2" wide by 10" tall with a resolution of 200. Since the file was scanned and saved in Photoshop, it will have an association to Photoshop. If you double-click on the file, it will open in Photoshop, not Illustrator. For this reason, you will need to open Illustrator and then load the file using the *File>Open* menu.

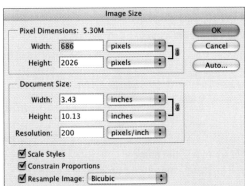

Step 2: Use the Image Size menu to control the image size of the graphic in Photoshop.

Loading the Image and Analyzing the Garment

This exercise uses a file called **keith.jpg** located in the *Trace* folder, which is found in the *Fashion Exercises* folder of the accompanying DVD. The original design was sketched in black and white and then scanned and colored in Photoshop.

The Photoshop file as Layer 1

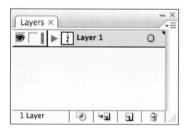

Note:

Bounding Box

In this exercise, the Bounding box has been turned off (View>Hide Bounding Box).

1. Use the *File>Open* menu to open the file. Notice that the sketch becomes *Layer 1* in the *Layers* panel. (Ensure that this panel is open and, if it is not, use the **Window** menu to open it.)

2. Resize the sketch, if necessary, using the **Scale** tool. If you are using the **keith.jpg** image you will not need to scale it, as it easily fits on an 8 x 10 inch document.

3. Using the *File/Save As . . .* menu command, save the file as **traceexercise.ai**.

Step 1: The original image loaded in Illustrator.

Stop for a few moments and take a good look at the jacket. Think about the different pieces of the garment and how you will translate them into objects. If you look at the jacket from the viewpoint of constructing a sewing pattern, you will start to think in "Illustrator terms" for drawing. Try to visualize a left and right jacket, two sleeves, two pockets, a left and right collar, and left and right lapels. Each of these garment parts will become an object in Illustrator, and some will be drawn on their own layer. The left sleeve (as you look at the image) will sit in front of the jacket, and the right sleeve will sit behind the jacket. This analysis will help you decide how to set up your layers.

Illustrator's Layers panel upon loading the Photoshop file

Step 1: Changing the name of Layer 1 to Sketch and setting up a template layer.

Setting up the Layers

1. Double-click on the words *Layer 1* in the *Layers* panel. Change the layer name to *Sketch*. Click on the *Template* check box to turn the template mode on. Notice how the **Dim Images** option automatically sets itself to **50%,** and other options are grayed out. You can change this to a smaller

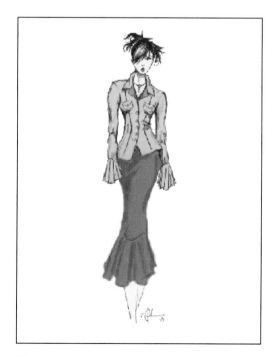

The image as a template in Illustrator

number to make the image lighter. Click **OK** to close the dialog. Your sketch will dim. This allows you to better view the tracing as you work. Notice also how the layer icon has changed to the template icon. You should see a lock appear in the second column of check boxes. This indicates that you can't draw on the layer.

2. Create a new layer by clicking on the panel menu button (arrowhead) in the upper right of the *Layers* panel. Choose *New Layer*. When the dialog window opens, name the layer *Jacket* and choose *Red* for the selections color.

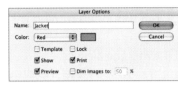

Note: It is helpful to choose a layer color that contrasts with the color of the image you are tracing, so that you may see your selections when necessary.

3. To try an alternative approach to creating layers, click on the *Create New Layer* button in the lower right corner of the *Layers* panel. Use this approach to set up a layer for the right sleeve. When you click on the button, a new numbered layer appears in the *Layers* panel. Double-click on the layer name to open the *Layer Options* dialog. Name the layer *Right Sleeve*. Use *Green* as your selection color.

4. Create another layer and name this one *Left Sleeve*. Use *Light Blue* as your selection color.

5. Save the file.

New Layer...
New Sublayer...
Duplicate "Sketch"
Delete "Sketch"

Options for "Sketch"...

Make/Release Clipping Mask

Locate Object

Merge Selected
Flatten Artwork
Collect in New Layer

Release to Layers (Sequence)
Release to Layers (Build)
Reverse Order

✓ Template
Show All Layers
Outline Others
Unlock All Layers

Steps 3–5: Setting up multiple layers using the Create New Layer button located at the bottom of the Layers panel.

All layers created with the Sketch template layer locked

Drawing the Jacket

1. Click on the **Pen** tool in the Toolbox.

2. Choose a black *stroke* with no *fill*. Set the *stroke Weight* to 1. (Note: A *stroke weight* of 2 is used in the illustrations here to make them easier to see.)

3. Click on the *Jacket* layer in the *Layers* panel to select it and ensure this is the layer you will draw on.

4. Draw the left side of the jacket as a complete object, being as careful as possible when you draw the shoulder, armhole, side seam, and hem areas. Draw around the armhole as you envision it. Use straight segments and curves as necessary. You don't have to be as precise when you draw the armhole, as it will sit under the sleeve. Draw under the collar. (Don't worry about total finesse here; the collar object will cover this later.) Do not draw in all the inner detail, just the outline. The detail will be added later. Make sure you close the object when you are finished. Save the file.

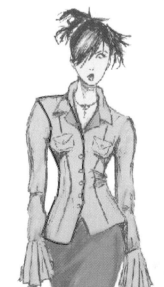

Step 4: Drawing the left side of the jacket.

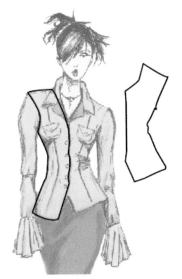

The left jacket (on the model) and right jacket (off the model)

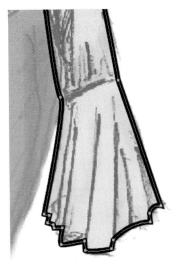

Step 4: Detail of drawn sleeve at cuff.

5. Draw the right side of the jacket. Since you drew this second, it will sit on top of the left side of the jacket. You do not need to be fussy as you draw the center front of this piece as it will later be moved to sit under the left jacket.

The illustration to the left shows you both sides of the jacket. The right jacket object has been moved off to the side.

Drawing the Sleeves

1. To facilitate the drawing of the sleeves, hide the jacket pieces by clicking on the eye icon on the *Jacket* layer. This will hide the layer from view.

2. Click on the *Right Sleeve* layer to make it active.

3. Continue using the **Pen** tool with a black *stroke* of 1 and no *fill*.

4. Draw the right sleeve, outlining its shape. Note that the selection color is green. Draw around the outer shape of the entire sleeve, including all the pleats at the bottom. You will draw the detail lines of the pleats later. (Alternatively, you could draw the sleeve cuff as a separate object.) Do not worry about drawing over the jacket, as you will move the sleeve behind the jacket later.

5. Click on the *Left Sleeve* layer to make it active.

6. Draw the left sleeve, outlining its outer shape. Note that the selection color is light blue.

Both sleeves should be complete objects. Save the file.

The left and right sleeves

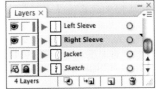

The Layers panel at this point

Using Fill to Test the Objects

Filling the jacket and sleeve pieces with a solid color will show you how the stacking order of objects on a single layer (the jacket pieces) and between layers (Jacket, Left Sleeve, and Right Sleeve) works. You will use the **Eyedropper** to make this process simpler.

1. Click on the eye icon box on the *Jacket* layer to display the jacket objects.

2. Choose the **Selection** tool in the Toolbox.

3. Click on the outer path of the left jacket piece. Note how the paths of the piece turn red (showing the selection) and how the layer is highlighted in the *Layers* panel.

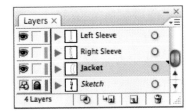

Selecting the Jacket layer

4. Double-click on the *Fill* icon in the Toolbox to open the *Color Picker* window. Choose a light orange color. Click **OK**. The left jacket will fill with orange.

5. Using the **Selection** tool, click on the right jacket piece.

6. Choose the **Eyedropper** tool in the Toolbox.

7. Click on the left jacket piece (which is filled) and the right jacket piece will now fill with the same orange.

8. Repeat the process to fill both sleeves.

9. Save the file.

Color Picker

Select Color:

H: 29 °
S: 73 %
B: 86 %
R: 221 C: 11 %
G: 140 M: 51 %
B: 58 Y: 89 %
DD8C3A K: 0 %

☐ Only Web Colors

OK
Cancel
Color Swatches

Steps 3 and 4: Filling the left jacket with an orange fill.

The Eyedropper tool

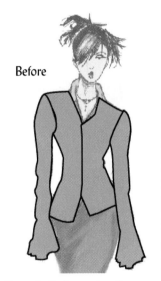

Before

Changing Stacking Orders between Objects on the Same Layer

By comparing the original sketch to the current drawing, you can see that the positions of certain objects and/or layers need to be changed. First, the left jacket needs to sit *on top of* the right jacket. Since both of these objects are on the same layer, we need to change their stacking order by using the *Arrange* command. *To do this:*

1. Choose the **Selection** tool.

2. Click on the left jacket piece to select it and it will turn blue. The *Jacket* layer will now become the active layer.

3. Choose the *Object>Arrange>Bring to Front* menu command. This will reposition the left jacket object on top of the right jacket object.

Steps 1–3: Arranging the position of the left jacket piece to bring it to the front using the Arrange command in the Object menu. The piece moved to the front of the stacking order (below).

Object

Transform	▶
Arrange	▶
Group	⌘G
Ungroup	⇧⌘G
Lock	▶
Unlock All	⌥⌘2
Hide	▶
Show All	⌥⌘3

Bring to Front	⇧⌘]
Bring Forward	⌘]
Send Backward	⌘[
Send to Back	⇧⌘[
Send to Current Layer	

Step 3: The Arrange menu is used to restack the order of objects.

After

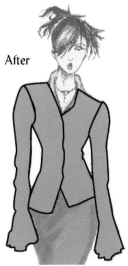

Alternatively, you could view the sublayers of the *Jacket* layer (click on the arrow on the left side of the layer) and drag the left jacket path above the right jacket path.

Click on the arrow on the Jacket layer to view the sublayers.

Changing Stacking Orders between Layers

The right sleeve needs to be placed behind the jacket, and since the *Sleeve* layers are positioned above the *Jacket* layer, both sleeves will sit on top of the jacket. For this reason, we need to move the *Right Sleeve* layer **beneath** the *Jacket* layer. This is done by changing the positioning of the layers.

1. Ensure all layers can be viewed by clicking on the eye icon to turn the view on, if necessary.

2. *Click+hold* on the *Jacket* layer and drag it up above the *Right Sleeve* layer. Note that as you drag the layer, you will see a black arrowhead appear on the left side between the lock well and the arrowhead of the layer. Drag the layer until it is above the *Right Sleeve* layer, yet below the *Left Sleeve* layer. Release the mouse.

Step 2: The right sleeve is positioned behind the jacket by moving the Jacket layer above the Right Sleeve layer.

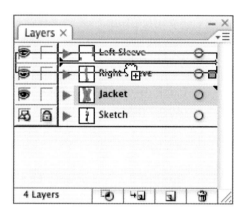

Step 2: Dragging the Jacket layer between the Sleeve layers. Observe the black arrowhead that appears as you drag the layer.

Save the file. It is now time to add the collar and garment details.

Add More Layers

1. Click on the *Jacket* layer to select it (as you want to position the new collar layer you are about to create above the *Jacket* layer).

2. Now, create a layer called *Collar* and use *Magenta* as the layer/selection color.

3. Click on the *Left Sleeve* layer to select it (as you want to position the new details layer you are about to create above all other layers).

4. Create a layer called *Details* and use *Teal* as the layer/selection color.

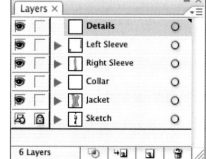

Steps 1–4: Adding Details and Collar layers in the appropriate layer stacking order.

Adding Layers
Prior to adding a new layer, click on the layer you want the new layer to be above, then add the layer. This will position the new layer directly above the currently selected layer.

Drawing the Collar and Lapels

1. Hide the *Sleeves (Left* and *Right)* and *Jacket* layers to easily view the collar and fashion details of the *Sketch* layer. Click on the eye icon to turn the view of each layer off.

2. Click on the *Collar* layer to make it active.

3. Using the **Pen** tool, (black *stroke* of 1, no *fill*) outline each side of the upper collar as an independent closed object (details will be added later). Using the **Selection** tool, move these objects off to the side so you can then draw the lapels of the collar.

4. Using the **Pen** tool again, draw the lapels of the collar. These need to be separate objects as their fill color differs from that of the rest of the garment and collar.

Continuing with the black stroke and no fill settings

Steps 3 and 4: Drawing the collar (left) and lapels (right).

5. Turn on one of the *Sleeve* layers by clicking on the eye icon. To select the same orange color as that used in the body of the garment, you need to see it.

6. Using the **Selection** tool once again, move the upper collar pieces into position, and fill them using the **Eyedropper** tool to pull the colors from the sleeve. You can *Shift+click* to select both collar pieces, then set the fill in one step.

7. Select one of the lapel pieces. Use the **Eyedropper** to set the fill the same as that of the collar. Double-click on the **Fill** icon to open the *Color Picker.* Move the color indicator circle to a color that is slightly deeper than the original orange. Click **OK**. Note that the lapel fill is now a deeper shade of the collar color.

8. Select the other lapel, and use the **Eyedropper** tool to make it the same color as the first lapel.

Use the Eyedropper tool to select the color of the jacket.

Step 7: Choosing a deeper shade of the collar color for the lapel color.

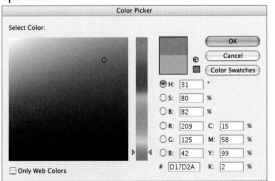

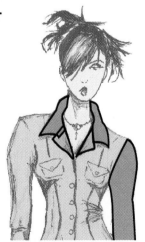

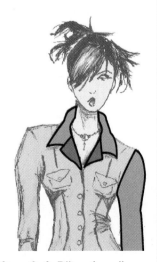

Steps 6–8: Filling the collar using the Eyedropper and filling lapels with a deeper shade of the collar color.

Hiding Layers
If you click, hold, and drag over the eyes in one step, you can quickly turn multiple layers off.

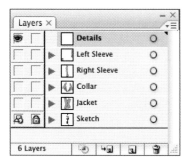

Step 4: Choosing the Details layer (above) and setting the Stroke thickness to .5 using the Strokes panel and Weight pop-up.

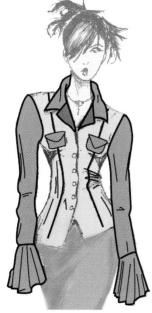

Steps 4–5: Adding the pockets.

Drawing the Details

1. Hide the *Collar* and *Sleeve (Left* and *Right)* layers.

2. Click on the *Details* layer to make it the active layer.

3. Set the *fill* to None.

4. Choose the **Pen** tool and draw in some of the jacket design lines (such as the princess line, fold lines, etc.). If you want, you can make these lines different stroke thicknesses using the *Stroke* panel. For very fine lines, use .5 point as your stroke thickness. You may also choose a deeper shade of the orange jacket color as your *stroke* color. Learn to use the *Cmd/Ctrl+click away* action to end objects.

5. Turn on the *Jacket* and *Sleeve* layers to view the details on the colored pieces. You may need to edit the details somewhat to align with the original outline of the garment.

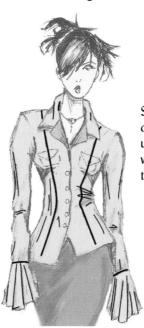

Step 4: Garment details are drawn on the Details layer, using the Pen tool, some with a thinner stroke than the outline of the jacket.

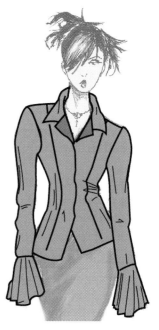

Drawing the Pockets

1. Hide the *Jacket* layer by clicking on the **Eye** icon for this layer in the *Layers* panel.

2. Ensure that you are on the *Details* layer.

3. Choose the **Pen** tool in the Toolbox and draw the pockets first, and then the pocket flaps. These will be closed objects. Since you drew these after the princess seam lines they will be positioned on top of them.

4. Using the **Eyedropper** tool, set the fill of the pocket objects to the same color as the sleeves. You will have to turn the view of a *Sleeve* layer on to borrow the orange fill color.

Drawing the Buttons

Create a new layer for the jacket's buttons, or you may draw them on the *Details* layer. If you use the *Details* layer, you will have to draw the pocket buttons off to the side, and then move them on top of the pocket flap later. For this reason, a *Buttons* layer is the best option.

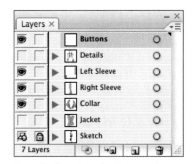

Step 1: Creating the Buttons layer.

1. Click on the *Details* layer, then add a new layer and name it *Buttons*. It will be positioned above the *Details* layer. Choose *Cyan* as the layer color.

2. Hide the *Details* layer by clicking on the **Eye** icon for that layer in the *Layers* panel.

3. Choose the **Ellipse** tool in the Toolbox (it is stacked under the **Rectangle** shape tool).

4. Choose a black *stroke* of 1 and a white solid *fill*. (You can click on the default *stroke/fill* icon, which appears to the lower left of the *Fill* and *Stroke* icons in the Toolbox.)

5. Zoom into the image over the button area.

6. Place your cursor over one button. Now press and hold the *Shift* key on the keyboard and *click+drag* the cursor to begin drawing an ellipse of the size of the button. Release the mouse button when the ellipse is the correct size. The *Shift* key serves as a constrainer and forces the ellipse to be perfectly round.

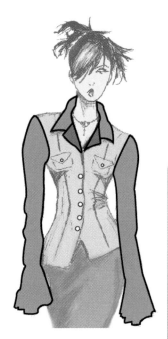

Steps 4–7: Drawing the buttons on the center front of the Jacket.

7. To create additional buttons use the *Opt/alt+drag* to duplicate the button you already have. Choose the **Selection** tool, and click on the first button to select it. Press the *Option* key (Mac) or the *Alt* key (Windows) and drag the button to a new location. This duplicates the button. Repeat this process until you have five buttons. Position them using the **Selection** tool.

8. Repeat the process to draw the buttons on the flaps of the pockets.

9. Change the *fill* of the buttons to the appropriate color.

10. Save the file.

Examine the Drawing

Turn on all layers and examine your work. Tweak any points/segments that need changing/altering.

Adding Shadows

If you want to add a little pizazz to your drawing, you can add shadowing to areas that warrant it. This is typically done by drawing open and closed paths with a color that is just slightly darker than the garment color. Set the *stroke* to None and the *fill* to the slightly darker shade of the garment color.

Setting up for creating shadow objects. Set the Stroke to None and the Fill to a color just slightly darker than the garment color.

You will need to experiment with this process. It typically involves turning layers on and/or off, locking layers, drawing, turning layers back on, tweaking

Creating the Shadows layer

the objects, etc. You will need to create a *Shadows* layer and place it beneath the *Details* layer.

The illustrations below show you the shadows that were added in given areas, and the finished drawing.

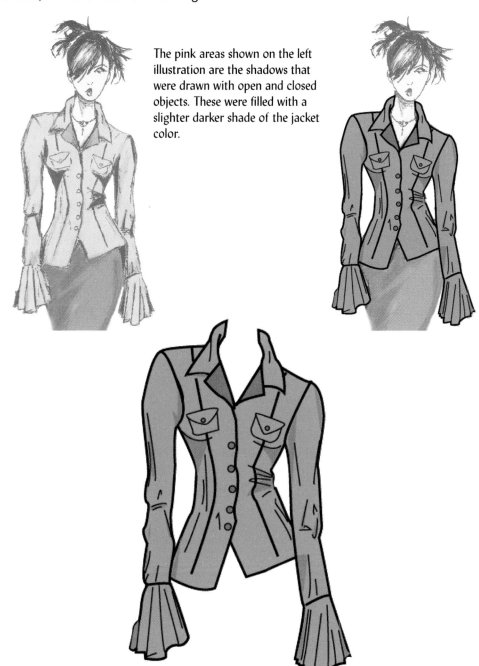

The pink areas shown on the left illustration are the shadows that were drawn with open and closed objects. These were filled with a slighter darker shade of the jacket color.

Completing the Drawing
If you want to complete the illustration, create additional layers to add the body and skirt of your drawing. Also, layers for the body, hands, face, pants, shirt, tie, etc., can be added. Consider what layers you will need, and where each should be placed in the stacking order.

Troubleshooting for this Exercise

The following are common issues/questions that arise in performing this exercise.

Question: I drew the object on the wrong layer. What do I do now?

Answer: Make sure the layer you want the object on is unlocked. Using the **Selection** tool, select the object. You will see a colored dot appear to the right of the Layer's name in the *Layers* panel. Drag the dot to the layer where you want the object.

Question: I can't see an object after I draw it.

Answer: Either you have both *stroke* and *fill* set to None, or another layer is covering the object.

Question: Illustrator is not allowing me to select an object. Why?

Answer: Most likely the layer the object is on is locked. Unlock the layer.

Question: What are sublayers?

Answer: Every time you draw an object on a layer, Illustrator creates a sublayer for that object. If you click on the arrowhead of a layer, it will open the various sublayers. You can move these layers around or delete them.

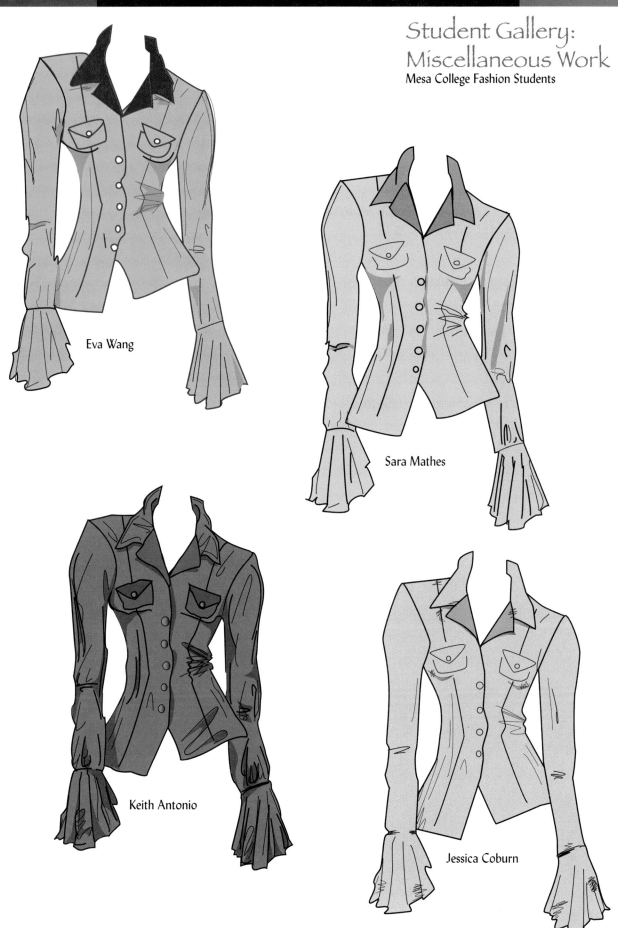

Eva Wang

Sara Mathes

Keith Antonio

Jessica Coburn

Exercise #11: Creating a Posed Fashion Figure from a Fashion Photo

Goal
In this exercise you will develop a fashion pose from a photograph to utilize in drawing and designing clothing.

Photoshop Tools and Functions
♦ *File>Browse* command (CS1) or Adobe Bridge (CS2/CS3)
♦ *Image>Image Size*
♦ *Image>Canvas Size*
♦ *Edit>Transform>Scale*

Illustrator Tools and Functions
♦ *File>Place* command
♦ **Pen** and **Selection** tools
♦ Layers, utilizing template layer, sublayers, locks, and viewing on/off
♦ **Eyedropper** tool
♦ Varying stroke weights (*Stroke* or *Control* panel)
♦ Stacking order between layers and objects
♦ Open paths

Overview of the Process
You will begin this exercise in **Photoshop** (or a similar program) by selecting and editing a fashion pose. *This entails:*
♦ Using the *Browse* command or Adobe Bride to locate and open an image.
♦ Adjusting the file size so that it does not take as much memory/space in the Illustrator file.
Optional
♦ Adding canvas to the bottom of the image.
♦ Making the legs of the model longer using the *Scale* function.

You will then move to **Illustrator** and place the image. This involves:
♦ Placing the fashion pose.
♦ Setting up layers for drawing the various body parts.
♦ Using the **Pen** and related tools to draw the torso, arms, legs, head, hair, and facial details.

Step-by-Step

Locating a Pose Using Photoshop
You can find great fashion poses by looking through fashion magazines, or utilizing photographs of posed positions. Look for an image where you can easily discern the figure under the clothing. In this exercise, we will use a library of images from a fashion shoot where different poses were encouraged and a variety of clothing was worn. It is best to browse through the images prior to loading one in Illustrator. The *Browse* feature of both Photoshop and Illustrator is a great tool that allows you to see images quickly.

Illustration by Renee Newstrum
Model: Paula Tabalipa

No Photoshop?
If you do not have Photoshop or a similar program, proceed directly to page 270 and begin working with Illustrator. Your file size will be slightly larger, as the original image you place in Illustrator will be larger.

Image Size (above) and Canvas Size (below) options.

This exercise will use a photo found in the **Photoshoot** folder of the accompanying DVD. There are various poses for you to choose from. It is best to move and/or save the photo of your choice to your working folder on your hard drive.

1. Open Photoshop.

2. Choose the *File>Browse* feature. In Photoshop CS1 or earlier, a *File Browser* window will open, similar to a file requestor. In Photoshop CS2/ CS3, the *Adobe Bridge* will open.

Steps 2–3: Using Photoshop's Bridge to locate files.

3. Using the folders and arrows in the left and/or upper left corner of the window, direct the browser to the **Photoshoot** folder on your DVD and double-click on it to open it. Once there, you will see thumbnails of the images in the folder. Scroll down to view all the images. Locate an image with a pose you would like to use. Click on the image to preview it in the *Preview* window. Note that all the files are .tif files. The image used in this exercise is **Design_084.tif**.

4. Double-click on the image to open it in Photoshop. Look at its size using the *Image>Image Size* menu. If you want to resize it, you may do it here, or wait until you get into Illustrator. You will see that these images are approximately 4 x 6 inches and use a resolution of 300. Each has a file size of approximately 7 megs. To reduce the size of your

Step 4: Adjusting the image size by reducing the Resolution to 150.

Illustrator file, it would be wise to reduce the resolution of this file to 150 or less. You can do this in the *Image Size* dialog. Set the *Resolution* to 150 and click **OK**. The file will resize to 1.5 megs. Save the file as **master photo.tif** in your working folder.

If you want to create a model that has a high fashion build (i.e., a 9- or 10-head tall model), you will need to alter the legs of the model in the fashion pose. You can do this in Photoshop now, or in Illustrator later. The choice is yours.

Stretching the Legs of the Fashion Pose in Photoshop (Optional)
Stretching the legs of this model will require two steps; first adding more canvas to the image, and then transforming the legs by selecting them and stretching them.

1. Choose the *Image>Canvas Size . . .* menu command. A dialog will open.

2. Set the height of the Canvas to **7.5** inches, and set the *Anchor* to the upper center by clicking on the upper center block in the Anchor area. Leave the canvas extension color as *Background*, which in this case is white (the current background color in the panel). Click **OK**. The document will enlarge with extra white area added beneath the model as shown below.

Step 2: Adding canvas to the document. The original image (left) and the new image (right).

3. Choose the **Rectangular Marquee** tool in Photoshop's Toolbox. Move over to the image and drag a marquee around the legs of the model. When you release the mouse, you will see a rectangular marquee and the "marching ants" surrounding the selected area.

The Rectangular Marquee tool

4. Choose the *Edit>Free Transform* menu. Note how the selection box changes and you now have eight squares (center and corner) on the rectangle. Move your cursor to the lower center square of the rectangle and note how the cursor changes to a *double arrowhead* when you are over this square. *Click+drag* the square down, which will stretch the selected area lengthwise. Stretch the legs until you think they are the

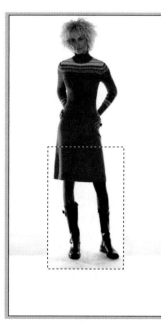

Steps 3–5: The process of stretching the legs of the fashion model using the Free Transform command.

The Cropping tool

correct length. Release the mouse button. To complete the action, click on the **check mark** that appears in the *Tool Options Bar* at the top of the screen. This finalizes the transformation.

5. You will now crop the image to keep only the portions you need to trace. Choose the **Crop** tool in the Toolbox and drag a box around the portions of the image you want to keep (i.e., the fashion model). Once you release the mouse button, the outer nonselected area will turn gray to show you what the cropped image will look like. Double-click inside the cropping box to finalize the operation.

Step 5: The process of cropping the fashion pose in Photoshop.

Original image (left)
Cropping in process (center)
Cropped image (right)

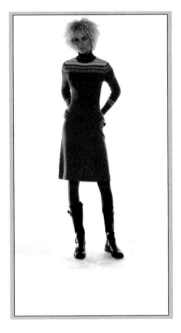

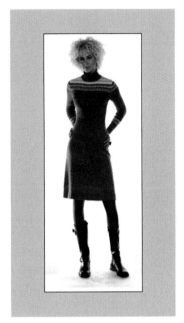

6. Save the file again. The file size will be smaller than it was before cropping.

You are now ready to move to Illustrator and begin the tracing process. You can use the transformed image (where the legs have been stretched) or you can use an original image and stretch the legs in Illustrator. We will do the latter in this exercise so that you learn how to alter the image in both Photoshop and Illustrator.

Loading the Image into Illustrator and Analyzing the Pose

1. Open Illustrator.

2. Create a new document using the *File>New* menu. Name the file *Fashion Pose* and choose either RGB or CMYK and 8-1/2 x 11 as your file size. Choose the *Portrait* mode. Click **OK**.

Note: Placing the Image
If you prepped an image in Photoshop, place this in Illustrator in step 3. Otherwise, locate an image in the Photoshoot folder of the accompanying DVD.

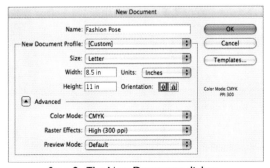

Step 2: The New Document dialog.

3. Use the *File>Place* menu to open the pose of your choice. You will need to direct Illustrator to the folder where the file is stored. When the

Place dialog opens, click on the *Template* option to turn it on. Leave the *Link* check box selected, as this will keep your file size smaller. Click on the **Place** button and the image will load as a template. This automatically locks and dims the template layer to 50%, and leaves *Layer 1* available for drawing. Note the icon is different on a template layer (you do not have the eye, but a template icon).

Step 2: The Place dialog.

A Template layer in the Layers panel is automatically dimmed and locked.

At this point you need to analyze the pose and determine if you want to increase its scale. Since the loaded image is 4 x 6 inches in size, we will increase its scale to fill the document more fully.

Scaling the Image

1. In the *Layers* panel, turn the lock on the *Template* layer **off** (click on the lock in the edit column).

Step 1: Turning the lock off.

2. Choose the **Selection** tool, and select the image so you can see its boundaries (as indicated by a red box and diagonal lines). If you can't see the boundaries, turn on the *Show Bounding Box* feature in the **Window** menu.

3. Double-click on the **Scale** tool in the Toolbox. A dialog opens. Type **160** in the *Uniform Scale* percent field of the dialog that opens. Click **OK** and the image will scale. You may want to undo and experiment with other scale amounts.

Note: Linked Files
Linking to an image allows the Illustrator file to be smaller, as there is simply a pointer to the original file. However, it becomes imperative that you not remove the linked file from its original location. If you do, you will need to reestablish the link. You must also include the file when you move the Illustrator file to a new location.

Step 3: Scaling the original image to better fill the document.

4. In the *Layers* panel, turn the lock on the *Template* layer back **on** (by clicking on the Toggle Lock checkbox in the edit column).

Setting up the Layers

Stop for a few moments and analyze your pose. Look beyond the clothing and determine where the torso meets the legs and arms. When planning your layers, consider which part of the body will sit on top of another part. This will dictate the order in which you create your layers, as the first layer created will be positioned lowest in the stack. Look at the arms on this fashion pose. You will see that the model's right arm sits more behind the torso than in front of it, and her left arm sits more in front. This will dictate where you place the torso layer in relation to the arm layers, and you will need to create two separate arm layers.

1. For the sake of this exercise, consider using the following layers, arranging them as follows:

♦ hair	layer 7
♦ facial features	layer 6
♦ head	layer 5
♦ left arm	layer 4
♦ legs	layer 3
♦ torso	layer 2
♦ right arm	layer 1
♦ photo	template layer

Don't worry about changing the layer colors, as Illustrator generally chooses good contrast colors as the default. If you need to change a layer's color, you can do this at a later time.

Note: You will rename *Layer 1*, and create new layers with identifying names for the additional layers.

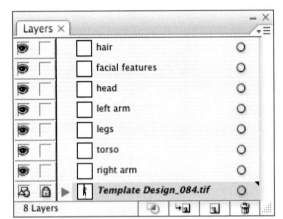

Step 1: Setting up the layers.

2. Save the file now, using the *File>Save* menu. You will not need to assign a name to the file since you named it when you set up the document.

Drawing the Torso

The best approach to drawing the pose is to begin with the torso. This helps you define where the leg and arm joints meet the limbs.

1. Click on the **Pen** tool. You might want to tear off the strip of Pen tools as you will likely move back and forth with the various tools as you work your way through this exercise.

Steps 1–2: Setting up the fill and stroke and choosing the Pen tool.

2. Choose a *fill* of *None* and a black *stroke* with a *Weight* of 1. (Note: The illustrations included here will use a wide stroke for demonstration purposes only.)

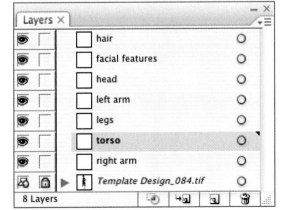

Step 3: Choosing the torso layer.

3. Click on the *torso* layer in the *Layers* panel to select it and ensure this is the layer you will draw on.

4. Draw the torso as a complete object. Add the curves for the bust as separate open path objects. These will help you determine if the proportions are correct.

5. When you are satisfied with the torso, lock the layer by clicking on the lock position of the edit column.

Drawing the Arms and Legs

1. Click on the *right arm* layer in the *Layers* panel to select it and ensure this is the layer you will draw on.

2. Draw the model's right arm as a complete object. You may add the finger details now or later. Begin by defining the outer shape of each arm. Use the torso as your guide, and adjust the points of both the torso and arm if you need to (unlock the *torso* layer if you need to edit it).

3. Click on the *left arm* layer to select it.

4. Draw the model's left arm as a complete object.

5. Click on the *legs* layer to select it.

6. Draw the left leg, and then the right leg. Do not worry about adding the inner details of the toes and crevices of the knees. You can add these later if you want them. If you didn't alter the leg length in Photoshop, you may choose to draw the legs longer at this time, or you may stretch them later.

Drawing the Head

1. You may choose to hide the *left arm, right arm, legs,* and *torso* layers so you can concentrate on the face. Click on the *eye* icons for each of these layers. Or, you can lock the body layers to prevent drawing on them.

2. Click on the *head* layer to select it.

3. The hair in this photo covers the ears, so it is not necessary to draw ears. If, however, your model does have ears showing, draw the head first and then the ears, each as a separate object.

Step 4: Drawing the torso.

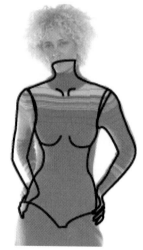

Steps 2–6: Drawing the arms and legs of the model on the appropriate layers.

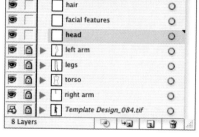

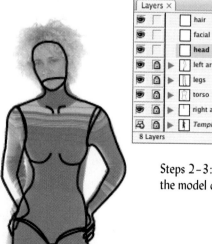

Steps 2–3: Drawing the head of the model on the head layer.

Sometimes it is possible to use the **Ellipse** shape tool to draw the head (if the model's face is relatively oval in shape), or use your **Pen** tool and outline the face. You may also start with the ellipse shape for the head, insert points, and edit point positions.

4. If your model has ears, temporarily set a white fill for the head and ears. This will allow you to see that the ears need to be placed behind the head. *Shift+click* on both ears and then use the *Object>Arrange>Send to Back* menu to send the ears behind the head. The illustrations below show you this process using a different model. Set the fill of the head pieces to None to see the facial details again.

5. Save the file.

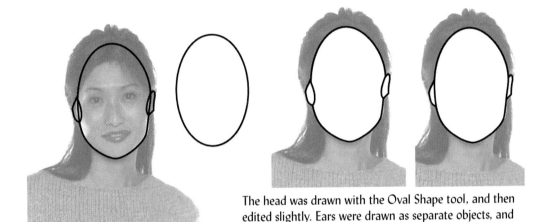

The head was drawn with the Oval Shape tool, and then edited slightly. Ears were drawn as separate objects, and the Object>Arrange>Send to Back command was used to position the ears behind the head.

Drawing the Facial Features

1. Hide the *head* and *torso* layers at this time so you can concentrate on the facial features.

2. Click on the *facial features* layer to select it.

3. Draw the facial features using whatever Illustrator tools serve the purpose best. Examine the **reneemodel.ai** file (included in the **Examples** folder on the accompanying DVD) to see how some of the facial features illustrated below were drawn.

Step 3: Facial features. Various techniques were used to draw the facial features shown to the right. See the list on the next page for a discussion.

There are various ways to draw the eyes, lips, etc., such as the following:

- Outline a feature's shape with the **Pen** tool, creating a closed object (the lips, eyebrows, etc.).
- Draw an open object with the **Pen** tool. Open objects can have fills (the nose).
- Use the **Brush** tool with an *Art Brush* option (e.g., charcoal), various brush strokes, and transparencies to create the feature (the blush, chin dimple, and forehead marks).
- Use a **Gradient Fill** tool to create a fill with greater interest (the eyebrows and eyes).

Drawing the Hair

1. Lock the *facial features* layer at this time so that you do not edit the features by accident. It is helpful to see the face as you draw the hair.

2. Turn on the view of the *head* layer by clicking on the eye icon in the edit column. Make sure this layer is locked as well.

3. Click on the *hair* layer to select it.

4. Draw the hair using whatever Illustrator tools best serve the purpose. Examine the file **reneemodel.ai** (included in the ***Examples*** folder on the DVD) to see how the hair was drawn. Look at other examples in this folder as well.

Step 4: Drawing the hair. Various techniques can be used to draw hair.

There are various ways to draw the hair, such as:

- You can outline its shape with the **Pen** tool, creating a closed object.
- Use the Brush tool and various brush strokes to create the hair.
- Use an outlined shape of the hair, but fill it with a gradient fill

Hairstyles will vary, and often you will need to draw the style utilizing several objects, some of which may need to be moved to a different layer (e.g., when long hair needs to be positioned behind the torso). Note, however, that if you were to draw the hair with extreme care, this wouldn't be necessary. But the

time invested is generally too great. Once the hair objects are drawn, it is often helpful to fill them prior to moving objects. Using the second model example, draw separate objects for each part of the hair on the *Hair* layer. The steps below can generally be used to move hair objects to a different layer:

1. Click on the *Edit* box of the *torso* layer to display the eye so that you can see the layer.

2. Using your **Selection** tool, click on one of the lower hair objects. Notice the color of the selection, and also notice that there is a little square of that color on the right-hand side of the *hair* layer.

3. In the *Layers* panel, click and hold on the little colored square and drag it to the *torso* layer. The lower hair objects will move to the torso layer. Note how the selection color of the objects changes to that of the layer. It will be necessary to move the objects behind the torso by choosing the *Object>Arrange>Send to Back* menu command.

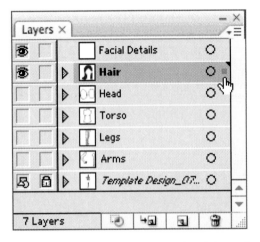
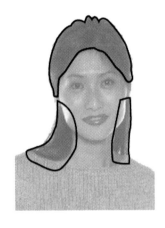

Steps 1–3: Objects may be selected and dragged to a new layer by clicking on the colored square that appears on the right side of the layer name and dragging it to the new layer. In the example to the right above, the lower hair objects were dragged to the torso layer and then arranged to go to the back.

Adding a Fill to the Various Objects

It is now time to add a flesh fill to all body parts. You might want to change the *stroke* color to a deeper shade of the flesh color (as opposed to black). Experiment with this. In the steps below, you will create a small rectangle of the desired *stroke* and *fill* colors and place it on the drawing. Then, you will select all the torso parts and use the **Eyedropper** tool to change all torso objects to the new flesh color in one step.

1. Lock the *hair* and *facial details* layers.

2. Turn on the view of all the body part layers (torso, legs, and arms).

3. Ensure that there are no objects selected in the document.

4. Double-click on the **Fill** icon in the Toolbox, and when the *Color Picker* opens, select a flesh color to be the fill color.

5. Double-click on the **Stroke** icon in the Toolbox, and when the *Color Picker* opens, select a deeper value of the flesh color to be the *stroke* color.

6. Using the **Rectangle** tool, draw a small rectangle on the torso layer, near the leg of the model.

7. Choose the *Select>All* menu command. All body objects and the small rectangle will become selected. You can see the selections in the *Layers* panel.

8. Choose the **Eyedropper** tool in the Toolbox, and click on the small rectangle of flesh *stroke* and *fill* on the screen. All the body objects will become flesh-toned.

9. Tweak any points, adjust positions, and perform any final edits or drawings.

10. Save the file.

Steps 1–2: Setting up the flesh-tone fill and stroke.

Step 7: Using the Select>All menu command in conjunction with choosing the desired layers.

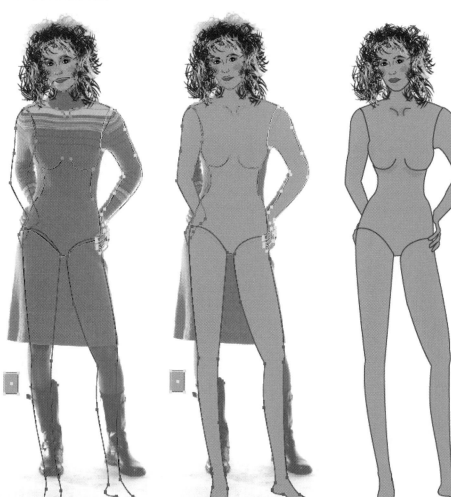

The final pose

Direct Selection tool

Stretching the Legs

If you want to create a pose that has elongated legs (and you did not stretch the legs in Photoshop), the process is simple in Illustrator. It is best to perform the stretch in two steps, first from the thigh level and below, and second from below the knee.

1. Ensure that the legs layer is visible and unlocked. Click on the layer to make it the active layer.

2. Choose the **Direct Selection** tool in the Toolbox. *Drag+select* an area from *mid-thigh downwards to include the feet.*

3. With the **Direct Selection** tool still active, click once on any selected anchor point and drag down the desired amount. Release the mouse button.

4. *Drag+select* an area from *upper calf downwards to include the feet.*

5. With the **Direct Selection** tool still active, click once on any selected anchor point and drag down the desired amount. Release the mouse button.

6. Save the file. This completes the exercise.

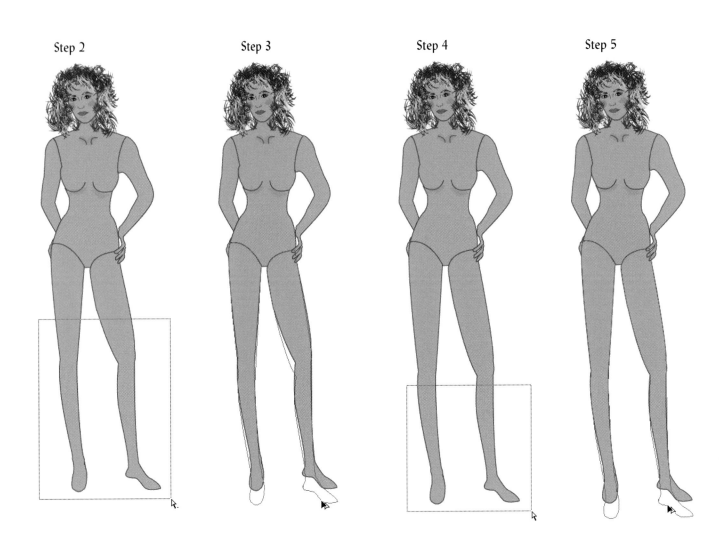

Step 2 Step 3 Step 4 Step 5

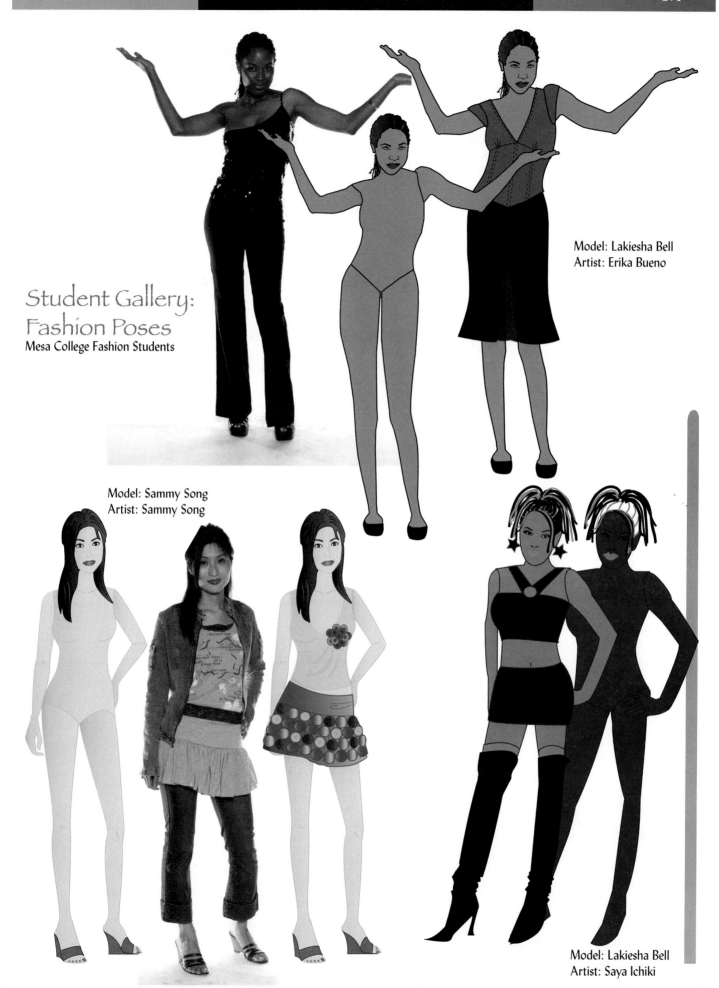

Model: Lakiesha Bell
Artist: Erika Bueno

Student Gallery: Fashion Poses
Mesa College Fashion Students

Model: Sammy Song
Artist: Sammy Song

Model: Lakiesha Bell
Artist: Saya Ichiki

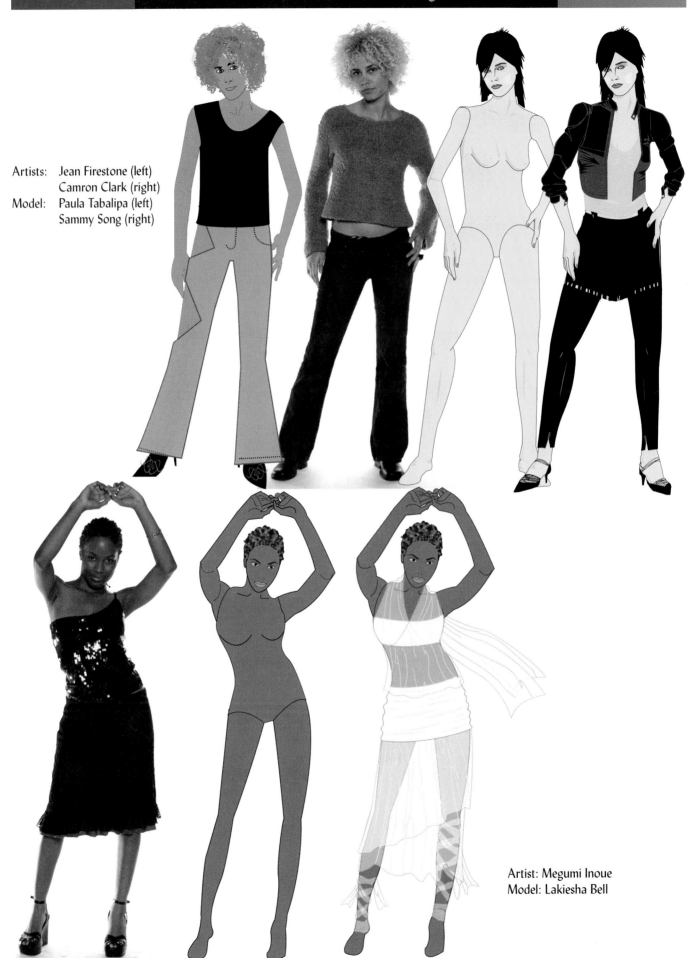

Artists: Jean Firestone (left)
 Camron Clark (right)
Model: Paula Tabalipa (left)
 Sammy Song (right)

Artist: Megumi Inoue
Model: Lakiesha Bell

Exercise 12: Creating a Screen Capture for Use in Illustrator

Goal
This exercise will teach you how to capture a screen image so that you may use it as a source/element of design. You will save the image and/or import it into Illustrator for use in design.

Why Create Screen Captures?
Performing screen captures is sometimes necessary if the software displaying the image source you want to use does not allow you to copy and/or save the file in a format that Illustrator will recognize. Both the Macintosh and Windows operating systems have built-in functions for performing screen captures. If you choose to take images from the Internet to bring into Illustrator, you must be conscious of copyright infringement and not violate an individual's or a company's rights. For the purposes of this exercise, we will go to the author's website and capture an image of a tote bag that is part of the *Couture Totes* pattern collection. The author expressly grants you permission to use any of the tote images as a tool in this exercise.

Images to be captured (with permission) and traced in Illustrator.

Macintosh and Windows Built-in Keyboard Shortcuts for Screen Capture

- *Shift+Cmd+3* Macintosh
 Captures the entire screen and creates a PDF file on the desktop of the hard drive.

- *Shift+Cmd+4* Macintosh
 Captures selected area to create a PDF file on the desktop of the hard drive.

- *PrintScreen* Windows
 Captures the entire screen and copies it to the clipboard.

- *Alt+PrintScreen* Windows
 Captures the active window and copies it to the clipboard.

Illustrator Tools and Functions
- *File>Place* menu command
- Layers

General Process
In this exercise you will:
- Locate an image on the Internet.
- Perform the proper keyboard shortcut to capture the image.
- Bring the image into Illustrator.

Note:

A Note on Copyright
One must always be cognizant of copyright violations when grabbing images from the Internet. There are lots of free graphics available for use. Perform a Google search to locate them (using free+graphics as your keywords for the search). In this exercise, you are sent to the author's website, with her permission to use graphics from certain pages of that site.

Step-by-Step
Locating an Image on the Internet

1. Go to the following URL: www.cochenille.com/gdgshtml/tote.html.
 This will take you to a page on the Cochenille Design Studio website
 that displays the various tote styles in a pattern collection called
 Couture Totes.

2. Click on the *Couture Totes* link at the top of the page, or scroll down
 the page until you see the *Bow Tie* design.

3. Click on the image
 to zoom to its
 largest version.
 It will open in a
 separate window.

Steps 1-3: Locating the tote image
and clicking on it to view it in its
largest format.

The Couture Collection on the Cochenille website

Performing the Screen Capture
Macintosh (OSX)

1. As you are viewing the large version of the Bow Tie image, press the
 following keyboard combination: *Shift+Cmd+4.* A crosshair cursor will
 appear.

The screen capture cursor
(Macintosh)

2. Drag your cursor over the area of the image you want to capture and
 release the mouse. You should hear a faint click sound, similar to a
 camera. The image will save as a PDF file, which is placed on your
 desktop. It will be named Picture x.pdf, (the x represents the number
 of the picture, so if it is your first screen capture, it will be named
 Picture 1.pdf). If you want, move to the desktop and confirm that the
 image is there. The PDF file is a bit-mapped or raster image.

3. Move the image from the desktop to your design folder so that you
 don't lose it. Make sure you know where it is located so you can find

it later. You can simply drag the file from the Finder into the folder you want to place it in.

Windows

1. If necessary, resize the window containing the Bow Tie image to crop it more tightly. Press the following keyboard combination: *Alt+Print Screen.* You will not see anything happen, but the active window will be copied to the clipboard.

2. If you want to save the file as a raster image, paste it into a paint-style program and save it in that program. If you do not own a commercial paint program, use the Windows built-in paint program (Paint). Click on *Start>All Programs> Accessories>Paint* to load the built-in paint program.

3. Choose the *Edit>Paste* command and the captured image will paste into the paint program.

4. If you want to crop the image, you will have to be creative, as there is no cropping tool in Paint. Choose the **Select** tool (the rectangular box in the upper left corner of the Toolbox) and *click+hold+drag* to frame off the part of the image you want to keep. Choose the *Edit>Copy* command. Create a new document, and choose the *Edit>Paste* command. The cropped area will appear in the document.

Steps 2–3: Opening Windows Paint (above) and pasting in the screen capture (left).

5. Save the file as a .tif file using the *File>Save As . . .* command. Saving the file allows you to place it in Illustrator as a linked image.

Step 4: The cropped version of the tote.

Bringing the Image into Illustrator: Opening versus Placing

There are two ways of bringing a raster image into Illustrator.

1. **Placing the image in Illustrator using the *File>Place* command**
 Using the *Place* function allows you to keep the Illustrator file size smaller, as you are pointing to or linking to the original raster image. The overall saved file size will be smaller but when transporting files, you must always include the linked image with the Illustrator file so that the link is not broken. Edits made to the linked file will be reflected in the Illustrator document the next time you open it.

2. **Embedding the file using the File>Open command or Edit>Paste**
 In this approach, the image will embedded in the file and the resultant file size will be larger than it would be if you placed the image. You do not need to worry, however, about including the source file with the Illustrator file if you are transferring files to other people. You cannot change the original artwork outside of Illustrator and have it update automatically once in the Illustrator file.

Note: Linked Files
Linking to an image allows the Illustrator file to be smaller, as there is simply a pointer to the original file. However, it becomes imperative that you do not remove the linked file from its original location. If you do, you will need to reestablish the link. You must also include the file when you take the Illustrator file to a new location.

The File>Place menu command (above) and a placed image (below)

Embedding Placed Images

If, after placing and linking to an image, you decide to embed the linked file, simply click on the Embed button in the Control panel (CS2/CS3). This will make the image part of the current file, and no link will exist to an outside file. The size of your Illustrator file will become larger.

Placing an Image

1. Open Illustrator. Set up a document using the *File>New* command. Choose the *Letter* size in *Portrait* mode. Name the file **Place example.ai**. Click **OK** and a new document will open.

2. Choose the *File>Place* command. When the *Place* dialog appears, direct the file requester to the location of the saved file. Once you have located it, click once on the file name to select it. Notice that you can choose to link to the file, and/or create a template. Ensure that *Link* is checked. Click on **Place**. A new dialog will open and you will see the option to control how the file is cropped. Choose *Art.* Click on **OK**. The file will appear in Illustrator. Note that it has a box around it with two diagonal lines crossing the file. This indicates that the file is a raster image.

Step 2: The Place dialog (above and below).

> **Note**: If you prefer to place the file as a *template*, Illustrator will place the image on a *template* layer, which automatically dims the image to 50% and locks the layer. You may opt to have the image linked or not linked to the source file.

3. Save the file.

Loading or Pasting in an Image

1. Choose the *File>Open* command. When the dialog appears, direct the file requester to the location of the saved file. Once you have located it, click on it once to select it. Click on **Open** and the file will open in Illustrator and appear as *Layer 1*.

OR

Ensure that you have copied the image you want to the clipboard (during the screen capture process or from a paint program). Create a new Illustrator document. Choose the *Edit>Paste* command to paste the image into the Illustrator file.

2. Save the file.

You have now successfully created a screen capture and moved it into Illustrator. It is ready for use.

Exercise #13: Automatically Tracing a Scanned Photo, Drawing, or Clip Art

The final traced top

Goal

In this exercise, you will learn how to automatically trace a nonvector, raster image. If you have version CS2/CS3, you will use the **Live Trace** tool, and if you are using an earlier version of Illustrator, you will use the Auto-Trace tool.

Illustrator Tools and Functions

- ◆ *File>Place* menu command
- ◆ **Live Trace** tool (CS2/CS3) or **Auto Trace** tool (prior versions of Illustrator)
- ◆ **Pen** and **Selection** tools
- ◆ Layers

Files to be placed in Illustrator must be saved in any format that Illustrator recognizes (other than an Illustrator .ai file). These formats include:

- • .eps
- • .tif
- • .jpg
- • .pdf
- • .psd

Overview of the Process

You will begin this exercise by creating or locating a raster (bit-mapped) source file. Place this in Illustrator and then use either the **Live Trace** or the **Auto Trace** tool to create a quick vector version of the image. You will then edit the paths, as necessary, to touch up the drawing. *The steps are as follows:*

- ◆ Open or place a raster (paint-style) file.
- ◆ Use the **Live Trace** or **Auto Trace** tool to create a quick tracing.
- ◆ Using the various **Pen** and editing tools, alter the traced path to improve the shape of the drawing.

Screen capture of the pattern pieces in the Garment Designer program

You may scan your own artwork for use in this exercise, or use a file provided on the Art DVD. This exercise will use a screen capture of a flat line-art drawing of a simple garment. The capture was made from a pattern-making program called *Garment Designer* by Cochenille Design Studio. Programs like Garment Designer can be used to quickly generate flats and then bring a screen capture of the pieces into Illustrator for tracing. Once you have created a vector file you can easily edit, add details, color the design, etc. The advantage of using pattern-making software is that the garment pieces are in proper proportion, which is helpful to users who have limited drawing skills. Since *Live Trace* is automated and will attempt to trace the entire selected object (including menus, toolboxes, etc.), the original screen capture was cropped so that only the pattern pieces remained.

Note:

Garment Designer Demo

A demo for Garment Designer may be downloaded from the Cochenille website: www.cochenille.com.

Step-by-Step
Placing and Scaling Artwork to be Traced

1. Create a new file using the *File>New* menu command. Choose *Letter* size, *Inches* measurement, *Landscape* orientation, and either RGB or CMYK color mode. Name the file if you like. Click **OK**. A new document opens in landscape mode.

2. Place the artwork you want to trace. We will use a file called **GDPeplumtop.jpg**. This is found in the **Art** folder of the **Fashion Exercises** folder on the accompanying DVD. If you have not already done so, move all the Exercises files and folders to your hard drive. This is important, as you will be linking to the placed file and you don't want to have to insert the DVD each time you open the traced Illustrator file you are about to create. Choose the *File>Place* command and, when the *Place* dialog opens, navigate to the folder on your hard drive where you are storing the files. Select the file. Click on the **Place** button.

3. The placed image is slightly wider than the document, so use the **Scale** tool to scale the image to 75% of its original size. Double-click on the tool and, when the dialog opens, type 75 in the *Scale* field and click **OK**. The image will scale.

The Scale tool

Step 3: Using the Scale dialog.

Alternatively:
CS2/CS3 users may choose to scale the image using the *Control* panel. Click on the lock between the 'W' and 'H' fields to lock the proportions. Type in the new width (9) and press the *Tab* key, or click on the blue 'W' by the width of the image to open the *Transform* panel. Then, type 9 in the width field, and press the *Tab* key to register the measurement change. The Height will automatically change to 5.1944 inches, which retains proper proportions.

Note:
Linked Files
When you place a file, you can choose to link to that file, which means that the file is not embedded in the image. Rather, a link exists between the image in the file and the original image. This means that you must always have the original image on the same computer as the Illustrator file.

Tip:
Placing EPS Files
If your placed file is an EPS file, do not link the file, as results will not be as good. If your placed file is a PSD (Photoshop) file, click the Flatten . . . option when you place the image.

Step 3: Using the Transform palette accessed through the Control Panel in CS2/CS3.

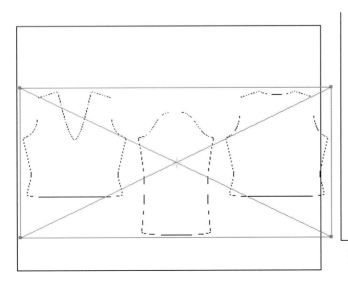

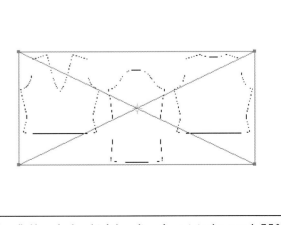

Before (left) and after (right) scaling the original artwork 75%

Note: If you do not have version CS2/CS3 of Illustrator, jump ahead to the next section, which deals with the **Auto Trace** tool found in prior versions of the software.

Using Live Trace in CS2/CS3

Live Trace is a new feature introduced in Illustrator version CS2. It is far superior to the **Auto Trace** tool found in earlier versions. *The general process of using the tool is as follows:*

◆ Open or place a file to be traced.
◆ Select the object you want to trace.
◆ Choose the approach you want to take in tracing the image:

• To trace the image using **default settings**, click on the **Live Trace** button in the *Control* panel or choose the *Object>Live Trace>Make* menu. Once you have chosen this option, you will still have an opportunity to explore other options.

• To trace an image using one of the **built-in presets**, click on the tracing **Presets and Options** pop-up menu (the down arrow) on the *Control* panel and choose one of the preset options.

• To set your own **custom tracing options** prior to tracing the image, click on the tracing **Presets and Options** button on the *Control* panel and choose the *Tracing Options* at the bottom of the list, then choose your settings in the dialog that opens.

◆ Experiment with tracing options.
◆ Expand the traced object to create final paths.

Click on the Live Trace button to choose the default settings.

Click on the Tracing presets and options button to choose the default settings.

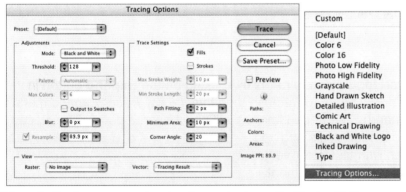

Click on the Tracing presets and options button to choose the Tracing Options menu command. A Tracing Options dialog will open and present you with numerous settings to explore.

Prior to performing the tracing, examine your artwork to determine what the best tracing option might be. The image is a basic black-and-white line art image. Upon exploring the various options, you might want to try the Technical Drawing, Black and White Logo, and Inked Drawing options as well as the default option. It's time to experiment!

1. Using the **Selection** tool, click on the placed image. It will highlight with a blue box and diagonal lines.

2. Experiment with the default setting of Live Trace by clicking on the

Live Trace button in the *Control* panel. As you will see by the results, the tracing looks good. Note that the options in the *Control panel* have changed. You now are viewing the *Tracing* options.

The Tracing options in the
Control panel

2. Zoom in to view the edges of the garments. Zoom right into the hem area and look at the trace. You can see how the line seems to have varied thickness. Now, click on the **Preset** pop-up menu and select the *Technical Drawing* option. Note how the threshold setting changes and look at the results of the trace on the magnified image. This appears to have a smoother line.

Step 2: Comparing the
Default tracing (left) to the
Technical Drawing tracing
(right).

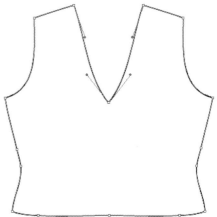

3. Convert the tracing to paths by clicking on the **Expand** button in the *Control* panel (or choose the *Object>Live Trace>Expand* menu command). The traced images will now become paths. The placed file no longer exists and you are left with Illustrator vector objects on your document.

Step 3: The Expand button is
used to convert tracing to paths.

4. Use your **Direct Selection** tool to click on various parts of the drawing to see the results of the tracing.

5. Edit as necessary using your **Pen** and **Selection** tools.

6. Save the file.

Step 4: Use the Direct Selection tool to click
on various paths on the drawing to see how
well the tracing worked.

Using the Auto Trace Tool in Illustrator versions prior to CS2

In versions of Illustrator prior to CS2, the software could automatically trace artwork with the **Auto Trace** tool in the Toolbox. Results varied according to the type and quality of the source image. From experience with students in the classroom, we have found the best results occur when you do the following:

♦ Separate multiple objects to be traced.

♦ Place the image to be traced as a template, which locks the layer.

♦ Perform tracing on a drawing layer.

♦ Consider enlarging the image to be traced temporarily, as Illustrator then has an easier time detecting the lines of the image. You can reduce the image size later, once the tracing is complete.

♦ Experiment a lot!

You may explore working with the placed file, as completed on page 286 (**GDPeplumtop.jpg**), or you may place a file of the front garment only, bringing it in as a template. We will do the latter in the steps below.

Step 1: Placing the artwork into Illustrator in preparation of Auto Tracing.

1. Place the artwork you want to trace. We will use a file called **GDPeplumtopfront.jpg**. This is found in the *Art* folder of the *Fashion Exercises* folder on the accompanying DVD. Choose the *File>Place* command and navigate to the folder on your hard drive where you are storing the files. Select the file. Ensure that the **template** option is checked. Click on the **Place** button. By using the Template option, the placed file will automatically become a *template* layer, which is dimmed and noneditable. If you need to reposition the image, unlock the *template* layer and, using the **Selection** tool, drag the image to its new position. Turn the lock back on when you are through.

2. In the *Layers* panel, double-click on *Layer 1* and rename it *tracing* in the dialog that opens. Click **OK**.

Steps 2–3: Setting up for tracing.

3. Set your *stroke Weight* to 1, and the *stroke* color to black. Do not use a *fill*.

4. Choose the **Auto Trace** tool in the Toolbox. (Note: It is under the **Blend** tool.)

The Auto Trace tool

5. Click on the *tracing* layer to make it the active layer. Place the cursor directly over a garment line on the drawing and click. You will see an object appear that has traced itself around an area of the garment/body. Experiment with the positioning of the Auto Trace *cursor*. Place it on

Step 5: Moving to the correct layer.

a line and click, then observe, and undo. Place it near a line, click, observe, and undo. You will most likely find the best results are achieved by positioning the tool directly on a straight line segment and clicking. Use the **Selection** tools to see how well the tracing worked.

6. Use your Illustrator editing tools to tweak and fine-tune the drawing. (Direct Select, Add, Delete and Convert Anchor Points, etc.)

7. Save the file.

The new object created by Auto Tracing, selected (left) and deselected (right)

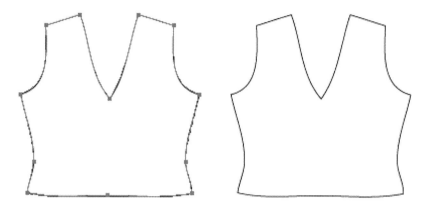

Note: You can control the way **Auto Trace** works by changing the settings in *Preferences.* Go to *Illustrator>Preferences>Type & Auto Tracing* (Mac) or *Edit>Preferences>Type & Auto Tracing (Windows).* If you set a higher number in the *Auto Trace Tolerance* field you will have fewer points, but the precision of tracing will lessen. The *Tracing Gap* controls the minimum width a gap in the line art must be in order to be traced. A high setting results in a lot of extra points.

You may find in certain situations that it is faster to simply set up layers and the **Pen** tool to trace the image. **Auto Trace**, although good for some drawings, is not the answer for everything. **Live Trace** in CS2/CS3 has drastically improved the ability to automatically trace images and is one of the main reasons users might choose to upgrade to this version.

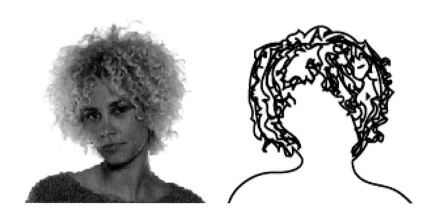

A creative use of Auto Trace, which is used here to trace lines of the hair

Exercise #14: Using Clipping Masks to Lay Scanned Fabric in Vector Images

Goal

In this exercise, you will learn how to combine a Photoshop bit-mapped fabric image with a vector drawing created in Illustrator using a technique called *Masking*.

Illustrator Tools and Functions

♦ *File>Place* menu command
♦ **Selection** tools
♦ Clipboard functions
♦ Stacking order of objects/layers and *Selection>Arrange* menu commands
♦ *Object>Clipping Mask* menu commands

Key Concepts

♦ A Clipping Mask allows you to place one object within the outline of another. Basically, it clips away the parts of shapes that extend beyond the border of the object in the front.
♦ The clipping mask is an object whose shape masks the artwork beneath it.
♦ Only vector objects can be clipping masks. Both vector and raster images can be masked.
♦ The stacking order of your objects or layers is important. In our case, the garment should be in front, and the fabric should be in back.
♦ Masks can be created and released.

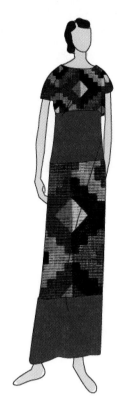

Vector illustration with raster-scanned fabric inserted into the bodice and skirt objects

Review the discussion of clipping masks found on pages 100–101 and Basic Drawing Exercise #10.

Overview of the Process

You will begin this exercise by creating or locating a raster (bit-mapped) fabric file in Photoshop or other raster-type program. Digital camera or scanned images may be used, but it is best to work with the image in Photoshop in order to enhance the colors, scale the image, etc.

♦ Prepare and save the fabric image in Photoshop or a similar program.
♦ Create or load a drawing of a garment in Illustrator.
♦ Place the fabric image into the Illustrator file using the *File>Place* menu command.
♦ Arrange the stacking order of the objects.
♦ Create a clipping mask.

Step-by-Step

Prepare the Fabric Image in Photoshop (or a similar program)

1. Scan or design your fabric. Prepare the imagery so that it is in an appropriate scale and so that you have enough imagery to cover the garment or garment area when you bring the fabric into Illustrator. It is helpful to think ahead and view the fabric (in Photoshop) and relate this to the drawing size you will be using in Illustrator (viewed at 100%).

The fabrics2sm file

2. If necessary, scale the image down using the *Image>Image Size* menu command. The *fabric2* sample here was scaled in half. Using this command allows you to resize the document at the same time as you scale the fabric. This reduces file size and minimizes memory use in Illustrator later.

3. Save the fabrics as a .PSD or .TIF file format so that you can place them into Illustrator. Sample files exist on the Art DVD. These files are found in the **Masking** folder, located in the **Fashion Exercises** folder. The example here was saved as **fabric2sm.tif**.

Changing the image size of the fabric file in Photoshop; before (left) and after (right)

There are two ways you can bring the fabric from Photoshop to Illustrator:
1. Using the *File>Place* menu command, which allows you to link to the Photoshop image, and thus keeps the Illustrator file size smaller.
2. Using the clipboard and copying the image in Photoshop and pasting it into Illustrator (resulting in a larger Illustrator file).

Both methods will be used to combine the fabric; one method in the bodice and the other method for the skirt.

The File>Place menu command

Placing the First Fabric into the Bodice

1. Create or load a drawing of a garment. You may choose to use the sample file found on the Art DVD (*Fashion Exercises>Masking* folder). This is called **FashionFigure.ai**. This exercise will utilize this sample file.

2. Once the file is loaded, examine what is on each layer. You will see that the garment pieces are the *clothing* layer. Click on the *clothing* layer to select it.

3. Choose the *File>Place* menu command and choose the **fabric2sm.tif** file (also found in the **Masking** folder). The fabric will appear on the document. Observe the *Control* panel for details of the fabric.

Steps 1–2: Loading the FashionFigure.ai file and examining the layers used.

The Control panel provides information on the placed image.

4. Using the **Selection** tool, position the fabric on top of the white bodice.

5. Choose the *Object>Arrange>Send to Back* menu command. This will move the fabric behind the white bodice.

6. Hold the *Shift* key down on the keyboard, and click on the white bodice to select it. You should now have the fabric and the bodice selected.

7. Choose the *Object>Clipping Mask>Make* menu. This will allow the bodice object to mask the fabric.

8. Click away to deselect all objects.

The bodice and fabric will now be grouped and the original *stroke* and *fill* of the bodice will disappear.

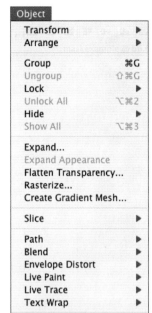

Steps 4–6: Positioning and arranging the fabric image behind the white bodice.

Step 7: Creating the Clipping Mask.

Repositioning the Print and Adding a Black Stroke to the Bodice

1. Choose the **Direct Selection** tool. Click on the fabric, and use your *arrow keys* on the keyboard to move it so that the imagery of the print is placed nicely within the bodice.

2. Still using the **Direct Selection** tool, click on the bodice. Click on the *Stroke* icon in the Toolbox, and choose black as the color. This will place a black outline on the bodice.

Using the Clipboard to Import the Second Fabric and Mask It into the Skirt

1. Move to Photoshop. Open the **fabric2.tif** image. This fabric is a larger scale version of the print used above.

2. Choose the **Marquee Selection** tool, and frame or select a piece of fabric that is larger than the skirt of garment you want to fill/mask with fabric.

3. Copy this to the clipboard using the *Edit>Copy* command.

Repositioning the print on the bodice (left) and changing the stroke to black (right)

The Rectangular Marquee Selection tool in Photoshop

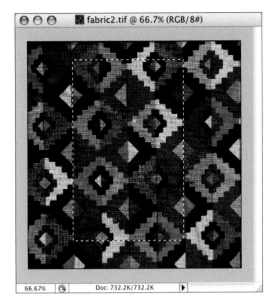

Steps 1–3: Moving to Photoshop,
selecting a portion of the fabric,
and copying this to the clipboard.

4. Move back to Illustrator. Ensure you are on the *Clothing* layer of the garment drawing.

5. Choose the *Edit/Paste* command to paste the fabric into Illustrator. It will appear as an object.

6. Using your **Selection** tool, move the fabric object over the skirt, and using the **Object** menu, choose the *Arrange/ Send to back* submenu to place the fabric object behind the garment. Leave the object selected.

7. Choose the **Selection** tool, press the *Shift* key on the keyboard and select the skirt object. You should now have both the skirt and the fabric selected.

8. Choose the *Object>Clipping Mask>Make* menu item. The fabric will now be cropped to the shape of the skirt. Note that the outline of the garment has disappeared into the mask.

9. Reposition the print as necessary and change the stroke of the skirt to black (see the prior section for the steps).

10. Change the fill colors of the midriff and lower skirt to coordinate with the print.

Note: You may click on the fabric object and move it around to get the best fabric placement. You may also perform additional operations to the fabric, like

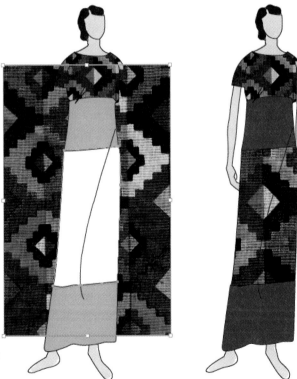

Steps 4–10: Positioning the fabric in Illustrator and creating the Clipping Mask.

Rotate, Scale, etc., using the *Transform* functions of the **Object** menu (with the fabric object selected).

Note: Masks may be released by choosing the *Object/Clipping Mask/ Release* menu.

This completes the fashion drawing exercises.

Textile Design Exercises

This chapter includes a series of exercises that focus on the development of textile prints. You will begin with a brief introduction to the terminology used in textile and print design. You will then learn how to work with Illustrator's built-in patterns, as this will teach you skills of defining and editing pattern fills within the software. With these basics covered, you can move on to designing your own motifs and textile prints, beginning with a simple approach, and moving on to more advanced techniques. Lastly, you will learn how to create multiple colorways of a print design.

Creating Colorways
Marina Savicevic

Exercises include:

Exercise # 1: Working with Built-in Patterns
Exercise # 2: Editing Existing Pattern Swatches
Exercise # 3: Creating a Pattern Tile (Simple)
Exercise # 4: Creating a Pattern Tile (Intermediate)
Exercise # 5: Creating a Pattern Tile (Advanced)
Exercise # 6: Setting up to Create Multiple Colorways for a Textile Print
Exercise # 7: Building Multiple Colorways of a Textile Print

Editing an Existing Pattern
by Alex Wright

Original Textile Print
Sharol Clay

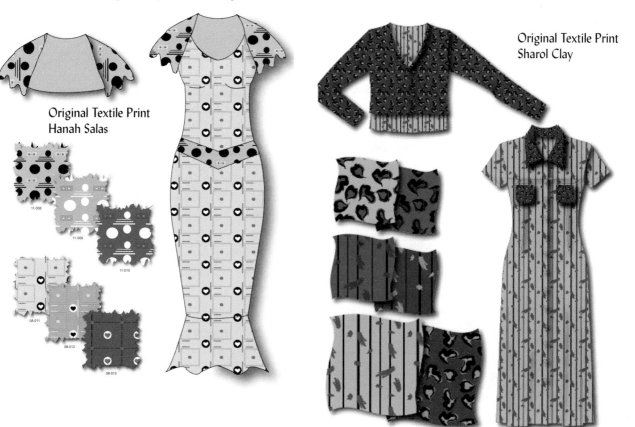

Original Textile Print
Hanah Salas

General Textile Terminology

motif

+

+

network

=

=

pattern

The evolution of pattern

Motif— An element (or elements) of design, developed to become the basic unit, which is typically repeated in textile patterns.

Network— The systematic manner in which motifs are repeated to create a pattern. Examples include block, brick, and half-drop.

Pattern— The resulting imagery created when a motif repeats in a regular design network.

motif + network = pattern

Illustrator Fill Pattern Terminology

Pattern Swatch—The way a pattern is stored for future retrieval. It becomes part of the *Swatches* panel.

Pattern— The result of motifs repeated in a systematic manner. Illustrator offers two types of patterns; Fill Patterns where the motif(s) tile perpendicular to the X-axis and Brush Patterns, which tile perpendicular to the path.

Tiling— The method Illustrator uses to create a fill pattern. Patterns begin tiling from the ruler origin and repeat in a left-to-right and top-to-bottom sequence until the selected object is filled.

Pattern Tile—An area defined either by the outer edges of selected objects, or by a pattern bounding box (a "no stroke, no fill" rectangle or square), which sits at the back of a stack of objects in Illustrator. The tile **must** be rectangular or square and it becomes the basic unit of design that repeats.

Fill Pattern—A single illustration that is small in size and repeats to fill an object/path. Patterns are accessed from the *Swatches* panel and are typically applied to fills only, although they can be applied to strokes.

Brush Patterns—A repeating image that is applied to the stroke of a path, which allows you to move around corners, etc. These are accessed from the *Brushes* panel.

Pattern Design by Sharol Clay

Things to Note When Working with Fill Patterns

Patterns take an incredible amount of memory. As you start to use them, you may find the following:
- File size increases.
- Printing slows down and can occasionally refuse to work.
- Screen refreshing takes longer.

Exercise #1: Working with Built-in Patterns

Goal
To learn how to utilize Illustrator's built-in pattern swatches to fill garments.

Illustrator Tools and Functions
- Pattern Fill of the *Swatches* panel
- Repositioning pattern fills
- **Scale** and **Rotate** transformation tools

Garments filled with pattern, the results of this exercise

Comments
- Patterns in Illustrator can be taken from the existing patterns found in the *Swatches* panel, or you can create your own custom patterns.
- You may edit the built-in patterns or any subsequent patterns you create.
- Patterns can be applied to a *fill* and/or a *stroke*, but patterned strokes can cause problems in printing (e.g., slow it down, refuse to print).
- After a pattern is applied to an object, you can use the *Transformation* tools to transform the pattern (e.g., scale, rotate).
- Pattern fills and strokes can only be viewed in *Preview* display mode.

Quick Overview of the Process
In this exercise, you will load a garment drawing and apply a pattern fill to it.
The steps are as follows:
- Load a predrawn garment.
- Apply a pattern fill to the body, arms, and sleeves.
- Scale the fill in one sleeve.
- Rotate the fill in the other sleeve.

Step-by-Step
Filling a Garment
1. Ensure that the *Swatches* library is available for use (choose the *Window>Swatches* menu command). To view the swatches only, click on the **Show Pattern Swatches** icon located in the icon strip at the bottom of the *Swatches* panel.

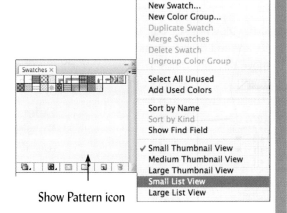

Show Pattern icon

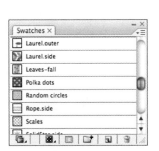

List View of the Pattern Swatches

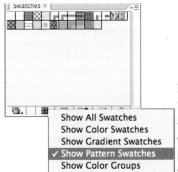

Clicking on the Pattern Swatch icon will allow you to view only the pattern swatches.

NOTE: If you do not have Jaguar or Optical Square in your Swatches panel, load the swatches file called textileexercises. ai from the Palettes folder of the Art DVD. To do this, click on the arrowhead in the upper right corner of the Swatches panel and choose Open Swatch Library>Other Library command. Navigate to the Palettes folder of the Art DVD files. A Textileexercises panel will open, which contains the pattern swatches used in this exercise.

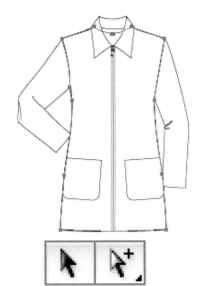

The Group Selection tool (above right) allows you to select individual objects within a grouped object file.

2. Load a file called **jacket1.ai**. This is found in the ***Textile Design Exercises*** folder located on the accompanying DVD. You may choose to use your own drawing or any of the garments on the **garments. ai** file located in the ***General Art*** folder on the art DVD. It is best to move all the files to your working folder on your hard drive. If you use a predrawn garment, use your **Direct Selection** tool to understand which objects in the drawing are closed objects to determine how the fill will work. Edit as necessary to close objects to be filled (see Fashion Drawing Exercise #7 for further explanation).

3. Using the **Selection** tool, or the **Group Selection** tool (if the object is grouped), select the body of the garment. Remember, the **Group Selection** tool is hidden under the **Direct Selection** tool.

4. Ensure that the *Fill* icon in the panel is in front of the *Stroke* icon, and thus active. If it is not, click on it to move it forward. In the *Swatches* panel, click on the pattern of your choice (e.g., Jaguar). Your garment will be filled with the pattern.

Choosing the Jaguar pattern from List view

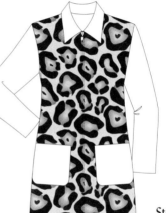

Step 4

Choosing the Jaguar pattern as the Fill results in the pattern filling the selected garment object.

Positioning the Pattern Fill Inside the Garment

To reposition the Pattern Fill inside a garment, select the filled object, then press and hold the tilde (~) key on the keyboard and drag your mouse to move the pattern inside the garment. The arrow keys can also be used to position the pattern as you hold down the tilde key.

drag onto the document

Step 3: Moving the Origin point on the Rulers.

Repositioning the Pattern within the Jacket

It is possible to reposition the pattern within the jacket body. *This can be done in one of two ways:*

1. Select the filled object using the **Selection** tool (or the **Group Selection** tool if the objects are grouped).

2. Press and hold down the *tilde* (~) key on the keyboard. Drag your mouse on the screen to position the pattern, or use the arrow keys to nudge the pattern's position.

OR

3. Turn on the **Rulers** (*View>Show Rulers*) and drag the origin point of the ruler to a new position. The originating pattern of the tile is tied to the origin point of the ruler. Therefore, when you move the origin you move the tile's position.

Repositioning the pattern. Note that the pattern position has changed from Step 4 above.

To change the origin point, click and hold on the crosshairs that appear in the upper left corner of the rulers and drag this onto the document to a new position. Save the file as **jaguar1.ai**.

Reducing the Scale of the Pattern

Once you have employed a pattern fill, you may experiment with various transformations such as scaling, rotating, etc. *To scale the pattern within a garment:*

The Scale tool

1. Select the filled object using the **Selection** tool (or the **Group Selection** tool if the objects are grouped).

2. Double-click on the **Scale** tool in the Toolbox and wait for the dialog to open. Ensure that the **Uniform** radio button is selected, and type 50 in for the scale. Since we only want the scale of the print to be reduced (and not the actual garment itself) ensure that the *Objects* option is unchecked and that the *Patterns* option is checked. Click **OK**. The scale of the pattern will reduce within your garment.

3. Save your file as **jaguarscaled.ai**. Note the location of the saved file as you need to use it in the next exercise.

Results of Step 2

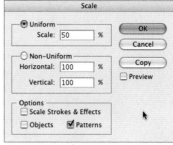

Step 2: Setting the scale of the pattern fill to 50%. Note that only the Patterns option is checked.

Rotating the Pattern

If your garment has sleeves that angle, you ideally should rotate the position of the print within the object. The jaguar pattern is the type of print that can be laid in garments without easily showing the linear pattern of repeat, so we will now use a different garment and pattern to demonstrate how to rotate a pattern fill in an object.

1. Load the file called **garmentrotate.ai** from the *Textile Design Exercises* folder on the art DVD (or your working folder). Note that the garment's body is already filled with a definite linear pattern. This pattern is one of Illustrator's built-in patterns called *Optical Squares*. It has not been scaled.

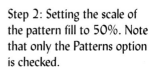

Eyedropper tool

2. Using the **Direct Select** or **Group Select** tool, click on the sleeve to the right of the body. Select the **Eyedropper** tool in the Toolbox and click on the body of the garment. The sleeve will fill with the same pattern as the body, but note that it is not angled, as would be ideal.

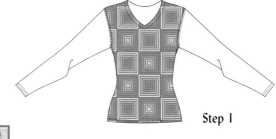

Step 1

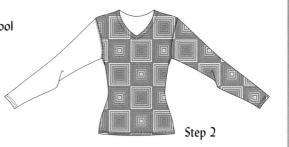

Step 2

Rotate tool

3. Ensure that the sleeve is still selected. Double-click on the **Rotate** tool in the Toolbox, and wait for the dialog to open. Ensure that the *Objects* option is unchecked and that the *Patterns* option is checked. Turn on the *Preview* by clicking on the check box. Set the angle to 50 degrees and press the Tab key to finalize the entry. The *Preview* will allow you to see if the rotation angle works. Experiment with different angles if you like. Click **OK** to complete the rotation.

4. Repeat Steps 2 and 3 for the opposite sleeve. Note that the angle of rotation needs to be -50 for the second sleeve. Press and hold the *Tilde* key and use the *arrow keys* on the keyboard to reposition the pattern as desired.

5. Save the file.

Step 3

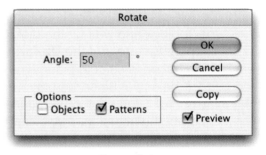

Rotate dialog

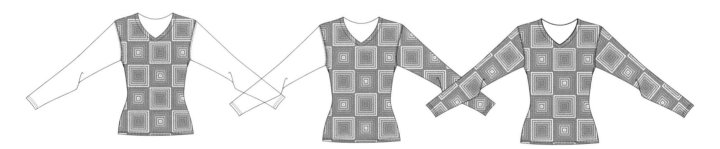

The steps of inserting the pattern with adjustments to scale and rotation

The final garment with a deeper value of one pattern color used as a fill in the back neckline of the garment

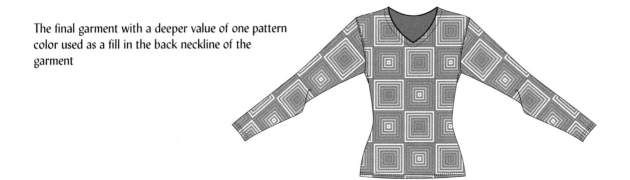

Exercise #2: Editing Existing Pattern Swatches

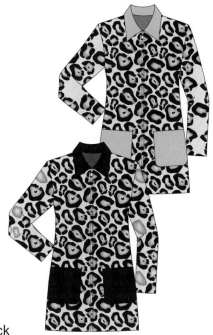

Goal

To learn how to edit existing pattern swatches and utilize them in garment design.

Illustrator Tools and Functions

- *Swatches* panel with *Show Pattern Fill* option active
- Repositioning pattern fills
- Define pattern through *Edit>Define Pattern* and through dragging the objects to the *Swatches* panel

Comments

- You can edit Illustrator's built-in patterns or any new patterns you create.
- Dragging a swatch from the *Swatches* panel onto your document allows you to see the objects used to build the swatch.
- All parts of a new edited swatch can be selected and dragged back onto the *Swatches* panel to create a new swatch. Double-click on your swatch in the *Swatches* panel to name it.
- You can also use the *Edit>Define Pattern* menu command to create a new swatch, in which case you will be asked to name the swatch immediately.
- The jaguar pattern is a complex pattern that utilizes not only multiple objects to create the gradient appearance of the spots, but advanced motif placement to allow for seamless tiling of the imagery. Read the instructions below carefully.

Quick Overview of the Process

For this exercise, we will use the Jaguar pattern from Exercise #1. *The process is as follows:*

- Load the file created in Exercise #1.
- Drag the Jaguar swatch off the *Swatches* panel onto the document so that it can be edited. Create multiple copies.
- Edit each object set to create new patterns by removing inner and/or edge objects.
- Redefine the pattern to create new pattern swatches (one for each edited version).
- Fill the sleeves with the new edited pattern(s).
- Determine the individual colors used in the original pattern so that you may fill the collar with a solid coordinating color.

Note:

Palettes

If you do not have the Jaguar pattern in your Swatches panel, either load a file that used the jaguar swatch, or load the swatches file called textileexercises.ai from the Palettes folder of the Art DVD. To do this, click on the panel menu arrowhead in the upper right corner of the Swatches panel and choose Open Swatch Library>Other Library. Navigate to the Panels folder of the Art DVD files.

Step-by-Step

Prepping to Edit the Pattern

1. Load the **jaguarscaled** file you saved in the last exercise.

2. Open the *Swatches* panel. View the *Pattern* swatches only, in whichever view you prefer (list view is used here). Click on the **Show Pattern Swatches** button on the button strip at the bottom of the panel.

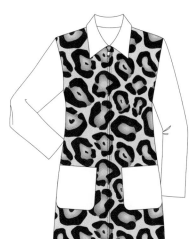

Step 1: Loading the scaled Jacquarscaled.ai file.

3. Place your cursor on the jaguar swatch, then *click+hold+drag* the swatch over to an available area on the document. Release the mouse button. You will see all the objects in the swatch in their selected mode; they are grouped. Click away to see the swatch in a deselected mode.

Step 3: Dragging the pattern off the panel. All objects of the swatch are selected.

Click away to deselect the objects.

In the illustration above, click+hold on the pattern swatch name in the palette and drag your mouse to the left, off the panel, and the swatch will appear on the document with all objects selected. Click away to deselect all the objects (as shown in the sample to the right).

Understanding How Tiling Works

Since the *jaguar* swatch is a complex swatch and you want to conserve its seamless tiling, you must be careful in editing. If you examine the illustration to the right, below, you will see how objects that extend over the edge of a tile align with the corresponding portion of the motif on the opposite side of the tile. You will learn more about this in Exercise #4 as you build your own complex tile. For purposes of this exercise, know and understand the following simple rules:

1. You may remove or alter inner motifs/objects (those that sit completely within the tile) in any manner you like (completely, partially, etc.)

2. If you remove or alter motifs/objects that touch the edge of the tile, you must perform the same action to the portion of the motif that sits on the opposite side of the tile.

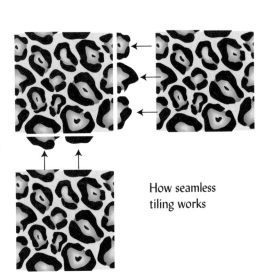

How seamless tiling works

Editing the Tile

1. Begin by making copies of the original pattern swatch. To do this choose the **Selection** tool and drag a box around the entire jaguar swatch on your document to select it.

2. Press and hold the *Option* key (Macintosh) or the *Alt* key (Windows) and drag the swatch to the right. Repeat this until you have three or four swatches on the document.

Opt+Drag (Macintosh) or Alt+Drag (Windows) the selected swatch to create multiple copies.

3. Remove and/or edit objects on the swatch. You will need to ungroup all the objects by selecting a tile and choosing the *Object>Ungroup* menu command. Observe the examples below for ideas. The tile on the right is the original tile. The two center tiles have had inner objects removed either completely or partially. Objects have been removed from the tile on the left and since these touched the edge, it became necessary to remove the objects at the top and bottom, and left and right (to ensure that the complete object was removed).

Choice of Selection Tool and Grouped Objects
If you use the Direction Selection tool or the Group Selection tool when working with grouped objects, you do not need to ungroup the objects in a pattern tile prior to editing.

Left to Right: tile with objects removed at the edge, tile with inner objects completely removed, tile with inner objects partially removed, original tile.

Edge objects removed Inner objects removed Original

Creating New Swatches from the Edited Tiles

Now that you have edited the swatches, you need to set them as patterns once again. If you did not ungroup the original tiles, the process will be simple. If you did ungroup the tile, you may want to select all objects and group them again. *There are two ways to define a pattern:*

Method One:

1. Using the **Selection** tool, select all objects in one of the pattern tiles.

2. Drag all the selected items into the *Swatches* panel to a blank area. You will see the swatch appear with the name *New Pattern Swatch 1*.

3. Click away on the document to deselect the object.

4. Double-click on the name of the swatch to open the *Swatch Options* dialog. Type in a new name for the swatch (e.g., Jaguar1). Click **OK**.

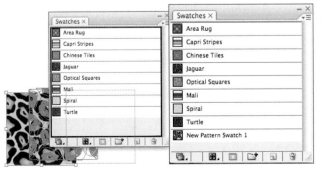 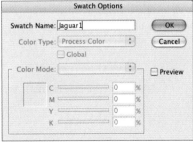

Method 1:
Select all the objects of the altered swatch, then drag them over and onto the Swatches panel. Double-click on the New Pattern Swatch 1 name to open the Swatch Options dialog and rename the swatch. Click OK.

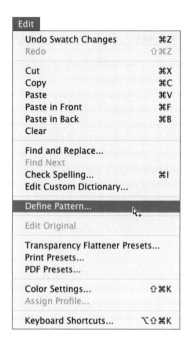

Step 2: Using the Edit>Define
Pattern menu command.

Method Two:

1. Using the **Selection** tool, select all objects in one of the pattern tiles.

2. Choose the *Edit>Define Pattern* menu. A *New Swatch* dialog will open. Name the swatch and click **OK**. The swatch will appear in the *Swatches* panel.

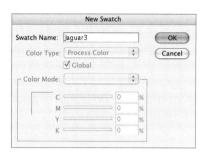

Method 2: Select all objects of the tile on your document. Choose the Edit>Define Pattern menu and name the pattern. Click OK. The pattern will appear in the Swatches panel, available for use.

Using the New Patterns to Fill the Sleeves

If you want to experiment with the various new pattern fills, make several copies of the garment. You can do this by using the *Option+Drag* (Mac)/ *Alt+Drag* (Windows) method. You may notice that operations are slowing down and the screen takes longer to refresh. Using *Pattern* swatches with multiple objects can do this. Save often.

Two variations of edited patterns. The sleeves on the left garment use a pattern that has removed motif elements. The sleeves on the right garment have some of the black elements of the spots removed.

1. Using the **Group Selection** tool, click on one of the sleeves to select it.

2. Click on the *Fill* icon in the Toolbox to make it active.

3. Choose one of the new Jaguar patterns in the *Swatches* panel. The new pattern will fill the sleeve.

4. While the sleeve is still selected, choose the **Scale** tool in the Toolbox and scale the pattern to 50%. See Textile Design Exercise #1 for a refresher if necessary.

5. Save the file to update it.

Continue to experiment with variations.

Pulling a Color from a Swatch

If you want to utilize a single color from a pattern swatch, tear the swatch off the *Swatches* panel as if to edit it, and then select an object on the swatch that contains the color you want as either a *fill* or *stroke*. Then, you will drag that color from the *Fill* or *Stroke* icon in the Toolbox to the *Color Swatches* panel. Since you still have access to the Jaguar swatches from the prior exercise, use these to locate a coordinating color for the collar and pockets of the jacket.

Step 2: Selecting an object to determine its color properties as shown in the Fill icon.

1. Ensure that you have a pattern swatch tile on the document, available for editing. If you don't, drag a jaguar pattern tile off the *Swatches* panel onto the document.

2. Using the **Group Selection** tool, click on a spot of the pattern on your document, and view its color in the *Fill* icon of the Toolbox. Experiment with colors by selecting different objects until you find the color you want.

 Step 4: New colors added to the Swatches panel by dragging the color from the Fill icon of the Toolbox to the blank area of the Swatches Panel.

3. In the *Swatches* panel, click on the *Show Color Swatches* icon at the bottom of the panel. This will display only the *color* swatches.

4. Drag the *fill* color from the Toolbox into the *Swatches* panel. This will place the color in the *Swatches* panel and make it available for use with this file.

 Step 3: Click on the Show Color Swatches icon along the bottom of the Swatches panel.

5. To place the solid color on your collar and pockets, use the **Group Selection** tool and click on the collar and pockets of the garment. Then change the fill of these objects to be the solid color you pulled from the pattern swatch.

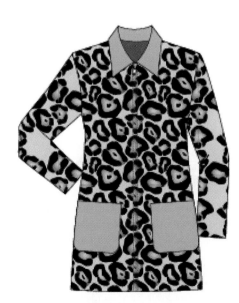 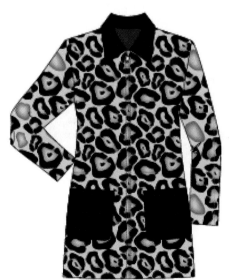

Final jaguar patterned jackets

Edited funky flower tile by Alex Wright

Edited jaguar pattern by Elizabeth Celaya

Edited jaguar pattern by Keith Antonio

Exercise #3: Creating a Pattern Tile (Simple)

Goal

To create a simple repeating tile, where the motif elements are contained within the boundaries of a colored background rectangle.

Illustrator Tools and Functions

- **Spiral** tool (located in the drawing tools pop-out)
- *Edit>Define Pattern* menu command
- *Swatches* panel

Comments

- You will combine motif elements with a solid-fill rectangle to create a repeating tile pattern.
- You can create the motifs first, then surround them with a rectangle and send it to the back; or you can create the rectangle/square first and then lay the motif objects above and inside it. In our example, we will create a spiral motif using the **Spiral** tool found in the *Drawing* tools pop-out, and stacked beneath the **Line** tool.
- The solid background color of the textile needs to be positioned behind the motif image objects.
- You **cannot** use gradients or other pattern fill swatches as fills while creating a new pattern swatch. Illustrator will not allow you to define a pattern if you use any of these.
- A new swatch can be created by selecting the motif elements and the background rectangle/square and dragging them over the *Pattern Swatch* panel. You will need to double-click on the swatch name to name the pattern.
- Alternatively, you may also use the *Edit>Define Pattern* as a method to create a new swatch, in which case you will be asked to name your swatch immediately.

A swirl pattern is created and inserted into the garment.

Overview of the Process

In this exercise you will create a pattern swatch by doing the following:

- Build the solid background of your pattern using a colored *fill* and no *stroke* and the **Rectangle** tool to define the size of the tile.
- Add motif elements on top of the rectangle. All motif elements will sit inside the tile and will not extend over an edge.
- Create a pattern swatch by selecting all objects and either dragging them onto the *Swatches* panel or using the *Edit>Define Pattern* menu command.
- Fill a garment with the pattern and scale it down to an appropriate scale.

Step-by-Step

Setting up

1. Create a new document by using the *File>New* menu or pressing *Cmd/Ctrl+N* on the keyboard. Name this file **simplepattern.ai** and choose the *Letter* size with a *Portrait* orientation, and the CMYK color mode. Click **OK**. The document will appear. Save the file.

Steps 1 and 3:
Setting the fill to your chosen fabric background color (above) and drawing the solid rectangle using the Rectangle shape tool (below).

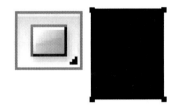

Developing a swirl pattern using the Spiral tool with a purple stroke and no fill

The Drawing tools pop-out

The Spiral tool creates a swirl-shaped object of a given radius and number of turns. You can either click+hold+drag your mouse to create a spiral or click on the screen to open a dialog where you can specify the radius and number of turns.

Dragging the selected objects onto the Swatches panel (in List view). Note that the Show Pattern Swatches button was used to view pattern swatches only.

2. Ensure that the following panels are open and in view: *Color, Swatches, Layers.* These are found in the **Window** menu. You may also turn on the *Control* panel (*Window>Control*, CS2/CS3 version only).

Building the Background Fabric Color of the Tile

1. Set the *stroke* to *none* and the *fill* to a color you would like to use for the background color of the fabric you are creating.

2. Turn on the Rulers (*View>Show Rulers*). Ensure that your preferences are set to *Inches*.

3. Choose the **Rectangle** tool in the Toolbox and draw a rectangle on your document. This will represent the background color of your fabric. Keep it relatively small, e.g., no bigger than two inches in either direction. This creates a boundary for the tile. You must use the **Rectangle** shape tool, as Illustrator will not allow you to use any other tool to define the outside boundaries of a *Pattern* swatch.

Building the Motif Elements of the Tile

1. Using the tools of your choice, and the *fills* and *strokes* of your choice, create shapes or objects on the image and position them (using the **Selection** tool) on top of the colored rectangle. The example here utilizes the **Spiral** tool, which is located under the **Line** tool in the *Drawing* tools pop-out.

2. Manipulate the motif by copying it and using the *Transformation* tools (such as **Rotate**, **Scale**, etc.). As you lay the objects onto the rectangle, do not allow them to extend over the outer edge of the rectangle.

3. Change the *fill* and *stroke* of the original rectangle if you want to make a change at this point. If you use a stroke, it will be part of the pattern design. The example here has a stroke of *None*.

Step 2: Developing the pattern.

Creating the Pattern Swatch

To view only the pattern swatches in the *Swatches* panel, click on the **Show Pattern Swatches** button at the bottom of the panel.

 You can create the Pattern swatch in one of two ways:

1. Using the **Selection** tool, select the rectangle and the motif element shapes within it. The easiest way to do this is to *drag+select* around all the objects. Then, drag all the objects into the *Pattern Swatches* panel. A new pattern swatch will appear in the panel. If you want to name it, double-click on the swatch to open the *Swatch Options* dialog, name the swatch, and click **OK**.

OR

2. Using the **Selection** tool, select the rectangle and the shapes within it. Choose the *Edit>Define Pattern* menu command. A *New Swatch* dialog window opens. Name the pattern. Click **OK**. The new swatch will appear in the *Swatches* panel.

Method 2: Select all objects and choose the Edit>Define Pattern menu command. Name the swatch and click OK. The new swatch will appear in your Swatches panel. The list view of pattern swatches only is shown above.

Filling a Garment

Load a fashion garment and fill it with pattern. You can use a fashion pose found on the art DVD.

1. Load the file called **woman1.ai,** which is located in the ***Textile Design Exercises*** folder on the accompanying DVD or your working folder on your hard drive (presuming you have moved the exercise files to this folder).

2. Take a few moments to analyze how the drawing was done. You will see that a different approach was taken to filling the shorts and bands of the top to give the illustration a more painterly look.

3. Using the **Selection** tool, click on the left top and change the *fill* to your fill pattern. Repeat for the right side of the top.

4. Scale the print following the instructions of Textile Design Exercise #1.

5. Save the file.

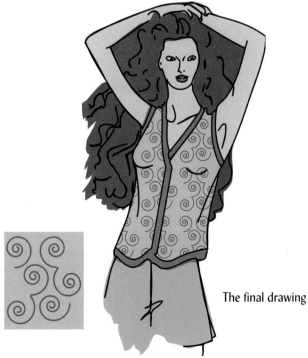

The final drawing

Simple Pattern Designs

Fabric Design by
Mildred Carney

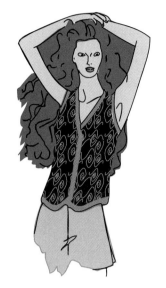

Master Tiles and Sample Prints

 Grass

 Night

Sunset

Purple Sun

Rain

 Watermelon

Style # 1979
Color: Grass

Simple Pattern Designs

Fabric Design by
Stephanie Saucier

Grass

master tile

Comparing a simple pattern (left) and a
more advanced pattern (right)

Fabric Design by
Leah Sheets

Exercise #4: Creating a Pattern Tile (Intermediate)

Goal
To experiment with the building of a more advanced pattern utilizing a *Bounding Box* to define the repeating portion of the objects.

The imagery in this pattern overlaps between tiles, resulting in a rhythmic flow of pattern.

Illustrator Tools and Functions
♦ **Star** drawing tool
♦ Creation of *Pattern* swatches
♦ *Swatches* panel with *Show Pattern Fill* option active
♦ Use of a *Bounding Box* to define the size of the pattern tile
♦ *Preview* vs. *Outline* view

Overview of the Process
In this exercise you will perform the following steps:
♦ Create several star motifs of varying sizes and arrange them near each other.
♦ On the same layer, create and utilize a Bounding Box of *no stroke* and *no fill* and send it to the back of the stacking order of all the objects. This box will instruct Illustrator to understand the size of the repeating tile.
♦ Experiment with three different Bounding Boxes, so that you can see the effect this box has on the repeating pattern.

Basic and Mandatory Criteria of the Bounding Box
♦ The Bounding Box needs to be made with the **Rectangle** tool.
♦ It must have **no** *stroke* and **no** *fill*, and thus it becomes hard to see in *Preview* view. For this reason, you may want to move to *Outline* view (*View>Outline* menu) to see all the objects, including the Bounding Box.
♦ The *Bounding Box* must be positioned **behind** all other objects. You will need to use the *Object>Arrange>Send to Back* menu command to ensure that it is the lowermost object. All objects must be on the same layer.
♦ If *any* of the above criteria are not utilized properly, the pattern will not repeat as desired.

Basic Concepts to Understand When Developing Pattern Fills
♦ Patterns will be built utilizing multiple objects.
♦ The term *Motif elements* will be used to describe the objects drawn to become the foreground and visual interest in the pattern.
♦ A solid rectangle/square (with a colored *fill* and a *stroke* of None) can be used to define the solid background color of the tile (and thus fabric) if a color is desired. This exercise will not utilize a colored background, but Exercise #5 will.
♦ The *Bounding Box* is necessary. It **must** have no *stroke* and no *fill* and it **must** be positioned at the back of all objects.

Note: Bounding Box Clarified... Two Different Meanings in Illustrator
The Bounding Box, discussed in this exercise and in Illustrator's Pattern Fill swatches, is a box used to define the area of design that will repeat and the positioning and spacing of the tiles. Objects within the bounding box will repeat. This is different from the bounding box that shows you the outer parameters of your objects when you select the View>Show Bounding Box menu. It is unfortunate that Adobe used the same name for both uses, as it causes confusion.

Step-by-Step

Setting up the Document and Creating the Motif Pattern of Stars

1. Create a new document by using the *File>New* menu or pressing *Cmd/Ctrl+N* on the keyboard. Name this file **intermediatepattern.ai** and choose the *Letter* size with a *Portrait* orientation, and the CMYK color mode. Click **OK**. The document will appear. Save the file.

Step 2: Setting the fill and stroke.

Step 4: Creating a grouping of multiple star patterns.

2. Set the *Fill* and the *Stroke* icons in the Toolbox to colors of your choice. Our example uses a fill of orange and a stroke of navy.

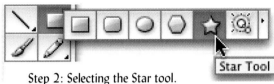

Step 2: Selecting the Star tool.

3. Choose the **Star** tool. It is one of the *Shape* tools and can be selected by clicking and holding on the current shape tool and sliding over to the **Star** tool in the pop-out menu.

4. Draw several stars on the document, varying the size and rotation of each by how you *click+hold+drag* the mouse. Try to keep your collection of stars in a small space, i.e., not much larger than a few square inches. This will allow you to see the repeating patterns more easily later.

Step 5:
Three groupings of the Star collection, arranged vertically on the document.

5. Once you have created a grouping, select all the stars (using the **Selection** tool), and make two additional copies of the star grouping for experimentation. You can *Opt+Drag* (Macintosh) or *Alt+Drag* (Windows) the group of stars. You will want three identical groupings. Place these vertically above/below each other. Leave ample space between blocks, as the copies are for experimentation and you will deal with one at a time. Click away to deselect all objects.

Step 1:
Setting the Stroke and Fill to None.

Step 4: Sending the Bounding Box to the Back.

Creating the Bounding Box and Defining the Patterns

1. Set both the *stroke* and the *fill* to None.

2. Choose the **Rectangle** shape tool.

3. Move to the top group of stars and draw a rectangle around the stars, leaving open space around the stars. This rectangle becomes your pattern *Bounding Box*.

4. While the rectangle is still selected, choose the *Objects>Arrange>Send to Back* menu to ensure that the *Bounding Box* is at the very back of the stacked objects.

5. Ensure that the *Swatches* panel is open and click on the **Show Pattern Swatches** button located in the lower strip of the panel.

Step 2: Select the Rectangle tool.

Step 3: Drawing the rectangle around the motif elements.

Step 5: Viewing the Pattern swatches only.

6. Using the **Selection** tool, select all objects, including the Bounding Box, and drag the group of objects over the *Swatches* panel to the empty area under the existing swatches to create the new pattern. The pattern will be named automatically (e.g., New Pattern Swatch 1). If you want to change the name, double-click on the swatch to open the *Swatch Options* dialog, type in the new name, and click **OK**.

Step 6: Creating a Pattern Swatch by dragging the selected motifs and Bounding Box over the Swatches panel.

7. Using the **Rectangle** tool, create a larger rectangle to the right of the pattern swatch. Fill this rectangle with your new pattern and set the stroke to black. This will show you the pattern repeat inside a box. Note that there is open space between the grouping of stars. This occurs because the *Bounding Box* was drawn larger than the stars group.

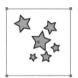
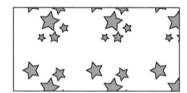

Step 7: The repeat of the first pattern. The pattern has some open space created by drawing a Bounding Box that is somewhat larger than the motif grouping.

Experimenting with Other Bounding Box Sizes or Options

1. Experiment with the size of the *Bounding Box* on the two other star groupings. Ensure that the Bounding Box is at the back, using the *Object>Arrange>Send to Back* menu command if needed.

2. On the second example, make the *Bounding Box* just slightly larger than the outer edges of the motifs. Build a pattern swatch with this combination.

3. On the third example, make the *Bounding Box* smaller than the outer edge of all motifs. You will actually cut through several stars. Build a pattern swatch with this combination.

The illustrations on the next page show you the resulting patterns created by each situation.

Study the Results

It is now time to stop and study the resulting patterns. *As you look at the illustrations on the next page, consider the following:*

♦ The size of the *Bounding Box* in relation to the motifs. As the box becomes larger, more open space appears in the pattern.

♦ If the *Bounding Box* intersects a motif, and no accommodations are made for this (as will be discussed in Exercise #5), the motifs will be cut off in the repeat pattern.

♦ Sometimes it is easier to understand and view the *Bounding Box* by shifting into the *Outline* view. This is achieved by choosing the *View>Outline* menu. You can return to the *Preview* view using the *View>Preview* menu. The illustration on the next page shows the *Preview* mode on the right and the *Outline* view on the left.

Note: Background Color of the Fabric

The fabric built in this exercise will have a transparent background color since you are not using a colored rectangle to define a background color. Thus, if you create a fabric and then place it over another object in Illustrator, you will be able to see through to the object. Exercise #5 will teach you how to create a solid background color and utilize it in the design.

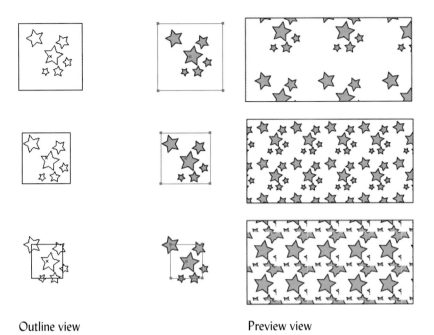

The illustration to the right shows you three examples of pattern, each resulting from a different size Bounding Box. The top example has a larger box and thus is more open in design. The center example crops the tile to the edges of the motifs. The lower example uses a Bounding Box that is smaller than the motifs, and you can see that the repeating pattern shows truncated stars.

Outline view Preview view

One Last Test

As a final experiment, create one more scenario where you have only the motifs and no Bounding Box. Create the pattern swatch and then fill a larger rectangle so you can see the pattern.

You will see that when no *Bounding Box* is used, the pattern repeated extends from the outermost points of the motifs selected. The same results would occur if the Bounding Box were not sent to the back of the object stack. The dotted line around the motifs on the left side of the illustration above shows you what area is used to repeat the pattern when no Bounding Box exists.

Exercise #5: Creating a Pattern Tile (Advanced)

Goal

To create an advanced repeating tile, where the edges of the imagery overlap between tiles, resulting in a rhythmic repeat that appears seamless.

Note: Read Carefully
This is the most difficult exercise in this book. You will need to read carefully.

Illustrator Tools and Functions

- Illustrator *Drawing* tools
- Creation of Pattern swatches
- *Swatches* panel
- Use of a *Bounding Box* to define the size of the pattern tile
- *Preview* vs. *Outline* view

Overview of the Process

In this exercise you will create a textile design that involves a solid-colored background and foreground motif objects. The motifs will be laid and arranged in such a manner that they overlap between the repeating tiles, resulting in a pattern that has more rhythm and camouflages the repeat of the pattern. *You will use three elements (on the same layer) in the design process:*

1. A **solid color square** that sets the solid **background** color of the tile/ fabric. Note that this shape could also be rectangular, although this exercise utilizes a square.
2. A series of **motif-objects** that create the design interest in the fabric and become the foreground pattern.
3. A **Bounding Box** of no *Stroke* and no *Fill* that tells Illustrator the precise area of the image you want to repeat as a tile. This box must be arranged at the back of the stacking order of the design objects. It will be the exact same size as the solid-colored square used for the fabric's background color.

The design process works as follows:

- Create the solid background rectangle/square and design and arrange motifs on top of it, allowing them to fall off the edge of the *right* and *lower edges* of the background.
- Select and copy all the objects to the clipboard and paste them back into the document, arranging the copies side-by-side and below the original set.
- Identify which of the four sets of objects is the master set by determining which set has motif imagery extending from all four sides. If you follow the steps as written in the exercise, the master set should be the lower-right set of objects.
- Remove all objects of the nonmaster sets **except** those motif objects that cross over and enter into the master rectangle/square.
- Create a Bounding Box of *no stroke* and *no fill* that is the exact size of the colored square, and send it to the back using the *Object>Arrange* menu.
- Finally, select all objects and create a *Pattern* swatch using one of the two methods discussed.

background color

motifs

Bounding Box

The Elements of Pattern Design:
1. The background square of solid color/no stroke = fabric color.
2. The motif objects.
3. The Bounding Box of no stroke and no fill, arranged to be the object at the bottom of the stacking order. (Note: For purposes of illustration, a black box representing the Bounding Box is used.)

Extending Motif Objects over the Edge of the Background Square/Rectangle

Although motif objects can be extended off all four sides of the background rectangle/square, it is simplest to limit your first attempts to one or two sides. Once you understand the logic and the process, you can explore more complex designs.

Basic Concepts to Understand with Pattern Fills

♦ Patterns are built utilizing multiple objects. These may **not** contain gradients, pattern fills, brush patterns, or other complex objects. If they do, you will not be able to create/define the pattern.

♦ A solid rectangle/square (with a colored *fill* and a *stroke* of none) is used to define the solid background color of the tile/fabric.

♦ As you create and position the motif objects, consider how a motif that crosses over the edge of the square will interlink with the next square as it repeats. For example, if a motif extends over the right edge of the square, leave some space on the left side of the square. This will allow the portion of the motif that extends over the right edge of the square to fit in as it tiles. This will become clearer as you work your way through this exercise.

♦ You will create a **Bounding Box** to define the portion of the pattern that is to tile. It must have **no** *stroke* and **no** *fill* and it is critical that it be sent to the back of all other objects (*Object>Arrange>Send to Back* menu).

♦ The *Edit>Define Pattern* method may be used to create a new swatch, in which case you will be asked to name the swatch immediately.

♦ Use the *copy+drag* technique to copy objects. In Windows you press the *Alt* key as you drag selected objects. On the Macintosh you press the *Opt* key as you drag selected objects.

♦ We will use the term "master square" to refer to the key block of the pattern, as you build it, which has motif objects extending from *all four sides*.

The Rectangle tool

Step-by-Step
Building the Master Set of Objects (the background square and motif objects)

1. Create a new document by using the *File>New* menu or pressing *Cmd/Ctrl+N* on the keyboard. Name this file **advancedpattern.ai** and choose the *Letter* size with a *Portrait* orientation, and the CMYK color mode. Click **OK**. The document will appear. Save the file.

2. Choose the **Rectangle** tool in the Toolbox. Ensure that the *stroke* is set to none and choose a *fill* color for the background of the fabric.

Step 2: Setting the Stroke and Fill.

Step 4: Drawing the background.

3. Turn the display of the object bounding box off (*View>Hide Bounding Box*).

4. Move to the document, press and hold the *Shift* key on the keyboard, and draw a one-to two-inch square on the screen. The *Shift* key serves as a constrainer key and forces the **Rectangle** tool to draw a square. Keep the square small so you can easily see the repeat later.

The example to the left shows you how the motif objects that extend off one side of the square will slide into the opposite side of the square when the pattern tiles. You need to leave some open space in your tile to allow this to occur gracefully.

5. Using the drawing tools of your choice, create a motif pattern. Ensure that you do not use gradients, pattern fills, or other complex Illustrator objects. As you position the objects to create your pattern, allow

Step 5: Drawing and positioning the motif objects.

some of the shapes to extend off the right side and lower edge of the square. Look at how much of the object falls off the square and ensure that there is enough *open space* at the opposite side of the square for that portion of the motif to fit into when it tiles later.

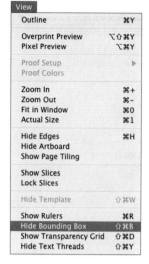

Duplicating and Positioning the Background and Motif Objects

1. Turn the display of the object bounding box off (*View>Hide Bounding Box*).

2. Using the **Selection** tool, select the background square and all the motif objects. You will be moving these in a very specific way to ensure that all objects are positioned correctly for accurate tiling of the motif.

Step 2

3. You are now ready to perform the *copy+drag* operation. Once the objects are selected, press and hold down the *Option* key (Macintosh) or *Alt* key (Windows), and move your cursor to the **upper left corner** of the square. You should see a double cursor, one black and one white (but only if the *Opt/Alt* key is depressed).

Step 3

Note: Copy+Drag Operation

You can copy selected objects by selecting them and then pressing down and holding the Option key (Macintosh) or Alt key (Windows) as you drag the objects to a new position.

4. Now, with the mouse, drag the objects to the right, moving your cursor to the right. You want to move all the objects so that the new set is directly to the right of the original set you are copying. As you drag to the right and position your cursor over the right corner of the original set of objects, the cursor should turn white. This shows you that the upper left corner of your new set of objects is directly on top of the right corner point of the original set of objects. When you see the double-white cursor, release the mouse and your squares should be aligned properly.

Step 4 (above): Copying and moving the original set of objects directly to the right, and then releasing the mouse (below) to align the two objects sets side-by-side. (Note the double-white cursor in the illustration above.)

5. Two motif objects are behind the new square. You will want to bring these forward. Do this by selecting the objects with the **Selection** tool and then choosing the *Object>Arrange>Bring to Front* menu command.

6. If you want to check the accuracy of your motifs/ square placement, move to *Outline* view (choose the *View>Outline* menu command). This view shows you all objects without colored fills. You can zoom in to see if the two squares align properly. When you are ready to continue to the next step, move back to *Preview* by

Step 5

View	
Outline	⌘Y
Overprint Preview	⌥⇧⌘Y
Pixel Preview	⌥⌘Y
Proof Setup	▶
Proof Colors	
Zoom In	⌘+
Zoom Out	⌘−
Fit in Window	⌘0
Actual Size	⌘1
Hide Edges	⌘H
Hide Artboard	
Show Page Tiling	

Outline/Preview menu command

choosing the *View>Preview* menu command. Note that the **Preview/Outline** views toggle back and forth (i.e., the menu switches names, depending on which view you are in).

7. Repeat the process of the previous step, but this time select both sets of objects using the **Selection** tool. Once again, you will be moving these in a way that ensures that all objects are positioned for accurate tiling of the motif. If you want, you can choose the *Select>All* menu command to select all the objects.

8. Press down the *Option* key (Macintosh) or *Alt* key (Windows), and move your cursor to the **upper left corner** of the left square. Once again, you should see a double cursor, one black and one white.

9. *Click+hold* the mouse and drag the objects vertically down. Move all the objects so that the new sets are directly below the original sets you are copying. As you drag down, move your cursor over the lower left corner of the left set of objects. It should turn white to show you that the upper left corner of your new set of objects is directly on top of the lower left corner point of the original set of objects. When you see the double-white cursor, release the mouse and your squares should be aligned properly.

Step 6: Moving to Outline view.

Note the double cursor.

Step 8: Preparing to copy+drag the objects.

Step 9 (above): Dragging a copy of the objects directly below. Note the double-white cursors, which indicate that the upper-left corner of the copied objects is directly above the lower left corner of the original objects.

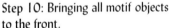

Step 10: Bringing all motif objects to the front.

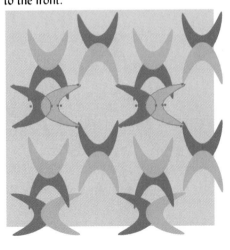

10. Once again, identify and select motif objects that are hidden by the solid squares of color and move these objects to the front using the **Selection** tool and the *Arrange>Bring to Front* menu command of the **Objects** menu.

11. Check the accuracy of your positioning by moving to *Outline* view (*View>Outline*), and return to *Preview* mode when you are through.

Removing Unnecessary Objects

1. The master square is now the lower right square, as this is the only square where the overlapping motif objects occur top to bottom, and left to right. This was the goal of the entire copying process, to establish one block/square where the motifs sit as they should on all four sides of the square.

 Note: The position of the master square will vary depending on which sides of the original square had motifs extending off the edge and which direction you moved when you copied motifs/squares. Always look for the square that has motif elements on *all four sides*.

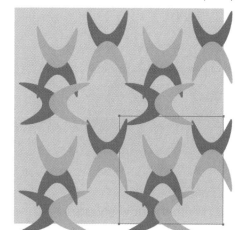

Step 11 (from prior page): Viewing all objects in Outline view.

Step 1: Identifying the master square.

2. Using your **Selection** tool, select all the other squares and delete them. Then, delete any motifs that are not **within** or **extending over** the boundary of the master.

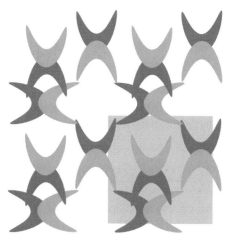

Step 2: Removing background squares and motif objects that are neither contained within nor touch the master square.

The final master square

Creating a No-Stroke, No-Fill Bounding Box to Define the Tile

1. It is now time to create a **Bounding Box** to define the area you want to repeat/tile. This box needs to be exactly the same size as the background square. The easiest way to create the box is to copy the background square and paste it into the document. Using the **Selection** tool, click on the solid background square to select it. Choose the *Edit>Copy* command to copy the object to the clipboard. Since the clipboard is an invisible storage, you will not see anything happen.

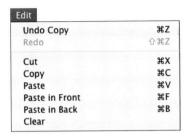

Step 1: Selecting and Copying the Background Square to the clipboard.

2. Now paste the Background square back into the document (*Edit>Paste*). Using your **Selection** tool, click and hold on the upper left corner of the new square, and drag it down directly over the original square. The cursor should turn white when you are directly over the original point. Release the mouse.

The new square

Repositioning the square directly on top of the original

Step 2: Pasting in a copy of the square and dragging it directly over the original square. Use the white cursor to help you see when the two squares are aligned.

3. With the new square still selected, set its *stroke* and *fill* to none. Then, choose the *Object>Arrange>Send to Back* menu command to move the Bounding Box to the back of the stacking order. This is critical to proper tiling success.

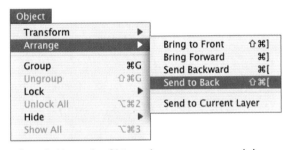

Step 3: Set the Stroke and Fill of the Bounding box to None.

Step 3: Using the Object>Arrange menu, send the box to the back of the stacking order.

Defining the Pattern

You are now ready to define your pattern. *At this point you should have the following in place:*

- ♦ A Bounding Box, which is at the back of the stacking order of objects.
- ♦ A Background square of solid color that defines the background color of the fabric.
- ♦ Motif objects, which extend off all four sides of the Background square.

1. Using the **Selection** tool, drag a box around all the objects.

2. Drag the selected objects into the *Swatches* panel, or choose the *Edit>Define Pattern* menu. The new pattern will appear in the *Swatches* panel. If you use the *Edit>Define Pattern* approach, you will be able to name your pattern as part of the defining process. If not, you must double-click on the swatch to open the *Swatches Option* dialog to name your pattern.

The final object set consisting of a colored square, design objects, and a no-stroke, no-fill square at the back of the stacking order.

Step 2: Creating or Defining the Swatches Pattern. If you use the Edit>Define Pattern approach, a dialog will appear asking for a Swatch name.

3. Test the pattern by creating a large solid rectangle and filling it with this pattern.

4. Lay the pattern into a garment by choosing the pattern swatch for your fill. Adjust the scale per the instructions in Textile Design Exercise #1.

5. Save the file.

The Edit>Define Pattern menu

Steps 3-4: Testing the pattern fill in a large rectangle and utilizing it in a garment.

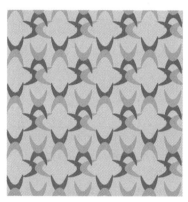

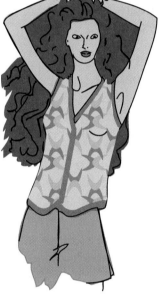

Additional example of an advanced tile design by Keith Antonio

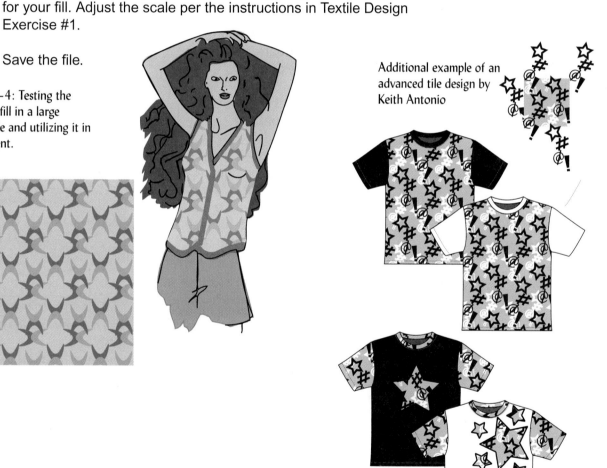

Troubleshooting

Creating this type of advanced repeat is complicated and there are many places along the way where you can make a mistake. When you drag the objects to the *Swatches* panel, you can usually tell if the tile will repeat properly by looking closely at the swatch for any white space around the outer edge. If there is any white space, you most likely are not going to have a proper repeat.

The examples on the next page are typical problems that occur when creating and building the repeat pattern.

White space around the swatch in the Swatches panel is a sign that the no-stroke, no-fill Bounding Box either does not exist, or it is not placed at the back.

Problem #1: There is white space around the pattern when it is repeated.

Possible Cause: Most likely you have either not created a Bounding Box of no *stroke* and no *fill*, or you do not have it at the **bottom** of the stacking order.

To test: Move to *Outline* view, and then click on the rectangle you can see. Observe its stroke and fill to determine if it is the *Bounding Box* or the Background color square. Once you have made this determination, use your cursor keys and nudge the square three nudges to the right. You should see the other square. Choose whichever square is the *Bounding Box* square and, using the *Object>Arrange* menu, send it to the back. Reposition the squares so that they align. Realign the square, redefine, and retest the pattern.

Example of white space appearing around the pattern when repeated

Problem #2: A small white section is included in the pattern.

Possible Cause: The Bounding Box is not aligned correctly beneath the solid background square.

To test: Move to *Outline* view, and look to see if the two shapes are mis-aligned. If they are, determine which one is correct (you may need to move back to *Preview* view). Then select and move the appropriate shape so that it is aligned correctly. Reselect the shapes and define the pattern. Test.

Example of misaligned squares in Outline view

Problem #3: There are fine white hairlines in the pattern.

Possible Cause: Either you have the same problem as #2, or it is simply the monitor display.

To test: If you zoom in with the **Zoom** tool, and the lines disappear or change location, this is most likely a monitor display issue, and not really a problem. Test print the fabric to ensure that the lines do not occur in your printout. If the lines are on the printout, then you are most likely dealing with Problem #2 above.

Problem #4: Printing takes forever.

Possible Cause: Illustrator graphics with patterns do take a long time to print, so be patient. If printing fails, save the file as a PDF and load it into Acrobat Reader to print it.

Exercise #6: Setting up to Create Multiple Colorways for a Textile Print

Goal

To plan and build a panel for use in creating multiple colorways for a textile print. A colorway is a term used in the textile industry to denote color combinations used in fabrics.

Illustrator Tools and Functions

- *Swatches* panel (using *Color* and *Pattern* swatches)
- *Color Guide* panel and *Live Color* dialog (CS3)
- Pulling a pattern swatch from the *Swatches* panel
- **Group Selection** tool
- *Select All Unused* function in the *Swatches* panel
- Creating new pattern swatches
- Color Picker
- Color Libraries
- Color Groups (CS3)
- Extracting colors from artwork using the **Get Colors from Selected Art** button in CS3

Colors can be pulled from photographs to create a custom colorway.

Overview of the Process

In this exercise you will select an existing pattern swatch from the *Swatches* library and evaluate it for the colors used. You will then plan two additional colorways and build a custom panel that contains only the colors needed for the original and new colorways. *The steps are as follows:*

- Pull a pattern swatch from the *Swatches* panel to the document.
- Using the **Group Selection** tool, select each object in turn, and transfer the colors used in it to the *Swatches* panel manually. If using CS3, use the **Get Color from Selected Art** function.
- Analyze the colors used in the pattern and create a chart that records them.
- Plan and build two additional colorways using the chart to stay organized. In CS3 you will create a Color Group of the new colors.
- Explore methods of developing colorways.

Thoughts on Planning New Colorways

As a general rule of thumb, when you build colorways of the same print, you tend to keep the values of the various objects similar. Therefore, it is a good exercise to stop and analyze the original colorway to determine which color is the prominent color, which is subordinate, which is a "zinger" color, etc. The intensity and value of the colors are often used to direct the eye and control how the user sees an image, so consider the colors of various objects as you look at the image.

Now, plan new color combinations. If you are working with a four-color print, plan two additional colorways. You can use photographs to inspire you, or you may use traditional color theory. If using CS3, you can use the Color Harmonies to assist you. You may also use a Pantone book to determine the colors you need and then use the Pantone color libraries in Illustrator to obtain the colors and add them to your swatches library.

Tip Colorways? A piece of cake in Illustrator CS3!

With just four quick clicks, you can create a color group from selected artwork, capturing its colors into a group for storage and use.

1. Select the pattern.
2. Click on the Recolor Artwork button in the Control panel.
3. Click on the New Color Group button in the Live Color dialog.
4. Click OK.

Step-by-Step

Pulling a Pattern Swatch from the Swatches Panel for Use

First, extract solid colors from the original pattern swatch in the panel. Either load a document that contains a pattern you want to recolor in various ways or use one of the default patterns built into the default *Swatches* panel of Illustrator.

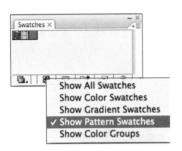

1. Ensure that the *Swatches* panel is open and visible on your screen (*Window*/*Swatches* menu).

2. Click on the *Show Swatch Kind* menu button that is located at the bottom of the panel and choose to view the pattern swatches only.

3. Move your mouse over the swatch you want to recolor, and *click+hold+drag* the swatch off the panel onto the document. The example here uses a built-in swatch called *Chinese Tiles*. A file containing this pattern can be found in the **Textile Design Exercises** folder on the art DVD. The file is called **chinesetiles.ai.** Colors have been altered slightly from the original tile.

Step 2: Viewing the Pattern Swatches only.

The original palette

Dragging the pattern swatch off the panel

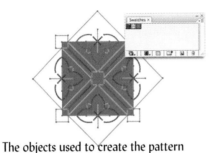

The objects used to create the pattern

Most likely, the objects within the swatch will be grouped, and you will be seeing all objects in the swatch in their selected mode. Click away so that the objects become deselected; that way your next click on a swatch in the panel will not change the color of any of the objects in the swatch.

Step 3: The process of pulling a pattern swatch from the panel to the document. Note the hand in the first two images. Once you drag the swatch outside the panel, it appears on the document with all its objects selected.

Tip: Let CS3 do the Work!

Illustrator can quickly extract the colors in a pattern swatch.
1. Select the pattern.
2. Click on the Recolor Artwork button in the Control panel.
3. Click on the New Color Group button in the Live Color dialog.
4. Click OK.
5. Reorder the colors in the Swatches panel if you like.

Identify Colors Used in the Swatch and Planning the Colorways

1. Examine the swatch and determine how many colors are used in it. It does not matter if the colors are a *stroke* or a *fill*; you are simply looking to see how many colors exist. The Chinese Tile swatch has three colors: green, brown, and beige.

2. On a piece of paper, create a chart listing the colors used. Label these as background, foreground #1, and foreground #2.

Location	Color
Background	Green
Foreground #1	Brown
Foreground #2	Beige

Building a Color Chart of the original colors used in the swatch

3. Now, plan two additional colorways, bearing in mind the values of each of the colors. Try to keep the value of each color the same so the print will retain its integrity and the elements you see when you look at the design won't change. The chart below shows you two new colorways. Note how the general values of the colors were retained. The background is a medium value, one of the foreground colors is dark, and the other is light.

Location	Color	Colorway 2	Colorway 3
Background	Green	Med. Purple	Dusty Red
Foreground #1	Brown	Dark Green	Dusty Teal
Foreground #2	Beige	Light Green	Tan

Additional colorways planned

Clearing Unused Colors from the Swatches Panel

1. View only color swatches by choosing the *Show Color Swatches Only* option in the button bar at the bottom of the panel. This will allow you to view the color swatches only.

2. At this point, remove all color swatches not used in the design. Click on the *Color Swatches* menu arrow (to the upper right of the panel) and choose the *Select All Unused* option. All color swatches not used in the art will become outlined and thus selected. Click on the **Trashcan** button at the lower right corner of the *Swatches* panel. A dialog will open confirming that you want to delete the selected swatches. Click **Yes**. All unused colors will disappear.

Step 1: Choosing to view only the Color Swatches in the panel.

Step 2: Selecting All Unused colors and removing them from the panel by clicking on the trashcan icon and confirming the action in the dialog.

Note: Several colors will remain, but these are not used in the design, as is easily discerned by looking at the *Chinese Tiles* image. Manually remove these colors by clicking on each one in turn and then clicking on the **Trashcan** button in the lower bar of the panel.

Removing the last several colors and color groups manually by clicking on each one in turn (above), and then clicking on the Trashcan icon. A blank panel results (below).

Transferring the Colors from the Original Pattern to the Swatches Panel

There are two ways to perform this function, depending on your version of the software.

In versions prior to CS3:

1. It is safe to presume that the objects in your pattern on the screen are grouped (as is the case with many of the built-in swatches). Click on the **Group Selection** tool in the Toolbox. This is buried under the **Direct Selection** tool, so you either need to tear off this Selection tool, or choose the tool to bring the **Group Selection** tool to the front of the slot in the Toolbox.

Step 1: Choosing the Group Selection tool, which is buried beneath the Direct Selection tool.

2. Using the **Group Selection** tool, click on the object that contains the background color of the pattern. This will make the colors used in the object appear in the *Fill* and *Stroke* sections of the Toolbox. Most objects used for background fabric colors in textile design have a fill but no stroke, as is the case with the *Chinese Tile* pattern. But if your pattern has both a fill and a stroke color, move the two separate colors to the *Swatches* panel in the next step.

3. Drag the color(s) from the *Fill* and/or *Stroke* icons in the Toolbox to the *Swatches* panel. If you want to name the color, then double-click on it and type a name in the *Swatch Options* dialog that opens. Click **OK** to close the dialog.

Step 2: Selecting the background object to move its color parameters into the Fill and Stroke area of the Toolbox.

Step 3: Dragging the color from the Fill icon in the Toolbox to the Swatches panel and naming the color in the Swatch Options dialog.

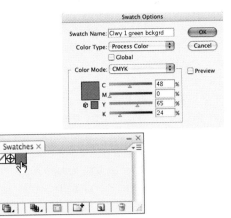

Step 4: The two colors of the foreground objects (brown and beige) in the design are added to the Swatches panel.

4. Now, select one of the foreground pattern objects (e.g., the brown) and look at the *Fill* and *Stroke* icons of the Toolbox. Note that the brown object is stroked only. Drag the stroke color into the *Swatches* panel and name it. Repeat the process for the beige object. You should have all three colors of the initial colorway in the panel.

In CS3:

1. Choose the **Selection** tool in the Toolbox and click on the grouped set of objects that comprise the pattern. All objects should select.

2. Move to the *Swatches* panel and click on the **New Color Group** button on the bottom strip of the panel. A dialog will open, asking for the name of the color group. Name it **Colorway1** and ensure that the **Selected Artwork** button is chosen. Click **OK**. The colors will now appear in a Color Group in the panel. You can drag the colors to re-order them according to your chart.

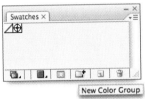

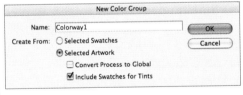

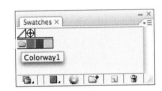

Using the New Color Group button in CS3 to create a color group from selected artwork

Planning Colorways

If your colors are somewhat gray in hue, you may need to change the value of the color to pull more color into it and thus to see the different hues as you move up and down the color strip. The closer your color is to the upper right corner of the Color Picker, the purer the hue. Therefore, understand that sometimes you may need to change the value of a color to create more distinct colorways.

Developing New Colorways: Options . . .

There are various ways of coming up with additional colorways for fabrics as well as other types of artwork.

Selecting Colors from the Color Picker

A simple approach to creating new colorways is to choose new colors from the *Color Picker. If you want to ensure that your colors are more or less in the same value scale, use the following steps:*

1. Ensure that no objects are selected on the screen. Click on the *Fill* icon in the Toolbox.

2. Click on the green background color of your original swatch by clicking on the green color in the *Swatches* panel. This will put the

color in the *Fill* icon of the Toolbox. Now, double-click on the green *Fill* icon to open the *Color Picker* dialog. Notice that a black circle appears in the main color box of the dialog. This is showing you the **value** position of the green. There is a

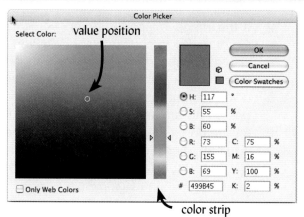

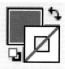

Steps 2 and 3: Using the Color Picker to choose new colors of the same value as the original. The purple (below) has the same value as the green shown in the palette to the left.

vertical color strip to the right of this that has two arrowheads on either side of it. These are pointing to the current hue that is selected (in this case, green).

3. Now, take your cursor and move the arrows on the color strip up and down to select a different hue, but with the same value as the green. Medium purple was the hue selected in the example here. Note how it has the same value as the original green, and how the *saturation* and *brightness* levels do not change. Note also how you can see the original green color and the new purple color above it in the color indicator section of the dialog. This shows you the original

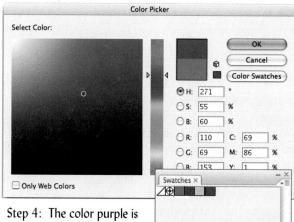

Step 4: The color purple is added to the Swatches panel.

and new colors. Click **OK** to approve and finalize the color choice. The purple color will now be the *Fill* color in your Toolbox.

4. Drag the new purple color from the *Fill icon* in the Toolbox to the *Color Swatches* panel and name it.

5. Repeat the process with each of the two remaining colors from the original pattern swatch (using the color chart shown here as a guide). Using this

Location	Color	Colorway 2	Colorway 3
Background	Green	Med. Purple	Dusty Red
Foreground #1	Brown	Dark Green	Dusty Teal
Foreground #2	Beige	Light Green	Tan

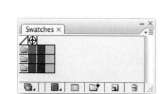

The final panel, with colors from the original and two new colorways added

approach ensures that you have chosen the same values for each of the colors in your design, and the resulting colorways/patterns you create will maintain the same look and feel.

6. Build the third colorway using the value approach if you like, or use an alternate method to create the panel.

7. CS3 users may create additional Color Groups by *Shift+clicking* on the three colors in a colorway to select them, and then clicking on the **New Color Group** button to create each group. Drag the colors if necessary.

Three individual color groups set up in CS3. Ensure the colors are in order, and if they are not, drag them to the proper position.

Borrowing Colors from a Photograph

1. Locate a photograph that contains colors you like. Consider National Geographic, your photo collection, art books, and other sources.

2. If the image is a paper image, you can simply look at it and use the *Color Picker* to choose colors. Or, you may scan it or take a shot of it with a digital camera. Once the image is in a digital format, you may load it into a paint program and use the **Eyedropper** tool to select colors from it. As you select each color, open the *Color Picker* of the paint program and record its formula. For example, the color formula for the purple we chose in the prior section was CMYK 56-63-5-0. You can translate this into RGB, if you like, simply by entering the CMYK formula (as discussed below) and then looking at the RGB equivalents in the *Color Picker.*

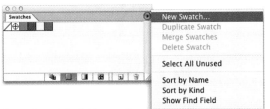

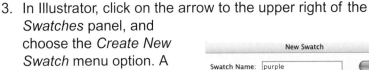

Steps 3 and 4: Adding a Swatch to the panel, using the Create New Swatch option (above), and naming the color in the New Swatch dialog (right).

3. In Illustrator, click on the arrow to the upper right of the *Swatches* panel, and choose the *Create New Swatch* menu option. A dialog will open.

4. Type in the *Swatch Name* and its formula. Click **OK** and the swatch will appear in the panel. Repeat for all the other colors.

Alternatively . . .

5. Load a photo image into Photoshop or some other paint-style program. (Instructions here are given for Photoshop.)

6. Open Photoshop's *Color* panel (*Window>Color*).

7. Using the **Eyedropper** tool, move the dropper over the image until you locate a color you like. Click on the color and it will become the foreground color in the panel. Observe the color formula in the *Color* panel. Record the color formula and note if it is RGB (red-green-blue) or CMYK (cyan-magenta-yellow-black).

Four colors from the Wheel photo image (above) were sampled in Photoshop using the Eyedropper tool. The RGB formulas appear to the right. These can be utilized in Illustrator.

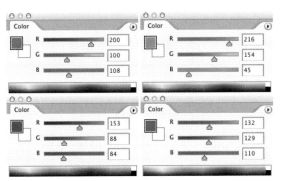

8. Follow steps 3 and 4 above to enter the colors into Illustrator's *Swatches* panel.

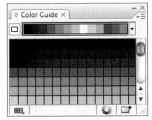

The Sunflower palette with suggested harmonies abilities in CS3

Alternatively Again . . .

1. Use Illustrator's **Live Trace** ability to trace and vectorize a raster image.

2. Then use the **Get Colors from Selected Art** button in the *Live Color* dialog. See page 133 for further discussion on this process.

Using the Pantone Color Library

If you own a Pantone Color book, locate colors that you want to use for the various colorways. Follow the principles of keeping tones and values in line with your original swatch. *To insert the chosen colors into your Swatches panel:*

1. Choose the *Window>Swatch Libraries>Pantone Process* menu to open the **Pantone** library of your choice, (assuming this is the same Pantone library you used). You may also open the Pantone library using the *Swatches* panel menu or menu button in CS3. Once a library is chosen, a new panel window will appear.

2. Experiment with different views and options of the *Pantone Swatches* panel. *These include:*
 - Move your cursor and hold it over any color, and wait to view the Pantone color number of the swatch.

 - Choose the *Show Find Field* menu option in the *Swatches* panel menu. A new field will appear at the top of the panel. Place your cursor in the *Find* field and type the Pantone number you want. The colors in the panel will shift to the area where the color is located, and a black box will surround the color.

 - Choose to see a list view of the colors by choosing *List View* from the panel menu.

3. Once you have located the color you want, click and hold on this color, and drag it into the *Swatches* panel.

4. Repeat the process for the next color you need in the colorway, following the same sequence you used in the original swatch above (i.e., background, primary foreground, etc.).

Step 1: Choosing a Pantone library from the Swatches panel menu.

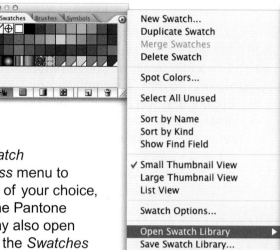

Step 2: Place and hold your cursor over a color to view its Pantone number (above). Choosing a Pantone color by typing the number in the Find field (below).

Choosing the List View of the panel (left) and the resulting panel (below)

Regardless of which method you use to locate the colors you want for the additional colorways of your textile, you will need to move the new colors into the *Swatches* panel.

Saving a Swatch Library

Once you have created your custom swatch library, you may save this as a Swatch Library. This allows you to retrieve it at any point in time, or open it in any document. *To save a swatch library:*

Step 1: Naming the colors in the Swatches panel.

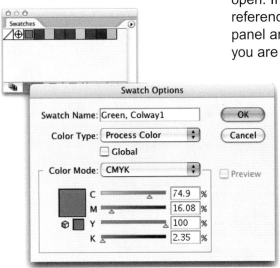

1. Ensure that you have the colorways panel created in this exercise open. If you haven't already, name each color in the panel for reference at a future date. Double-click on the color in the *Swatches* panel and, when a dialog opens, name the color and click on **OK**. If you are using CS3, you can choose to name your Color Groups if you have not already done so.

2. *Click+hold* on the arrowhead in the upper right corner of the *Swatches* panel to access the panel menu.

3. Slide down to the *Save Swatch Library . . .* option and release the mouse. A dialog will open.

4. Type in a name that you want to identify the swatch library with. The example here uses the name **fabriccolorways.ai**. Notice that the file will be saved in the *Swatches* folder, which is located in Adobe's **Presets** folder (inside the **Illustrator** folder). Click on **Save**.

Three color groups saved

Steps 3–5: Saving a swatch library using the Swatch panel menu command.

You may now retrieve this custom swatch panel from any file, at any point in time.

Exercise #7: Building Multiple Colorways of a Textile Print

Goal
To create multiple colorways of the same fabric utilizing the panel built in Exercise #6. The process will vary depending on the version of Illustrator you are using. Instructions will be given for both CS3 and versions prior to CS3.

Illustrator Tools and Functions
♦ *Swatches* panel (both Color and Pattern)
♦ **Group Selection** tool
♦ *Select>Same>Fill & Stroke* menu command and creation of new Pattern Swatches (prior to CS3)
♦ Use of the *Color Guide* panel, **Color Groups**, the **Assign** function of *Color Live* dialog in CS3

Overview of the Process
In this exercise you will utilize the custom panel you built in Exercise #6. You will take the master Chinese Tile pattern and recolor it twice to create a total of three fabrics, each in its own colorway. This process is much simpler in Illustrator CS3, but techniques for all CS versions are presented.

The steps of creating multiple colorways of the same fabric in versions CS2 and earlier are as follows:
♦ Create a new file and load the **fabriccolorways** swatch library saved in Exercise #6.
♦ Pull off the *Chinese Tiles* pattern tile from the *Swatches* panel to your document.
♦ Using the **Group Selection** tool, select an object in the Chinese tile pattern.
♦ Choose the *Select>Same>Fill & Stroke* menu command to select all other objects with the same colors (stroke and fill).
♦ Change the *stroke* and/or *fill* to the new desired colors of the next colorway.
♦ Repeat this process for all the objects in the tile using the colors you created in Exercise #6 and then create a new swatch with this colorway.
♦ Repeat color swaps and the building of a new pattern swatch for the third colorway.
♦ Build three fabric swatches and label them.

The steps of creating multiple colorways of the same fabric in CS3 are as follows: *(detailed instructions begin on page 334)*
♦ Create a new file and load the **fabriccolorways** swatch library saved in Exercise #6.
♦ Build three swatches, each filled with the same pattern (Colorway 1) of the Chinese Tile pattern.
♦ Using the Color Guide panel, open the Color Live dialog.
♦ Use the Assign button and recoloring functions to build the new colorways.
♦ Label the swatches.

Examples of multiple colorways of two prints
Print design by Emily Blickle

Tip: Building Colorways? A piece of cake in Illustrator CS3!

With a few simple clicks, you can create multiple colorways of a textile or garment using CS3's new Recolor and Assign Color functions. These are found in the Live Color dialog accessed in various ways after selecting the art on the document:
1. Recolor Artwork button in the Control panel (with art selected).
2. Edit or Apply Colors button on the Color Guide panel (with art selected).
3. Edit Colors option in the Color Guide panel menu.

Loading the Custom Palette Panel

1. Create a new file and save it as **Colorways.ai**.

Step 2: Loading the fabric
colorways panel, CS3 with Color
Groups (below).

2. Load the custom color panel created in Exercise #6. To do this, click on the *Swatches* panel menu and choose the *Open Swatch Library>Other Library* option. A dialog will open. Navigate to the *Preset>Swatches* folder within the *Illustrator* folder. Locate the **fabriccolorways.ai** file and click on **Open**. The custom panel will open as a separate panel window. Note that colors, patterns, and gradients are displayed in the panel. Note also that no icon strip appears at the bottom of the custom panel. This is one major difference between standard and custom panels. You cannot add to a custom panel. This will be discussed further later in this exercise.

Step 1: Choosing the Default Fill
and Stroke settings.

Creating Fabric Swatches for the Colorways
You are now ready to build and stack swatch templates to receive the multiple colorways of the fabric.

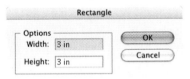

1. Choose the default fill and stroke by clicking on the *Default Fill and Stroke* icon in the lower Toolbox.

2. Choose the **Rectangle** tool in the Toolbox. Move over to the document and click and release the mouse. When the *Rectangle* dialog opens, set both the width and height of the rectangle to 3 inches. Click **OK**. A square will appear on the document. Using the **Selection** tool, position the square in the upper left corner of the document.

Steps 2–4: Creating the fabric squares
using the Opt/Alt+Drag to create
the second square (center) and the
Transform Again command to create
the third square (right).

3. Using the **Selection** tool and *Option/Alt+Drag*, move the square to the right and down slightly to create a second square.

4. To obtain the exact same offset as in step 3, choose the *Object>Transform>Transform Again* menu command. A third square will appear with the precise same offset (square 2 to 3) as the original offset (square 1 to 2). Click away to deselect all squares.

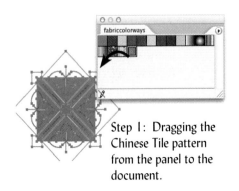

Step 1: Dragging the
Chinese Tile pattern
from the panel to the
document.

Creating the Second and Third Colorways in CS1/CS2

1. Drag the Chinese Tiles pattern swatch from the panel to the document. All objects in the master pattern tile should be grouped.

2. Choose the **Group Selection** tool in the Toolbox. Click on the

background color of the tile to select the object. The *fill* color in the Toolbox should change to match the object (in this case, green). Click on the *Fill* icon to make it active.

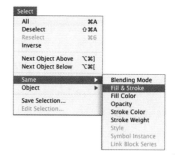

The Group Selection tool

3. Click on *Medium Purple* color in the panel. The background color of the tile and the **Fill** icon in the Toolbox should change to brown. Click on the **Stroke** icon to make it active.

Location	Color	Colorway 2	Colorway 3
Background	Green	Med. Purple	Dusty Red
Foreground #1	Brown	Dark Green	Dusty Teal
Foreground #2	Beige	Light Green	Tan

The plan for changing colorways

Steps 2 and 3: Changing the background color.

4. The **Group Selection** tool is still active. Click on an object in the tile that contains the brown stroke. The stroke color in the toolbox should change to brown. Click on the **Stroke** icon to make it active.

5. Choose the *Select>Same>Fill & Stroke* menu command. All objects of the same parameters should select.

Choosing the *Select>Same>Fill & Stroke* menu command to quickly select all objects with the same attributes. This is used to facilitate the color swapping process in CS2/CS3.

6. Click on the *Dark Green* color in the panel. This color represents the color from Colorway #2 that is being exchanged for the brown in Colorway #1. All objects using the brown stroke should now change to Dark Green.

Steps 4-6: Changing Brown (Colorway 1) to Green (Colorway2).

7. Repeat the process (steps 4–6) for the third color in the original swatch; change the *Beige* of Colorway #1 to the *Light Green* of Colorway #2.

Step 7: Changing Beige (Colorway 1) to Light Green (Colorway 2).

8. Create a copy of the objects in the pattern for the third colorway.

9. Repeat the *color swapping* and *defining pattern* processes you performed with the second colorway to create the third colorway. The new swatch will appear in the *Swatches* panel.

The third colorway

10. Click away to deselect all objects.

Step 1: Selecting all objects in
the pattern.

Creating the New Pattern Swatches in CS1/CS2

At this point, you are ready to create new pattern swatches of the two
additional colorways. *To do this:*

1. Choose the **Selection** tool in the Toolbox. Select all objects of one
 of the new color-altered patterns on the screen by dragging a box
 around them.

2. Choose the *Edit>Define Pattern* menu. A dialog will open. Name this
 swatch Colorway #2 in the *Pattern Options* dialog that opens. Click **OK**.
 A new swatch will appear in the *Swatches* panel. Note that the swatch
 did not appear in your custom *fabriccolorways* panel. This will be dealt
 with later in the exercise. Repeat for the third colorway swatch.

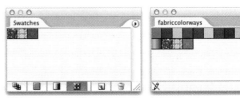

Step 2: Defining the pattern for the new colorway. Note
how the new swatch appears in the Swatches panel.

Filling the Fabric Samples with the Colorway Patterns

1. Ensure that the *Fill* icon is the forward icon in the Toolbox and that the
 panels are available for use.

2. Using the Selection tool, click on the upper left square on the
 document to select it. Click on the first colorway pattern swatch (the
 green background colorway) in the fabriccolorways panel. The pattern
 will move into the square and the Fill icon in the Toolbox. Notice that it
 also moved into the Swatches panel.

The three colorways.
Note: The scale of the
pattern was increased for
illustration purposes.

3. Select the second square on the document. Now, click on the
 second colorway pattern (the purple background pattern). The
 purple pattern will move into this square and the **Fill** icon in the
 Toolbox and the *Swatches* panel. Repeat the process for the
 third colorway. Now all three colorways exist in the *Swatches*
 panel. Click on the **Show All Swatches** button at the bottom of
 the panel to view patterns and solid-color swatches.

Creating the Second and Third Colorways in CS3 Using Live Color and the Assign Function

The new *Live Color* function of CS3 simplifies the building of colorways,
and this alone is reason to upgrade to this latest version of Illustrator. You
no longer need to create multiple pattern swatches, manually swap colors,
and rebuild/define new patterns in the *Swatch* panel. Now the process is
as simple as assigning quick color swaps. You will begin with the swatch
templates built on page 326. There are two approaches: One involves
utilizing existing or prebuilt color groups (e.g., from Exercise # 6), and the
other involves setting up color groups *as you create each colorway*. In the first
appoach, the order of colors in the Color Groups may shift from the original
order. In the second approach, the order of colors in the Color Groups will not
shift, which may be important if you need to visually see the translation.

Method #1: Using Prebuilt Color Groups

1. Change the fill of each of the rectangles of the swatch templates (created on page 326) to Colorway1 of the Chinese Tile pattern. Use the fabriccolorways panel. Deselect all objects.

2. Click on each of the color groups in the *fabriccolorways panel* to move them to the *Swatches* panel, thus making them available for *Live Color* work. Remove any irrelevant color groups to simplify the process.

3. Click on the *Colorway2* color group in the *Swatches* panel. Note how the button bar at the bottom of the panel changes to show the **Edit or Apply Color Group** button.

4. Using your **Selection** tool, click on the middle fabric swatch to select it.

5. Click on the **Edit or Apply Color Group** button at the bottom of the *Swatches* panel. The *Live Color* dialog will open. You will see the three color groups shown in the group storage area.

6. Click on the **Assign** button. The dialog will change slightly, and you will see how Illustrator initially chooses to assign the color exchanges. Note that a black color appears on the left. This is the outline stroke of the swatch. It has not been included in the mapping initially, as an option to preserve black is turned on in the *Recolor Options* dialog (accessed through the Color Reduction Options button in the dialog).

7. You can experiment with different color exchanges using the **Randomly change color order** button, or you may drag colors to exchange their position. You can also limit your swatch library to a specific swatch library, which is very beneficial to companies mixing color palettes for different design seasons/collections.

8. If necessary, drag the *New* color to its proper position to match it to the color it is being exchanged for. In this example's case, you will need to exchange the positions of the *Light Green* and the *Medium Purple*. Once you have moved the New color, click **OK**. You will be warned that you are about to save changes to the color group. Click **Yes** to approve the change and finish the recoloring process.

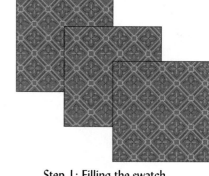

Step 1: Filling the swatch templates.

Steps 3–5: Selecting the center swatch, choosing the second colorway, and entering the Live Color dialog.

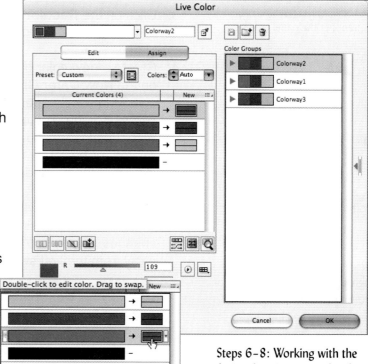

Steps 6–8: Working with the Assign function to recolor the swatch.

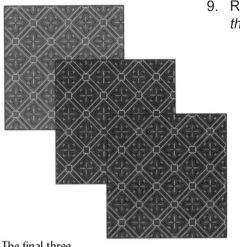

The final three
colorways of the
Chinese tile pattern

9. Repeat the process for the third swatch/colorway. *A quick reminder of the steps is as follows:*

♦ Click on the Colorway3 color group in the Swatches panel.
♦ Select the third fabric swatch
♦ Click on the **Edit or Apply Color Group** button at the bottom of the *Swatches* panel.
♦ Click on the **Assign** button in the *Live Color* dialog.
♦ Drag *New* colors around as necessary to perform proper color swaps.
♦ Click **OK**, and confirm that it is OK to save the color group.
♦ Click **Yes** to finalize the change.

When you have completed the recoloring process of the two additional swatches, you will notice that new pattern swatches exist in the *Swatches* panel. You did not have to redefine the pattern tile to create the new swatch.

Method #2: Creating Color Groups as You Create Colorways.

This method presumes you have colors mixed/chosen in the *Swatches* panel, ready to use, and that you have pattern swatches laid out. You do not have Color Groups built.

Step 1: Filling the swatch templates
and prepping the panel colors.

1. Change the fill of each of the rectangles of the swatch templates (created on page 326) to Colorway1 of the Chinese Tile pattern. Deselect all objects.

2. Select the first pattern swatch.

3. Click on the **Recolor Artwork** icon in the *Control* panel to open the *Live Color* dialog.

4. Create a new color group by clicking on the **New Color Group** button. The color group will appear in the Color Group storage. The order of the colors is controlled by the use of colors in the swatch (or by your settings in the dialog). Note that the black outline color of the swatch is included in the group.

5. Rename this Colorway1, if you like, by typing this name in the color group field and clicking **OK** to close the dialog. Click **Yes** to save the changes. The new color group should be in the *Swatches* panel. Click away from the first swatch to deselect it.

6. Create your two additional color groups in the *Swatches* panel, one at a time. For each, *Shift+click* on the chosen three colors of a colorway, and then click on the **New Color Group** button. Name the color group and click **OK**. Organize the colors in the *Swatches* panel as necessary to have the colors align in the order that makes sense (e.g., following the color chart on page 324). The alignment of the new colors in the color groups will be based on the saved group from Step 5.

Undoing a Color Group

You may ungroup existing Color Groups to return the colors to the palette in an ungrouped way. Select a Color Group in the Swatches panel, then choose the Ungroup Color Group command.

7. Using the **Selection** tool, select the second swatch on the document AND click on the color group you want to use for recoloring in the Swatches panel. Then click on the color wheel (edit or **Apply Color** button) at the bottom of the *Swatches* panel. This will open the *Live Color* dialog, and the swatch will be recolored. Click **OK** to approve the colorway.

8. Repeat Step 7 for the third swatch and the third colorway.

Reorganizing the Swatches and Colorways Panel

If you want to save a final panel with only the colors and patterns used in the fabric swatches, it will be necessary to edit the *Swatches* panel once again and save it. This becomes necessary because you cannot edit a custom palette panel.

Steps 7 and 8: Recoloring using Color Groups selected in the Swatches palette.

1. Remove the unused colors from the *Swatches* panel by choosing the *Select All Unused* option in the *Swatches* panel menu. All swatches that are not used in the document will be selected. Click on the **Trashcan** icon at the bottom of the panel and approve the removal of the swatches. You will have to manually remove the black, white, and gray swatches, which remain by default. Select each one and click on the **Trashcan** icon.

2. In CS3, no further work is necessary, as the colorway Color Groups were moved to the panel in the process. In CS1/CS2, you will need to move over to the *fabriccolorways* panel. Press the *Shift* key and select all the solid colors used in the three colorways. Then, choose the *Add to Swatches* option in the *fabriccolorways* panel menu. All the solid colors will transfer over to the *Swatches* panel.

3. Move the green colorway pattern to the left by dragging it to the first position. At this point, all swatches (other than the stroke and registration swatch) should have names and be positioned in order. Close the *fabriccolorways* panel by clicking on the close icon in the upper left corner of the panel.

4. On the *Swatches* panel, choose the **Save** *Swatch* library option. When the dialog opens, type in the same name used before, fabriccolorways.ai, and click on **Save**. When asked if it is ok to overwrite the old file, choose **Replace**. Save the file.

Much more remains to be explored in recoloring swatches using Live Color in CS3. Refer to the Help files for additional techniques and capabilities.

This completes the textile design exercises.

In the Presentation exercises in this book, you will learn how to create fabric swatch templates, which will allow for more polished textile print presentations.

Student Gallery: Fabric Colorways

Mesa College Fashion Students

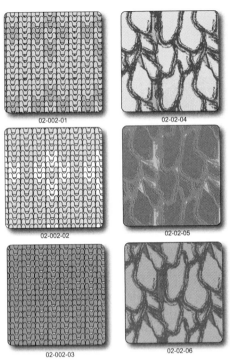

02-002-01

02-02-04

02-002-02

02-02-05

02-002-03

02-02-06

Mai Nguyen

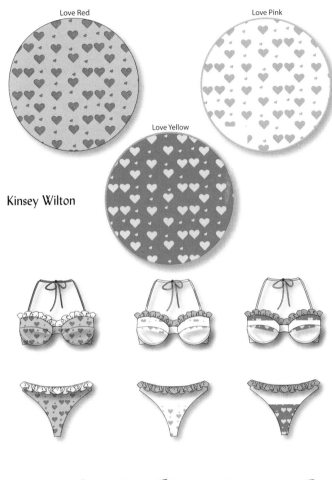

Love Red

Love Pink

Love Yellow

Kinsey Wilton

Ken Shoup

Presentation Techniques

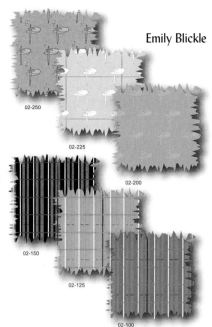

Emily Blickle

This chapter includes a series of exercises to assist you in improving your design presentations. You will learn how to use Illustrator's tools and menu commands to prepare fabric swatch layouts and merchandise presentations. In addition, you will learn how to match actual fabric colors to your printouts and build a library of printed color swatches for reference.

02-250
02-225
02-200
02-150
02-125
02-100

Exercises include:

Exercise # 1 Color Matching between Fabrics and Printouts
Exercise # 2 Using Filters and/or Effects to Create Fabric Swatch Templates
Exercise # 3 Creating Fabric Swatch Layouts
Exercise # 4 Creating a Merchandise Presentation Using Snapshots

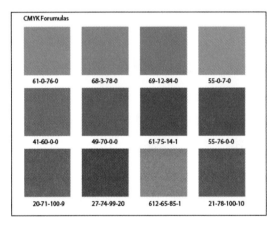

CMYK Forumulas

61-0-76-0	68-3-78-0	69-12-84-0	55-0-7-0
41-60-0-0	49-70-0-0	61-75-14-1	55-76-0-0
20-71-100-9	27-74-99-20	612-65-85-1	21-78-100-10

Exercise # 1
Color Matching between Fabrics and Printouts

03-456

03-457

Exercise # 3
Creating Swatch Layouts

03-458

Effect>Warp >Twist

Effect >Distort & Transform>Twist

Effect >Distort & Transform>Zig Zag

Effect >Distort & Transform>Pucker & Bloat

Effect >Stylize>Round Corners

Effect >Distort & Transform>Roughen

Exercise # 2
Using Filters and/or Effects to Create Fabric Swatch Templates

Exercise # 4
Creating a Merchandise Presentation Using Snapshots

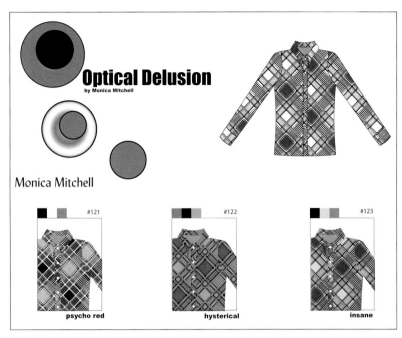

Exercise #1: Color Matching between Fabrics and Printouts

Goal

In this exercise you will learn how to match colors printed on paper to actual pieces of fabric. You will use CMYK (Cyan, Magenta, Yellow, Black) color mode. You will need four pieces of solid dyed fabric.

Illustrator Tools and Functions

♦ **Rectangle** tool with a colored *fill* and *stroke* of None
♦ Color Mixer
♦ *Option/Alt+Drag* to create multiples of one item
♦ *Transform>Transform Again* menu, or *Cmd/Ctrl+D* to repeat the last step
♦ **Selection** tool
♦ **Eyedropper** tool

It is a well-known fact that the colors you see on screen are typically not the colors you get when you print your document. Since many fashion merchandising decisions are made from computer printouts, it is imperative that the printout be an accurate representation of the fabric colors.

If you are designing for an upcoming season, one of the first tasks typically performed will be to build a custom swatch panel of the colors chosen for the season. The color that appears on your printout is the most important color, so matching to a printout is the approach you take. Even careful color calibration between the monitor and printer can still leave room for improvement. Purchased calibration software can assist you, but it is still wise to learn how to achieve the greatest level of control manually.

Quick Overview of the Process

In this exercise, you will perform the following steps:
♦ Create a series of squares on the screen
♦ Fill the rectangles with "best guess" colors, with the goal of matching the printout to the fabric.
♦ Print the results and record the color formula on the printout.
♦ Compare the color on the printout to the fabric and analyze accuracy, then determine what tweaking will be necessary.
♦ Adjust colors as necessary (adding more cyan, magenta, yellow, or black).
♦ Reprint, and record the updated formulas on the printout.

It will take several attempts to achieve a good match. But if you record and save the color formulas from your experiments, you will build a reference library of printed color swatches. These can be mounted in a notebook for easy reference.

Color Matching Tip

If you change the ink cartridge on your printer, color information from prior test printouts may be slightly inaccurate. Thus, if you are embarking on an important project, it is imperative to print new test swatches of the colors you are matching. Changing paper types will also make a difference.

Choosing a Swatch Size

Choose a rectangle size of 2" x 2" for your test swatches so that you may store the samples in plastic slide sheets in a notebook.

Step-by-Step

Setting up

1. Create a new document using the *File>New* menu command and name this file **Color Match Template** in the *Name* field.

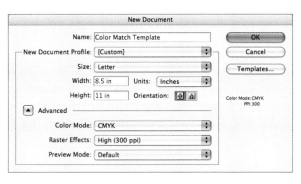

The New Document dialog

2. Select the *Letter* Size, *CMYK* color mode, and *Landscape* orientation. Click **OK**.

3. Save the file using the *File>Save As* menu command.

Creating the Swatch Rectangles on the Document

1. Choose a light to medium *fill* color and set your *stroke* to None.

Steps 1–2: Setting the fill and stroke (above), and choosing the Rectangle tool (below).

2. Choose the **Rectangle** tool in the Toolbox.

3. Click once on the screen and a dialog will open. Set the width and height to 2". Click **OK** and a rectangle will appear on the screen. This will actually be a square as the width and height are the same.

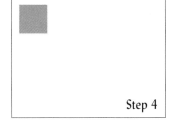

Step 4

4. Using the **Selection** tool, move the square to the upper left corner of the document.

Step 3: Setting the Width and Height of the rectangle in the Rectangle dialog.

5. Press and hold the *Option* key (Macintosh) or the *Alt* key (Windows) and drag the square to the right, creating a copy. Carefully align it on the same row, leaving space between the original and the new square. If you press the *Shift* key after you have started to drag the object, you will find that it aligns perfectly on the same row. Using this *Option/Alt+drag* operation allows you to create copies of the original.

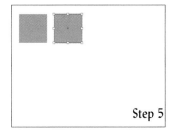

Step 5

6. Now, press *Cmd/Ctrl+D* to duplicate the last movement action. This is the keyboard shortcut for the *Object> Transform>Transform Again* menu. You will see the *copy+drag* operation occur again. Ideally you moved the first copy to be positioned directly to the right of the original, thus allowing all

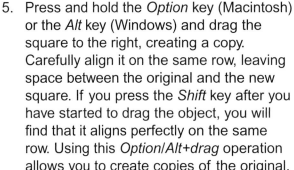

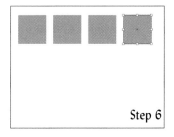

Step 6

Steps 4–6: Creating copies and performing the transformations.

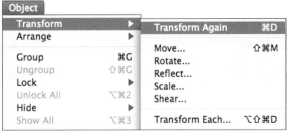

The Transform>Transform Again menu command

subsequent copies to be aligned. Continue this step until you have completed the first row with four squares.

7. Choose *Select>All* from the **Select** menu. This will select all the squares in the first row.

8. Perform the *Option/Alt+Drag* operation again, offsetting the second row with some space between it and the first row.

9. Perform the *Cmd/Ctrl+D* operation to repeat the last offset.

10. Save the document using the **Color Match Template** name.

The Color Match Template image

Using the Color Picker to Mix Colors

You are now ready to mix colors in the *Color Picker* and test your accuracy by creating a computer printout. If you are matching three fabrics, plan to use one row of swatches for each fabric. Hold the color up to the screen and match the swatch to the colors you see in the panel in the next few steps. Assume that the three swatches we are matching are green, lavender, and burnt orange.

1. Using your **Selection** tool, click on the first square to select it.

2. Double-click on the *Fill* icon in the Toolbox to open the *Color Picker*. You can view the current formula for the color in CMYK as well as RGB and other color modes.

3. Drag your mouse up and down the center vertical bar to choose the hue you want.

4. Move your cursor over the various shades and tints of the color until you find a color that seems close. Note the CMYK formula in the *Color Mixer*. If you want, write it down on a scratch piece of paper to transfer to the printout later. Click **OK**. The fill of your square will now become this color.

Steps 1–5: Coloring the first four swatches with the same color.

5. Using the **Selection** tool, select the second square in the first row, then press the *Shift* key and select the remaining squares in the row. Now, all squares in the row (except the first one) will be selected.

6. Click on the **Eyedropper** tool in the Toolbox. Now, move your cursor on the screen and click on the first square. The selected squares will take on the *fill/stroke* attributes of the original colored square.

The Eyedropper tool, used to sample colors

7. Using the **Selection** tool, select each square in turn, double-click on the *Fill* icon in the Toolbox to open the *Color Picker*, and edit its color slightly. Your goal is to have four similar but slightly different guesses of the green color in Row 1 to test print.

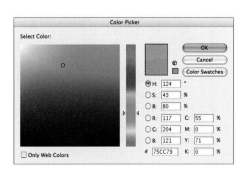

Steps 6–8: Altering the color slightly.

8. Repeat the process using the next two rows of squares for your second and third fabric swatches (lavender and orange). Continue until you have at least four variations of each color to test print.

9. Save the file and print it.

10. Compare each fabric swatch to the printout and determine how you need to adjust the CMYK percentages to achieve better results.

11. Record the color formula on each swatch underneath the swatch or on the back of the swatch. This will become part of your color swatch library, and you can use this for reference in later projects.

12. Perform color adjustments as necessary, using the *Color Picker* to alter the colors on a swatch. You may need to increase the yellow (to make a color warmer), the blue (to make the color cooler), etc.

13. Reprint the page and see if your color matching is closer.

This process of matching colors to fabrics allows you to build a library of colors and their formulas for future use in matching fabrics to printouts.

Recording Color Formulas

You can either record the color formula directly on the file, or hand write it on the printout.

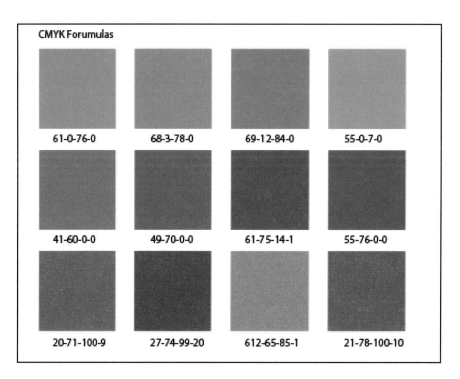

The final Swatch file with formulas

Exercise #2: Using Filters and/or Effects to Create Fabric Swatch Templates

Goal

To learn how to utilize Filter and/or Effect functions in Illustrator to build creative fabric swatches.

Illustrator Tools and Functions

- Rectangle tool with a colored *fill* and black *stroke*
- **Selection** tool
- *Option/Alt+Drag* to create multiples of one item
- *Transform>Transform Again* menu, or *Cmd/Ctrl+D* to repeat the last step
- *Filter* and/or *Effect* menu commands
- *Appearance* panel

Things to Note

- If you use a **Filter** you will alter the shape permanently. If you use an **Effect** you will change only the appearance of a shape without changing its underlying structure. Thus, you can easily return the altered object to its original shape, etc. Simply click on the *Reduce to Basic Appearance* icon at the bottom of the *Appearance* panel.
- You can view the components of your selection by observing the *Appearance* panel.
- You can view the *Effect* you use in the *Appearance* panel. If you want to see the specific settings you used, double-click on the Effect name in the *Appearance* panel and the dialog will open showing the settings used.
- If you utilize an *Effect* on a shape and then create new shapes, the effect will automatically apply to all new shapes until you remove it from the *Appearance* panel. Do this by clicking on the effect name and then clicking on the *Trashcan* in the *Appearance* panel.
- If you are trying to simulate a true fabric swatch, don't use a stroke; simply use a fill.
- You can create multiple swatches of the same shape by using the *Opt+Drag* (Mac) or *Alt+Drag* (Windows) function.

Quick Overview of the Process

The Filters and Effects functions in Illustrator allow you to have fun creating unique shapes, which may be used to present your fabric swatches. Start with a basic rectangle, and then alter its shape using either a filter or an effect.

In this exercise, you will perform the following steps:

- Build a basic rectangle.
- Create multiple rectangles on your document and arrange them on the page.
- Experiment with applying varying filters or effects to the Rectangles.

Samples of Swatch Templates.

Step-by-Step

Setting up

1. Create a new document using the *File>New* menu command and name this file **Swatch Template** in the *Name* field.

2. Select the *Letter* Size, *CMYK* color mode, and *Portrait* orientation. Click **OK**.

3. Immediately save the file. Since you typed a name in step #1, you simply need to choose *File>Save As* and click **OK** to save the file.

4. Turn on the *Appearance* panel (*Window>Appearance*).

Step 4: Setting the Fill and Stroke.

5. Set a *Fill* color of your choice and a *Stroke* color of black.

Building the Squares

The Rectangle tool

1. Select the **Rectangle** tool and click once on the screen to open the dialog. Make your rectangle 2.5 inches wide by 2.5 inches tall. Click **OK**. A square will appear on the document.

2. Choose the **Selection** tool and move the square to the upper left corner of the document. Ensure that the square is still selected.

Step 1: Setting the dimension of the initial rectangle.

3. Press and hold the *Option* key (Mac) or *Alt* key (Windows) and drag the square to a new position to the right, leaving some space between the two squares. If you press the *Shift* key as you are performing this operation, the new square will align horizontally with the original one.

4. Now, using the **Selection** tool, select both squares and *Opt/Alt+Drag* them down to create the second row of squares. Again, using the *Shift* key will aid in alignment.

5. Choose the *Object>Transform>Transform Again* menu command. This will create a third row of squares, using the same alignment as was set up in the first to second row.

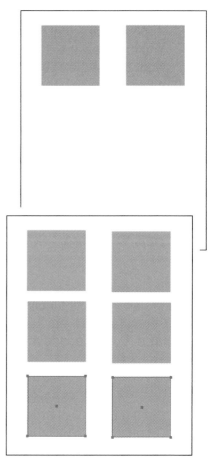

Steps 2-5: Setting up the squares.

6. Save the file.

Applying Filters or Effects

Note: The examples below will use *Effects*.

1. Select one of the rectangles on your document.

2. Choose the *Effect>Warp>Twist* menu command. A dialog will open. Click on the **Preview** check box.

3. Explore changing the settings, watching the preview of your shape. Change the *Horizontal Distortion* to 30 and see if you like the result. Experiment further if you like. When you find a shape you like, click **OK**. Note that the *Effect* is now listed in the *Appearance* panel.

4. Select a different rectangle on your document.

Steps 2-4: Applying the Warp>Twist filter to a shape. Note the options in the Warp Options dialog and note the Appearance panel.

5 . Experiment with various other effects as you change each square on the document. Explore changing the settings, watching the preview of your shape. When you find a shape you like, click **OK**. Again, note that the *Effect* is now listed in *Appearance* panel.

6. Save the file. You will use this file in the next exercise.

The samples on the next page show you some of the possibilities for creative swatch templates.

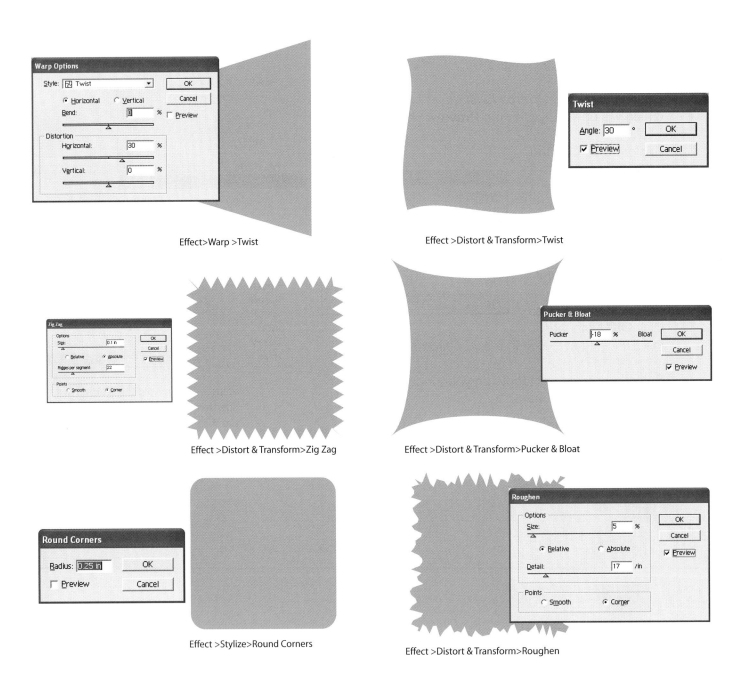

Effect>Warp >Twist

Effect >Distort & Transform>Twist

Effect >Distort & Transform>Zig Zag

Effect >Distort & Transform>Pucker & Bloat

Effect >Stylize>Round Corners

Effect >Distort & Transform>Roughen

Examples of various effects and the settings used to achieve them

Exercise #3: Creating Fabric Swatch Templates

Goal

To learn how to build swatch layouts of multiple colorways of a fabric for use in presentations.

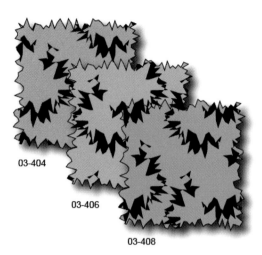

03-404

03-406

03-408

Labeled swatches created in this exercise

Illustrator Tools and Functions

- ◆ Drag and drop objects between documents
- ◆ Importing a Swatch Library
- ◆ *Opt/Alt+Drag* to create multiples of one item
- ◆ *Object>Transform>Transform Again* menu command, or *Cmd/Alt+D* to repeat the last step
- ◆ **Selection** tool

Quick Overview of the Process

In this exercise, you will perform the following steps:

- ◆ Open the Swatch Template file, then create a new document and arrange them on the screen so you can see both. Then drag one of the swatches from the Swatch Template file to the new document.
- ◆ Create two additional swatches and align them with a dropped offset.
- ◆ Import pattern swatches from another file.
- ◆ Place the patterns of differing colors in each swatch.
- ◆ Create a *Drop Shadow* effect for the swatches.
- ◆ Use the **Text** tool to add colorway numbers to the document. These will serve to uniquely identify the swatches.

Step-by-Step

Setting up

1. Create a new document using the *File>New* menu command and name this file **Swatch Layout** in the Name field.

2. Select the *Letter* Size, *CMYK* color mode, and *Portrait* orientation. Click **OK**.

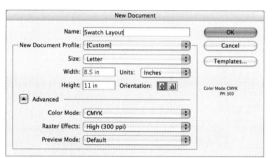

3. Immediately save the file. Since you typed a name in Step #1, you simply need to choose *File>Save As* and click **OK** to save the file.

4. Open the **Swatch Template.ai** file you created in Exercise #2 (if it is not already open). A sample file is found in the **Presentation** folder on your DVD.

5. Resize and position the two documents so that you may see both at once. Windows users may tile the documents (*Window>Tile*).

Positioning two documents so that you may drag and drop easily

Using Drag and Drop to Transfer a Swatch from One Document to Another

You may select objects in one file and drag them into another file. This is known as *Drag and Drop*. It may be helpful to zoom out in each document so you can see more of the artwork on the screen. A 50% zoom level is good. You are now ready to drag and drop a swatch. *To do this:*

1. Click on the *Swatch Template* file to make it the active file.

2. Choose the **Selection** tool and *click+hold* on a swatch object of your choice on the *Swatch Template* file. It is now selected.

3. Drag the swatch object over to the *Swatch Layout* document.

4. Close the *Swatch Template* document. Click on the document to make it active and then click on the close box or choose the *File>Close* menu command.

Steps 1–3: Dragging a swatch object from one document to the other.

Setting up the Swatch Layout

1. Using the **Selection** tool, position the swatch object in the upper left corner of the document.

2. Hold down the *Opt* key (Mac) or the *Alt* key (Windows) and drag the swatch over to the right and down slightly so that you are creating the second swatch offset from the first swatch.

3. Choose the *Objects> Transform>Transform Again* menu command and a third swatch will appear with the same offset as the second to the first sample. Repeat for as many samples as you want to create.

4. Save the file.

You are now ready to place the pattern imagery in each swatch.

The Windows
Transform>Transform Again menu command

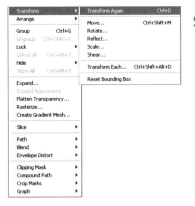

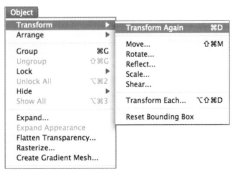

The Macintosh
Transform>Transform Again menu command

Steps 1–3: Copying a swatch (above), and repeating the transformation (below).

Importing and Using Patterns from Another File

For this exercise, the pattern swatches you want are in another file called **pattern1.ai**. You will therefore need to import the swatches into the current file. This file is located in the *Textile Design Exercises* folder on the Art DVD.

Step 1: Opening the Swatch library.

1. Choose the *Window>Swatch Libraries>Other Library* menu command. A dialog will open. Locate the **pattern1.ai** file in the *Textile Design Exercises* folder of your Art DVD and choose it. Click on **Open**. A new panel called *pattern1* will open on the screen. If you move your cursor over the pattern swatches in this panel, you will see the names of the swatches. Look for the squiggle1, squiggle2, and squiggle3 swatches.

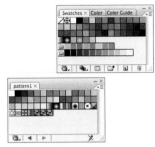

2. Using your **Selection** tool, click on the upper left fabric sample on the document to select it, and click on the *Fill* icon in the Toolbox.

3. Choose *squiggle1* in the *pattern1* panel as the fill. Notice that as you do this, the pattern swatch appears in the main *Swatches* panel.

4. Click on the second swatch and choose the *squiggle2* pattern swatch as the fill.

5. Repeat for the third pattern (*squiggle3*).

6. Click on the arrowhead of the layer being used in the document to open the sublayers and observe each of the paths on this layer. You can see that each fabric sample became a different path. You can selectively turn off the view of each square by using the eye icon.

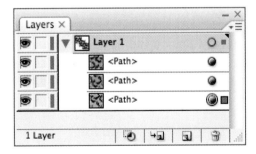

The Layers panel, showing each swatch as a path

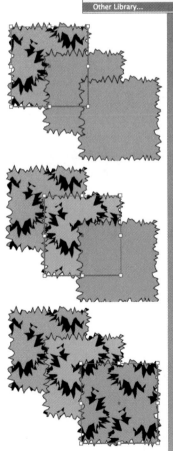

Adding a Drop Shadow Effect

1. Choose the **Selection** tool and drag a box around all three swatches to select them.

2. Choose the *Filter>Stylize>Drop Shadow . . .* menu command. A dialog will open.

Steps 2-5: Filling each swatch with pattern.

3. Ensure that there is a check mark on the *Create Separate Shadows* check box. This allows the drop shadows to become separate in the

The Drop Shadow menu command

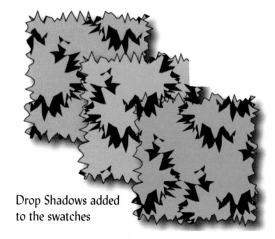

Drop Shadows added
to the swatches

Layers panel, one for each path.
Click **OK**.

4. Choose to undo (Edit>Undo) and
 experiment with the settings in the
 Drop Shadow dialog. Try turning
 off the separate shadow option
 and view how the layers and
 sublayers change in the *Layers*
 panel.

The Drop Shadow dialog

The Layers panel on the left above uses the Create Separate Shadow option
and the sample on the right does not use the Separate Shadow option, and
so the shadow is grouped with the swatch. In both cases, the shadow can be
turned off by clicking on the Eye icon.

Using Text to Number the Swatches

1. Click on the *Window>Type>Character* menu command to open the
 Text Character panel (or you may use the *Control* panel at the top of
 the window, if it is open for use).

2. Choose the Arial font set to size 14.

The Type tool and panel

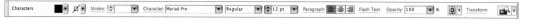

The Text settings in the Control panel

3. Click on the **Type** tool.

4. Click next to the first swatch and type in a style number (you can
 create any number).

5. Using the **Selection**
 tool, reposition the text if
 necessary. While it is still
 selected, *Opt/Alt+Drag* the
 text to the next swatch.
 Repeat for the third swatch.

6. Using the **Type** tool, edit the
 numbers for the second and
 third swatches. Save the
 file.

03-404

03-406

03-408

Exercise #4: Creating a Merchandise Presentation Using Snapshots

Goal

To build a merchandise presentation showing a sample garment and snapshots of additional colorways.

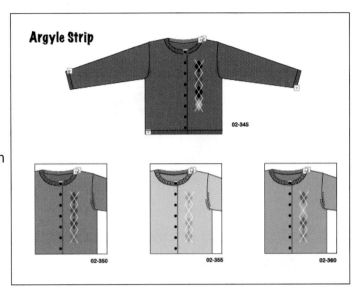

A merchandise layout utilizing snapshots. Nadia Lopez

Illustrator Tools and Functions

- **Selection** and **Direct Selection** tools
- **Rectangle** tool
- *Opt/Alt+Drag* to create multiples of one item
- Grouping of objects (*Object>Group)*
- Creation of multiple colorways
- Drag and drop objects between documents
- **Type** tool

Quick Overview of the Process

In this exercise, you will perform the following steps:

- Load a file that contains the garment you want to work with.
- Save the file with a new name.
- Group all parts of the garment (*Object>Group).*
- Scale the garment, as necessary, to fit the master garment and snapshots on one page.
- Duplicate the garment (using the *opt/alt+drag* copy function).
- Use the **Rectangle** tool to draw the cropping rectangle (which will become the clipping mask). Add this rectangle to the group. These objects are your clipping set.
- Duplicate the clipping set (garment/cropping box) two more times.
- Change the colorways for each of the garments.
- Create the clipping masks.
- Position the master garment and the snapshots on your page.
- Add text and titling to complete the presentation.

Key Concepts

- A *clipping mask* allows you to place one object over another and crop or clip away the parts of the objects that extend beyond the edge of the top object. The upper object serves as a mask to the objects below.
- The *stacking order* of your objects is important. In this exercise, the garment should be in back, and the rectangular cropping box should be in front.
- Once the mask is made, the clipping mask object loses its fill and stroke. You will have to use the **Direct Selection** tool to redefine its stroke parameters.

Review the discussion on clipping masks found on pages 100–101.

Step-by-Step

Setting up the Master Garment

1. Load the file that contains the garment you will be working with. If appropriate, change the orientation of the file to suit the size and proportion of your garment and your anticipated layout of the garment and snapshots. If you want to use the same file as the illustrations here, load **sweater.ai**, which is found in the ***Presentation*** folder on your Art DVD. The document uses a *Landscape* orientation.

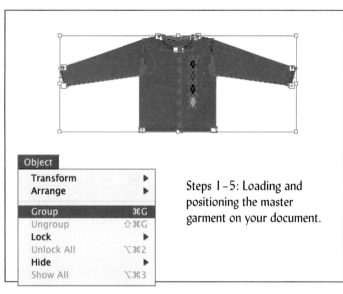

Steps 1–5: Loading and positioning the master garment on your document.

Sweater illustration by Nadia Lopez

2. Resave the file with a new name (e.g., **sweaterlayout.ai**). This allows you to keep the original file intact and available for use for future projects.

3. Choose the **Selection** tool and select all parts of the garment by dragging a box around all the objects.

4. Group all parts of the garment by choosing the *Object>Group* menu command. If some of your objects were on different layers, they will move to the same layer once grouped.

5. If necessary, resize the garment to the proper size to allow the garment and all the snapshots to fit on the document. Ensure that the garment is selected and then double-click on the **Scale** tool in the toolbox. Type in the desired scaled amount. Click **OK**. The garment will scale on your document.

> **Note:** **Text Technique**
> The ribbing on the sleeves and lower band of the garment is actually text that was placed on the angled path.

Tools used in this exercise: the Scale, Rectangle, and Eyedropper tools (above), and the Selection and Type tools (below)

The approach you take at this point will vary according to how much detail exists in the master garment. If the garment is simple, you can build the multiple colorways on the same document as your master. If the master garment is more complicated and there are numerous objects that need to have the colors changed, you can simplify the process by using the *Select>Same>Fill and Stroke* menu command and then change the fill and/or stroke of all in the same step. However, using this approach can become complicated when you want to build the third version of the garment, as you will want to change colors on the third, but not the second or first. Thus, it is easier to work between two documents, building a new colorway on one document and dragging it to the layout document.

Approach #1: Creating Multiple Colorways and Snapshots on the Same Document

You will begin the snapshot process with one master garment on the document.

1. Choose the **Selection** tool and select the master garment. Press the *Opt/Alt* key on the keyboard and drag the garment off the document and onto the scratch area. This operation is called *drag+copy*. You will work with this one garment to create your snapshots.

2. Deselect the garment. Set your *stroke* to black, and the *fill* to None. Set the stroke weight to 1 or 2 pixels.

Step 1: Using the drag+copy process to create a copy of the original garment and place it on the scratch area outside the document.

3. Choose the **Rectangle** tool, and draw a cropping box over the portion of the new garment that you want to use as the cropping box. Position the rectangle on the garment so that the snapshot area shows a portion of the garment that best portrays the design of the garment and includes all colors in the design. Use the **Selection** tool to move the rectangle if necessary.

4. To simplify things, select both the original grouped garment and the new rectangle, and group them by choosing the *Object>Group* menu command. The rectangle will be added to the group.

Steps 3 and 4: Drawing a hollow rectangle and positioning it on the first copy of the garment.

5. Duplicate the garment and rectangle two more times so you have a total of three new garments (use the *drag+copy* operation). You will be changing the colors on the garment for each of these.

6. Using the **Direct Selection** tool, change the colors of each garment to create the three new colorways. You may use the **Eyedropper** tool to assist you if you want to use the same color in more than one spot.

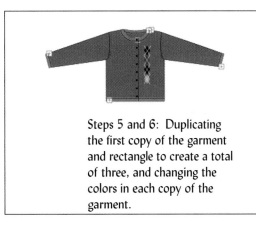

Steps 5 and 6: Duplicating the first copy of the garment and rectangle to create a total of three, and changing the colors in each copy of the garment.

Using a Clipping Mask to Create the Final Snapshots
You are now ready to create a snapshot of each of the colorways. The rectangle object is used to mask the garment beneath.

1. Choose the **Selection** tool. Select the first garment and its cropping rectangle and then choose the *Object>Clipping Mask>Make* menu command or press *Cmd/Ctrl+7* on the keyboard. You may encounter a warning message; if so,

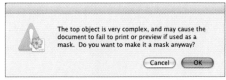

A mask warning that may appear. Click OK and continue.

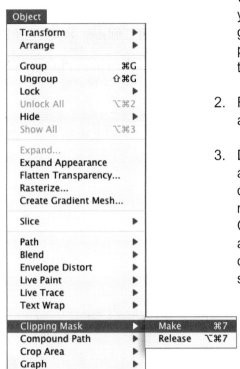

The Clipping Mask menu

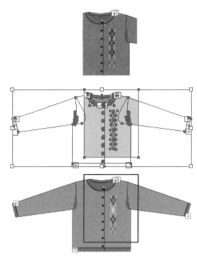

click **OK** to continue. The garment will be cropped, but if you select it, you will see all paths in the original garment (although those paths and portions of the paths that lie beyond the rectangle will be invisible).

2. Repeat the process with the two additional colorways.

3. During the masking process, the fill and stroke of the masking object disappeared. You will need to redefine the stroke of the rectangle. Choose the **Direct Selection** tool, and drag the mouse over an area on the first sweater where the rectangle should be located. This will select the rectangle. You might choose to move into *Outline* view (*View>Outline* menu) to select only the rectangle.

Steps 1 and 2: Creating the clipping mask.

4. Set the *stroke* color to black.

5. Repeat for the two additional colorways.

Creating the Layout

1. Position the three snapshots at the bottom of the page under the master sweater. It doesn't matter if the invisible parts overlap. Try to arrange the snapshots so that they are parallel to each other.

The following are tips to assist you in this process:
- You can turn on the rulers (*View>Show Rulers*) and drag *guidelines* off the rulers to assist you in arranging your snapshots.
- Use the *Align* panel (*Window>Align*) to assist in aligning the garments horizontally. The *Vertical Align Top* function will aid you in aligning the top of the rectangle on the same level. The *Horizontal Distribute Center* will assist you in evenly spacing the garments.
- It also helps to switch into *Outline* view (*View>Outline*).

Using the Align panel (above) and Outline view to position and align the snapshots at the bottom of the document (right)

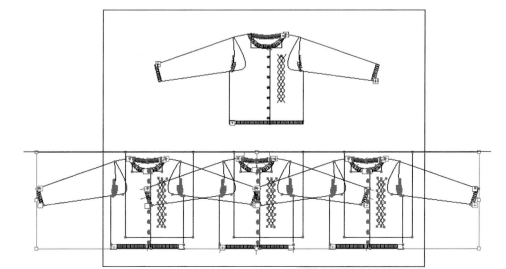

Argyle Strip

02-345

02-350 02-355 02-360

Step 2: Using the Type tool to add colorway numbers and a Style name to the layout.

2 . Using the **Type** tool, number and/or name your garments and colorways as appropriate. To simplify things, create a new layer for the text. This will make the process of selecting objects easier.

The Type tool

Approach #2: Working with Complicated Colorways

Creating multiple colorways with complicated garments is most easily handled using the *Select>Same>Fill and Stroke* menu command. You will work with two documents, one for building the colorways and the other for the layout. Begin by loading your master garment file. *Then, proceed with the steps as follows:*

1. Create a new file for the layout by choosing the *File>New* menu command. When the dialog opens, type **MerchandiseLayout** in the file field, choose *Portrait* orientation, the color mode that corresponds to your original garment's file, and click **OK**.

2. Move, resize, and position both the new **MerchandiseLayout** file and your garment file so that both are visible on the screen. (Windows users may use the *Window>Tile* menu command.)

3. Move to the master garment document, and select the master garment using the **Selection** tool. Since the objects in the garment are grouped, all parts should become selected.

4. Drag and drop the master garment from the master garment file to the **MerchandiseLayout** file.

5. Position the full garment on your page, anticipating the location of the snapshots, logo, and other supportive information.

Steps 1–5: Dragging and dropping the sweater from your master file to the layout file.
Sweater illustration by Mildred Carney.

6. Click on the master garment document to make it the active document.

7. Set the *stroke* to black, and the *fill* to None.

8. Choose the **Rectangle** tool, and draw a cropping box over the portion of the new garment that you want to use as the cropping box. Position the rectangle on the garment so that the snapshot area shows a portion that portrays the design of the garment and includes all colors in the design. Use the **Selection** tool to move the rectangle if necessary.

9. To simplify things, select both the original grouped garment and the new rectangle, and group them by choosing the *Object>Group* menu command. The rectangle will be added to the group.

10. Choose the **Direct Selection** tool, and change the colors on the garment to build the second colorway. You may use the *Object>Same>Fill and Stroke* menu command to simplify the process. Refer to Textile Design Exercise #7 for specific steps on how to create colorways. If you used a pattern fill, you will have to create new pattern colorways and define the pattern as necessary to create a new colorway.

The MerchandiseLayout file with the three new colorways, ready for clipping masks

11. When you have completed a new colorway, choose the **Selection** tool and drag the new garment to the **MerchandiseLayout** document. For now, position it outside the document on the Artboard.

12. Repeat steps 4 through 6 for the additional two colorways. When you are through, you should have a total of four garments on the **MerchandiseLayout** document: three outside on the artboard and one on the document.

Use the instructions on pages 355 through 357 for making the clipping mask and arranging the layout to complete the exercise.

Final Layout of a complex garment with text added

Student Gallery: Merchandise Layouts

Mesa College Fashion Students

Illustrator: Gentry Cole

Illustrator: Kathy White

Illustrator: Megumi Inoue

Illustrator: Saya Ichiki

This completes your tour of Illustrator and the various projects that will aid you in drawing fashion-related art.

Many thanks to the numerous students of Mesa College's Fashion Program, who have aided in the discovery process and contributed their art. Thank you also to the Honors program at the college for assisting with the development and running of computer design courses in the program.

Index